About the Author

GINGER ROGERS (July 16, 1911–April 25, 1995) was an Academy Award–winning American film and Broadway stage dancer, singer, first-rate comedienne, and actress, and made headlines as the highest-paid movie star in Hollywood for her time. In a film career spanning fifty years, she was best known for her famous on-screen partnership with Fred Astaire, and the duo made ten musical films together. Rogers also starred in a variety of comedies and dramas, and found Oscar success with her titular role in *Kitty Foyle: The Natural History of a Woman* (1940). One of Hollywood's legendary divas, Rogers was honored with a Lifetime Achievement Award by the Kennedy Center in 1992.

GINGER ROGERS

Ginger My Story

DEY ST.
AN IMPRINT OF
WILLIAM MORROW *PUBLISHERS*

All photographs courtesy of the author unless otherwise noted.

A hardcover edition of this book was published in 1991 by HarperCollins Publishers.

HarperCollins books may be purchased for educational, business, or sales promotional use. For information, please e-mail the Special Markets Department at SPsales@harpercollins.com.

First Harper paperback published 2008.

Library of Congress Cataloging-in-Publication Data is available upon request.

ISBN 978-0-06-156470-3

17 18 19 ID/RRD 10 9

For by grace are ye saved through faith; and that not of yourselves; it is the gift of God.

Eph. 2:8

INTRODUCTION

CELEBRITY BOOKS HAVE FLOODED THE MARKETPLACE FOR the past decade, giving ghostwriters and unauthorized biographers a field day to extract and print every secret and skeleton of famous film stars.

I vowed that mine would not be a sensational book. Too many people have been hurt by revelations and misinformation in that kind of book. When I refer to my relationships with famous personalities in these pages, I have tried to use discretion and taste. My faith in humanity leads me to believe that people are looking for something more elevating than the sordid details of the intimate aspects of one's personal life. Gossip is hardly uplifting. For my purposes, this had to be a book of substance.

So I set forth in 1982 to write my own book. After a quick tutoring session on my new word processor, I tapped out the memories of my life from childhood to the present. That way, I could control the gossip, inaccuracies, and misinformation spread about me over the years. One of those pernicious rumors that refused to die concerned my relationship with Fred Astaire. Now I have the opportunity to set the record straight. Fred and I had the great privilege of working together in ten films. Magical as they were, my movie career included a total of seventy-three films, which afforded me a variety of roles ranging from comedy to drama. I had the great fortune of working with some of the finest—and most handsome—leading men in the movies. Not only did I work with skilled actors, but I was associated with the most professional producers,

directors, cameramen, dress designers, makeup artists, and theatrical hairdressers in the business.

Although this is a book about my life in show business, it also parallels the history of the film industry. At the time, I wasn't aware of the great changes I would witness from black and white films into Technicolor and beyond. Perhaps I am old-fashioned, but black and white films still hold an affectionate place in my heart; they have an incomparable mystique and mood. Believe me, the technique and expertise for achieving these effects were almost more challenging than the splendor of color. Certainly the result was as powerful as an Ansel Adams photograph.

Yes, I have had some failed marriages. I yearned for a long, happy marriage with one person. I always loved being married. Caring, cooking, and being a companion with a husband were as natural to me as breathing. Perhaps, in show business, such a marriage is doubly hard to maintain. But my life has been blessed in so many other ways that I wanted to share the good times and the hard times with a public that has shown me unbounded appreciation and loyalty.

Of all the many gifts bestowed on me, there is one I treasure above all others—my dear mother, Lela. My professional life would have been nothing without her guiding hand and that of my precious stepfather. They launched me on my beautiful and rewarding career.

Beyond that, however, is something far greater than success or even family ties—my religion. I owe my health and happiness to it. Without it, I would not have had such wonderful and devoted friends and I couldn't have become the dancer, actress, and person that I am.

So you see, this won't be your ordinary book. It will tell things from a different angle. My hope is that the reader will find some inspiration in these pages.

Ginger Rogers
May 1991

ACKNOWLEDGMENTS

MY THANKS TO JANE SCOVELL—WHO HAS THREE BEAUTIFUL children and a beautiful attitude, and who realized in helping me with my book that the only date that means anything to me is 1492.

Thank you to Libby Hughes—a beloved and helpful friend, if only she could cook.

Thank you to Paul Becker—my friend who took my dictation of my first rough outline.

Thank you to Roberta Olden—my secretary of fourteen years. She does everything well, though she can't spell worth a darn; nor can I. Her nose was always over a typewriter or in a dictionary.

My thanks also to Debby Sterling; Russell Galen of Scott Meredith Literary Agency; Stan Evans, for his tireless interest in the futherance of my book; William Kenly of Paramount Pictures Corp.; Jim Jeneji of Columbia Pictures; Leith Adams of USC Warner Bros. Archives; Ned Comstock of USC Archives for the Performing Arts; the late John M. Hall of RKO General.

Thanks to the collaborative editorial team at HarperCollins for all their help, especially Tom Miller, Senior Editor, and Jim Hornfischer, Assistant Editor, and most gratefully to Gladys Justin Carr, Vice President and Associate Publisher.

To my family and friends, who needled me and gave me their support over the last eleven years to *finish this book,* I thank you for your patience and your love.

And finally, as Norma Desmond said, " . . . and all those wonderful people out there in the dark." My love and thanks to you and you and you for making this whole thing possible.

1

THE DISAPPEARANCE

MY MOTHER TOLD ME I WAS DANCING BEFORE I WAS BORN. She could feel my toes tapping wildly inside her for months. Prophetic as this was, my birth was a dramatic one in the steamy heat of a Missouri summer.

In July of 1911, Lela Owens McMath moved to Independence, Missouri. Not quite twenty years old, abandoned by her husband, she left her home in Kansas City. She desperately needed to find a place to live. More important, she wanted her child to be born at home. The little four-room house at 100 Moore Street was the perfect choice.

Once settled, Mother began looking for a job to help support herself and her soon-to-be-born child. She found it through an advertisement calling for "a lady of quality as secretary for the Sand Company," which was located close to her new home.

On a humid July morning, nine months into her pregnancy, Lela applied for the job. She was interviewed by three bearded young gentlemen. Her condition obvious, Mother headed off all questions by admitting she was

expecting a baby at the end of the month. She said her husband traveled a lot and she needed to hold a job in order for them to make ends meet.

"If it's agreeable with you," she told the speechless trio, "I will be able to start work for you the first week in August." Mother seemed to radiate a charm that could captivate even the toughest of critters, and despite the unusual circumstances, the Sand men could do no less than hire her.

"We'll expect you on August 1st, Mrs. McMath—or a bit earlier if you can make it." They shook hands all around and Mother started back to her new little home.

She had gone a half a block in the sweltering heat when she felt a sharp pain warning of the impending event. Calmly, Mother went into a drugstore, called the doctor, and advised him her labor had begun. She asked him to hurry to her place on Moore Street where she would meet him. "I think I can make it, Doctor, it's only a block and a half away. If I'm not at my house when you get there, look up the street—you just might find me sitting on the curb."

Mother left the drugstore and hurried as best she could. Now the pains were more frequent, forcing her to bend to the oncoming labor. Though embarrassed, she was determined to keep going. Wringing wet, she finally reached her front door. The doctor arrived one minute later. He was amazed at her tenacity in getting home.

The labor took longer than anticipated. Day turned into evening and another day began. Then, at 2:00 A.M. on July 16, 1911, in her own home, Lela McMath gave birth to a seven-and-a-half-pound baby girl. Mother told me she had prayed for a daughter and months before had decided to name the baby after the oldest of her three younger sisters, Verda Virginia. Mother asked the doctor to wait until a reasonable hour and then call her parents, Walter and Saphrona Owens, who would soon come to

visit their new blue-eyed grandchild, Virginia Katherine McMath.

Shortly after giving birth, Lela announced that she'd be going to work. Saphrona begged Mother to come home and let her help with the baby. Mother said no to both requests. She had told her employers she'd be there on the first of the month and she would neither budge nor relinquish her baby to anyone.

On August 1, Mother reported to the Sand Company— and so did I. Mother wrapped me up, put me in a basket, and carried me right along. I was raised in the workplace, literally.

"I'm ready to begin," she told the astonished executives. "Where's the typewriter?" Those gentlemen had not bargained for a secretary *and* an infant, but, like so many other men, they were enchanted by this 5'1" dynamo and gave her her way. Fortunately, I was a good little baby and rarely cried. If ever I did disturb anyone in the other offices, Mother would offer to take on extra typing without pay. She earned $6.00 a week and hoped her devotion to the job would ultimately raise her to $8.00 a week. Those sums sound ridiculous now, but in those days they were considered decent wages . . . for women.

On Sundays, Mother would take me by streetcar to Kansas City and leave me with my grandparents for a few hours while she went to the movies. Mother loved motion pictures, and sitting there in the dark, she vowed that one day she would do something—perhaps write for them. On one of those Sundays, my father made a surprise visit to the Owens house and saw me, his daughter, for the first time. His reunion with Mother was not a happy one. Eddins pleaded with her to take him back, promising that his wandering days were over. Lela knew his promises were empty, and so refused. She told him that as soon as she had the money for a lawyer, she would seek a divorce. Chastened, my father left and, for a while, dropped out of sight.

Over the next few months, Mother and I were together constantly. Spring days in Missouri are beautiful, and Mother wanted me to enjoy the outdoors. Under the mottling shade of a weeping willow tree, in the grassy area next to her office, she put a rug and made a makeshift barrier around it. This four-foot-square area was my kingdom. She'd put me in the center and pile little pillows and soft toys around me. "Mommy is right over there," she'd say, pointing to the window near her desk. Then she'd go into the office building, open the screen, and call, "Mommy's right here!" From her workstation, Mother could monitor my actions. I soon became a familiar sight in the neighborhood. People played with me as they went by, and occasionally someone would call up to Lela at her desk to ask permission to take me down the street for an ice cream cone. My love for ice cream came at an early age . . . and has never left!

The April days were blending into May, and I would soon be celebrating my first birthday. One beautiful spring day, Lela got lost in a mountain of work and did not check on me for some while. When she did look out the window, I was nowhere to be seen. At first she was not particularly worried; I had done a disappearing act once before when a gentleman had taken me for ice cream without seeking Lela's permission. Lela admonished him upon our return; the young man apologized and was forgiven. Now I was missing again, and Mother assumed I had been taken on another sweet excursion. She busied herself and awaited my return. After fifteen minutes, she became alarmed. She went to her boss, told him I was gone, and then ran to find me.

The railroad tracks ran in front of the Sand Company building, and when the Pullman cars were parked there, steps were put on either side so that people could cross over the tracks without having to go to the end of the

train. Mother flew up and down the steps of the Pullman car and ran to the drugstore. No one had seen me. Mother was frantic, and went to the policeman on the block. She told the officer her story. "Listen," he said, "that train is pulling out. Maybe someone on that train took your little one." Mother and the officer started running after the moving train, but they were too late.

The policeman and Mother went to the stationmaster to find out the train's number and destination. When she heard it was headed for St. Louis, Mother panicked. The policeman calmed her down and took her to police head-quarters where a description could be wired to the main office in Kansas City. As Mother filled out the necessary papers, tears flooded her eyes. There was nothing more to do.

Mother left the station and, in a daze, boarded a street-car for Kansas City. She sat down and began to pray. Crying and praying for the entire journey, she reached Kansas City and got off the streetcar in the center of the city. She hadn't thought to get a transfer to get to her parents' home, if indeed that was where she wanted to go. Aimlessly she wandered down the main street, crying and sobbing as though her heart would break. She drifted into an office building and into its iron-cage elevator. The buzzer sounded, the attendant closed the door, and the elevator began to ascend. It arrived at the third floor and Lela saw a sign on a translucent glass door that read "Dr. Tutt." In a half-moon under his name were printed the words "Christian Science Practitioner, C.S.B." Sob-bing, she walked to the door, opened it, and stood there, still unable to control her emotion. A kind-looking gentle-man opened an inner door and, seeing the agony of this young stranger, said, "May I help you?"

Something about his warm and loving tone touched my mother and she poured out her story. "Can you help me?" she cried. Dr. John Tutt said that he could and would. He sat with her and talked quietly about what God does for

man. Words of encouragement issued from his lips. He explained that there is nothing lost in God's Kingdom and to believe Him capable of evil was to dishonor God! He asked if Lela had any acquaintance with Christian Science. And, in fact, she did. Eddins's mother, Louisa, was a Christian Scientist and, long before I was born, she had given Lela a copy of *Science and Health with Key to the Scriptures* by Mary Baker Eddy. Lela used to take the book back and forth to work. In order to read it on the streetcar, she covered the binding with a newspaper, for at the time there was much bigotry against the new religion—even within families, which Lela discovered firsthand. One evening, when Eddins was away, Lela spent the night at her parents' home and inadvertently left Mrs. Eddy's book on the bedside table. My grandmother found it and threw it into the furnace. Lela was very upset. "Mother, that was a gift. How could you do that?"

"I don't care," replied Saphrona. "I won't have one of those books in my house!" Despite her parents' disapproval, Mother had found much in the teachings and continued to explore the Christian Science faith. Now, in her darkest hour, she had found her way to a practitioner.

"I don't have the book any longer," Mother told Dr. Tutt, "but when I saw 'Christian Science Practitioner' on your door, I felt like it was a port in a storm." She told him that she loved what the book had taught her about God—things that she had never really understood before. Dr. Tutt asked Mother to pray with all earnestness to her loving Father-Mother God and to know that He was everpresent with her, her child, and everyone. While she quietly prayed, he did some metaphysical work for her. (Metaphysical work is a method of praying scientifically to resolve any inharmonious condition such as sickness, troubled relationships, or financial need.) Then he suggested that she go to her parents' home and telephone him the next morning; meanwhile, he would continue to pray for her. Dr. Tutt offered to loan her a copy of *Science and*

Health, which Mother gratefully accepted. Vowing to trust in God, she left Dr. Tutt's office. For the first time since my disappearance, she began to feel in control. My mother's search for a faith to give her a greater understanding of God led to Christian Science. I benefitted from her search, and for that I am eternally grateful.

Mother reached her parents' home and calmly told them what had happened; remembering Dr. Tutt's counsel, she was able to hold back her tears. My grandparents were beside themselves with worry. Walter had a good friend on the police force and went downtown to see him. Lela went to her old bedroom and threw herself onto the bed. This time her tears were slowly checked by turning her thoughts to one of her favorite passages from the Holy Bible: "For the word of God is quick, and powerful, and sharper than any two-edged sword, piercing even to the dividing asunder of soul and spirit, and of the joints and marrow, and is a discerner of the thoughts and intents of the heart." (Heb. 4:12). Dozens and dozens of times she repeated this quotation to herself.

As the last slivers of daylight were fading, Granddaddy returned with a terse report: "I gave them a snapshot of her when she was eight months old. There was no baby on that train who fit the description Lela gave them of Virginia. They have scoured the neighborhood around the Sand Company, but found no clues." That night, it was dark outside and inside at 3306 Bellefountain Street.

Early the next morning, Granddaddy went out to get the morning newspaper. Breathlessly he rushed in to show Lela and Saphrona the front-page headline of the *Kansas City Star Telegram:*

Virginia McMath Kidnapped.

Granddaddy called his friend at the police station, but there was no news. Mother called Dr. Tutt and told him that there was no trace of her child. Dr. Tutt reassured her

that God had not forsaken her. He quoted from the Bible: "'Before you call I will answer, and while you are yet speaking I will hear.' Remember those words, Mrs. McMath. Listen, and try to hear what God is telling us! You'll hear, my dear, you'll hear!"

"Dear God," she prayed, "I am listening!"

There was no need to fix breakfast; no one was hungry. Walter, Saphrona, and Lela sat around the dining-room table, leaning on their elbows and staring at the morning newspaper. The silence was broken by a knocking at the front door. Saphrona got up to see who it was. A young man stood on the doorstep and politely asked, "Is this Mrs. McMath's parents' house?" At those words, my mother sprang from her chair in the dining room and raced across the living room to the front door. She knew this young man had news of her baby. The youth, whose name was Charles Hubbard, did have information for the anxious mother and grandparents. Charles's uncle had been on the train to St. Louis and was seated across from a man holding a baby girl. The little girl cried continuously and the man tried unsuccessfully to quiet her. In St. Louis, the man and child boarded another train. Later, the uncle saw the newspapers and realized that the crying infant was the missing McMath girl. He called his sister and she sent her son over to the Owens house.

After Charles Hubbard left, Mother called Dr. Tutt. She told him all she had learned, and added that she was going to St. Louis. Dr. Tutt told her that God was in control. Lela packed a small overnight bag and took a streetcar to the Kansas City railroad terminal. On her way to the station, attempting to collect her thoughts, she remembered something that Louisa McMath had told her some time before. Louisa had mentioned a cousin who lived in Ennis, Texas, just outside of Dallas. When they were living together, Eddins had often talked to Lela about going to east Texas and getting a job. Lela began to

believe I had been taken by Eddins and that they were probably on their way to Ennis.

My mother reached the terminal, bought a ticket on the next train to Dallas, and called her parents. Granddaddy told her he had just spoken to a neighbor of Louisa McMath's; it seemed Louisa had left the day before . . . for Texas.

"That clinches it," cried Lela. "Eddins stole my baby!"

With Walter's blessing, Lela prepared for her trip. Mother tried to call Dr. Tutt, but his office was closed. Even though she could not reach him, she knew he was praying for her and for the protection of her baby.

The overnight train trip to Dallas was uncomfortable because the sleeping car was full, and Mother had to sit up all night in the coach. But her waking hours were filled with constant prayer.

Mother later told me many times of the lonesome trip on the train and her thoughts at the time. She thought back to the early days of her courtship with William Eddins McMath and wondered how she could ever have become involved with him.

Like most girls of seventeen, she had been in love with the idea of love. When Mother first saw William Eddins McMath in Kansas City, Missouri, he fit the picture of the ideal suitor: tall and lean, blond and handsome—everything a girl could want. But there was one thing even more appealing about him—his blue eyes. Lela herself had often been complimented on her own pair of sparkling blue eyes.

There were other things about the young Scottish McMath that made her heart pound a little faster. When he took his cap off, he had a nervous habit of running his hands through his blond hair, giving him a boyish, tousled look. Of course, it was the smile, too, that caught her heart. When he smiled, the blue of his eyes spread to the edges of his reddish-gold eyelashes. It was a devastating

smile. Because of that smile and the most fascinating blue eyes she had ever seen, the romance began.

My father was equally smitten with this petite brunette. But the lovers were parted almost at the outset. Lela's father, Walter Owens, was a building contractor who moved where the jobs were. His next assignment was in Salt Lake City, Utah, miles away from Lela and Kansas City.

During their separation, Eddins bombarded Lela Owens with cards and letters. Because of his magical gift for words, Mother waited longingly for his letters and read each one over and over. She carefully kept all of them under her mattress, where she could reach them any time of day or night. Each one filled her heart with romantic fire. Knowing that her mother and father were enthusiastic about the tall Scotsman, Lela broached the subject of marriage with them. Walter's comment to Saphrona was, "He has the sound and serious look of a man who knows his way around the track."

Immediately, Mother wrote to Eddins, telling him about her talk with her parents. He quickly replied, "I'm encouraged to know your mother and father approve of me. I miss you desperately and am sending you a railway ticket. Please pack your clothes and hurry here to me. We can be married right here in Kansas City the day you arrive. Don't wait! Each day you wait is a year to my arms. I love you, Lela. Your impatient Eddins."

When Mother showed the letter to Granddaddy, she was amazed at his reaction. He was aghast. "Any man who wants to marry my daughter will have to come where she is—here in Salt Lake City—and have a formal church wedding."

Once Lela relayed that message to Eddins, he willingly agreed and plans were made for the wedding. After attending many weddings and receptions, she was happy to be the bride at her very own nuptials.

Thus, in the fall of 1909, Lela was married in a white

satin gown with matching pearls sewn into the gown, headdress, veil, and her tiny satin shoes. Everything seemed perfect.

On the very day of the marriage, however, Mother was to discover that my father had not been completely honest with her. He had passed himself off as being her contemporary in age, but in fact he was twelve years older than she. This news upset her parents, who would have taken a different attitude to the marriage if they had known. Mother never could tolerate deceit in anyone. However, she was still in love with Eddins, but from now on she regarded him with a jaundiced eye.

One year into the marriage, Lela was due to give birth to their first child. When the due date came, my father forced Mother to go to the hospital. She wanted to have her baby at home, but Eddins insisted, and she felt too weak to argue. Her parents also insisted. The labor was long and difficult. Finally, the doctor asked Eddins to give him permission to use forceps. Without consulting her, he gave the doctor free license.

In using the forceps, the doctor broke the baby's neck. To offer Lela consolation for this tragedy, the doctor said, "You can have another child. Remember, you are very young." My mother secretly blamed both men for the death of her child and vowed that the next time it would be different; no one would give orders about her baby's birth—no one.

Mother did become pregnant again, but by then, the marriage was beyond saving, and Eddins left. This time, Mother took matters into her own hands. She refused to go back to her parents. Against their protestations and pleadings, she determined to find a job and live on her own. The only solution was to put distance between herself and my father in case he tried to inveigle his way back into her life for another round of betrayals. And now he *had* come back into her life.

Mother's reverie was suddenly interrupted by the

screech of train wheels pulling into the Dallas station. The waiting time between trains was very short and in no time Mother was standing on the platform in Ennis. How would she proceed to reclaim her child? Mother thought of one way, a desperate measure, and felt the outline of the small revolver she had in her purse. She vowed she would use the gun if she had to, but she also knew that violence was not the way to solve this problem. She noticed an empty taxi nearby and went over to speak with the driver. He was a ruddy-complexioned man with shiny black hair and a rolled band around his head. He appeared to be an Indian.

"Did you by any chance see a man get off the train from Dallas yesterday with a year-old little girl?"

"Why, yes, ma'am. That man asked me to take him to his cousin's house on the south side of town. The baby was real cute, but I could see she was not very happy."

Mother got into the cab and confided to the driver, "Young man, that little girl is my daughter. That man stole her from me. He's a kidnapper. Please take me to the house and when I go in, you keep the engine running. When I get my baby, I'll run out and we'll speed away." The driver immediately agreed to the plan and seemed pleased to be in on some excitement. Ever practical, Lela asked the cost of the round trip. The charge was three dollars, and she paid in advance.

As the open touring-car taxi bumped along the dusty roads of Ennis, Mother wasn't quite sure how she was going to get me back safely, but she knew she'd think of something.

The taxi arrived at its destination, and the driver swung the car around for the getaway. Mother jumped out and ran to the front door. Through the wire mesh of the screen door, she saw a high-chair with me in it. I remember it as clearly as if it had happened yesterday. I was chewing on a pretzel, and when I saw Mother, I began calling, "Mackey! Mackey!" Mother almost tore the screen door

from its hinges as she raced into the house. She pulled me from the chair and, hugging me tightly, ran out of the house and toward the waiting cab. Behind her, two women suddenly appeared. One was Louisa, and the other, Mother knew, had to be the person with whom Eddins was now living. "Stop! Stop!" yelled Louisa. Lela hastened into the taxi and cried out, "Hurry, let's go!"

Louisa was quick, too, and ran to the taxi. As it was pulling away, she grabbed the folded top of the open car. But, her grasp was not secure, and she was dragged some fifty yards before she finally let go in despair.

The dusty cab arrived at the station just as the last train was pulling out. The driver told Mother the train was headed for Houston with a stop in Corsicana. Mother asked if he would drive her to Corsicana, where she could spend the night and make plans to get back to Kansas City.

"Well, ma'am," the driver explained, "there's an early train, a fruit train that goes from Houston to Dallas and it comes through to Ennis at 5:45 A.M. It's mostly freight but there are a couple of passenger cars. You need someplace to stay, and if you want, I could take you to my mother's tepee. You and the baby could stay for the night and I'll get you to that Dallas-bound train in the morning."

Mother looked a bit dubious so the driver quickly added, "Oh, and ma'am, don't worry, I don't live with my mother. I have a tepee of my own." Lela considered his gracious, if rather unusual, invitation, and she wondered what sleeping in a tepee would be like. However, there was one problem. If Eddins was looking for her, he'd most likely be on that early train too. But she couldn't think of that now, she wanted to get settled for the night.

"Are you sure your mother wouldn't mind?"

"Why don't we drive over and ask her?"

Within a short while, Mother and I stood at the front flap of a tepee and were introduced to a friendly Indian woman.

"This is my mother. We call her 'Radio' because she knows everything that can be heard on the crystal set."

Radio welcomed us with open arms, and soon we were inside the tepee happily stuffing ourselves with goat's milk and cheese as the crystal set blared in the background. Radio was apprised of our predicament and said that she would waken us at four in the morning and that her son would drive us to the station.

"You can ask Wilbur, the stationmaster, to let you wait for the train in the storm cellar so no one will see you. Just tell him Radio said so. He's related, so I know he'll do it."

The kindly Indian woman saw that her guests were tired and ready for a rest. She pointed to three cow skins lying on the bare dusty floor and told Mother to lie down on them with me. She covered us over with a larger, furrier buffalo skin to keep out the chilly night air.

And so the first night of our reunion, my mother and I slept spoon style, smothered in animal skins on the floor of an Indian tepee.

At four, we were awakened and driven off to the station by our hero in the taxi. As she bought the tickets, Mother was advised by the stationmaster that a man was waiting in the storm cellar. Mother sent the driver to see if the man was Eddins. He came back and reported that it indeed was the man he had seen with the baby two days earlier. "Don't you worry about him, ma'am. I've barricaded the storm cellar door and it will take that kidnapper a good three hours to beat his way out of there. By that time, you and your baby will be well on your way." Twenty minutes later the train pulled in, and when it took off again, Mother and I were safely aboard.

Back in Kansas City, Lela went right to the telephone and called Dr. Tutt.

"Didn't I tell you God was looking out for your little Virginia," he said joyfully. "Let us thank God for His ever-present goodness."

"And thank *you*, Dr. Tutt, for your prayers," Lela said, as she hugged me closely to her.

Mother later learned that Eddins was trying to find a religious school in which he could enroll me under a phony name, to prevent Lela from finding me.

I wish I could say that this was an isolated incident, but the truth is, two years later, my father once more attempted to kidnap me, and that time Mother took him to court. The judge imposed a fine and warned my father that if he tried it again, he'd go to Leavenworth. "I'll throw the book at you," were his words. After that episode, life became more normal for both Mother and me and I never saw my father again. Soon after this, my mother divorced my father. Unencumbered by fears of losing me, Lela was able to get on with her own life.

2

\mathcal{T}HE OWENS HOUSE

My mother was proud of her Welsh heritage and enjoyed telling me our family history—even the exciting tales of her marriage and my kidnapping.

In the mid-nineteenth century, the Owens family emigrated from Wales, the land of music and poetry. Lela's father—my grandfather—Walter Winfield Scott Michael Owens, was born in Parkersburg, West Virginia, where many Welshmen migrated because of the coal mines nearby. His parents later moved to Owensboro, Kentucky, where he grew up and entered his father's trade of carpentry at the age of fourteen. After a few years of apprenticeship, he struck out on his own. His travels took him to Omaha, Nebraska, and into Iowa where he met a handsome young widow, Saphrona Ball, who was clerking in a grocery store. Until her husband's passing, Saphrona had never worked a day in her life. Once he was gone, she was forced to provide for herself and her infant daughter, Pearl. Though it must have been a bit of a comedown—nothing in her genteel background (she was a descendant of Mary Ball Washington, George Washing-

ton's mother) had prepared my grandmother for common labor—Saphrona was willing and able to work. Come to think of it, the women in my family have always pitched in, from my grandmother, to my mother, to me.

Walter courted Saphrona and, when he was offered an overseer's job in Colorado, immediately popped the question. They were married by a justice of the peace and took off for Denver along with little Pearl. The whirlwind romance was over and a prosperous and good marriage had begun.

My grandfather's goal was to become a contract builder, but meanwhile, he worked as an overseer. Once the building was completed in Denver, he was sent on another overseer's job, to Council Bluffs, Iowa. It was there, on December 25, 1891, that my mother, Lela Emogen, was born. Mother was a much-wanted child whom grandfather called "the light of his young male life."

Being somewhat of a raconteur in her later years, she was frequently asked to tell the story of her birth.

She recalled that on that night, my grandfather didn't come home on time. Finally, he telephoned my grandmother and apologized for being late. He said, "I'm bringing Mr. Osbourne, my boss, home with me for dinner."

Poor Grandmother! She had prepared a sparing dinner for the two of them, and now he was bringing a guest, his boss. To top it off, Grandmother was pregnant with their first child, and it was Christmas! Grandmother didn't need this extra burden.

Finally she heard the clip-clop of their horse and buggy. Granddaddy and Mr. Osbourne entered the living room. She decided that she wasn't presentable, so she vanished out the back door into the barn, remembering to take a shawl with her.

As she entered the barn, she heard the chickens kicking up such a fuss that she went to investigate. A big old bear was trying to corner some chickens. Grandmother, putting

on her thinking cap, went in search of a pitchfork. She found it, and as she pointed it at the bear, the labor pains began, but through it all, she was successful in fending off that bear. When she had gone to find the pitchfork, she had opened the back door to the barn. When the bear felt the prongs of the pitchfork, he made a hasty exit out the back door!

All this time, Walter was wandering through the house calling "Saphrona" over and over. In desperation, he came to the barn and found Saphrona stretched out on a large mound of hay in the throes of giving birth to Lelee, my mother. Granddaddy and Mr. Osbourne were just in time to be of service to Grandmother Owens. That was what my mother used to describe as almost being born in a hayloft, as Jesus was. At least, the date was correct. I wish you could have seen the faces of those who listened to this tale. She'd have them "on the ropes" until the story was finished.

Anyway, Mother had three younger sisters: Verda Virginia; Wilma, known as Billie; and Genevieve, called Jean. My grandfather's career flourished. He became a tract developer and built the first apartment hotels in the United States. They were quite something for their day, and included built-in ironing boards, a real luxury. Grandfather also built the Egyptian Theatre in west Denver. In 1916 he invented the cement block with a hole in which to insert a steel rod, and this idea for reinforcement became fundamental to all construction. Because of his work, my grandparents led a peripatetic life; during her growing-up years, my mother called many places home.

My father's family was of Scottish origin, but the McMaths were now southerners. His great-grandfather, Dr. John Sappington, was another of my celebrated ancestors. Dr. John introduced the use of quinine pills to ward off malaria. He first sold his packaged formula from the back of a wagon, then set up a permanent practice in Arrow Rock, Missouri. Dr. John and his wife, Jane, raised

five daughters, and many stories were told of the comely Sappington sisters. A favorite concerned Claiborne F. Jackson, the governor of Missouri. First he wooed and wed daughter Jane. They had four children, but then Jane became ill and died. After an appropriate time of mourning, the governor turned up at the Sappington plantation again, this time to ask for the hand of the next daughter, Louisa. Alas, this marriage, too, ended sorrowfully when Louisa suddenly sickened and died. Undaunted, Governor Jackson approached Dr. John and asked for his eldest daughter, Eliza Sappington Pearson, a widow with four children. When Governor Jackson popped the question this third time, Dr. Sappington replied emphatically, "Yes, but don't come back for Mama!"

The last Mrs. Jackson, Eliza Pearson, was the mother of Louisa Eddins, and Louisa's son was William Eddins McMath, my father.

Lela Owens McMath proceeded on her independent way as sole support of her child and herself. She continued to earn her keep as a secretary, although she had other, higher aspirations. In 1915 the *Kansas City Star* ran an essay contest with a $1,000 prize. Mother wrote a piece on the devastating effects of the prison system on inmates and won first prize. Friends advised her to send it to Hollywood, where it might make a feature film. Lela said, "I'll go one better, I'll TAKE it to Hollywood." Which is exactly what she did. She took me to stay with my grandparents and hopped the next train to Hollywood.

At the same time that I moved into 3306 Bellefountain Street in Kansas City, my aunt Verda Virginia and her two girls, Jean, aged four, and Helen, eleven months, also returned home to live. Verda Virginia's husband, Percy Brown, had been killed in a gas explosion at their apart-

ment house and she needed to earn a living to support her children.

Saphrona and Walter Owens now had a houseful of youngsters. Having no sisters or brothers, I found it a delight to be surrounded by one older than I, my grandparents' youngest daughter, Genevieve, who was ten; one younger than I, my cousin Jean; and one toddler, baby Helen, whom I treated as my own walking, living doll. She was a beautiful child, with fair skin and blue eyes and resembled her mother, whereas baby Jean had olive skin and brown eyes and resembled her father. We kids got along wonderfully together, with just enough difference in our ages to make it interesting for all of us.

Helen made up words to express what she wanted to say. She is responsible for my name being Ginger. Because she couldn't say a "V," my name came out like "Ba-din-da." Helen worked on my name until she got it to sound like "Dinda," then "Ginga," and she finally got it to its present sound. So ever since then I've been officially "Ginger"!

For the next years, life was particularly full. I missed my Mackey, of course, but my grandparents made a special home for me and my cousins. All the pleasures of small-town life were ours. We children were always happy when a food vendor would come by with all his beautiful vegetables and colored fruits. The jovial Italian, with his fruit syrups and shaved ice, would push his little cart and ring his bell, which signaled "Cone for a nickel." The youngsters crunched the cracked ice between their teeth, savoring the five minutes of that nickel cone. When the ice man made his early rounds, he swung huge blocks of ice, held by scissor-like tongs, across the leather that covered his back, making his way to our "ice box." Once in a while, an organ grinder and his red-capped monkey would walk down the street and entertain us for pennies, which we would beg from our grandmother. Occasionally, a photographer with a donkey would walk down

Bellefountain, offering to take pictures of the young ones riding his donkey. I still have a photo taken at that time.

Bellefountain was a lively street. Next door to my grandparents' house was an empty lot. My granddaddy had permission from the lot's owner to use a thirty-foot-square area for his kitchen garden. He taught me to plant seeds and put me in charge of the radish row. I felt an obligation to run out each morning to see if any green had appeared. Nothing happened for quite a few days, but I kept my vigil. And finally the day came when, from each little seed, two perky green leaves pushed their way through the mound of soft earth. I squealed with delight. I rushed over and took the two little leaves in my finger and thumb and pulled the plant up.

My grandfather, who'd come up behind me and observed my actions, called out strongly, "Virginia, what have you done?"

"I just wanted to see if they were grown up yet," I replied.

He took the two little green leaves and the whitish string hanging from them and held them up for me to see. "Virginia, you have ruined this plant. It can never grow again."

"But I'll go put it back, Granddaddy."

"No, that won't do it." He sat me down and explained, "In planting, you cannot pull things up from the earth before they are full grown. That would be like telling tales of things that should not be spoken of until the action is accomplished. In either case, you spoil the fruits of your labor. Remember this, Virginia."

Over the years I have remembered this and have been cautious not to take the bloom off the rose by heralding premature ideas that have no root as yet.

The vacant lot next door was also where I had a secret rendezvous with a potato, before my mother went to Hollywood. One of my playmates had noticed the ugly warts on the back of my hands and told me that his grand-

mother said that if you cut a potato into four sections and bury it at night while there is a new moon, the next day the warts on the back of your hands will be gone.

I thought about this when I went to bed one night and the next morning at breakfast, I asked my grandmother when the new moon was scheduled to appear.

To satisfy me, she took the almanac and flipped through it, and said it was the next Monday night.

"Are you going to see it? Is that it?"

"I don't know," I replied, my mind on other business.

When Monday night came, I went to the basement, where Grandmother kept her vegetables, and found a hefty Irish potato. Guardedly, I cut the potato into quarters and sneaked out of the kitchen through the back-porch door with my toy shovel. I looked up to see if the moon was still there, because this was no time for it to be down. I buried the potato as my playmate had prescribed. I scurried home through the back door and crept upstairs to my room.

I breathlessly watched. One day and night passed. Two days and nights passed. Three days and nights passed. Each morning I examined my hands. They were just like they were at the beginning, when my little friend told me about the new-moon cure. I confronted my childhood witch doctor. "I did what you told me. I have waited three nights, and look, nothing! I have still got them! My warts are just the same as they were before."

"Did you do what I told you?"

I repeated each step and at the end of my explanation he said, "But you didn't look over your left shoulder at the moon when you finished burying the potato."

"You didn't tell me that!" I said.

"Virginia, would you come in the house, please, right now."

Oh, dear. I hadn't counted on being overheard by my mother, through the side window. How, I wondered, was I going to explain this episode to her!

"Virginia, in Sunday School, haven't you been taught that God is the creator of all good? And the First Commandment is one none of us should break. 'Thou shalt have no other gods before me' means that you are to look to God only, for the good each one of us receives. Now you go upstairs to your room and pray a prayer of forgiveness. Why didn't you tell me that you needed help with this problem concerning your hands? When you get through with your prayer, you come downstairs, and we will call Mrs. Frazier, our practitioner, and tell her what you've done and ask her to help you in prayer about this situation."

I was obedient. I did as Mother said. Mrs. Frazier told me she would pray for me, and I was to call her again tomorrow. She had explained to me, as Mother had, that we did not honor God if we trusted in a source that claimed to have power other than God. I began to see what that commandment meant.

The next afternoon I talked to her again. This time she told me how Jesus loved little children, and how God had sent Jesus to explain His teachings by demonstrating all that He did through His Father, and how God's ever-presence did not admit anything contrary to good. She explained more about prayer and reminded me that God loved me. As she was going to the Wednesday evening church meeting, she asked me to call her the next morning.

Mother wanted me to have this experience of personally talking to a practitioner so that I would know how to ask for prayerful help in the future. I was sorry that I had ever turned away from thinking God-like thoughts. The next morning, as I was tying my shoelaces, I saw the backs of my hands. Not one spot! Not one tiny vestige of warts! Running to my mother, I said, "Look, Mom, look, look!"

She hugged me and said, "Dear, see what prayer does. Now let's go get Mathilda on the phone."

Mrs. Frazier was joyous with us and reminded me that

we must constantly thank God and not turn to little gods by looking over our shoulder at the moon while burying a quartered potato. I couldn't wait to see my little doctor friend to tell him that I had a better God that healed me! I didn't need any old potato. In my rejoicing, I told every one of the kids on our block and at Sunday School, and I showed them how clean my hands were of warts. This was an important milestone in my religious education.

Even my grandmother was impressed. The old saying "Seeing is believing" now proved true, and she recognized and admitted that God has the power to heal. Saphrona had had many bouts with my mother over Lela's turning away from the family religion. While my mother and father were dating, there had been a few months of separation when Mother moved out rather than give up her faith. This proved to be difficult for both sides. But, happily, the relationship was restored through the same deep conscientious turning to God in prayer. As for me, I was raised in Christian Science and have practiced it faithfully. My faith has enriched my life and enabled me to maintain the strength necessary to make each and every moment mean something.

While I was living with my grandparents in Kansas City, I made my first appearance before a movie camera. Local commercials were shown in theaters during the silent era even as they are today. A Kansas City optician wanted to make a three-minute spot, a simple narrative between a grandmother and a grandchild. More than a dozen youngsters were seen before one blue-eyed, curly-haired blonde was chosen . . . me. I do not know if I was taken to the representative or if he saw me by chance. I do remember the commercial. As the grandmother fumbled for something in her parlor, a caption at the bottom of the screen said, "Virginia, have you seen Grandmother's reading glasses?" The camera then cut to little Virginia, who

tossed her golden curls, flashed a happy smile, and pointed her finger upward. Underneath, the caption read, "Yes, Grandmother, they're on your head!"

Can you imagine how I felt when all my family and friends went to the movie theater and saw me on the screen? I was the talk of Bellefountain Street.

3

\mathcal{M}OTHER GOES TO HOLLYWOOD

MY MOTHER CARRIED OUT HER THREAT TO GO TO Hollywood with her idea for a movie. She went in 1915, armed with her talent, her grit, and an abiding interest in social reform, particularly the iniquities of the penal code. In researching her prize-winning essay for the *Kansas City Star*, she received permission by letter from the governor of Kansas to visit the penitentiary in Leavenworth. She gathered copious notes and came away with a list of "lifers." Mother wanted to alleviate some of their suffering, and she began to exchange letters with them. However, her own mother did not take to the idea. Saphrona was furious at Lela for corresponding with murderers and thieves, because she was fearful that sooner or later one of these inmates would be paroled, and wind up on her doorstep! Once her essay had won the prize, Lela became convinced that she could use her research to make a dramatic and moving film. This medium could show the horrors of the prison system and force a change. With this in mind, Lela felt she could show Hollywood a thing or two!

Upon her arrival in the "Orange Grove Country," she

quickly discovered that producers were concerned less with penal reform than with finding scripts for their glamorous stars. Rumor had it that stories were desperately needed for the reigning movie queen, Theda Bara. Mother scorned such nonsense. Lela thought this actress a bit risqué in her attire, and she laughingly described Theda as "too thread-Bara!"

However, if every writer in Hollywood was chasing after this rumor, Lela decided she'd grin and Bara-it! Mother's fertile imagination went to work on thinking about a possible plot. At a party one evening, Mother met film director Raoul Walsh, and asked him if material really was needed for Theda Bara. When he said yes, she told him her idea. Walsh liked it, and he encouraged Mother to put it down on paper. Practical as well as idealistic, Mother sat down at her trusty, big old Underwood typewriter and banged out twenty pages of an outline. Before long, Lela's script was purchased, and production was under way, with the voluptuous Bara as the film's star. She received her check and considered herself an active motion picture scenario writer.

But Mother's joy was short-lived. When Mother saw "her" movie, she could find no resemblance in it to her original idea. She heard that first, the director changed it.

Next, the producer changed it.

Finally, the *Star* changed it. The attitude toward the writer is the same today as it was yesterday.

That experience was one of the bitter pills Hollywood made her swallow. Her future writings reflected somewhat her fear of the movie studios' not being true to a story they'd gone to the trouble to purchase. Lela was to learn a great deal. Little by little, she had to overcome a writer's agonizing sense of timorousness. However, she refused to give up!

Swallowing her disappointment, Mother assessed the situation. She needed to make money and could either go back home and get a job as a typist, or stay in Hollywood

and get a job as a typist. She decided to stay. After all, she might hit the jackpot with her next script.

A chance meeting with another movie director, Henry King, gave her a boost. Lela admired this clever, intelligent director, and she told him the story of the Theda Bara deal and of her desire to do something worthwhile about the prison system. She also revealed her sadness at being separated from me. Mother was ready to pack it up and go home. King advised her to stick it out. He thought the prison reform issue could be a blockbuster. "Why don't you get yourself a few more movie credits and then present this idea to a top-notch producer? And what's more, sounds like your little one is in good hands with your parents. Why don't you get yourself over to Fox studios where they're making films with Baby Marie Osborne? They're crying for stories for her. Since you are a mother, certainly you can write ideas for Baby Marie that they've not yet touched on." Mother took Henry King's advice. She went to Fox and for the next months Lela was hard at work writing stories that reminded her of me and suited Baby Marie. Mother provided a steady supply of scripts for the child star.

One day, Mother showed the director of the Osborne films a snapshot of me. He suggested, "Why don't you bring Virginia out and we'll put her in movies and make her a star?" Mother didn't hesitate in her answer. She had been around long enough to see how movie children were treated in order to get them to emote. They were slapped, pinched, and stuck with pins to make them cry. Why, in order to get them to weep, some were even told that a parent had just died. These little ones were worked long hours, often without time for education or even sufficient time to complete a meal. Stringent laws concerning working children weren't enacted until the late 1930s.

"Never in a million years would I submit my child to the harassment given to that little Marie," Lela replied to him in her ever-forthright manner. This was a wonderful char-

acteristic of my mother's (well known to anyone who knew her). She had the ability to "tell it like it is." If you asked her a question, you'd have to stand back because she'd tell you exactly how she saw a situation. If you didn't want to hear her opinion, the best thing to do was not to ask her. If you did, she'd tell you why your underskirt was showing and how to fix it.

Mother wrote for the Fox studios for five months, and during this period became good friends with a charming lady who was looked upon as a top scenarist, Hettie Gray Baker. These talented ladies developed a mutual admiration for each other. Fox was sending a number of writers, directors, and cutters to New York for an upcoming film. Hettie had praised Lela's work to the Big Boys in the front office and before long, Mother was chosen to join the eastern brigade. She was excited at the prospect of being in Manhattan as a bona fide writer for Fox studios. Moreover, once she established herself, Mother would have my grandparents pack my things and put me on the train for the journey back to my "Mackey." (My mother's friends would introduce her to new friends, and, continually hearing, "This is Mrs. McMath," I, in my childlike mimicry, shortened the sound to "Mackey." So, my mother was Mackey to me in my early years. Later on, I changed her name, Lela, to Lelee, which had a tender sound to it—at least to my ears!).

4

JOINING MY MOTHER IN NEW YORK

IMMEDIATELY AFTER SHE SETTLED INTO HER SMALL HOTEL apartment, Mother sent for me. My grandparents were told to put me on the train to Chicago, where I would be met by my Aunt Billie, who would transfer me to the New York train.

Granddaddy pinned a large tag with my name, address, and destination onto my waistcoat and advised me never to remove it. My waistcoat and I were never to separate during the long days of travel, until the moment when I would arrive in my mother's welcoming arms in New York. I was excited about seeing my mother and almost as thrilled about the long-distance train ride.

I shall never forget the adventure of climbing aboard that train, traveling alone, and the sheer pleasure of sleeping in an upper berth. The train ride was like a dream in which I was whisked away to unknown lands. The passing countryside was all Missouri to me. I got special treatment because I was an unaccompanied minor. Every other passenger seemed duty bound to stop and say something to me.

What fun it was to go into the dining car and sit at a table for two. Though a new person would be seated across from me at each meal, the questions were always the same. My companions automatically assumed I was on my way to see my grandmother. When I told them I was going to see my mother, they'd ask, "And your daddy, too?" I'd honestly reply, "Oh, I haven't seen my daddy since I was three."

With that, the questions would generally stop. Despite the way it sounds, I seldom felt any lack in not having a daddy or in being separated from my mother for so long. My emotional needs were more than met by my loving grandparents.

The ice cream on the train was good. I could always eat ice cream, whether I was hungry or not. Ice cream just seemed to fit into the tummy cracks and never made me complain that I was too full, the way "Eat some more of your carrots and peas, dear" would.

Finally we reached Chicago and the train came to a positive, absolute stop. Pressing my nose against the window, I could see people, but no one that looked like my mother's sister. Someone from the Travelers Aid Society came and took me off the train so I could meet my Aunt Billie in the society's office. When I saw her, I ran into her open arms. She lifted me up, swung me around, and heartily kissed me. We sat down on a highly polished mahogany seat and had a nice four-hour visit. Then, once again, my waistcoat tag and I were on a train—this time bound for New York. One thing bothered me; Aunt Billie said she would be bringing my Uncle Ed to see me on my return trip. This was the first intimation that I was not to be permanently reunited with my mother, and it made me a bit uneasy. I enjoyed life with my grandparents, but I wanted to be with my Mackey. But I decided to push all apprehension aside; maybe Mother would find she loved me so much, she wouldn't want to send me back.

That last night was both very long and very short. I

could hardly wait. I got up early, dressed, and combed my hair over and over. I wanted to look my best for Mother. As the train pulled into the station, I looked out the window, hoping to see my Mackey. She wasn't there. I continued to gaze longingly, not knowing I was looking out the wrong side of the train. I heard a familiar voice behind me asking, "Is there a little girl, Virginia, in this car?" The next thing I knew, I was clinging fiercely to my mother's hand. Though she had obviously not meant to cry, big tears rolled down her cheeks, and she impatiently brushed them away. I was skipping with happiness as I tried to keep up with my mother's pace and answer all her questions about the family and my trip. We walked through Grand Central Station for what seemed ages, and then got into a yellow and black taxicab for the ride to the Bristol Hotel at 122 West 49th Street. This was my new home where, over the next months, I would spend many hours alone in our apartment playing with my toys, while Mother was at work. Eventually, I was enrolled as a student in the public school next door to the Fox offices.

During these early Manhattan days, Mother and I shared many good times. She had to keep an eye on me, though, for I was into mischief from the very beginning. Mother had a makeup drawer stuffed with the latest in rouge, creams, lipsticks, astringents, and lotions.

Hurriedly one evening, Mother ran into our tiny apartment and said, without looking at me, "Go wash your hands. We're going out to dinner." She rushed to get ready. As we left the room, she plunked a little sailor's straw hat on my head. As we were walking down the street, she noticed that I was looking in the various windows more intently than usual. When we passed by a mirror, Mother suddenly looked at my reflection and, much to her amazement, saw on my ears a long pair of

dangling coral earrings, and bright-colored lip rouge on my lips. "What's this?" she exclaimed.

"I had to dress up, Mother. I just borrowed these from you."

She whipped the earrings off my ears and took a handkerchief and wiped my mouth clean, reminding herself never to go out the door again without looking at me to see what stylish things I might be wearing.

Another day, when Mother came home from work, she looked around the apartment and I was nowhere to be seen. Finally, she called my name quite loudly. "Virginia! Where are you, I don't see you . . . Virginia?"

"I'm here, Mother."

She followed the sound of my voice, and there I was, sitting in front of the mirror with fingers, face, hands, and neck covered with white cream.

"What have you done, Virginia?"

"You can't see me, Mommy, you can't see me, Mommy!"

"What do you mean, I can't see you? With all that stuff on your face . . ."

"You can't see me, Mommy, because I've got on 'vanishing' cream!"

Like most children, I assumed that vanishing cream meant exactly what it said. Mother got a kick out of this incident and, much to my embarrassment, recounted the story well into my maturity. Oh, Mother, not again!

New York City was a magical place to live. Right around the corner from the Bristol, at 1600 Broadway, was Rector's, a very fancy restaurant which catered to the elite. Every evening an orchestra played there, and we could hear the music from our hotel. Imagine how thrilled we were when Mother was invited to dinner at Rector's. I say "we" because there was no such thing as a babysitter in those days and invitations to Mother had to include me.

Walking into Rector's hand in hand with Mother was like walking into paradise. My eyes were wide as saucers and my mouth hung open at the very splendor of the place. We were seated at a round table, and the waiters rushed about to find as many telephone books as possible to place me at the same height as the grown-ups. Much attention was showered on "little Virginia," as the waiters called me. When the waiter came to take my order, everyone burst into laughter. I couldn't imagine what was so funny about asking for "a ham sandwich and a pot of beans." I had no idea the plainest item on the menu was pheasant-under-glass.

As we dined, my eyes were drawn to the cigarette girl who wandered about the floor. Her tray of tobacco items was augmented by a marvelous display of stuffed animals. Whichever way she walked, that was the way my head turned. Wonder of wonders, the cigarette girl brought her tray over and stood in front of me. What's more, she took out a stuffed bear and placed it in my hands, saying, "An admirer across the room sends this to you with his love."

There was much laughter and gaiety that evening . . . and a particular excitement of which I was unaware. There was a great stir in the restaurant over a very important personage, seated across the room with an entourage of twelve. It was the King of Sweden, who had danced with only one lady in his party until he looked over and saw me, sitting at our table on a stack of books. He said, "Now there's a young lady I'd like to dance with." He moved toward me and asked, "May I?" My mother nodded, and he picked me up in his arms and danced around the floor with me.

One of the many friends Mother made while working for Fox was motion picture star Mae Marsh. One afternoon, we went to her apartment to visit Mae and her sister, Lovey. Lovey Marsh had a daughter, Leslie, who was

around eleven years old, and for three days Leslie and I did everything together. It was the Fourth of July weekend. During the afternoon, while we were playing, Leslie's mother suggested that we walk down the street to the Italian store that sold ice cream. Leslie whispered to me, "Why don't we walk down to the ferry that goes to Jersey and take a ride? It will only cost a nickel for kids."

Never having been on a ferry, I figured she knew what she was talking about. We ran into the elevator and flew down the street, racing to the ferry so that we wouldn't miss it. Plowing back and forth from Jersey every twenty minutes, the ferry was waiting for us. We paid our fare, and across the river we went. It was kind of scary. I'd never done anything like this before without a grown-up nearby. This was truly a wicked adventure—and even more so when Leslie said, "Let's go into this store and buy some cigarettes." While she was buying cigarettes, telling the clerks that they were for her daddy, I asked for some matches. After paying for our prize merchandise, we hurried out of the store like two little thieves.

"Let's hurry to catch the next ferry back. When we get back, we can go right on the shore next to some big rocks. It'll be real private," Leslie proudly stated.

Once off the ferry, we found the big rock boulders she had described. Leslie began to open the silver-foiled top, and there were the cigarettes. It almost took my breath away to smell them. She took one out and told me to take one, too. Obediently, I did what she did. I imitated her, and very soon, my cigarette, too, started to glow, and I nearly choked. A bit of cigarette tobacco caught in my throat from pulling in the air. We talked and puffed, talked and puffed. And very shortly, I was sick as a dog! I felt like I wanted to up-chuck, but I couldn't. Oh . . . I felt terrible! All I wanted to do was go home and lie down. When we arrived at the apartment, Lovey called to my mother, "Lela, come here. Your daughter looks sick."

"What happened, darling?" Mother embraced me and,

suddenly, smelled the odor of cigarette smoke in my hair. "What have you two been up to?"

After the spanking Leslie and I both got, I never thought of a cigarette for many years!

New York was full of new experiences for me. The first time I had ever been in a legitimate theater was in New York City. I don't remember the name of the play, but the star was Jane Cowl, one of the legendary names of Broadway. I didn't understand the play; the dialogue went right over my head. It didn't matter. The costumes were spellbinding. Jane Cowl walked on stage wearing a beautiful green velvet iridescent dress and my eyes remained riveted on that gorgeous costume throughout the first act.

At intermission Miss Cowl came bounding back on stage, made an impassioned speech about the war effort, and ended by asking everyone to purchase war bonds. She said she would announce the names of all the states in the Union and there would be a competition to see which one bought the most bonds. "Who is ready to tell our soldiers over there, we are doing our part? Or tell them we're willing to sacrifice some of our hard-earned cash to support them with the best materials money can buy?"

She began to call out the states alphabetically, and the audience members responded with raised hands. I was sitting on the arm of the theater seat and when she got to the M's I began to wave my arm. I caught the attention of the ushers, who pointed me out to Miss Cowl.

"Where are you from, little lady?"

"Missouri," I shouted, loud and clear.

"Well, why don't you come up here on the stage with me?" Miss Cowl signaled and the two ushers escorted me down the aisle and lifted me up over the footlights. There I was on a stage for the first time in my life, and a Broadway stage at that! Jane Cowl came over, stood be-

hind me, and crossed her arms over my chest. I looked out
and saw a sea of faces all gazing up at me. I was transfixed.
This was fun—how did I get here?

Jane Cowl looked down at me and now, for the first
time, I looked deep into her large, luminous eyes as she
said to me, "What's your name, dear?"

My six-year-old voice was somewhat overcome by that
sweet sparkle of tender affection in her eyes. I quietly
responded, "Virginia."

"All right, Virginia, you are going to ask your
Missourians to come on and be the biggest bond buyers in
all the forty-eight states. Tell them to 'Show you!' "

With her prompting, my childish voice tried to imitate
the power behind the voice of this talented actress. Each
time I said "Show me" not only drew laughter, it also
began to achieve what this lovely and charming thespian
yearned to accomplish: to help in some small way to bring
the horrible World War I to an end.

5

\mathscr{D}ADDY JOHN AND FORT WORTH

THE HEADLINES IN THE NEWSPAPERS FOCUSED LELA'S ATTEN-
tion on the worsening clouds of war rumbling in Europe.
Patriotic by nature, she wondered if it wasn't her duty to
help in some way.

So in 1918 Mother decided to join the Marine Corps.
Lela E. Leibrand (her pen name) was one of the first ten
women to join the corps.

After having been united with my mother for over a
year, it was very difficult to be parted again. Upon joining
the Marines, she was transferred to Washington, D.C.,
and thought it would be better for me to go back to Kansas
City to my grandparents. Once again I boarded the train
and returned to my cousins and grandparents in Missouri.
I remember saying goodbye to her and thinking how
handsome she looked in her olive green uniform with its
Sam Browne belt, and the overseas cap with the Marine
emblem over one eye.

Lela was assigned to many different posts and flew
orders from Commandant Colonel Albert McLemore to
Quantico, Virginia, in a two-seater biplane. Later, she

was placed in the publicity department of the Marine Corps. As a publicist, it was her job to see that photographs were taken of all visiting VIPs. She was on many a "shoot" for the Marine Corps, one of which included photographing the Assistant Secretary of the Navy, Franklin D. Roosevelt.

At one point, because of the absence of the military men who edited the Marine Corps newspaper, *The Leatherneck*, Lela was temporarily made the editor. It was a decided thrill for her to fill that role, even for a brief time. She laughingly described herself as "The only woman who ever edited a man's newspaper."

Although mother's career was all-consuming, her introduction to John Logan Rogers caused some changes in her life. My mother met him after his release from a Veterans Hospital, where he had been recuperating from a collapsed lung. John Rogers had been gassed in the Argonne forest and spent six months in a New York hospital. At his discharge, the doctors warned him that with only one lung, he was a target for heavy colds. If he was stricken with pneumonia, they sadly told him, it was "curtains."

When he and my mother fell in love, he advised her of his disability and its potential danger. Deeply in love, she convinced John Rogers that her love for him was not diminished by the medical limitations. After Mother left the Marines, they were married in May 1920 in Liberty, Missouri, and traveled to Kansas City so that he might meet the family. My new "daddy" greeted me warmly and naturally, as though I really was his child. I called him Daddy John and loved him immediately. My affection for that wonderful man who became my daddy never changed. Though he did not adopt me, it was natural for me to use his name. It was easy to feel his tender love for me, and I could well understand why Mother loved him so.

Daddy John got a job with the Interstate Life Insurance company and within days of his arrival in Kansas City, he, Mother, and I boarded a train for Dallas where we settled down in Oak Cliffe. The Rogers family was all set with a vegetable garden and chickens, including a pet bantam rooster which followed me around like a puppy dog.

Daddy John's work in Dallas proved successful, and life for us was going very smoothly. Music was his hobby, and he loved to compose. His piano was in constant use, although he couldn't read a note of music and played by ear. He published one song that sold an amazing number of copies. It was a catchy tune with unforgettable lyrics:

> I've got a gal, seven feet tall
> Sleeps in the kitchen, with her feet in the hall
> She's got a sister, lives across the lake
> She can shake the shimmey like a rattle-snake
> A thousand miles, a thousand mi-hi-hiles,
> Honey, won't you follow me.

While we were in Dallas, my Aunt Genevieve, known as Jean, came to stay with us. My grandmother had died and my grandfather did not feel that he could raise a sixteen-year-old on his own. He thought his eldest daughter could help to guide her sister through her teens. Realizing that she had been practically abandoned, Jean asked Mother to help her find a job. Daddy John came up with a good idea, and she went to work at Woolworth's. Jean's job at the music counter was to ring up the sales while a song plugger pitched the melodies. Jean and the singer became very chummy. Jean brought her friend home and I thought he was the greatest thing since Green River (a bottled drink all the kids were crazy about). He was so attractive, and dressed in the most up-to-date fashion: bell-bottomed trousers, saddle shoes, a porkpie hat, and a bow tie. When I met him, I thought he was a charmer. Not only was he good-looking, but his profile was the South's

answer to John Barrymore. His laughter was not manufactured, but seemed to well up from his toes. His love for show business was obvious as he had memorized all the show jokes from way back. Daddy John was impressed with his talent and suggested that he should write his own song-and-snappy-patter act. Mother and Daddy John were delighted that Jean had met such a nice chap. Also, since Daddy John was a published songwriter, he didn't mind having a friend who could plug his songs.

Aunt Jean and her beau spent many evenings together sitting on the front-porch swing, spooning. I would slyly peek through the lace curtains and try to invent reasons for me to go out on the porch. With the most innocent expression on my face, I would say, "Excuse me, was that Florine who just went by on her bicycle, Aunt Jean?" or "Daddy was looking for his newspaper, have you all seen it?" With that, I would fake a cursory glance to the right and then to the left to see him and to make him aware that *I* was there, too.

One evening when they were sitting in the swing, I walked out on the porch, feeling jealous. I had to do something to put an end to all this. Did I look the role of a jealous twelve-year-old? Did he know that I was jealous? What did he do? He crooked his index finger at me, gave me a "come-hither" look, reached into his pocket, and took out a quarter. "Here, Virginia, take this and go buy yourself a chocolate sundae." I was crushed. To think that I had to be paid off. I'm sure Aunt Jean must have recognized that I had a crush on her beau. Little girls often get crushes on men who are many years older than they. Even his name was romantic: Edward Jackson Culpepper. It conjured up images of a dashing young southern cavalryman, singing "Dixie" astride his horse. It was a name worthy of Margaret Mitchell's inventiveness.

After a year and a half with the insurance company, Daddy John was promoted and we moved to a house at 1510 Cooper Street in Fort Worth. Life went along

smoothly. I was enrolled at the Fifth Ward Elementary School and had lots of neighborhood school chums. Six of us formed a group called the Cooper Street Gang. We played games and climbed trees and telephone poles, and I was the leader. One part-time member was a girl from Weatherford, Texas—Mary Martin. Though I've had many honors in my life, I still think being the leader of the Cooper Street Gang was one of my greatest achievements.

The real challenge in Texas living came from the weather. Summers were unbelievably hot and air conditioning had not yet been invented. The winters were unbearably cold, especially when it snowed. One day Daddy John came home shivering and went to bed. After a grueling night with this flu, he asked my mother to call a doctor. Though she would have done differently for herself, she called the doctor for him. The doctor came and pronounced the seriousness of the case. The doctor told my mother that Daddy John's one lung was infected and that he would not last the night. Mother did not tell me this, but I could tell by her actions and silence that she was deeply concerned. When the doctor left, Mother went to the dining room with her Bible and *Science and Health*, asking me to leave her alone, *please*.

Shortly after that, I saw her go into Daddy's room. I felt the intensity of the situation, as children sometimes do. She did not know that I followed her and stood by the open door while she moved to Daddy John's side. She bent over and said, "Daddy, the doctor has given you up. There's nothing more he can do for you. Would you please give me your consent to call a Christian Science Practitioner in Dallas and ask her to pray for you? I'm praying too, Daddy. Please may I do that?"

The dew of death was on his brow. And his sallow color in the winter twilight made him appear twenty pounds thinner than he had been the day before. Daddy John nodded his head, and Mother hastened to the telephone to call Mrs. Gallie W. Indermille. Mrs. Indermille agreed

to take up metaphysical work for Daddy John. Mother's attention was fastened on her books, prayerfully considering each word. I didn't know what to do with myself, so I stayed within earshot of my mother and tried to look at my schoolbooks. Then I decided I should pray, too, for the only daddy I had ever known—Daddy John.

Hours later, we heard a knocking coming from Daddy's room. Mother and I rushed to his bedside and found him knocking on the board under the mattress. He said to Mother in a weak, but firm, tone, "I'm hungry."

From deep within, Mother heaved a huge sigh of gratitude. "I'll fix you some cinnamon toast floating on hot milk."

"No," he countered, "that's not what I want, I want a steak, potatoes, and salad."

Mother stopped for a moment in astonishment and merely answered, "Yes, darling." Then she turned and hurried into the kitchen. I could see her eyes glistening from the tears that she held back. "Help me, baby," she said to me. "Help me. Get a tray."

Until that time, none of us had even thought of eating. Mother fixed his favorite foods: cottage-fried potatoes, a green salad, and a thick beefsteak. She brought it up in a tray and he ate the whole thing. His eyes were now clear and his coughing less frequent. Gone from his face was that clammy, sick look. Mother reached over, kissed his cheek, and said, "Now that was a good boy. You ate every bite." She took the tray away and started out of the room. I followed her as she brought it to the kitchen and placed it on the sideboard. Then, and only then, did she give way to a flood of tears. Back in my little corner, I too was crying, after seeing this healing take place in front of our very eyes. These were tears of gratitude. As soon as she was in control again, Mother telephoned Mrs. Indermille and told her the good news. This earnest Christian lady had the pureness of the Christ understanding. Where I had felt the doom of darkness and sadness a few hours

before, now an indescribable light had burst into the room, and its brightness made us feel warm and joyous. Three days later, Daddy John backed out the little Essex with the red wheels and went back to work.

During the day, he called my mother and told her how wonderful it was to have been saved. He admitted that after he arrived at his office, he went into a corner to wipe away the tears of gratitude and to thank God for letting him live. An exalted feeling of gratitude swept over him. After this experience, Daddy John came into the church with Mother and me and joined the local branch church and the Mother Church in Boston. Very shortly, Daddy John was selected by the congregation to be its First Reader.

Our home was a very happy one. Antoine de Saint Exupéry in *Wind, Sand, and Stars* said, "When two people love each other, they do not look *at* each other, but both look in the same direction." And here we were, all three of us, looking in the same direction and learning more each day, more about the Truth, and more about God and man. For the next three years, our house reflected the growing spirit of the Christ in our lives.

In Fort Worth, Mother found an exciting job as a reviewer for the *Fort Worth Record* and covered all theatrical events, including motion pictures and vaudeville. Lela Emogen Rogers had worked her way up through the newspaper ranks from a reporter, covering murders, rapes, and suicides, to this new job, which carried clout and distinction.

Because of her position, theater managers vied for her attention. One of these gentlemen, Bill Hart, the manager of the Majestic Theatre, became a very good friend of the Rogers family. Another was Bob O'Donnell, head of the Interstate circuit, who often took me on business trips with him. He said I was good company and that my ques-

tions amused him and kept him awake while he was driving. These business trips gave me a nodding acquaintance with the managers of most of the theaters in the Interstate chain. These contacts also gave Lela an opportunity to write exclusive stories about the theatrical business and brought her newspaper a devoted readership. Her knack for colorful writing made the residents of the little town of Fort Worth hang by their fingernails as they read every word.

Vaudeville was in its prime at that time, and most of the top acts on the Orpheum circuit also played the Interstate circuit. Stars like George Burns and Gracie Allen, Jack Benny and his wife, Sadie (later Mary), Eddie Foy and his five kids, George Jessel, Billy House, and Sophie Tucker appeared in Dallas, Fort Worth, Houston, and San Antonio, and I met all of them. Because of Mother's position on the newspaper, she frequently invited the headliners over to our house for some homey atmosphere and a fried chicken dinner. One evening I did an imitation of Sophie Tucker singing "Some of These Days." Sadie and Jack Benny were at the house that night and enjoyed my performance. Thereafter, whenever Jack and I were at the same party, he would goad me into doing my "imitation." He would laugh until he was almost on the floor!

Many adventures stemmed from Mother's association with the theater. Some were fun, some were sad. Indeed, one even might have been tragic had Mother not been involved. The Bird Lady was a headliner on the Orpheum circuit. She was an elegant woman who worked with ten gorgeous cockatoos. At her command those proud birds would bring her any article that she named. We watched her often.

One evening, Mother casually asked the Bird Lady how everything was going. To Lela's surprise, the woman suddenly burst into tears. Mother immediately invited her to come to the house that night after the show to talk about her problem and, Mother hoped, to set her mind at rest.

That night, the Bird Lady arrived carrying two covered cages housing her cockatoos. She sat down and poured out her sorrows. Her marriage was in trouble; her alcoholic husband had threatened to kill her if she tried to get away or even attempted to call a lawyer. Mother calmed her down. "I bet he is just a big talker, like most drinkers. You spend the night with us and tomorrow we'll get in touch with a lawyer friend of my husband's." After giving her a warm cup of hot chocolate, Mother led the Bird Lady to the little guest room, and the cockatoos were put on the screened porch at the back of the house. Mother gave me that "to bed, little one" look. Off I trotted to my adjacent bedroom. It was a very quiet night and I wasn't sleepy enough for slumberland, so I found myself waiting to hear the next-door neighbor's cat do her nightly prowl.

About 3:30 in the morning I awoke to the sound of the doorbell. It was still dark outside and I was half asleep. The cat couldn't ring the doorbell! Was I dreaming? Mother and Daddy John went to the front door and asked who was there.

"You have my wife in there, and I want to talk to her. Open the door and let me in or I'll kick the door down," was the drunken command. Meanwhile, I had gotten out of bed and come to the front hall. Standing in the background, I watched everything.

"I've got a gun and if you don't let me in, I'll start shooting." Daddy John opened the door, and there stood a tall man brandishing a shiny silver pistol.

"Just get my wife and I'll be gone." Suddenly he saw me, standing in the shadows. I had met the Bird Lady's husband at the theater and he knew me by name. "Sorry to awaken you from your sleep, little Virginia." Meanwhile, he kept waving the pistol around like a diviner's rod looking for water. Mother looked at me. "Go back to bed, Virginia," she said. I looked at my frightened mother. Between us there had always been a look from her eyes to mine that needed no words to tell me what to do. This

time her eyes told me: "Somehow, go next door. Get help!" She had always controlled me with her eyes, and this time Mother knew I understood her "eye" message. I slowly ambled down the hall to my bedroom as if regretting being told to "go to bed."

Once in my bedroom, I hurried to open the screen on the window. Hastily I slid down the five-foot drop to the gravel driveway and headed for the back door of our neighbors, the Cartwrights. "Mr. Cartwright, please call the police. That person has a gun, and he has threatened to kill us."

Time passed like an eternity, but at last the police arrived. The tall man was arrested and taken to the police station. The poor Bird Lady had ducked out of the house and was hiding. For over an hour, my mother and Daddy John looked for her. They finally found her hiding between a telephone pole and a fence in an alley.

When the sun came up that morning, I felt like I had just played the heroine's role in a menacing dream.

Another great theater thrill happened when I was twelve or thirteen. Mother came home from the newspaper one evening breathless with delight.

"You'll never guess who is coming to the Majestic next week!"

Daddy John and I couldn't imagine, and we didn't have to wait long for the answer.

"Gloria Swanson and Rudolph Valentino!" They were doing some publicity for their starring vehicle *Beyond the Rocks* and were coming to Fort Worth as part of the publicity tour.

It was a very special occasion for me to go with Daddy John and Mother to the Majestic that night. The theater was crowded, and everyone was anxious to see "the main event." I had seen both these stars in their silent films before, but seeing them live on stage together was a spe-

cial event. As the audience settled into their seats, the lights dimmed and the music started. Then, there in the spotlight, were Swanson and Valentino, dancing a bit of the tango they performed in their upcoming film. You could feel the electricity they generated coming across the footlights.

When they finished their dance and took their bows, the audience wouldn't let them go. Even after the encore, the applause was deafening. It was a night I shall always remember.

If I wasn't visiting the theater, I was going to my mother's office. On one occasion, she introduced me to her editor, Tommy Thompson. I had learned to play the ukulele and carried it everywhere.

I sat on the corner of his desk, while he asked me questions about myself. Even while I was answering him, I continuously played my ukulele.

"I'll bet you're going to be on the stage, aren't you, Virginia?"

"No, Mr. Thompson, I'm going to be a teacher. An English teacher."

Later, Tommy had the cartoonist for the newspaper draw up a caricature of himself and his whole office staff. In the cartoon, Tommy is calling out to my mother, saying, "Lela! Would you get this kid and her ukulele off my desk!" My direction soon would veer from the classroom to the theater.

Backstage at the Majestic Theatre was becoming a hangout for me because of my mother's newspaper job. One day, coming from school with my books in one arm and my ukulele in the other, I met the Foy kids in the alley behind the theater. Eddie, Jr., asked me if I liked to dance. I told

him I danced all the time at home. "Well, do you know how to do the Charleston?" asked Eddie.

"Uh, uh. What's it like?"

"You want to learn?"

"Sure, why not!"

Eddie stood next to me and slowly started doing the steps. I began to follow, and before long I'd gotten the hang of it. I couldn't wait to get home and show my mother. She, too, was fascinated, and I taught her how to do it. Daddy John came into the kitchen, hoping we were preparing dinner, and found us sliding around on the linoleum. At first he scowled, then smiled, and finally laughed.

"Daddy John, it's easy. Come here, let me show you how."

Suddenly I was an instructor, showing my mother and dad something they didn't know.

I've often thought of the three of us in that little kitchen—throwing our legs around, each of us counting one, two, three, four, again and again.

During Eddie Foy's stay in Fort Worth, I went down to the theater to show everyone how well I had mastered the dance Eddie, Jr., had taught me. They must have been impressed, for one Friday night, Mother got a call from the theater manager, Bill Hart. One of the five performing Foy kids was ill, and Eddie asked Bill to call the "local" girl he'd taught and see if I'd come down and dance with him. Mother asked me if I wanted to do it. I was torn between fright and love of the theater. She encouraged me, saying, "It will be fun, particularly since you're doing Eddie a favor. You're really helping him."

Now I had found a good reason for going, and that helped quell the electrifying panic that consumed me when I thought of going on the stage to perform.

When Eddie Foy introduced the "local girl," the house went wild with applause. Though perhaps I wasn't as good as I would like to think I was, the audience thought

I was splendid. There's nothing like a hometown crowd to cheer you on.

My theatrical talents would soon blossom in a school play. Because of my mother's writing ability, the school cajoled her into writing a two-act play about Texas history, called *The Death of St. Denis*. Naturally, who should get the leading female role but the daughter of the author. In my first dramatic part, I played a settler's wife whose homestead was besieged by Indians. I shall never forget the emotions I felt during the final scene of the second act, when one of the arrows struck St. Denis and he fell to the floor. I stood over him crying, "Please don't die! Please don't die!" Despite my importuning, he died and the curtains closed. I was so emotionally wrought in playing this role that I was still sobbing as I took my bows. In my desire to thank the audience, I curtsied, but the sobbing continued until my mother came backstage. She put her arms around me and said, "It's all right, baby, this is just acting, you know."

"I know, Mother. I know."

That deep inner feeling that caused me to perform correctly with tears and sadness was prompted by more than just acting a scene. The emotion came with the strong conviction that I could do it. I could act. But now the play was over and my acting would stop. That was what prolonged my tears. Later, Mother wrote a musical for the Cooper Street Gang and I was again cast in the lead. Mother not only wrote my material, she also acted as seamstress and, from the beginning, created all my costumes. She made me a black satin dress, trimmed in red, with red stockings and red shoes. I was some kid!

In addition to her journalistic work, Mother was an active member of the community. She volunteered for many

worthy projects, one of which was spearheading the organization that established a symphony orchestra for Fort Worth. Since I was the first person to buy a ticket for its premiere concert, a photograph was taken of me with Mrs. Alva Lockhead, director of music in the city schools. The orchestra is still in existence.

Music was always a part of our family. Since Daddy John couldn't read the music he played on the piano, he wanted me to learn. So he arranged for me to take piano lessons from a local teacher, Mrs. Rufie Smith. All the neighborhood parents thought she was an excellent instructor, and my next-door neighbor, Jane Payne, was considered living proof of her teaching ability. The competitive spirit within me urged me to try to be as good as Jane, and the three "B's" were beginning to become familiar to me. After I had become fairly proficient, Jane and I would get together to play "Etudes for Four Hands." I wanted to keep up with Jane more than anything.

Fairly soon, Mrs. Smith announced that I was ready to give my first recital. I really worked. After my school lessons were done, I'd sit down at the piano and practice until Mother would call me to help her in the kitchen and dining room. The recital was given at Rufie Smith's house and my program consisted of "To a Wild Rose" by MacDowell, "Voglein" by Grieg, "Melodie" by Massenet, "Prelude, Opus 28, No. 7" by Chopin, and "Solfeggietto" by Bach.

My mother and dad applauded more than anyone else. I didn't want to look at Jane to see if she approved or not. I was in childish fear of not being as good as she. It was unusual for me not to taste the cake and pink lemonade. Though the goodies passed my lips, my stage fright had not subsided. I remember thinking, by the time I arrived back home, "Well, now that's over, what can I tackle next?" In later years, I regretted that my enthusiasm for the piano was so short-lived.

✿ ✿ ✿

Seven months later, I appeared before the public in another musical vehicle, but this time I showed my dancing ability. Adolf Bohm, formerly a star in Diaghilev's Ballets Russes de Monte Carlo, had become a ballet master in New York City. He traveled to the major cities and held auditions for local talent. The best would be offered a three-month course in classical dance in New York. I was one of a group of Fort Worth youngsters chosen to dance before him. Baum asked us to invent our own choreography, which I was delighted to do. I loved making up my own steps and moving to them. After the auditions, Mr. Baum spoke to my mother.

"Mrs. Rogers," Mr. Baum began, "how do you feel about your daughter coming to New York City for a free three-month training course in my school?"

"Free?" Mother questioned.

"All you have to do is pay for her keep and the train fares each way."

"What do you see as the outcome of this instruction?" she inquired.

"I could see if she was qualified to become a premier ballerina."

"You could judge that in three months' time?"

"In three months," he hesitated, "I would find if she is . . . star material"—he hesitated again—"and if so, I would want to know *right now* if you would let me . . . adopt her."

That last remark closed the door on the whole proposition. "Adopt my daughter? If she has to become a star through adoption, leaving me, her own mother, I will wish that she shall never become a star." And that was the end of what one might call my ballet career!

✿ ✿ ✿

On most occasions I was a good child, but occasionally the mischievousness in me came out. One such childish indiscretion happened at our Cooper Street house. Left alone one afternoon, and feeling quite bored, I went to the kitchen for an ice pick. For some reason, I began to punch holes in the screen door to form the name "Virginia." When my mother came home and saw the screen door, she said, "Now, who would do this?" Who but yours truly?

Another incident happened after I got home from Sunday School with Daddy John. He had been ushering and had to stay long after the congregation had left, so Mother went home right after church with our next-door neighbors, the Paynes. I knew that when we got home, Mother would have breakfast ready. On Sundays we always came home after church and had a late breakfast, in place of early breakfast and lunch.

I was very proud of the dress Mother had made me for Sunday School, and I felt quite grown up in it. The dress was navy blue satin, almost like a jumper. I wore white bobby sox and Mary Jane shoes of patent leather. Daddy John drove our black Essex toward the curb to park the car, but I opened the door before the car stopped and ran into the house. I wasn't surprised when Daddy John said to me, in a most unfriendly tone, "You couldn't have waited until the car stopped before you had to get out of the car, could you?"

He was so rarely angry with me that I didn't know how to answer him. Naturally, I knew he was right, and I should have waited. There wasn't anything keeping me from behaving properly.

As I entered the kitchen, where Mother was fixing breakfast, she said, "Baby, will you get the bacon out of the icebox for me, please?"

I responded, most ungraciously, "No, Mother, I don't want to."

"Virginia, I've asked you to do me a favor. Now, you do it, do you hear?"

Again, I responded negatively. "No, Mother, I won't."

I didn't expect what was coming next. She slapped me rather forcefully, and I went sailing across the kitchen floor in my nice Sunday dress. With great dignity, I got up from the floor, brushed myself off, and walked over to her at the stove. I foolishly said, "In Sunday School today, we studied the Sermon on the Mount and in Jesus' talk with his disciples, he told them, 'Whosoever smites thee on the right cheek, turn to him the other cheek also.'"

With great dramatic emphasis, I turned the other cheek. That did it. Mother smacked me once again, and back on the floor I went. By now, my Sunday dress was truly spoiled. I thought I was being so holy. I never did anything like that again and learned a hard lesson about insubordination. Of course, in those days, children were punished for bad behavior by the rod more often than by reason.

\mathcal{T}HE DANCE CONTEST

ACROSS THE COUNTRY, THE CHARLESTON WAS THE RAGE. When Eddie Foy, Jr., taught me the steps, he gave me my ticket into show business.

Henry Santrey, a popular bandleader, announced a series of Charleston contests in each Texas city on the Interstate circuit, which included Fort Worth. Prizes would be given and local winners would be invited to travel to Dallas to participate in the Texas State Charleston Championship. The kids in my school could talk of nothing but the upcoming competition. Mother objected when I told her that I wanted to enter the Charleston contest. "You don't realize, dear," she said, "that your mother is working on a newspaper and if, by some strange quirk, you happened to win, the whole community would think that I had wangled your victory. They would accuse me of fixing it. Some people have been fired for something they did not do in order to pacify the community." The day after Mother's speech, I walked over to the paper and up to the second floor, eager to change her mind. I started running down the hall, but when I was halfway to

Mother's office, Tommy Thompson suddenly appeared and we collided head-on. The uke and my schoolbooks went flying in every direction. The papers in Mr. Thompson's hands went skyward, creating an instant snowstorm. I was scared.

"Oh, I am so sorry, Mr. Thompson. Please don't fire my mother because of this. It was *my* fault, only mine. I just didn't see you coming out of your office. Oh, please, don't fire my mother!"

He asked me into his office. "Virginia," Mr. Thompson said, "what is this obsession you have about your mother getting fired?"

"Well, if I entered the Charleston contest and won, Mother would be fired. I can't let that happen."

"Virginia," he said, "who told you that your mother would be fired if you entered the contest?"

"Mother said that I couldn't enter, because if I won, someone would surely think that she had something to do with my winning since she was on this newspaper."

"Let's go in and have a talk with Lela."

Tommy stated to Lela, "If by some chance she wins, I will deal with any political repercussions."

I shall never forget Mother's expression. I waited in the hall while they talked. When Mother and Tommy finally appeared, I could tell by the smiles on their faces that I was going to enter the contest. Mother immediately began sewing a special costume.

I was excited when the day came. Thirty of us stood backstage at the Texas Hotel in Fort Worth, waiting for our turn, jittery and anxious. Mother and Daddy John had gathered our friends and were sitting out front.

My name was called and the neighborhood applauded wildly, recognizing one of their own. I walked to the center of the stage and stood for a moment. I loved the feeling of being "on." The music started and then the contagious Charleston triggered my toes. The Charleston wasn't difficult; anybody who could lift one foot off the floor could

learn to dance it. The music had an exciting and compelling beat, and once you'd started, you never wanted to stop. You just couldn't resist the pull of its rhythm. I poured all my energy into those swinging steps, and when I finished, the applause was deafening. I swear I could hear Daddy John's big hands clapping harder than anyone else's.

After we had all taken our turns, the contestants were lined up. Henry Santrey stepped forward and made a nice speech about all of us. He called us talented, energetic, and wonderful.

The audience was tense, and so was my mother. I knew she and Daddy John were praying hard.

"The local winner from Fort Worth is . . . Ginger Rogers!"

I jumped joyously and ran to my mother. We hugged and kissed. Daddy John swung me around in his big arms and kissed me. He was so proud.

"I knew it," said Lela. "I just knew it. Now, on to Dallas."

The minute Mother said Dallas, the butterflies began to dance around in my stomach. Fort Worth was home; my friends and family were there to encourage me and I competed with people I knew. Dallas was unknown territory; I'd be up against strangers from all over the state. Until that moment, I hadn't a qualm. But the thought of the finals in Dallas made me apprehensive.

On the evening of November 9, 1925, we arrived at the Baker Hotel in Dallas where the contest would inaugurate the opening of the new rooftop ballroom. The audience formed a half circle around the floor and watched as each of the competitors performed. My knees were knocking long before the contest began; I was scared to death. "And now Ginger Rogers from Fort Worth." The minute I heard the name of my town, the adrenaline started

pumping and my nervousness vanished. I didn't know how many Fort Worth people, if any, were out there, but I had to do it for them, for Lela, for Daddy John, and for me.

The contest narrowed to myself and a boy from Dallas. The fact that Fort Worth and Dallas were rivals in everything only added to the excitement. The two finalists came forward.

My heart was pounding hard.

I danced the Charleston with all my heart. Then the boy from Dallas danced.

Henry Santrey held his hand over each of us to determine the winner by the applause.

It was a draw.

We each had to dance again. I could feel my mother and Daddy John praying and cheering me on. I've always loved competition, no matter what the arena. In this contest I had the music to urge me on. The Bible says, "Do what you have to do and do it quickly," and that's what I did. I finished the race joyously and quickly.

I put everything into that second try. So did my competitor.

Mr. Santrey called for the applause once again. This time, he had a winner.

"The new Texas State Charleston Champion is . . . Ginger Rogers!"

My prize was an engraved silver medal, and a four-week engagement to perform on the Interstate circuit, which included Fort Worth, Dallas, Houston, and San Antonio, as well as bookings in Galveston and Waco. Two weeks after the contest, I received a telegram from Henry Santrey reminding me of when I had to be in Waco to start my first engagement. This was the beginning of my professional life. Indeed, in order to collect the money I *had* to perform on the circuit, so Mother put together a little

act for me and signed two of the runners-up, Earl Leach and Josephine Butler, to be part of my act. It looked much more professional to have a troupe. As "Ginger Rogers and The Redheads" we were so successful that we continued performing after the Interstate circuit contract was over. However, money was tight and we had to split the $375 three ways. By the time we paid train fares and living expenses for Mother and I, $125 per week did not go very far.

From 1925 to 1928 my mother and I traveled by train in crisscross patterns across the country, from Waco to Chicago, to St. Louis, to Phoenix, to Pittsburgh, and into many cities in California, Oklahoma, Arkansas, Indiana, Wisconsin, Michigan, Massachusetts, and New York. Although I was fourteen, I posed as a twelve-year-old to get half fares. I carried a huge Egyptian doll, named Freakus. Freakus did her part, too. She was the size of a pillow with large cotton-stuffed arms and legs. Freakus's size made me look smaller and those bulging legs made a great pillow for my head when we couldn't afford a sleeper. My hair was arranged and my clothing was styled so I could pass as a plausible preteen. Some years later, it was not surprising that I fell in love with a story called *The Major and the Minor*. In this film, I portrayed an adult trying to pass as a child. Actually, I played a child a few times in my movie career, and each time I drew from my early days on the road.

I performed in large theaters and supper clubs, doing my song-and-dance act, sprinkled with vaudevillian humor. Earl Leach and Josephine Butler stayed with me for a year and a half and then were lured away from me by Billy House, a fat comedian. He offered them more money than I could; understandably, they went with him. From then on, I was alone except, of course, for my mother. Lela was my writer, designer, seamstress, busi-

ness manager, confidante, and chaperone. I sang songs like "He Don't Wanna," "It's a Million to One You're in Love," and "So Will I." Sometimes I teamed up with the local master of ceremonies and did duets. The routine was well established, yet there was the occasional surprise hitch. During an engagement at the Winter Garden Supper Club in Galveston, Texas, the police raided the place for illegal gambling and serving liquor. Luckily, the owner had warned my mother beforehand about the possibility of a raid, and we escaped just in time.

At the age of fourteen, I was on a tight performance schedule in motion picture presentation theaters. In St. Louis, there were two: the Ambassador and the Missouri; in Chicago, there were seven: the Oriental, the Uptown, the Chicago, the Tivoli, the North Shore, the Roosevelt, and the Central Park. All of the Chicago theaters were operated by Balaban & Katz. Each theater opened at 10:30 in the morning and showed a combination of film and live entertainment. The movie began running at 11:00. During the film, show performers would straggle in through the stage door to prepare themselves for the first performance of the day. On the way to our dressing rooms, we'd peek from the wings into the darkened theater to see if anyone was out there. Amazingly, even at that hour, there was always someone. There was a snide little show business expression that just fit the bill: "If it's a Paramount Picture, there's a row for every patron!" After the movie was shown, the ruby velvet curtains would part to reveal a small set which contained the bandstand. The small set made the large stage space look more intimate and friendly. In the center stood the master of ceremonies, swinging a baton. He was usually a local "heartthrob," the "personality" whom audiences came to see. The stage show lasted for about an hour, and would be followed by the movie and then the show again. There

were usually three or four shows a day, and I did them all. Paramount Publix had discovered a very successful formula for its theaters.

In St. Louis, Ed Lowry was the local bandleader. Although not a musician, he was a bright-eyed fellow who managed to conduct the orchestra with great believability. More important, he was a singer who knew how to sell a popular song. St. Louis loved Ed and he could do no wrong. When I arrived there as a single act, the producers of the show felt I could act as Ed's "foil" and do comedy skits with him. I would sing about four storytelling lyrical songs, followed by comical patter between Ed and me. This was known in the business as "happy songs and snappy chatter." When we would sing a duo, the audiences lapped it up. We were a hit.

The producers of the show, the Skouras Brothers, came to my mother with an offer; if I continued to perform in their Ambassador Theatre in St. Louis for a minimum of four successive weeks, they would pay me $75 a week extra. Not only was that a heap of money, it meant we could stay in one place for a good length of time. Mother happily accepted their offer and we settled into our hotel for the month.

Many years later in Hollywood, Spyros Skouras became head of the Fox studio, and Charlie became my good sweet friend. He always felt his company was responsible for my theatrical success. Whenever we were at the same Hollywood dinner party, sometime during the evening he would enter into a rapturous monologue about my beginnings with the Skouras chain and wind up by giving me a resounding pat on the back. Charlie was a big man and I really felt his backslapping. He was a sweetheart, though, and his proud affection for me was gratifying.

Living on the road was an expensive matter, even though I now made between $225 and $350 per week. Fortunately, at this point in my career I no longer had to split my salary three ways. Mother knew how to cut fi-

nancial corners and make life more comfortable. She would ask the manager of the hotel for a little side table for my stage makeup, so I could make up at the hotel and go to the theater all ready for my performance. This simple request would give me an extra half-hour of sleep.

Hotel managers were usually quite considerate of their theatrical trade and they complied happily with Lela's request. Sometimes, though, there were rules, and on occasion, we broke them. Because of fire laws, most hotels did not allow cooking in the rooms. Nonetheless, preparing your own meals was the cheapest way to eat, and Mother's thrifty nature would not allow her to pass up any opportunity to save money. We traveled with a locked suitcase, a portable kitchen in fact, that contained our most important money savers: a percolator, a hot plate, a toaster, salt, pepper, sugar, and all the necessary implements: knives, forks, spoons. Believe me, nothing tasted as good as the toast and coffee Mother made each morning in our hotel room. Then, at night after the show, it was great to come back to the room and get comfortable in my pajamas and bedroom slippers, while Lela fixed some soup with crackers, canned chili, or a toasted cheese sandwich with a glass of milk. During the winter months, we would keep a bottle of milk on the window ledge. Fresh fruit and a box of little cream-filled wafer cookies were always on hand too. Lela saw to it that we had the best our money could buy, even though it wasn't the most expensive. However, once or twice a week we'd splurge and go to a nearby restaurant for a steak and a baked Idaho potato.

I never felt cheated having to eat hot-plate fare. As far as I was concerned, I wouldn't have had it any other way. I loved every minute of my theatrical experience.

Ed Lowry and I enjoyed great press in the local papers and the rave notices for "Ed and Ginger" spread into the

East and Midwest. The next thing I knew, Balaban & Katz offered me a substantial salary boost to come to their Oriental Theatre in Chicago and join up with their local bandleader, the matinee idol of the "Windy City," Mr. Paul Ash. Unlike Ed Lowry, Paul Ash was a bona fide musician and did conduct the stage orchestra. That's all he did—he was not an entertainer—but he was an extremely popular figure, especially among the females. Paul Ash was a handsome man with a full head of copper-colored curls. He was aware that the women in his audience liked the way he dramatically tossed his curly locks while conducting. Many times I heard a Miss or Mrs. Public remark, "I'd give anything to get my hands in that curly red hair." But he was a happily married man, who had the same problem of fighting off the stage-door ladies that my good friend Frank Sinatra did, years later.

Before I arrived at the Oriental, Peggy Brenier, a cute little brunette, sang with Paul Ash. She was very popular and specialized in singing "boop-boop-a-doop" à la Helen Kane. I wondered if I might not be making a mistake trying to swim through her wake of popularity.

Lela saw the possible problem as an opportunity for me to learn the right attitude toward competition. "Never compare yourself disparagingly with another or strive to be better than another individual. Gratefully recognize your own worth as His uniquely individual idea, for you must love the other fellow with the same gratitude for *his* God-reflected qualities." I stopped worrying about Peggy Brenier and began working with Paul Ash.

We did a comedy routine, utilizing the same laugh-tested dialogue I'd done with Ed Lowry. Paul was stiff at first, but then he loosened up and got into the rhythm of these little comedy exchanges. I would point things out to him, saying, "There's a good laugh there, after you answer me. So wait for it." Timing was an essential ingredient of our patter, and when he saw that I had led him accurately, he began to trust my comments. I, naturally,

was assisted by Lela. Mother wrote all my material and sat in the audience at every performance. She was my one-man critic and came backstage afterward to tell me to slow down my joke for a better laugh, or to speed it up, or to enunciate clearly.

In the act with Paul Ash, I was in a rope swing and pumped myself over the stage. On one occasion, during the finale, I was happily kicking back my heels and swinging up and down stage in an ever-widening arc. It was thrilling and a bit frightening, too, to be that high above the stage. All of a sudden, the left rope hanging from the ceiling bar came loose at the top, and the swing dropped. I was left hanging onto the right rope for dear life. I can still see the expression on Paul Ash's face as he heard the rope break. He stopped conducting and quickly took three steps in my direction. The audience held its breath.

Fortunately, the stagehands, who were supposed to hold the swing for each show, were on top of the situation. One fellow grabbed my broken rope and with all his strength stopped the forward motion as best he could. Without his muscular effort, I would have sailed right through the canvas-painted stone wall and might have ended up wearing footlights on my head. The stagehands caught me just before I hit the floor. My mother was out front when the rope broke and yelled out, "Dear God, my child." She sprinted up the aisle and arrived at my side. She was paler than Paul Ash. I was okay except for a slight rope burn on my hands.

Several months later, I was working at the Circle Theatre in Indianapolis when Paul Ash sent me a telegram asking me to join him and his orchestra at the Paramount Theatre in New York City. We'd be doing the same song-and-dialogue routine that had been so successful in Chicago. Go to New York with Paul Ash? What a break!

Up to then, Mother had kept me away from New York;

she felt I needed all the experience I could get before I hit
the big town. She always contended that "only when you
have gotten rid of all amateurish overtones will I give my
permission for you to be seen on the stage of a New York
theater. I don't want you to be embarrassed by any of
their criticisms." Now she felt I was dry enough behind
the ears, and gave her consent. Off we went. Constantly
changing cities was disruptive, but doing the same
"snappy-patter" routine gave me something familiar to
hold on to and helped give me confidence. I still remem-
ber bits and pieces of my dialogue; some of it was real
wacky. Laughter in those days was generated by offbeat
shaggy-dog type material and I would bring down the
house with a deadpan recitation of the following:

> Fishie, fishie in a brook,
> How they look and look and look.
> Like little children they play all day.
> My sister has a horse!

On August 19, 1928, I performed for the first time on a
New York stage. I couldn't believe that I was here again
in this great city. We did five shows a day during the
week, and six on Saturday and Sunday. What a workload!
When the three-week engagement with Paul Ash was
over, I went back on the road for another six months,
traveling to Boston, Los Angeles, Detroit, Dallas, New
Orleans, and Atlanta.

7

CAN'T YOU SEE I'VE GROWN UP?

DURING MY DALLAS ENGAGEMENT, I WAS SITTING IN MY dressing room at the Palace Theatre when someone knocked at the door. "Who is it?" I asked.

"It's Jack Pepper, Ginger. I've come to say hello."

Jack Pepper! It was Aunt Jean's beau, Jack Culpepper, the man I had secretly fallen in love with while watching him smooch with my aunt as they sat on our front-porch swing. I could hardly believe he would come backstage and see me as grown up. The haunting love theme of the past tugged at my heart the moment I heard his unmistakable voice. I couldn't get myself together fast enough to open the door and greet the man I had long identified as the most attractive man I had ever met.

"Did you see the show?" was my fill-in remark. "How did you like it?"

"I thought it was swell," he said.

I waited for him to say, "My, you have grown up, haven't you?" I was hoping he would recognize that I had finally become a young woman. But his interest seemed to be in the performance I gave. He commented on the

musical numbers and the choreography, but not on what I wanted him to notice. Me! What about me, I thought. His remarks were pleasant, but somewhat impersonal. That made me want to shake him and say, "Don't you see, I've grown up."

Mother walked in and was visibly surprised to see Jack after almost six years. Jack invited Mother and me out for Chinese food the following evening and I accepted before my mother had a chance to open her mouth. I could hardly wait. Tomorrow couldn't arrive soon enough for me.

The next night, after the show, the three of us went out to eat. Like most actors, I've always been grateful for Chinese restaurants; they were often the only places that stayed open late enough for performers to get hot food after the show. The conversation was lively and we laughed and exchanged vaudeville jokes. He was such fun and so good-looking, I wondered how many girlfriends he had. I found myself staring at him while I carried on a constant question-and-answer dialogue with myself in which the answers came harder than the questions.

Mother was oblivious to my feelings. She had never known of the aching valentine heart that I had for Jack Culpepper. I kept my passions to myself and she was always too busy with her projects, juggling sixteen oranges and trying not to drop one, to see the emotional gymnastics I underwent whenever Jack came to the house. Moreover, in those days, mothers didn't, as a rule, discuss such matters with their daughters. I never got one stitch of information from Lela on the "how to's" or "what for's" of sex. At the age of ten, I thought if a boy kissed you on the lips, you would have a baby, and I surely wasn't the only youngster who believed that! I had been part of the adult entertainment world for years, but still had not reached a personal maturity. I really had never been alone with a man. Harboring thoughts of Jack all those years on the road, I had convinced myself I was in love with him. Seeing him again only proved to me that I was

right. I was so in love with love, I couldn't think straight.

Within a few weeks, Jack asked me to marry him. I accepted his proposal and went to tell Mother. She was furious.

"How could you accept a proposal of marriage? You're not old enough to know anything about love or marriage. Don't you realize he's at least ten or twelve years older than you? It's the same thing I went through with your father. After the first four or five months, once the mystery of sex has worn thin, he'll leave you. So don't you come back to me one year from now dragging a baby, ready to leave it on my doorstep. You are headed for some wonderful opportunities in the theatrical business. And you want to throw all that away? Let me tell you something, young lady, if you pursue this idea and marry Jack Pepper, you have LOST ME FOR GOOD! I shall return to Fort Worth. And one other thing, I shall never want to SEE YOU AGAIN, EVER AGAIN, and that's final!"

With that, she got out her suitcases and started to pack her belongings with the same furious action that her words had expressed. It was obvious that she was ready to weep with disappointment and desperation, but she was too angry to cry. She knew I was wrong—dead wrong.

A cold chill ran through me. The thought of never seeing my mother again was shocking. Somehow, I had never anticipated this turn of events. The little girl in me thought that marriage solved all problems and made everybody happy. But now I was discovering rusty spots in the machinery of life. Couldn't she just accept this and allow me to find out what marriage, life, and love are all about? I was angry at her for not understanding, and even angrier that she didn't want to understand. My infatuation was so strong, I turned my back on my mother and refused to listen.

On March 29, 1929, at the age of seventeen, I was married to Edward Jackson Culpepper in the office of a New Orleans justice of the peace. In the absence of any

of my family, I was grateful to have the Rogers family friend Bob O'Donnell there to stand up for us as best man. I couldn't ever want to be anything in the world other than Mrs. Edward Jackson Culpepper. One of these days, Mother would realize how wrong she was. True to her words, my mother had packed her belongings and returned to Fort Worth.

For the next four months, Jack and I lived together on the road and marriage proved not to be what I had expected. I had nothing to do except help my husband get dressed for his show or listen to him argue with his partner. As the dutiful wife, my main task was to see that Jack's toupee was cleaned after each performance and ready for the next one. Otherwise, I was more or less like a third thumb. Instead of performing, I was hanging around backstage watching from the wings. The first two dozen times were fine, but not for a performer, who should be polishing her craft. I was jealous of the opportunities I was missing. It wasn't long before Jack and I were arguing with each other over things that seemed unsolvable. I was beginning to hear the playback of my mother's words.

"Oh, rue the day I wanted to marry," I thought. "Why wasn't I alert enough to recognize a mistake before I made it?"

A little voice inside said, "But you didn't listen when you were told, and you were told quite distinctly."

My marriage to Edward Jackson Culpepper was indeed a disaster. He had many good qualities, but the one flaw that I could not tolerate was his constant drinking. That was our major "bone of contention," especially when he would come home full of "firewater" (for me that was grounds for war). I didn't drink, and I couldn't understand why anyone would want to allow himself to be in a state of not knowing what he was doing at all times. We lived in a vacuum. I find it impossible to communicate with any individual who continuously indulges in alcohol. The fun,

joy, and humor dry up in a relationship when one of the partners is swimming in gin. To my way of thinking, it is selfishness personified to see life through the bottom of a liquor bottle. Marriage is supposed to be a "give-and-take" agreement—not all TAKE! I couldn't talk, discuss, or plan anything with Jack, knowing that by tomorrow he'd not recall what he'd agreed to yesterday.

I telephoned Mother in Fort Worth, and my darling Lelee listened as I poured out my heart. As I talked to my mother, I suddenly became aware of what a stupid child I had been. I instantly made up my mind to leave Jack Culpepper and go back to my career. Mother couldn't have been happier. There were no recriminations, she just thanked God that I had come to my senses. She rejoined me immediately and once again, we were on the road.

While I was married to Jack Culpepper, something had happened to my parents' marriage. My darling mother obviously had problems, too. Lelee was a very private person and she never revealed the reason why she and Daddy John divorced. I never insisted on an explanation, for she knew how much I adored Daddy John.

My vaudeville stage career flourished and I acquired an agent, Abe Lastfogel, at the William Morris Agency. While I was appearing in the New York area, he found work for me in motion pictures in a number of three-reel films. These fifteen-minute "shorts" were more like vaudeville song-and-dance sketches than a full-length movie. One of the major "shorts" (actually, my first) was *Campus Sweethearts*. Rudy Vallee was in the cast, and while we were friendly, we were never as close as he intimated in his autobiography. Rudy claimed I had asked him to marry me! He wouldn't back down from this foolishness even when I confronted him in person. I told him there was no way I could have married him, because I was still married to Jack at that time. He stuck to his guns and,

I must say, his lie got my goat. Now I'm setting things straight. I NEVER proposed to Rudy Vallee. Period.

Among the other short two reelers were *A Night in a Dormitory, A Day of a Man of Affairs,* and *Office Blues.* The titles give away the film's plots. *Screen Snapshots* had a cast of established stars, such as Mary Pickford, William Powell, William S. Hart, Clark Gable, Hoot Gibson, Tom Mix, Joan Crawford, and Will Rogers. Just listing them takes almost as long as the film did. *Hollywood on Parade* was another film with a bevy of stars-to-be. At the same time that I made the shorts, I was still working on the vaudeville circuit. During a return engagement in New York at the Paramount Theatre with the Paramount Publix shows, Bert Kalmar and Harry Ruby, the composer and lyricist of an upcoming musical comedy, *Top Speed,* came to see the show. They were looking for a comedienne to play the role of Babs Green. After watching me perform, Kalmar and Ruby sent word to my agent requesting that I come to an audition.

Mother and I showed up at the audition just as another potential Babs went on stage to perform. We watched as this girl sang, danced, and did cartwheels and flips. When she was finished, my name was called. I gave the pianist my music, sang two songs, and headed for the wings as someone approached my mother. I arrived at her side just as the other person walked away. Mother told me that she had been asked by the people out front to have me do some cartwheels and some flips.

I put my nose in the air and said, "Tell them I will not turn my body over for anyone!" Mother was flabbergasted by my quick and very definite response. I was adamant. We retrieved my music and left. Two weeks later, my agent called to say I had landed the job in *Top Speed.*

What a delight it was to be working with musical comedy people. Everyone pulled together for the good of the show. Not only that, the musical comedy schedule was

completely different from vaudeville. After two weeks of *Top Speed*, I was convinced that eight shows a week was to my liking. *Top Speed* boasted an impressive cast. Irene Delroy, a lovely young woman with a sweet singing voice, was the leading lady. Paul Frawley, our leading man, had a strong singing voice and a definite masculine appeal. He needed a strong voice, because there were racing speedboats in the background that made a lot of noise. Lester Allen, the comedy man, kept us laughing all through rehearsals. He had a Chaplinesque quality that captivated our audiences. They were the stars, yet there was one member of the cast, a chorus boy, who would prove to be a very important person in my life. His name was Hermes Pan, and he and I made our Broadway debuts together. Hermes and I became good friends. Many nights after the show, he would come up to our hotel room and Mother would make delicious hot sandwiches on an electric toaster we had. Nothing cements a friendship more than eating together and chatting about all the odd or interesting things that have happened during the performances. That camaraderie would be reinstated at RKO Studios and endured right until his passing in October 1990. He was a darling friend, and I miss him.

Top Speed opened at Chanin's 46th Street Theatre on December 25, 1929, and ran for 102 performances. In it I sang a number called "Hot and Bothered." The debut of my first New York musical was a memorable night for me. Being on Broadway for the first time is like having somebody give you a set of snare drums for Christmas. It's thrilling! You begin to see what you can do when you stretch your concept of yourself. Suddenly you feel six feet tall and full of ambition. Mother always knew I would make it, but I had millions of doubts. To think that I had come all the way from a Texas Charleston contest to the magic of the Great White Way! I really thought I'd

reached the pinnacle until something happened that almost knocked me off that peak.

Mother and I were living at the Paramount Hotel. Late one afternoon, there was a knock at the door and again came that familiar voice, saying, "It's Jack, I need to talk to you." We let my husband in; he was drunk. Jack began to abuse Mother verbally and then, without a pause, he turned on me, ending by saying, "If you don't come back and live with me, Ginger, I'll cause such a scandal that you'll wish you had." As he spoke, he grabbed my arm and pulled me toward the open window. Before I could do anything, he flung one leg over the windowsill and said, "Say you will come back and live with me or I will jump out this window and pull you after me." I couldn't break his hold on my arm. "Mother, Mother," I cried out, "he'll do what he says. Do something to stop him!"

I had never been so frightened!

Lela, cool as a cucumber, stared Jack straight in the eye and said firmly, "Let go of her. *You* go ahead and jump if that will solve things for you, but you will never hurt her, now or ever. Now, get out!"

Lela's commanding tone made Jack cower. Much to my surprise, he sheepishly released my hand and pulled his leg back into the room. Without a word to either of us, he weaved toward the door and walked out.

8

WANT A SCREEN TEST, LITTLE GIRL?

JACK'S VISIT WAS THE ONLY DISCONCERTING NOTE DURING THE three-month run of *Top Speed*. Everything else in my professional life was just fine—hectic, but fine; I was featured on the Broadway stage *and* I had begun to make movies.

At the premiere of *Top Speed*, we heard a rumor backstage that there were some movie bigwigs out front in Mr. Kalmar's house seats. When I came off stage, Mother handed me a note that had been given to her by the stage manager. As I looked at it, she read aloud over my shoulder: "If you would be interested in making a screen test at Paramount, call this number. (signed) Walter Wanger." Mother took the note and hurried out to the box office. Lelee asked the fellow to check the reservations, to see if Walter Wanger was in the theater this night. The box office attendant found Wanger's name listed next to that of Adolph Zukor; Zukor was the head of Paramount. Mother came back and reported the good news to me: the note was legitimate.

The next afternoon, Mother telephoned the Paramount

studios in Long Island. I sat next to Lelee and listened. Walter Wanger got on the line and told her that they were interested in testing me for a new film that was to start early in February. Mother made an appointment for me to go to the Astoria Studios in Queens that Friday.

We made the trip to Long Island and I tested for the role of Puff Randolph. I won the role and on January 22, 1930, was signed to a seven-year contract.

When filming began a week later, I reported to the studio along with the star of the film, Claudette Colbert. The leading man was the popular Norman Foster. It was a great thrill to be working with Claudette. I'd admired her on the screen and now I'd be up there with her. She had a marvelous sense of humor, which was evident in everything she did. Claudette and Norman were rumored to have been married. Neither of them would admit to the union so the New York movie colony decided the two of them were just in love. Not until a year later, when they sought a Mexican divorce, did anyone realize they actually had been man and wife. Charlie Ruggles was also in the film and we got along famously. He had a wonderful sense of humor and we constantly exchanged jokes and jibes.

Shifting from a nighttime theater person to a daytime movie person and then back again was no easy process. Sleep became the operative concern, and it wasn't easy to get any. I had become used to a life in which sleeping-in was the norm. I rarely went to bed until after 2:00 in the morning and didn't rise until 10:30 or 11:00. Then I'd order breakfast to be sent up from the coffee shop and eat my toast and jam while reading the theatrical dailies. But everything changed when I began making movies. I had to report to the makeup department at 7:00 A.M. I was lucky; if I had been required to do character makeup, I'd have had to get there hours earlier. Once the makeup was

applied, I moved to the next station, the hairdresser. She dampened my hair, wrapped it on paper rollers, and shoved me under the helmet-like hair dryer. When my hair felt like an old horse-hair mattress, I came out from under the dryer. Heaven help you if you needed to have your hair washed; that threw the whole schedule into disorder and you'd have to change places with some other actor in line for makeup. Alterations in the assembly-line procedure were greeted with sour looks. Frankly, a lot of the rigidity came from staff members who didn't want to change their coffee breaks. Unbelievable.

Young Man of Manhattan was a romantic comedy by Katharine Brush about the adventures of a newspaper-woman. I played the role of a society flapper who flirted with the leading man and sang one song, "I Got It, But It Don't Do Me No Good." (I was rehearsed for this number by a talented young man I came to know and love, Johnny Green, composer of "Body and Soul.") An interesting line of dialogue, which my character had to repeat many times during the film, was a remark that sounded like something Mae West would have said: "Cigarette me, big boy. Well, light it!" The expression caught on.

Monta Bell, the director, instructed me to puff furiously on a cigarette during a scene in which I was supposed to pace up and down the room nervously. This was my very first feature film and I was eager to be as obedient as possible, but I didn't know how to smoke. Monta pointed to the corner of the stage and said, "Go over there and learn!" I went into the far corners of the stage and practiced, lighting one cigarette after another, puffing on each one. I soon turned green and felt sick as a dog. My mouth felt like a barnyard floor. Why would anyone want to puff on this weed? Immediately, visions of that Fourth of July with Leslie Marsh and my first cigarette came vividly back to me. After this film I had to smoke in another film and, though I viewed smoking as an ugly habit, like so many people I got hooked. I indulged for about six years. Then,

after my fingers, my hair, my clothes, and my bedroom all began to smell of cigarettes, I decided to give the habit up. With a great deal of prayerful thought, I stopped smoking—completely. I was so grateful. Everything seemed brighter and food tasted better. The scent of morning air was an odor I hadn't recalled for a long time.

When it became clear that I would be working steadily at the Long Island studio, as well as performing in *Top Speed*, Mother and I decided to get a place in the country where I could hide from the hubbub of the city. We found a dear little house in Douglaston, Long Island, near the film studio. The house stood in a direct line to the theater over the Brooklyn Bridge. I could be at the stage door of the 46th Street Theatre in eighteen minutes. Somehow, I don't think you could do that today.

Eddie Cantor, one of the most celebrated performers of the day, came to see *Top Speed*. Like all good colleagues, he went backstage to say a few words to some of his friends. I didn't know him and was surprised when he popped into my dressing room. I thought he was looking for someone else and told him he'd gone one flight too high for Paul Frawley or Irene Delroy.

"No, my dear little lady, I have come up to this floor to see you," he said as his big brown eyes snapped. "I've come to tell you that I enjoyed your performance tonight, and I think you have a healthy career ahead of you in this business."

"Thank you, Mr. Cantor, thank you very much. A compliment like that from you is certainly most encouraging."

I felt he was looking me over, not in an uncomplimentary way, but sort of in a quick appraisal. "I suppose your manager had you sign a run-of-the-play contract with Kalmar and Ruby?" I told him I had, and added that my mother, Lela Rogers, was my manager. "I'd like to meet your mother. Is she here?" he asked.

"Yes, she's downstairs at the stage door saying hello to some Texas friends who saw the show tonight. I know she'd be thrilled to meet you, Mr. Cantor."

I described her to him so he couldn't miss her.

"Well, I hope we meet again, Ginger," he said smilingly, "and I'll look for your mother as I leave."

I was pleased I had lingered longer in my dressing room and had not, this night of all nights, followed my usual pattern of leaving the theater with Mother ten minutes after the final curtain on our way to Ruben's Restaurant.

I was just putting on my hat when Lelee appeared at my dressing-room door, all smiles, and said, "I've just met . . ."

"Yes, Mother, I know. Eddie Cantor. Isn't he charming?"

"But you don't know the best part."

"All right, Mother, drop the other shoe. What's the *best* part?"

Mother proceeded to tell me that Florenz Ziegfeld was producing a new musical with Al Jolson as the star and they were looking for a leading lady. "And that's where you come in. Mr. Cantor thinks you'd be perfect opposite Jolson and wants to introduce you to Ziegfeld." What a gift . . . and a fitting example of show business at its nicest. Eddie Cantor didn't know me from a hole in the wall; he wanted to help because he thought I was good. You don't ever forget the generosity of people like him.

A week later, there was a note at the stage door from Eddie Cantor telling us to be at Mr. Ziegfeld's office at a designated date and time. Cantor said he'd be waiting for us to make the introductions.

When the big day came, I washed my hair and set it, applied the proper touch of makeup—not too stagey—buffed my nails, polished my tap shoes, and pressed and donned my prettiest dress. I vocalized an hour ahead of time, and did the necessary stretching and flexing. I was all set.

Mr. Ziegfeld's office was in the executive area of the Ziegfeld Theatre. A private elevator took us to the reception area. Ziegfeld's outer office looked like a stage set—large and airy and furnished sparsely, the whole place reflected taste and elegance. The secretary smiled and motioned for Mother and me to take a seat. I was still marveling at the surroundings when Eddie Cantor came joyously bounding out the door of Mr. Ziegfeld's office with a boyish grin on his face.

"I've told him all about you. He's going to try to come and see your show. For now, he's arranged a private audition right here. Now, don't be nervous," he said as he patted my hand. "Ziegfeld is a wonderful man and will make you feel completely at ease. What's more, I will be right there with you."

"Thank you so much, Mr. Cantor," I said, swallowing hard to ward off the nervousness I had promised myself not to take into the audition with me.

Then he ushered Mother and me into one of the handsomest offices I have ever seen. The colors were muted tones of lavender, pale blue, silver, and gray. There were yards and yards of gray-white velvet draperies, lined with lavender satin, which you could see in the folds as they cascaded down to meet a two-inch-thick gray wool wall-to-wall carpet. A massive Louis XIV gilt-edged desk was positioned at the far end.

Florenz Ziegfeld stood in the middle of the room looking more like a peer of the realm than a Broadway producer. He was a handsome man, tall and imposing, with a full head of beautiful white wavy hair. "Eddie has told me all about you, young lady," he said, stepping forward to greet me. "And about you, too, Mrs. Rogers. When the pianist gets here we'll begin." Until the accompanist arrived, Ziegfeld chatted politely, his eyes bouncing from me to Mother and back again. I got the feeling he could look right through me. The pianist arrived and I gave him

my music. I'd carefully selected a song that was very different from my repertoire in *Top Speed*.

You'll meet somebody,
Some sweet somebody.
So will I.
So will I.
You'll go to parties,
Yes, lots of parties.
So will I.
So will I.
And you'll say, "Off with the old love,
On with the new,"
I'll say the same thing too.
Then you'll be sorry,
You'll be so sorry.
So will I.
So will I.

I thought this number had an emotional content suitable for playing opposite such a dynamic entertainer as Al Jolson. I was halfway through the song when the inter-office telephone rang. Mr. Ziegfeld picked up the receiver. He listened, then hung up and reached for a second phone, saying, "I'm sorry, I have to take this call; I'll be finished in a minute." I couldn't help overhearing Ziegfeld's side of the conversation. "Yes, Jolie." There was a long pause, after which Ziegfeld said, "Is that the young lady I met Friday night?" Then another pause. "All right, yes, then we'll talk about it. Yes, that's fine. We can have lunch right here in my office. Yes, if that's what will make you happy. All right, goodbye."

I didn't have to be Sherlock Holmes to figure out that Ziegfeld was talking to Al Jolson, the man I hoped to play opposite. Ziegfeld put the phone down and signaled for me to continue. I finished the song and the impresario smiled warmly. He called Eddie Cantor to his side and

spoke with him quietly. Mr. Cantor said, "Really, well, I'll be darned." Once again, the great Ziegfeld addressed his attention to me and complimented my efforts. We shook hands and Eddie Cantor accompanied Lelee and me out to the street. Cantor spoke first.

"Ginger, Ziegfeld thought you were terrific, really great, but, um, you couldn't begin to guess what that telephone call was about."

"No, I couldn't," I replied, "though I think it was from Mr. Jolson."

"That's right, and the unfortunate thing is" Cantor sighed. "Well, this is a Jolson show, and he just told Ziegfeld he's found the girl he wants to play the leading lady opposite him, and I'm afraid that's that."

Quickly, Eddie hailed a taxi for us and helped us in. He was obviously upset at what had happened. So was I. "Well, Ginger," he said as Mother and I sat back in the cab, "I'm sorry this didn't work out. But I'm telling you right here, you'll have another show very soon that will give you the opportunity to show your talent. I'm bettin' on you!" He closed the door and the taxi took off.

A few days later, the newspapers announced that Al Jolson's leading lady in the new Ziegfeld show would be Miss Ruby Keeler. Shortly thereafter, Miss Keeler married Al Jolson. I had learned another show biz lesson. As disappointing as it was to lose out, at least I knew my defeat had nothing to do with my talent or ability.

Top Speed closed in March 1930, and in April I began another movie, called *Queen High*, directed by Fred Newmeyer. I played the love interest of Stanley Smith, with whom I sang two songs. Frank Morgan, known later as the Wizard of Oz, and I also sang two songs. My friend from *Young Man*, Charlie Ruggles, was in the cast too, and we continued our fun. In May I was paired with Jack Oakie in *The Sap from Syracuse*. I played an heiress

who has a shipboard romance with Jack. A. Edward
Sutherland was the director.

In July, Norman Taurog, the top director at the New
York studio, was selected to mastermind *Follow the
Leader*. Ed Wynn played a waiter who is mistaken for a
gangster. Again I played Stanley Smith's girlfriend. Ruth
Etting was supposed to play the part of Helen King, a
musical comedy star, but at the last minute she was re-
placed by another young woman.

A few weeks prior to shooting this film, Mother and I
had gone to a movie theater in White Plains. The emcee
introduced Ethel Zimmerman, a new singer who would do
some songs with her accompanist, Al Siegel. She strode
forcefully to the front of the stage and began to sing. She
was sensational; her voice was clear and brilliant and
every word could be heard in the far reaches of the thea-
ter. And now here she was in the same movie with me
with a shortened name, Ethel Merman.

I loved doing motion pictures for many reasons, not the
least of which was the opportunity to make new friends.
I liked film people, and talking shop with them made me
feel as though I belonged. I not only made movies, I also
was an avid moviegoer myself.

Shortly after *Top Speed* closed, Universal Studios invited
Mother and me to the grand premiere of a new and highly
touted motion picture, *All Quiet on the Western Front*,
based on Erich Maria Remarque's novel of World War I
Germany and directed by Lewis Milestone. Movie pre-
mieres were lavish and dazzling events in those days.
Everyone who was anyone came dressed to the nines.
Mother and I put on our long evening gowns and joined
the excited throng that gathered in the tiny foyer of the
Central Theater. The V.I.P.s from the business world
were joined by the Hollywood stars who happened to be
in Manhattan. We brushed shoulders with Vilma Banky,

Ben Lyon, and Rod La Rocque and saw Bebe Daniels, Douglas Fairbanks, Sr., and Lilyan Tashman. Reporters and photographers were everywhere. The cameraman's powder flashes went off like lightning in a bottle, making the foyer look like a shower of meteors inside a tinsel box. Though it was April, ladies wore gorgeous long evening coats and capes trimmed with silver and white fox, ermine, mink, and sable. Diamonds sparkled on throats and around wrists. Gentlemen were attired in black tie or white tie and tails and sported black derbies or top hats. Evening clothes were special in those days and dressing up was the norm.

The audience was ushered into the theater and seated, and the film began. *All Quiet on the Western Front* needs no review from me today. It remains a Hollywood screen classic. That evening I was as enthralled as the rest of the audience. And then it happened! Larger than life in front of my eyes, there he was. I fell head over heels in love, then and there, with the picture's leading man, Lew Ayres. I couldn't take my eyes off this incredibly handsome and gifted actor. He made me feel a deep sympathy for the gentle German boy he was portraying. The applause at the end of the premiere was thunderous. I left the theater in a daze. I couldn't stop thinking about Lew.

I had to force myself to stop daydreaming, for I was plunged into a new round of professional activity. A new opportunity presented itself and I had to put Lew Ayres out of my mind and concentrate on the work at hand.

9

*G*IRL CRAZY AND A SURPRISE GUEST

EDDIE CANTOR'S PREDICTION CAME TRUE.

Alex Aarons and Vinton Freedley announced auditions for the new George and Ira Gershwin musical, *Girl Crazy*, and I joined the ranks of hopefuls at the tryouts. That was the first time I saw George Gershwin. He played for the auditions. Gershwin was a masterful pianist, who could switch keys in the twinkling of an eye to accommodate any singer. Unlike my Ziegfeld experience, there was no hidden agenda in the casting. I sang and danced and won the leading role. However, I had to get permission from Paramount to appear on Broadway as I had recently signed a seven-year contract. But a lead in a Gershwin show enhanced my importance to the studio, so the studio gave me its blessing. I signed with Aarons and Freedley and began my association with the great Gershwins. I was nineteen years old and about to star on Broadway, earning $1,000 a week. I was on top of the world!

Before production started, Mother and I were invited to a dinner party at the Gershwins' apartment at 55 Riverside Drive. Their soirées were legendary and I was

very nervous at the prospect of being among the elite. Mother and I dressed in our best and appeared at the appointed time. I was immediately put at ease when George, Ira, and Ira's wife, Lee, greeted us at the door with open arms. The Gershwins couldn't have been more gracious and hospitable. Individually, they were extraordinarily gifted men; together, they were a magnificent team. George and Ira complemented each other's genius. Ira had a deep understanding of human nature and knew everything about people and their passions and feelings; that's why he wrote so fluently. George was a performer, an actor, really, who loved more than anything to strut his stuff, and what stuff he had to strut! As long as he had an audience, George was happy.

Among the other guests were Alex Aarons and Vinton Freedley, Guy Bolton, who wrote the book for *Girl Crazy*, comedians Willie and Eugene Howard, Abe Lastfogel, my agent at that time, and a couple of gentlemen who were described as potential backers, or angels. Dinner at the Gershwins was an event. The meal was well planned, but the best came afterward. Coffee was served in the salon and as we sat around, George sauntered over to his concert grand piano and lit up an enormous Havana cigar. The minute his fingers touched the keys, there was a hush. The guests knew that they were about to experience the best of Gershwin, 1930. After a grandiose warm-up, he stopped, then, with a big grin, launched into a potpourri of the new score. George seemed to embrace the Steinway. The magic of his quiet presence seemed to bewitch the keys to move as he willed them.

After a few numbers, George stopped. He looked over at me, crooked his index finger, and said, "Ginger. Come sit here beside me." He pointed to the piano seat. I walked over and slid in beside him. He removed the cigar from his mouth and slowly placed it in a very large Lalique ashtray on the port side of the piano. The ashtray had the initials "GG" carved in the crystal.

"Ginger," said George, addressing me again, "I've written a special song for you. I hope you like it." Putting some beautiful chords together, he started his characteristic sing-talk of Ira's lyric, beginning with the verse:

> Old Man Sunshine—listen you!
> Never tell me Dreams Come True!
> Just try it—
> And I'll start a riot.
> Beatrice Fairfax—don't you dare
> Ever tell me he will care;
> I'm certain
> It's the Final Curtain.
> I never want to hear
> From any cheer
> Ful Pollyannas
> Who tell you
> Fate supplies a Mate—
> It's all bananas!

George held the chord on the piano, leading into the chorus, just long enough to tell me, "You will be seated at a table on stage all alone while you start to sing this forlorn little love song":

> They're writing songs of love,
> But not for me.
> A lucky star's above,
> But not for me.
>
> With Love to Lead the Way,
> I've found more clouds of gray,
> Than any Russian play
> Could guarantee.
>
> It all began so well,
> But what an end!

This is the time a fell
Er needs a friend.

Love ain't done right by Nell,
However, what the hell—
I guess he's not for me.

The song, "But Not for Me," called for exactly the kind of emotional acting/singing I loved to do, and to think the Gershwins had written it just for me. As if being given this incredible melody wasn't enough, George turned and said, "Now I'm going to play for you the first song you sing in the show." Once more he turned to the piano and, for the first time in public, the strains of "Embraceable You" were heard.

"Please play it again," I asked. The others in the room echoed my request. I couldn't get the theme out of my head. This has to be a hit tune, I'd bet on it, I said to myself. As generations have proved, I wouldn't be the only one enamored of that very special love song. "Now," George said, "here is the final number you do in the second act, and this one will include a tap dance with some boys singing an accompaniment behind you. It's called, 'Cactus Time in Arizona.' "

What a thrill to sit there and listen to George Gershwin play and sing his music! Every now and again, Ira would catch his brother in a mistake and good-naturedly call out the correct lyrics. Ira told us they had written three songs for the character of Kate Fothergill, but they hadn't found a singer yet. They included the jazzy "I Got Rhythm," plus "Sam and Delilah" and "Boy, What Love Has Done to Me."

After that, George played "Could You Use Me" and all the other tunes they had written for the show. What a score! When George and Ira concluded their rendition of the songs, my mother and I looked at each other and winked. That meant, "Isn't this wonderful." We both felt

that we had just witnessed a hit musical. That was an evening I would never forget.

Not long after the party, Vinton Freedley told us they were still looking for a girl to play Kate Fothergill. Mother remembered the singer from the White Plains movie theater and suggested that the producers audition her. They did, and she was signed to do the show. Ethel Merman stopped the show every night with her rendition of "I Got Rhythm." It was the beginning of one of the greatest careers in musical comedy.

Rehearsals for *Girl Crazy* began at the Alvin Theatre in August, at the same time that the lease expired on the house in Long Island. My mother and I thought it made more sense to move back to the city to be closer to the theater. We found a perfect two-bedroom apartment at 55 Central Park West. I was happy with our new residence because I could furnish my own home for the first time.

During rehearsals, our dance director, Alexander Leftwich, was leaving things too much alone to suit our producers. The next thing I knew, Alex Aarons and Vinton Freedley were complaining to the actors that the dances weren't looking the way they wanted. So Alex called a knowledgeable friend of his and asked him to come over and look at the routines.

That afternoon around 4:00, a very dapper gentleman walked into the theater and up to the mezzanine, where we were working. His name was Fred Astaire. Alex Aarons suggested we go through all the numbers, so Fred could see them. Fred then asked to see the "Embraceable You" dance again. We stopped and started a dozen times while he added little steps here and there. Finally, Fred said, "Here, Ginger, try it with me." That was the first time I danced with Fred Astaire.

At that time I was such a newcomer to the New York world theater that I didn't know anybody by name or

sight. Besides, there were a million things to do before the opening of the show—costumes, interviews, and working on scenes. Fred was brought in by the producer to fix a few routines. Our choreographer wasn't very good, and Fred was able to change and tighten some valuable moves. He was easy to follow and I fell right in step with him. But to me he was just a man summoned to polish a few rough spots. There was no reason to be particularly impressed. I honestly didn't think of him again.

Girl Crazy opened on October 14, 1930, and ran for 272 performances. What a happy show it was, too. The orchestra deserves special mention. The group was billed as Red Nichols and His Five Pennies. Some of the participants were Gene Krupa on drums, Roger Edens on piano, Benny Goodman on clarinet, Jimmy Dorsey on saxophone, and Glenn Miller and Jack Teagarden, both on trombone. For the opening-night performance, George Gershwin conducted the orchestra himself. Thereafter, our composer would occasionally come into the pit with the orchestra during the performance to gleefully play the piano for a few numbers. The cast was always elated when they knew that George was in the pit; there was a special zest when we performed *with* and *for* our composer. Some members of the audience would recognize him and start to applaud; others were bewildered by the commotion. Then George would get up from the piano bench, happy as a clam that he'd had his musical "outing" for the evening, and vanish through the door that led to the theater basement.

As Molly Gray, I played the postmistress in a western town, carrying the mail in my buckskins and boots. In one scene my leading man, Allen Kearns, and I sat on a bench. Allen, as Danny Churchill, said a number of flattering and very amorous words to my character, ending with, "Molly, I love you." One night, out of the blue, Allen looked at me and said, *"Ginger, I love you."* I was completely taken aback. I watched open-mouthed as Allen's

face turned bright red. Like a strong wind on a field of hay, the laugh started at the front row of the theater and slowly rolled to the back, lasting at least half a minute. If he could have dropped through the stage floor, he would have. After the show, Allen came to my dressing room and apologized, saying he'd just forgotten my stage name and had not known what to do.

The next night, he approached the situation from a different angle. Since the slip had gotten such a big laugh, maybe he should make the same mistake again. He did it that evening but it came out so forced that the audience didn't react at all. I suggested we try the next night to be very casual and that Allen re-create his original "Oh, dear, what have I said" look. It took a couple more performances to work it out properly, but by the fifth night his little error got a good laugh. Allen continued to call me "Ginger" in this spot throughout the run of the play. Even today, I run into people that tell me they saw *Girl Crazy* on the night the leading man called me Ginger. (When *Girl Crazy* was made into a musical film, starring Judy Garland, the name of the postmistress was changed to Ginger Gray because of this charming mishap.)

While I was doing eight shows a week, including matinees on Wednesday and Saturday, I was getting up at 6:00 A.M. to make movies. I'd have my breakfast and then be chauffeured to the Paramount studios in Long Island where I went through makeup and hairdressing to be on the set at 8:00. At 6:00 P.M. I would go directly from the movie studio to the Alvin Theatre. I took off the screen makeup, a base of ocher yellow and a lip rouge of chocolate brown, and replaced it with normal flesh tones, pink rouge, and red lip rouge. I felt restored to life by the stage makeup. The natural flesh tones of today are not as depressing as the Egyptian colors of screen makeup in days past.

The fifth film I did for Paramount was *Honor Among*

Lovers with Claudette Colbert and Fredric March. Charlie Ruggles and I were the comic relief in the story of a business executive and his secretary. This time, the director was the talented Dorothy Arzner, one of the few female directors in movies at that time.

The Blue Angel nightclub was next door to the Alvin Theatre, and at one point, for two weeks, I stepped off the stage of *Girl Crazy* and went into the Blue Angel to perform. I'd shoot at Paramount until about 5:30 P.M.; do *Girl Crazy* until 11:00 P.M.; and run next door to perform in this nightclub. This got me home around 1:00 A.M. Got a match?

Times have changed and so have schedules. In the 1930s, Sunday actually was a day of rest. There were no performances, so Broadway actors could relax after the Saturday night show, knowing that a free day was coming up. Every Saturday night, there would be a big bash at the Mayfair Club. The most famous, and sometimes infamous, people of the day were at the Mayfair and it was *the* place to be seen. That's where I met for the first time such stars as William Gaxton, Victor Moore, and the Marx Brothers. Al Jolson and his heavy date Ruby Keeler came often. Top songwriters and lyricists—Irving Berlin, George Gershwin, Ira Gershwin, and Jerome Kern, as well as Buddy DeSylva—went to the Mayfair Club. Frequently, that big bear of a man, Bernard Baruch, would be at a table holding everyone spellbound with his wisdom. It was not unusual to see some members of the Algonquin Hotel's Round Table—Dorothy Parker, Marc Connelly, Moss Hart, Robert Benchley, Alexander Woollcott, George S. Kaufman, Donald Ogden Stewart, and Harold Ross—frequenting this elite club.

Jimmy Walker was the mayor of New York and a frequent customer at the Mayfair. Walker was a fashion plate and was constantly in the newspapers. He escorted

the most attractive women of the day, including society beauties and actresses. His favorite lady, at the time, was the very stunning screen siren Louise Brooks, who had decided to leave Hollywood for New York. They went everywhere together. No wonder I was surprised when my mother announced one day that Jimmy Walker had invited me to a party at the Mayfair. Why had he asked me instead of his steady girlfriend? That Saturday, Jimmy Walker picked me up at 8:00 and took me over to the club.

I shall never forget walking into the Mayfair on the arm of the mayor. We stood at the top of the twenty steps which led down to the dance floor and the mayor removed the white mink jacket from my shoulders. I was wearing a long green chiffon gown with four tiers of handmade chiffon petals, which started four inches above my ankle and cascaded down to the floor. Around my shoulders, the same petal trim created a cowl effect that made me appear very tall. I could sense how fluttery and graceful the petals must have appeared to the onlookers on the dance floor. I felt terrific. Mayor Walker gave me his arm, and we walked down the long steps together. I felt the five hundred pairs of eyes watching this entrance and I could imagine the whispering. "It's not Louise Brooks. Who is that with Mayor Walker? Oh, it can't be. Yes, but it is . . ." And suddenly I was a gossipy news item, however unintentionally.

The next day a large bouquet of red roses arrived. The note said, "It was charming of you to go out with me. Did anyone ever tell you, you're an excellent dancer? Thank you so much, Jimmy Walker." Later, I learned through the gossip mills that Louise Brooks had walked out on the mayor a few days before I had received his invitation. So much for my being a stopgap in one of New York City's famous romances.

✦ ✦ ✦

I dated quite a few men, though none seriously; I had precious little time to develop a relationship with anyone. I daydreamed about that gorgeous man Lew Ayres and found that none of the surrounding males could come up to the fertile imagination of my crush. One Sunday, Mother and I were at home when the phone rang. She answered it and then, covering the mouthpiece, handed it over to me. "It's for you, dear. I don't recognize his voice, but he said Fred Astaire. Do you think it might be Jack Benny giving you a tease?"

With that, I prepared myself for my funny friend from vaudeville and in an exaggerated tone answered the phone, "YESSS?"

"Hello, Ginger?"

"YESSS," I repeated, not wanting to be caught off guard while simultaneously trying to figure out who was calling me.

"This is Fred Astaire, and I've been wanting to call you to ask you out for a bite of supper. How's your calendar? Got your date book handy?"

I was really caught off balance. We only had a brief professional encounter during my rehearsals. "Oh, my, hello, Fred. Excuse me, I thought you were someone else. What a nice surprise. Yes, I'd love to go out any night but . . ."

"Wednesday. I know," laughed Fred, completing my sentence. "I couldn't agree with you more. Going out after two shows isn't great fun. So how about Thursday night next week?"

"That sounds good to me. I'd love it."

"How about the Casino in the Park? I think our shows let out about the same time. Does 11:45 give you enough time?"

"Fred, I think 12:00 would be easier for me."

"Then, it's a date. I'll pick you up on the dot of 12:00, next Thursday night."

"Swell. On the dot. See you then."

This date with Fred Astaire was something to look forward to, though I didn't know whether he was a good ballroom dancer. Just because a person dances well on the stage doesn't automatically mean he is delightful on the dance floor. Of the hundreds of partners I've danced with over the years, I would consider a scant dozen as able dancers. A few that come quickly to mind are Los Angeles attorney Greg Bautzer, Jimmy Stewart, Dennis Morgan, Cary Grant, Hermes Pan, Earl Blackwell, and Cornelius Vanderbilt (Sonny) Whitney. All of them rate a ten on my dance card.

At precisely midnight the next Thursday, Fred called for me. He was charming and alive with smiles! Fred was very well dressed in a dark blue suit, starched white shirt, and burgundy silk tie. He was the epitome of the well-dressed gentleman and could have posed for an Arrow Collar ad.

The ageless question "What do I wear?" confronted me for my date with Fred. I brought three outfits to the theater that night so I could make my choice. I put on one outfit and looked in the mirror. No, that's not right. I put on the second outfit. It was wrong, too. I put on the third dress, and looked at myself in the mirror, still unsure. One of the showgirls wanted to talk with Lelee and came into my dressing room. She looked at me as I stood in front of the mirror and said, "Hey, that's a pretty dress." I decided then that this was to be the dress. It had a soft silk-chiffon navy-blue blouse with a ruffled "V" neck. The skirt was semicircular and loose so I could move easily. I wore a pair of blue pumps that were glove-soft and made for dancing, with two-inch heels. Fred complimented me on my appearance, I thanked him and took his arm, and off we went on our first date.

The Casino in the Park was a magical place. The atmosphere was dreamy with soft lights and floral and spice

aromas in the air. The circular sand-colored hardwood dance floor came right up to the bandstand. The Casino was indeed a charming place for a quiet rendezvous. The low background music was perfect for a romantic dinner for two. We dawdled over the menu and finally ordered our supper, and then Fred asked me to dance. I made the happy discovery that as wonderful a dancer as Fred was on the stage, he was equally superb as a partner on the dance floor. Part of the joy in dancing is conversation. Trouble is, some men can't talk and dance at the same time. They lose the rhythm. Fred was a delightful conversationalist and we chatted away. He really knew how to lead a girl around the floor and used each rhythm to introduce different footwork. Mind you, there was nothing showy about Fred's ballroom dancing, it was understated and elegant. You could put yourself in his hands and trust to his feet. We returned to our table and found our food waiting. It was cold, but we didn't care. We were having such a good time.

We got up to dance again and moved toward the bandstand to compliment Eddy Duchin on his music. Eddy was pleased and looked at us with a twinkle in his eye as he said, "Fred, you and Ginger really look good together." Fred laughed and put us into a three-second whirl while Eddy smiled approvingly. Too soon, Duchin's band began its goodnight tune, signaling that the evening was over. I felt as though I could have danced all night.

Within ten minutes we were on our way home in his handsome Rolls-Royce town car. Like an aperitif, Fred's well-trained chauffeur drove us through the park, so we could talk a wee bit more before we said adieu. Finally, the car stopped in front of my building. The chauffeur got out and walked around the car, waiting on the sidewalk near the trunk for a signal as to when to open the car door. He must have waited about five minutes.

Inside the car, Fred had me in his arms, and the kiss that we shared in that five minutes would never have passed the Hays Office code!

10

TICKETS TO A CIRCUS

MOTHER AND I HAD A SPLENDID VIEW OF CENTRAL PARK West from our apartment. I'd look out and see the people going in and out of the park; most were on foot or bicycle, and some were on horseback. This intrigued me and I decided I wanted to learn to ride. Naturally, I had to outfit myself.

The moment I looked in the window display for lady equestrians at I. Miller's Shoe Salon in New York City, I went crazy. Like the character of Liza Elliott in *Lady in the Dark,* I couldn't make up my mind. Instead of "the Easter cover or the Circus cover," I couldn't decide between the black shiny riding boots or the chocolate-brown ones. I simply didn't know which. So I purchased both pairs. Next I bought a pair of white heavy cord riding-breeches and a pair of deep brown heavy cord breeches to match my brown boots. I was going to be the best-dressed lady equestrian in Central Park.

There was a stable just two blocks away from our apartment building. Dressed in my finery, I appeared there one weekend for riding lessons. I began atop a walking nag.

Then, when I found my "seat," I was moved to taller, classier horses. Soon, a rollicking good gallop through Central Park got to be my steady diet. I loved it. Eventually I became a good horsewoman, and when I moved to California, I found an excellent stable and continued to take my jaunts. Believe it or not, we rode our horses right in the center of Sunset Boulevard. The traffic flowed on both sides and it was a great challenge to keep the horse on a straight line. People would lean out of their traveling Rolls-Royces or Pierce-Arrows and yell, "Ride 'em, cowboy," scaring the horse and the rider half to death.

Phillip Houston, a very handsome man who made Arrow Collar ads, promised to go riding with me and to give me some pointers on the proper way to hold the reins, how to test the saddle to know that it has been properly cinched, and how to get immediate attention from your horse by using your knees as well as your heels. One particular afternoon, Phillip and I trotted up the bridle path. Suddenly, in the middle of our ride, it started to rain. By this time we were past the reservoir, far from any shelter or stable. For shelter, we rested under some trees, and whatever else we could find.

Because he had a business appointment, we had to get back. So when the rain subsided, he yelled, "Let's go. It's late." He started off at a gallop, and I was right behind him. My white duck pants, my horse, my hat, and my boots were mud-drenched. The horses knew they were going home. Soon I lost a stirrup and then my reins. Within seconds, I was rolling on the muddy ground of the riding path. When I hit the ground, I fell on my shoulders, but fortunately, I wasn't hurt. Phillip looked back and saw me and my riderless horse. He chose to go after the horse. I was so shaken, I felt like walking back to the stable. But he said that if I didn't get on the horse then, I would never ride a horse again. I followed his advice.

I picked up another sport during my Broadway days, one that became increasingly important to me. Press

agent Bob Taplinger called me on the telephone and invited me for a game of tennis.

"Who do you think you are talking to, Alice Marble? I've never played a game of tennis in my life."

He wouldn't take no for an answer and told me to get on my deck shoes and wait for him to pick me up. We went to the tennis courts in the middle of Central Park where, for a quarter, you could play for an hour. Bob decided I picked up this game so quickly because I was a dancer. Really, it wasn't just that. I enjoy sports, and love being involved in any outdoor sport from volleyball to softball. I'm not being immodest when I say I'm a natural athlete.

One of Mother's good friends was Harold Ross, founder and editor of *The New Yorker* magazine. Harold came around a lot and Mother soon realized that this brilliant intellectual had a mighty big crush on her daughter. Harold often would act as my beau and escort me to various functions. Mother wasn't concerned. Harold was a gentleman and surely would treat her nineteen-year-old daughter with the proper respect. Some of her friends felt different and warned my mother to be alert. Her instincts, as usual, were right. Harold always behaved properly. Whatever his inclinations really may have been, I had no romantic feelings about him whatsoever; he was my pal and I welcomed his company.

Harold invited me to many a Sunday-in-the-country luncheon and cocktail party given by those who wished to entertain show business people. Harold would hire a car and a chauffeur to drive us to Huntington, Long Island, or Southampton to the gathering of the week. We'd talk about show business, a topic he adored—Harold knew every last bit of information on all the latest Broadway shows. There wasn't anything concerning shows or show business about which Harold didn't have firsthand information.

He had a charming apartment on the Upper East Side and his cocktail parties were the last word. His guest lists were collections of the cream of the intelligentsia and included such names as Alexander Woollcott, Neysa McMein, Robert Benchley, Franklin P. Adams, Edna Ferber, Marc Connelly, and Dorothy Parker.

One time I complained to Harold that he never introduced me to some very special people at his parties. Often they were in the other room. Believe it or not, there is a shy streak in my nature.

"Then you'll never get ahead," Harold grumbled.

"Oh, Harold, this has nothing to do with getting ahead. I want to meet Dorothy Parker," I said.

Harold said he would arrange the meeting at the Stork Club for supper. There were supposed to be about eight or nine guests coming. Almost everyone had arrived, except Dorothy Parker. Then a dark-haired Asian lady appeared. There was a "staged pause."

"Harold has told me how you have chided him. How nice to finally get to meet you, Ginger. I'm Dorothy Parker."

Unexpectedly the blood rushed wildly to my face.

"Well, Ginger," teased Harold, "you wanted to meet Dorothy Parker, so here she is! The other one of the same name has gone to California. I just couldn't disappoint you again."

It wasn't until I arrived in California that I finally got to meet the real Dorothy Parker.

Through Harold Ross, I met a collection of fascinating people, some of whom became my lifelong friends. One of these was Deems Taylor, the talented composer. He was an encouraging friend for more than twenty years. Once, when he came to dine at my house on the hill, he had Cuno, the butler, bring out a gift that he waited to present to me over our demitasse and black chocolate chips. He had framed a sheet of music that he had just composed,

and had spelled my name across it in musical notes. It is one of many unique mementos.

At another of Harold Ross's gatherings, the guests were treated to a wonderful buffet-style dinner that included some of the most delicious chili I have ever tasted. Dave Chasen, the chili maker, was a good friend of Harold's, so much so that Harold financially backed Dave when he wanted to open a restaurant in Beverly Hills. Chasen's has been in that same location for over forty years. Not only was the food good, but many a night at that time, there would be a rousing good game of table tennis in the back room!

Another memorable evening for Harold was a black-tie dinner party. He finally found his place card among the chattering group and sat down. Not recognizing anyone at his table, he decided that the lady to his left must be very important as she was a nonstop chatterer. Harold put on his glasses to read the name of this talkative lady. To his surprise, it was the one and only Emily Post, the well-known expert on etiquette.

Harold waited to see how Emily Post would break her hard dinner roll before he tried his. He didn't have to wait too long. She broke the roll in half, and the crumbs spread all over the butter plate. Once the waiter removed the butter plate, she took her place card and scraped the stray crumbs to the edge of the table. She then swished the crumbs into her cupped hand and popped them into her mouth without skipping a beat in her conversation. She slapped her hands together to dispose of any loose crumbs on them. Harold copied everything she did and popped the crumbs into his own mouth. If it was okay with Emily Post, it was okay with Harold Ross!

One Sunday, Harold called early to ask if I liked circuses.

"As long as I can sit up close, I love them!"

"Wonderful," he replied. "Noel and I are both circus crazy. We'll pick you up at noon." Meeting Noel Coward

would probably be a circus in itself. I enjoyed his dry humor and melodic tunes.

"Forgive us for not getting out, but the traffic is intolerable." Harold's chauffeur helped me into his limousine and off we sped, downtown to Madison Square Garden.

It was a little cozy, sitting in the back seat between the two of them as they hurled humorous insults at each other. My head couldn't swivel fast enough to keep up with them. Noel expressed his desire to have a "go" at being a trapeze artist and wearing those shiny sky-blue tights. "I'll remind Mr. Ringling to loan you one of his old nets next time he's in London," retorted Harold.

Once at the Garden, we were given house seats at the center of the three rings in the first row. Noel was like a little boy throughout the trapeze fliers' act. He gasped, groaned, and applauded. Physically he was on the ground with us, but mentally he was up there performing on the swings with them.

After we ate popcorn, hot dogs, and soft drinks, Harold bought twelve bags of peanuts to feed the elephants backstage. Noel and I took our four peanut bags each to pop into the trunks of the elephants, swinging their great bulk across the sawdusted floor. The feeder asked if we had a cigarette. Apparently, the huge elephant, Emma, liked the taste of tobacco. Harold gave her one and started to walk away, but Emma grabbed his eyeglasses and held them high above him in her trunk. Harold was frantic. One of the helpers came to the rescue and retrieved the glasses.

We almost lost Noel the minute he met the Flying Wallendas. When he pumped them with dozens of questions, I figured Noel's next play must be about a circus and the amazing top-of-the-tent gymnasts.

During my New York years, celebrities provided the fodder for many journalists. Walter Winchell's daily column

was one of the most popular. Every actor would rush to read Winchell's report, hoping to find his or her name favorably mentioned. Fortunately, he seemed to like me, and my name was mentioned often and without any critical remarks. Whenever I saw him at a nightclub or at a restaurant, he would wave at me with a smile; sometimes he'd introduce me to whomever he was sitting alongside. I met Jack Dempsey that way and a number of underworld characters, too. Although I honestly don't remember their names, I seemed to feel a secret excitement whenever Winchell introduced me to these characters.

One afternoon, as I was heading for the theater, Winchell called my apartment to ask Lelee if I would do a benefit performance in Brooklyn that evening. Lelee told him I'd been at the sound stage all morning and afternoon and was now showering and about to do my turn in *Girl Crazy*.

"It's difficult for me to ask her to do *another* performance, Walter," Mother explained. "Furthermore, I think the benefit would be over by the time we weaved our way through the after-theater traffic."

"You leave everything to me," countered Walter. "I'll think of something. Just tell Ginger to be ready immediately after the final curtain."

At the end of the show, Winchell rushed backstage and said, "Come on, let's go!"

"But, Walter, I have to go and change my costume. The producers would have me by the ears if I wore their costumes out of this theater."

"I have already taken care of that," he said as he grabbed my elbow and directed me out the stage door.

Sitting at the curb was a New York City ambulance. When the white-suited attendants saw Winchell, they flung the back doors open and hurriedly pushed Walter and me inside. "All right, fellows, let's get going."

Sirens wailing, the ambulance took off. Traffic parted for us like the Red Sea for Moses. I held my breath. We

must have been doing seventy and never stopped till we reached Brooklyn's Paramount Theatre. Walter and I emerged from the ambulance and hurried through the stage entrance. My ears were still ringing from the sirens. I didn't have time to clear them; I went right onto the stage and sang two songs.

My ears didn't stop humming till the next morning and then they were burning! I was a hot topic in the press. What had occurred the previous evening was blown out of proportion. Among other distortions, the papers said I HIRED an ambulance to take me from the film studio to the theater. I'd never been in an ambulance before that evening . . . and haven't been in one since. Poor Walter Winchell, who arranged for the ride, caught it from his editor, too. According to the city authorities, he had endangered the lives of innocent people by using city property to exceed the speed limit just to take an actress to perform a benefit. I assure you, people dined out on that story for weeks.

As much a part of the big-city scene as I was, my life was surprisingly insular. I knew little of what was going on around me other than what I was doing. This was where Mother was invaluable; she stayed on top of the news, theatrical and otherwise, and kept me informed. Basically, I didn't give a hoot. I was having a ball just doing what I was doing, and never realized I might be missing anything. Mother took care of everything in order to make it easy for me to do my job.

In June 1931, I received a telegram from Charles R. Rogers, a producer with RKO-Pathé in Hollywood. He had seen my Paramount films and wanted me for a Pathé picture, *The Tip Off*. Charles Rogers sweetened the deal by offering me a three-picture contract. I liked the sound of this agreement and so did Lelee; the one obstacle was

Paramount. I had to get a release from my contract with that studio in order to go to Hollywood.

Lelee and I went to see Walter Wanger in his office. Mother had to be with me because, since I was still a minor, she signed my contracts. Also, I was always grateful to have her accompany me since Walter Wanger had to restrain himself when she was present. Mr. Wanger, a nice enough man under ordinary circumstances, had a roving eye and fancied himself a ladies' man. When he arrived on the set for a conference with the director, he always found time to check out the new females. He'd spot a starlet and look her up and down like a horse trader. Most of the crew snickered when they saw him on the prowl! Since the movies began, maybe since entertainment began, certain producers have assumed they could have whatever they wanted. My mother knew the weather report on most of these fellows and never left me alone with any of them. She could not, however, stay around the sound stage all day. Innumerable times during shooting, I was told that Mr. Wanger wanted to see me in his office. Wanger was the boss and I had to go. Walter Wanger was a clever man, but he never had his way with me. Although I was nervous about appearing before him, I'd bluff it out by talking and talking and talking. At the end I'd say, "Excuse me, Mr. Wanger, but I know they are setting up for a scene I am in, so I'd better get back to the set."

This was a surefire way to get out of any predicament. No matter how furiously his libido raged, no executive would ever willingly hold up production on a set. Therefore, that line brought immediate results. Whenever he saw me in public, he would hold up his right hand in cat-like fashion, clawing the air. This was his way of saying, "I'll get you yet!" In all my motion picture experience, no other executive ever behaved quite like Mr. Wanger.

I sat with Mother in Wanger's office as she explained

that we wanted to terminate my contract. She finished her speech and without batting an eye, Wanger said okay. I admit I was a bit crestfallen at his willingness; I figured at least he'd want to think it over. As we left the office, Wanger looked at me with a straight face and said, "Good luck, Ginger. I'm sure someday I'm going to regret this."

My New York days were drawing to a close. *Girl Crazy* had finished, my contract with Paramount had been agreeably cancelled, and I was about to head for Hollywood. Lelee called Harold Ross to tell him we were leaving the following week for Los Angeles.

"That's wonderful. You see, I was leaving for the Coast, too. I'll try to book a compartment on your train. Sure hope this can work out!"

At this happy news, I got on the other telephone. "Is it true? Oh, that would be great fun. We can have a marathon card game of hearts, clear across the nation."

"Only if Lela keeps score, you cheater! I'm glad you called because this afternoon I fell heir to two orchestra seats for tonight. Would you like to go? It's *The Band Wagon.*"

I gladly accepted. What a glorious opportunity to see Fred and Adele Astaire's new show before I had to tear myself away from the Great White Way for Cinema-ville! We had been performing in the same city for months, but I had never seen them perform together.

That evening, I had the great pleasure of watching Adele and Fred Astaire perform in the Howard Dietz and Arthur Schwartz musical. *The Band Wagon* was a sheer delight—a smorgasbord of ear-bending melodies. One of Fred and Adele's numbers was "I Love Louisa." Fred termed that "the run-around number." They chased each other in a circle and no one really won the race. "Dancing in the Dark" was a romantic vignette danced by Fred and Tilly Losch. In a way, Fred and Tilly blazed the trail for

Fred and me. Though his dances with Adele tended to be nonsexual because of their relationship, a number like "Dancing in the Dark" had very sensual undertones. If I had known that I was going to be Fred's partner in a matter of months, I would have paid closer attention to each move and pause; as it was, I just sat there enraptured with the joy that his dancing brought to my eyes and heart. Tilly was a graceful and supple partner for Fred, but Adele was the crowd-pleaser.

When the curtain came down, Harold and I went backstage to congratulate Fred. I told him I was off to Hollywood to make pictures and he was excited for me. Suddenly, Adele burst in and hugged Harold close. She smiled and said hello to me. I said hello and told her it was really goodbye because I was leaving.

"Well, goodbye, and have a good trip, wherever you are going!" She grinned as she took my hand, and just as quickly released it. "My date is waiting. So, 'bye, Fred, goodbye, Harold, and goodbye, whoever you are!"

With that, she happily zipped out the door as fast as she had entered. Adele Astaire was an inventive and utterly charming performer, yet she didn't want to continue on the stage. She married a titled Englishman, Lord Charles Cavendish, and retired.

Harold invited Fred to join us at the Stork Club, but he couldn't make it, so Fred and I said our goodbyes, without jokes this time. "And thanks again for my 'going-away present,' your joyous performance tonight! Keep the Broadway lights brightly shining until we meet again!"

Only a few days later, I did see Fred again, at an after-theater party on Saturday night. It was lovely getting to talk to him outside the theater atmosphere, where both of us could be a little more relaxed. This time I could warmly tell him how very delightful I thought he was in his show.

"Fred, I cannot begin to tell you what a delight your dancing is to these hungry eyes, witnessing such perfec-

tion. Did you ever consider teaching? Because if you did, I'd love to have such a professor as you to instruct me."

"Well, Ginger, I guess in lean times I have thought of it and am always so grateful when a job comes up. That takes me away from starting such a laborious future as teaching."

"Fred, they'd be standing in line to sign up. I know I would."

"Well, someday I just might try teaching."

"Do call me if you do, because I wish to be—ha!—on tap!"

Interestingly enough, when Fred became a Californian, a gentleman came to Fred with this very proposition. So, what did he do? He *did* start a dance school and made quite a lot of money from it. But I was working with him at the time, so I was not first in line.

If I had stayed in New York, I think Fred Astaire and I might have become a more serious item. We were different in some ways but alike in others. Both of us were troupers from an early age, both of us loved a good time, and, for sure, both of us loved to dance.

11

\mathcal{H}OLLYWOOD, BEWARE.
HERE I COME!

WITH THE LAST PERFORMANCE OF *GIRL CRAZY* ON JUNE 6, 1931, at the Alvin Theatre, I was sad to think of putting this show to bed. All of us knew we would miss it, and the last performance of the Gershwin musical was a tearful one. But I was less sad, knowing that I would be on my way to Hollywood!

My first trip to sunny California would be with a film contract in my hand, for not just one film, but three. That was a comforting feeling. I was grateful for the time off between films. I could rest a bit instead of running back and forth incessantly from the studio to the theater every day. The routine of doing movies by day and playing the leading lady in a musical comedy by night was too much, despite the excitement and charm of it at the time. This trip was truly a heaven-sent opportunity for rest and sleep. I'd soon be basking in the California sunshine for a change. Mother and I couldn't have been more delighted.

Early one morning, Lelee and I headed for New York's Grand Central Station. Harold Ross was waiting there,

rarin' to go. Our compartments were in the same car, which meant more games of hearts and backgammon. Both Lelee and I were avid backgammon fiends, when we weren't practicing a sharper approach to our bridge game.

Harold greeted us warmly; he too was looking forward to the trip—with added pleasure, it turned out, because of whom he'd just seen boarding the next car.

"Guess who's going to Hollywood with us?" he asked Lelee.

"Anyone we might know?" Lelee inquired.

"Okay. How about the most celebrated couple on the American stage?"

Harold had to be referring to Alfred Lunt and Lynn Fontanne, and Mother and I were duly impressed. The idea of being on the same train with the preeminent actors of the American stage couldn't have thrilled me more. The Lunts had just finished a Broadway run in *Meteor* and were on their way to Hollywood to film one of their biggest stage hits, *The Guardsman*, for MGM. Harold had found all this out and filled us in on the details. Even better, he promised to introduce us to the illustrious couple once we were under way.

Soon Mother and I were settled in our compartment. "All aboard!" was the warning we heard. The train lurched, and our necks snapped. The passenger coach groaned as it rolled forward slowly. Then the engine began increasing its speed until we were clipping along at about sixty miles per hour on this long overnight run to Chicago. I love progress, yet thinking of that first transcontinental train ride and the many subsequent ones that followed brings back memories of an all-but-forgotten pleasure. I'm talking about the luxury of boarding the Twentieth Century Limited and settling in for a few days of enforced relaxation. Sure, jets are fast and economical, but, oh my, what fun we've lost and what leisure we've sacrificed in the race to efficiency. Somehow, stepping onto a plane and zooming across the United States in a

matter of hours doesn't hold a candle to the dear, old-fashioned train ride.

The first leg of our journey was overnight to Chicago. Then, early the next morning, we'd find our way through Union Station in Chicago to our waiting train, the Santa Fe Chief.

The Chief became our home for the next few days. The first thing you did upon boarding the Chief was to go to the dining car to get a bite of breakfast—only on the first day, though. If you were an old hand at this, you'd have the porter bring breakfast to you on a tray for the rest of the journey. Sitting in your pajamas and bathrobe, chewing on an egg and toast, was fun. You could stare out through those big windows and watch the fields of wheat wave at you.

I can't resist commenting on the wonderful service that existed aboard those transcontinental carriers. Over the years I was taken care of by many of the same porters and got to know them by name, learned about their families, and saw pictures of their wives and children. "Hi-ya, Ben, how's the seventh grade treating your young son?" Alas, there just isn't time for this kind of interaction anymore.

That evening on the Twentieth Century, Harold arranged for us to dine with the Lunts. As far as Mother and I were concerned, this was better than being presented at the court of St. James's. I don't know what track the Limited was on, but we were on Cloud Nine!

Mother and I dressed for the occasion and, with Harold in tow, made our way to the dining car. Shortly after eight o'clock, the Lunts made their entrance—and I mean entrance. Though they didn't try to call attention to themselves in any obvious manner, there was something electric about them, an aura of elegance that charged the atmosphere and set them apart. I guess you couldn't call Lynn Fontanne beautiful—her features were too irregular—but like all truly great actresses, she gave the impression of beauty. In the long run, Lynn Fontanne's kind of

attractiveness was much more lasting than the ordinary "pretty" face. Alfred Lunt was a nice enough looking man, but not a matinee idol. No, it wasn't looks that made them special; the Lunts projected an inner quality. They were noted for their seamless interaction on the stage and almost always appeared as a team.

Many backstage stories were told about them; my favorite happened when they were appearing in *O, Mistress Mine* in New York. Alfred occasionally forgot his lines and, as a precaution, asked the stage manager to throw out the dialogue whenever he snapped his fingers. During one performance, Lynn was sitting on the divan when Alfred came alongside her and put his head in her lap. After a moment, he snapped his fingers. The stage manager whispered the next line. Silence. Again, he snapped his fingers impatiently. The stage manager said the line again. This time, Alfred whirled his face stage left, and cried aloud, "Yes, yes, I know . . . but whose line is it?"

That evening on the Twentieth Century Limited every head in the dining car turned and all eyes were on the Lunts as they glided down the aisle to our table. Harold stood up and made the introductions. The Lunts sat down and the meal began. I was nearly tongue-tied, since I was a musical comedy person and they were theatrical royalty.

At first, the conversation was a bit stiff, then Alfred mentioned that they were contracted to MGM and a bit nervous about appearing on the screen again. Harold broke in and said, "You know, Ginger is also on her way to make three films for Pathé." I couldn't believe Harold would mention the two studios in the same breath; MGM was the most prestigious studio in Hollywood, while Pathé turned out fast-paced action potboilers. "Furthermore," continued Harold, "Ginger has made a number of films in New York City, so she's really a movie veteran." Harold knew what he was doing.

Immediately, the Lunts began bombarding me with questions about filmmaking. They were concerned about

the advancements in filmmaking since the silent days and had questions about talking film production: Who is the best director you've ever worked with? How long is the longest scene you've ever shot? How many times do you have to shoot a scene?

They treated me as an equal and I was thrilled to be of help and tried to answer the Lunts' questions as best I could.

Lynn was very concerned about makeup: not whether it could hurt the skin (she was too savvy to worry about that); rather, she wanted to know what tone would appear the most attractive in black and white. I had to speak from my own experience.

"Try for the shade that makes you look as suntanned as possible. Personally, I think *that* color makes me look the most attractive."

I don't know whether or not she took my advice; I do know her skin looked like porcelain on the screen. The Lunts were delightful in *The Guardsman;* unfortunately, it was not a commercial success. They never starred in another film and returned to their familiar and beloved turf to delight generations of theatergoers. How ironic that these two giants have become a cherished memory, while scores of lesser actors are more vividly recalled because their fame was sealed on the silver screen.

By the end of our dinner together, the five of us were laughing and talking nonstop. Mother and I both felt that we'd known the Lunts for years; they were like family. Sometimes it happens that way in show business. Alas, our friendship was curtailed when Alfred and Lynn returned to New York.

Time passed quickly on the Santa Fe Chief. The day before we reached Los Angeles, Harold mentioned that he had been invited to a cocktail-dinner party on his first night in Hollywood. "Marilyn Miller is having a crowd over and I'm sure she'd be delighted if you and Lelee joined us." Mother and I could barely contain our plea-

sure. Good old Harold always had a welcome surprise up his sleeve. Thanks to him, I arrived in Hollywood and plunged right into the scene.

Marilyn Miller, a top Broadway star, had been brought to California to make a film for Warner Bros. She rented a house on Lexington Road at the foot of Coldwater Canyon in Beverly Hills. Though she never made it as big in Hollywood as she had on Broadway, Marilyn was a vivacious and charming personality who was able to gather the Hollywood elite around her. I walked into her home for my first Hollywood party and was thrilled.

The fabulous "faces" I had admired on the screen were milling about the room. I recognized Colleen Moore instantly because of her signature Dutch-boy bob and found myself rubbing elbows with the likes of Conrad Nagel, Charles Chaplin, Rod La Rocque, Vilma Banky, Douglas Fairbanks, Sr., ZaSu Pitts, Norma Talmadge, Gilbert Roland, Groucho Marx, Claire Windsor, and Robert Montgomery. These were the top celebrities of the day and their images were indelibly imprinted in my brain. What a thrill! and how fortunate I was to meet Hollywood at its highest level. I also met my first mogul on that premiere night of stars, Marilyn Miller's boss, Jack L. Warner. The youngest of the Warner brothers turned out to be just the opposite of what I had envisioned the head man of a major studio to be. He was warm, friendly, and quite gregarious. We enjoyed each other's company that evening and for many years to come. Among other things, Jack was a good dancer and a sly tennis player. My only disappointment at Marilyn Miller's had to do with the absence of a particular screen luminary; I looked in vain for the handsome Lew Ayres, the one star I really wanted to meet.

The morning after the party, I was up early, ready to work hard. I was inspired by the people I'd met at Marilyn Miller's and wanted to do everything in my power to become one of them. While Mother was unpack-

ing, I left our temporary residence, an apartment at the Garden of Allah, and reported to Pathé.

My first Hollywood film was Charles R. Rogers's *The Tip Off* with Eddie Quillan and Robert Armstrong. Eddie is pretty much forgotten but Armstrong ensured his fame by appearing in *King Kong*. Mr. Rogers took me to lunch and then arranged for me to meet everyone who could show me the ropes—production assistants, lighting men, costume designers, makeup artists, and the like. These were the people who would guide me through the intricacies of film production.

The hairdresser told me to take a seat in her chair. "I'll give you some magazines to read and I'll fix your hair," she said and brought back a stack of movie magazines. I was delighted to be in her hands because my hair had not had any professional attention since my train trip West. I sat back, thumbed through the magazines, and paid little attention to what she was doing. Suddenly my scalp began to smart. It felt as if little bites were being taken out of it.

"Say, what's going on?" I demanded.

"Well," replied the hairdresser, "Charles Rogers said your hair should be lighter, so we're turning you blonde for this picture." I couldn't believe it. In the five movies I had made for Paramount in New York, my hair was a deep chestnut with a touch of henna. Under my mother's supervision, a touch of Egyptian Red was added, which she thought reflected nicely under the lights in *Girl Crazy*. I got up and ran to the nearest phone, called Lelee, and told her what had happened. She came rushing right over to the studio.

"How dare you do this to my daughter without her permission? I'll sue you, I'll sue Charles Rogers, and I'll sue Pathé." Mother was so furious she was ready to sue everyone. We left the studio in a huff and went back to our apartment. I was shaking as I combed my hair out. I

looked at myself in the mirror, and surprise—I liked it. I told Mother; she wasn't pacified. "It's the principle of the thing, baby," she said. "They had no right to do it without permission. They could have used a wig on you." Mother paced up and down in the living room, giving everybody "what for," while I continued to admire myself in the mirror.

The next two or three days were very serious. Mother let everyone at the studio know of her displeasure. While I believed the color softened my expression and enhanced my looks, I hated to go against my mother, and I held back my opinion as long as I could. Mother sought further advice and telephoned an old friend from vaudeville days, Herbert Rawlinson. Herbert, a handsome man who had done numerous silent films as well as a few talkies, would appear in future films with me—including *Follow the Fleet*. Herbert listened to the "Blonding of Ginger" story, and agreed with mother.

"They had no business bleaching Ginger's hair without her permission, Lela," he advised, "and you've every right to call them on the carpet, but," he added, "I'm certain the studio thought you had approved or they never would have taken that chance; that would have been too risky a business for them to take a chance on a thing like that."

Mother put down the receiver and reflected on Herbert's counsel. Maybe it was just a stupid mistake. Maybe she was overreacting. She calmed down somewhat. Taking advantage of the lull, I said, as persuasively as I could, "Mother, I like this color on me, and I want to keep it."

"Frankly, baby," she said, "I'm beginning to like it myself."

So we hugged each other and the issue was dropped then and there.

From the moment I began working at Pathé, I knew I wasn't involved with Hollywood epics. In truth, I had

been doing higher-quality films for Paramount in Astoria! The Pathé products were B pictures, made quickly and cheaply. The A movies were Hollywood's distinguished products, the B's were the other half of the double bill. A, B, who cared? I was still making a thousand dollars a week, not bad for those Depression days, and I was enjoying the California weather, too.

In *The Tip Off*, I was cast as the girlfriend of a prizefighter played by Robert Armstrong. I thought it was a pretty fair script for my initial appearance, and according to the *New York Times*, I made "a clever foil for the comedians in the role of Baby Face." Many reviews of *The Tip Off* referred to me as a gangster's moll, but it was the other girl in the film, Joan Peers, who was the moll.

The second film for Pathé was *Suicide Fleet*, with Robert Armstrong again, James Gleason, and William Boyd, who was soon to be Hopalong Cassidy. It was a minor little film about ships at sea and three gobs who like the same girl on shore. I provided the love interest—and the taffy. The song I sang was really like a commercial jingle, "Dream Kisses, Dream Kisses, Only a Dime." Musically, I was a long way from "Embraceable You."

The third film, to round out my deal with Pathé, was *Carnival Boat*, filmed on location in the Sierra Nevadas. It was an action-filled story of a logging operation and contained many thrilling stunts. I played a carnival boat entertainer and sang "How I Could Go for You." Again I worked with Bill Boyd, and Hobart Bosworth, that wonderful character actor, played his father. As director, Al Rogell gave his personal attention to all three of these films.

Meanwhile, a bit of unfinished personal business needed some attention. Although we'd been apart for a couple of years, legally I was still married to Jack Culpepper. I don't know why I had kept putting off the inevitable. Mother

stepped in and, after shooting *The Tip Off*, arranged for
Nathaniel Jacks, an attorney from Dallas, to take care of
my divorce. Mother had insisted on absolute secrecy and
Jacks pledged his support. The proceedings went off with-
out a hitch and on July 11, 1931, Mother and I took a train
to Dallas where I signed the necessary papers. My mar-
riage was officially over.

Mother and I were on our way back to Los Angeles
when Nathaniel Jacks, Esq., leaked the story to the press;
naturally, his name was featured very prominently in the
coverage. So much for lawyer-client confidentiality.

In October of 1931, before filming started on *Carnival
Boat,* the attraction of the live stage came into play again.
I liked doing my song-and-dance routines and getting im-
mediate feedback. I missed hearing the applause. I signed
to make some personal appearances in St. Louis at the
Ambassador Theatre and then at the Broadway Theatre
in New York City. I contacted Roger Edens, who had
been the pit pianist of *Girl Crazy*—except when George
Gershwin sat in—and asked him to act as my accompanist
and musical arranger. I knew I'd be comfortable with
Roger because he was a top-notch musician and he knew
the keys in which I performed. Roger accepted my offer.
Later, Roger Edens was called to the coast by MGM and
became the musical supervisor for some of the studio's
biggest hits. He won three Academy Awards and eventu-
ally became Judy Garland's right-hand man.

I joined a revue at the Broadway Theatre and was
featured along with comic Frank Fay. Not only did I have
a chance to perform before an audience and bask in their
reception, I also made $2,000. My brief engagement was
successful on the entertainment and financial fronts. I was
thrilled to be back in front of an audience. Can you beat
it? I had run myself ragged doing movies and shows, yet
once I was in Los Angeles making films, I couldn't resist

going back on the stage. Well, this time it was a fling and not a daily chore, but it does illustrate how incapable I am of remaining idle.

The transcontinental train trip east was soothing and restful after four months of work, and Lelee and I enjoyed the peace and quiet. Trains beat out such a wonderful rhythm as they roll along the tracks—*clickity-clack, clickity-clack, clickity-clack*. I was sitting in my compartment listening to the wheels underneath us when a song rhythm popped into my head. After a few times of repeating this rhythm to myself, the lyrics jumped out onto the page:

Remember the boy who used to be you,
That kind of a boy would always be true.
He flirted, he laughed, he danced so divine,
No fingers were crossed when he said he was mine.
Oh, where has he gone who used to be you,
I find in his place a stranger who's new.
The boy in my mind, I'll love my life through,
The boy who used to be you.

When I returned to California, I immediately had an arranger put my song, "Used to Be You," down on paper for me. A year later, Paramount asked me to perform it in a short they were producing, *Hollywood on Parade*. Inspired by this musical success, I wrote another tune, "I Can't Understand." I sang it for my friend from my early Paramount days, Johnny Green. He orchestrated it for me and used it as one of the numbers he was about to perform on a radio broadcast. Fortunately for me, both songs were published by the Leo Feist Music Publishing Company.

FAMILY COMES FIRST

WHEN THE BROADWAY STINT WAS OVER, LELA AND I DECIDED to break up our return trip to California by stopping in Denver and Oklahoma City. In Denver, we'd have a chance to visit with Granddaddy and his new bride, Maude; then we'd be able to spend time with my mother's sister Verda Virginia and her two daughters, Jean and Helen. Verda Virginia had recently remarried and was now Verda Virginia Nichols. I could hardly wait to see my relatives, especially my grandfather and my beloved Helen. I wanted to look my best for Granddaddy, so before leaving New York, I went to Bergdorf Goodman to outfit myself. I bought a tomato-colored wool traveling suit with a semicircular skirt and a peplum jacket, a silk shirt, a handsome pair of high-heeled brown pumps, a purse to match, and a tricornered brown straw hat. It certainly was not the flamboyant look of the typical actress, but rather was quietly chic.

I was decked out in my subdued finery and seated with Mother in our Pullman drawing room when the porter announced our imminent arrival in Denver. It had been

nearly ten years since all of us had been together and Lelee and I eagerly awaited this family reunion. I loved my grandfather's Welsh-Irish wit well enough to put up with the long, smelly cigars he favored. Because of those ever-present stogies, the family had nicknamed him "Smokey."

The train made three squeaky lurches before coming to a stop. Mother was third in line to disembark and I was behind her. Smokey was standing at the bottom of the train stairs, and when he saw Mother, he called out, "Where's Virginia?"

"Right behind me, Daddy," answered Mother as she reached the bottom of the stairs and fell into his arms. Smokey planted many cigar-smelling kisses on her face, and again he asked, "Where's Virginia?"

"She's right behind you, Daddy. Here she is."

Smokey turned to greet me with a huge smile on his face—a smile that disappeared the moment he saw me. His face just fell. He managed to give me a kiss on the cheek, as though I was a stranger. He barely spoke to me as he led us to his car. We drove to his apartment in a strained silence, at least between him and me; Mother managed to carry on a conversation with him. Neither Mother nor I could figure out what was bothering him. Once inside their apartment, Maude, Smokey's new wife, greeted me with open arms; she apparently did not share my grandfather's reserve. We put our luggage down and Granddaddy beckoned to my mother.

"Lela, come in here." He directed Mother into the next room and closed the door.

Well, here I was all alone with my step-grandmother whom I'd just met. Maude was shy and I was disheartened by Granddaddy's reception. What had I done or not done to warrant my grandfather's disdain? One thing for sure, Lela would get to the bottom of it. Like a jury sequestered behind closed doors, they were in there for about fifteen minutes. In the meantime, I ran out of small

talk with Maude. She wanted to know all about "the movies," and I was too distracted to converse.

Finally the door opened, and I knew Mother had found out the reason for his behavior. Her expression said, "This'll kill you."

Mother and I excused ourselves and went into another room. "What is the matter with Granddaddy?" I asked.

Mother explained. Basically, my grandfather was totally unprepared for my unprepossessing appearance. For nearly a decade, Mother had been writing Smokey about all my theatrical doings. She sent him photos of me from New York and Hollywood, pictures of me in my screen wardrobe. Smokey had saved a stack of photographs and clippings about his dancing, singing, and acting granddaughter. He couldn't believe that "glamour-puss" was the ordinary person who had stepped off the train.

"Well, you'll never believe it. He has spent fifteen minutes giving me 'what for.' He said you looked like an everyday girl, not a movie star. He actually expected you to arrive in a long chiffon gown with a big picture hat and a bouquet of roses in your arms. It's incredible. I never realized that he is such a country bumpkin. I'm afraid he just doesn't understand show business, honey. Now, you go out there and explain to him it's not my fault that you prefer to keep things simple."

"But why," I said, "would he be *mad* at me? It's the angry way he looked at me, Mom, when we arrived."

"I know, I know," she said, "it's just ignorance, dear."

I returned to the other room and tried to explain myself to my grandfather. I took a deep breath and hoped my words would not be angry, petulant, or impatient. I may have become famous but I was still his granddaughter, the same little girl who had lived with him at 3306 Bellefountain Street and walked hand in hand with him to the grocery store and delighted in the penny candies he bought me. I was still Virginia, only I'd grown up.

"I don't wear those outlandish get-ups off the screen,

Smokey, I'd look like an idiot! Bebe Daniels, or Claudette Colbert, or Jean Harlow wouldn't get off a train dressed like that. In their personal life, they dress in the finest of taste and wouldn't be seen anywhere in Hollywood clothes, except in front of a camera." My grandfather sighed and looked at me with soulful eyes.

"But, Grand-baby," he pleaded, "how do you think I feel? All of the neighbors know you're coming to visit me and they're expecting a movie star, not an ordinary girl. You're supposed to be like a—like a—" He paused, trying to find the words to explain, so he thought of the most expensive flower he could. "Like an orchid," he said. "You're supposed to be different. Who wants to see an ordinary field flower or buttercup or daisy? Everybody expects you to look like a movie star. You're a star!"

I couldn't believe my grandfather was angry with me because of my appearance. I still felt the same; the trappings of my initial renown hadn't changed me. Unfortunately, my grandfather didn't want his little granddaughter, Virginia Katherine McMath, he wanted Miss Ginger Rogers. That was a hard moment for me. I realized then that even if I kept my feet on the ground, others would try to put me on a pedestal for their own purposes. I told my grandfather I could only be what I was. He shrugged his shoulders. Though he wasn't pleased, there was nothing he could do. At that point, Maude invited us to sit down to lunch. With all the talk about glamour, I half expected to be served pheasant under glass, but fortunately it was sliced ham with raisin sauce and hot muffins, a dish I much preferred to pheasant.

During the meal, we talked about only one subject, the movies. Maude was just as much taken by tinsel as my grandfather and assailed me with questions about people I didn't know and places I'd never been. Like Smokey, she believed everything she read in the fan magazines.

After lunch, there was a knock on the door, and a pro-

cession of neighbors began pouring in. Neighbors? . . . I
must have been introduced to everyone within a three-
mile radius. They laughed and chatted, patted me on the
back, and asked for my autograph . . . not for themselves,
mind you, but for their friends, cousins or uncles, sisters or
brothers. Let me tell you, in all the years I've been re-
quested to sign my name, I could count on my fingers the
number of autograph seekers who admitted that the sig-
nature was for themselves and not someone else. I've
never quite understood it; I guess people are so shy about
asking that they have to manufacture a story to get what
they want without divulging their personal motivation.
Who knows? I only know there's no need for excuses; I'm
delighted to sign my name for anyone.

I figured the neighbors had settled in for the duration of
my stay when some sensitive soul said, "Well, I guess we
should leave you to your granddaddy. After all, he's the
one you came to visit." Gradually, the crowd departed
and Mother and I were alone with Smokey and Maude.

After a dinner that featured more movie talk, Mother
and I retired to the guest room. I was tired and fell asleep
right away. I was also anxious for the alarm to ring so we
could get out of there. I didn't want to be a "moooovie
star" in my grandfather's house and found it wearing. I
just wanted to be his granddaughter.

The next morning, Maude prepared my favorite break-
fast: orange juice, eggs sunny-side up, crisp bacon, and
hot chocolate; of course Lelee had filled her in on my
preferences. To this day, though I occasionally substitute
waffles or hot cakes, I rarely deviate in my morning menu.
We sat down and Granddaddy quickly asked all the ques-
tions he had missed the night before. "Does Rin-Tin-Tin
really have a stand-in? How did Harold Lloyd hang off the
clock over a city street? Was there a net below? Was he
on a wire? How did they do that?" Smokey was interested
in the technical side of films, while Maude zeroed in on
the personalities.

"You must know all those famous people. What is Garbo like? And is John Gilbert as handsome as he appears to be?"

Unfortunately, Granddaddy and Maude were no different from most people. For some reason, everyone thinks that because you're in the picture business, you know every actor, actress, director. They wouldn't believe it when I told them I did not know Garbo, John Gilbert, Mary Pickford, Doug Fairbanks, Rod La Rocque, Vilma Banky, Richard Dix, or Gary Cooper. I had been in tinsel city for such a short time and had met very few people. After filming all day, I usually was too tired even to think about going out at night. Truly, it wasn't that easy to get around unless you were a party girl. Generally speaking, actors who are working long hours in front of the camera leave the party-going to the producers, directors, and starlets. If I had attended one-tenth the number of parties the RKO publicity department had me attending, I would never have made it to the set the next day.

Maude asked me that most dreaded question, "What movie are you going to do next?" Actors don't like to pinpoint their next production; you can't make definitive statements without a signed contract.

"I haven't anything exactly, Maude dear, but there are many things in the works."

At long last, it was time to leave.

Smokey and Maude drove us to the station. We hugged and kissed them goodbye and hurried into our drawing room.

As the train pulled out, Mother and I reviewed the granddaddy episode. I still was disturbed by my grandfather's total absorption in what I did rather than who I was. Furthermore, I couldn't get over how dumb his questions were. Mother was kinder.

"Don't forget, baby, your granddaddy doesn't know beans about the movies but could tell you plenty about the

construction business. We can't expect him to be sympathetic about something he doesn't understand."

Mother's logic reinforced feelings I had been experiencing, feelings which I then shared with her. "You know, Mom, I'm not really at ease with people who don't have a nodding acquaintance with show business. I guess I'm impatient about explaining the whys and wherefores."

Mother understood what I meant and smiled. "Just try to be tolerant, baby. After all, he is your granddaddy and he's getting on in years." After a brief pause, Mother continued, "You know, Virginia, I asked Smokey to consider moving to California. I think it would make him happy to get away from the snow and ice."

I reacted immediately, and perhaps selfishly. "I hope you didn't ask him to live with us. I just can't have a house full of people when I work, Mom. It wouldn't give me room to relax or practice."

"I know, dear. I wouldn't ask them to do that. They could get a house of their own." Smokey and Maude did eventually move to Los Angeles and Mother paid ninety percent of their expenses. Her generosity with her family and others was not always apparent to outsiders.

Many writers have overlooked this quality in delineating her personality and her drive. My mother knew what she wanted, and ninety-eight percent of the time she was right, even though I, as a daughter, rarely wanted to admit it. Her foresight was tremendous. She foresaw the turn in my career before I knew I was going to have one. When I was only doing my beginning vaudeville bits, occasionally Mother would say to some close friend, "This is just the beginning. She'll be going into movies soon. You'll see." This embarrassed me.

Because of my youth and worldly inexperience, I relied totally on her instincts, her business acumen, her instant recognition of the good guys or the villains within our gates. I'd watch her size up people, particularly those who might be involved in business relating to me.

The journey continued and I became increasingly apprehensive. I hoped my Aunt Virginia and cousins Helen and Jean would be less trying than my grandfather. I didn't want the upcoming visit to deteriorate into the kind of "fandango" we'd just experienced in Denver.

As our train pulled into the Oklahoma City station, we caught a glimpse of Verda Virginia and the girls standing by the tracks. When Mother stepped down onto the porter's train box, she was greeted with screams of delight, "Aunt Lela, Aunt Lela." Then I appeared to shouts of "Ginger, Ginger." The next second, we were hugging and kissing.

Aunt Virginia looked very well; her beauty shop business kept her busy. Jean was nineteen and helped her mother at the shop. Helen was sixteen and as pretty as ever. Our time spent with them was full of reminiscences and catching up. I wasn't a "movie star," I was just cousin Ginger and I loved it.

I couldn't get over how pretty and lively Helen was—pretty enough, I thought, to be in pictures. I got an idea and went right to Mother.

"Mom, why don't we take Helen back to California with us? She could be in pictures. Maybe if *you* ask Aunt Virginia, she would let her come out on a trial basis." This was not an unusual ploy for me. To this day, I'm reluctant to ask for what I want straight out, partly because I'm shy and partly because I got in the habit of asking Mother and certain other people to do things for me. Mother thought I had a good idea. She said she'd speak to her sister, but she told me to check it out with Helen first. No sense doing anything if Helen wasn't willing.

My little cousin held a special place in my heart. I felt a great communion of spirit with her and thought she felt the same. I had no brothers or sisters and acted like an older sibling or a "young" mother to her. One thing did

trouble me. If Helen went with us, it would be hard on her sister. Jean was older, though, and had responsibilities at her mother's salon; she did not have the freedom of choice. I knew if Helen wanted to make a move, now was the time.

I sat Helen down and revealed my plan. I described the Garden of Allah, where Lela and I lived, and told her about our two-bedroom bungalow with its red tiled roofs, and the lovely swimming pool, and the fountain filled with goldfish. "You could stay in our apartment and use the twin bed in mother's room or we could set up a daybed. You see, Helen, I think you should be in movies, and I would like to help you." I have to laugh. I tried so hard to be impartial in my presentation. Realistically, how could any youngster resist an offer to come to Hollywood and be a movie star? Helen's eyes kept getting bigger and bigger. She eagerly accepted. "I hope Mother will let me go," she said. "It'd be swell even if I only got to stay a few weeks." Aunt Virginia gave her consent and Helen prepared to join us. I knew it was a responsibility to take my cousin along; I was willing to accept it because I had a special feeling for her. I'd been through the trials and tribulations of vaudeville and knew full well how risky the movie business was. I thought Helen had a chance, and here was an opportunity for me to help someone I loved take the obstacles in stride. Most important, whatever happened, Lela would be there for her daughter and her niece.

One little detail bothered me, and I expressed my concern to my cousin. "We're going to have to do something about your name. I don't think 'Helen Nichols' has enough fire in it. If we're going to get a contract for you, we've got to think up a good theatrical name." (I had wanted to create a new name for myself and was very disappointed when Walter Wanger refused to let me call myself Kendall Cortland. Wanger was adamant. "We hired you because your personality suited your name and vice versa.")

For the next day or so, I began concocting combinations in my head. The name that kept coming to my thoughts was "Frazier." I loved the name of the Christian Science Practitioner I had known as a child in Kansas City, only now I would spell it "Fraser." Now to find a matching first name. After skipping through a list of thirty or more names, one favorite first name seemed to alliterate— Phyllis. Phyllis seemed to fit with Fraser. Phyllis. Phyllis Fraser.

And so my cousin Helen Brown Nichols became Phyllis Fraser and returned with us to Hollywood.

13

WHO SAID THERE WERE NO MEN AVAILABLE?

OUR TWO-BEDROOM BUNGALOW IN THE GARDEN OF ALLAH on Sunset Boulevard consisted of a small living room, petite dining room, and miniature kitchen sufficient for breakfast and small lunches. A bit cramped, our quarters gave us the needed feeling of home. Ours was one of a cluster of four bungalows whose front doors faced a center circular walk around a terra-cotta elevated water fountain. Some two dozen goldfish swam in its lower basin and the constant splash of water spilling from the top basin to the larger one below was a comforting sound. Indeed, the entire Garden of Allah was a lovely and tranquil place. Scattered incidents shattered the tranquility of the Garden, but while we were residents, it provided a happy ambience. I swam every day and met quite a few of our neighbors at poolside.

I have some happy and humorous memories of the time that I lived at the Garden. I recall one afternoon when I ran into Jeanette MacDonald at a benefit luncheon for disabled children. Jeanette introduced me to a very handsome singer, John Boles. She added that when he hit the top notes of his register, crystal broke all over town!

129

I thought to myself, he is handsome indeed, and if he sings half as well as he looks, I'm certain he breaks hearts even more than crystal. "I'm delighted to meet you," I said, smiling back at his flirtatious eyes. "However, should you ever come to my house, I promise you I shall put all my fine crystal in the garage."

"I should love to come to your house. I'd even help you put your crystal in your garage," he parried smilingly. "Incidentally, where do you live—in Beverly Hills?"

"No, not as yet. I'm at the Garden of Allah," I answered, as I made an exaggerated gesture to try to hide my nervousness.

I thought, what is it about this stunning man that is making me nervous? Am I wrong—or is he coming on awfully strong?

Jeanette, sensing I was in a kind of girl-boy bind, came up with a momentary answer. "I'm going into the powder room. Would you like to join me, Ginger?"

I jumped at the chance. Jeanette told me that John Boles had put her up to the introduction and had said to her, "I want to meet her, the one in the blue dress." To me, she said, "Just be careful, he's been known to charm the birds off the trees. It is widely known that he is girl crazy."

We returned to the table, but his attention was elsewhere. Phew, that was an unexpected situation. Why did I tell him where I lived? Oh, not to worry, my little inner voice said, he's forgotten all about it by now.

Three days later, after I'd long forgotten the meeting at the luncheon, the telephone rang in our bungalow. My flirt from the luncheon announced himself at the reception desk. "What is the number of your bungalow?"

Like a schoolgirl, I nervously repeated the number, and he said, "I'm on my way over."

I quickly related the background of my meeting to my mother and Phyllis. "I fear John Boles may be under the false impression that I live here alone," I added.

Lela, with her ever-present sense of humor, said, "Never fear, Mother's here!"

Phyllis laughed and kiddingly added, "Maybe he likes younger women," as she preened herself in a stylish pose in an overstuffed chair.

Just then, there was a knock on our front door. I went to open it, and collided with Lela. We both started to laugh as we opened the door. When it was fully open, the outsider could see inside the room. Finding three women instead of one must have surprised him! Our laughter must have disoriented John, for he backed down three steps to make a hasty retreat or a more casual exit. But he misjudged his distance and backed up, PLOP, into the water fountain! Suddenly he found himself up to his waistband in goldfish water. Horrified, he found he had no leverage to extricate himself from this unglamorous position. Frantic, he began pulling himself up, forcing some of the goldfish out onto the cement circle.

He kept repeating, "What in the world?" Followed by, "I can't get . . . I can't get . . . I can NOT get out of this **BLANKETY-BLANK @@: #@%0:**!!!! THING!!!"

I couldn't help feeling sorry for this very handsome fellow. I ran down to him, extending my hand to help him up. He grabbed it, and after a few tries, dripping wet, he stood before us.

"This obviously is not my day, NOT my day at all," he said.

"Oh, John, this is my mother, Lela, and my cousin, Phyllis. Some day when you want a 'real' swim, there's a big pool right behind you. Come on over, and we four will make up for this unfortunate entrance. But the next time—bring your bathing suit and your rear-view mirror!"

One of the most charming men I ever met lived in the building next door to the Garden of Allah. I had gone to

the tennis court at the Havenhurst apartment building for
tennis lessons. The pro, Mr. Larson, was an excellent
teacher and his court was very popular with the film
crowd. During one of my lessons, Mervyn LeRoy, the
director, came over to talk with Mr. Larson. We were
introduced and Mervyn asked if I cared to play a few
games with him after my lesson was finished. I happily
agreed.

After that, Mervyn and I had many dates. He gave
wonderful parties at his apartment, and it was there that
I met many interesting people from the movie world. At
one of his parties I met Carole Lombard and William
Powell. They were a real item then, and would soon
marry. I adored Bill, and though I didn't know Carole as
well, I was impressed with her delightful sense of humor.

Mervyn was not only a marvelous companion, he was
also very helpful to my career. He believed I was star
material, and when my contract with Pathé was up, he put
in a good word for me at Warner's. I was signed by
Warner Bros. to appear in *The Tenderfoot* with Joe E.
Brown, directed by Ray Enright. Brown, a deservedly
popular comedian, couldn't have been nicer. Considerate,
friendly, kind, and thoughtful, he was everything you
could wish for in a colleague. Though he was the star, he
took the time to make sure I was okay and kept thinking
of ways to turn *my* face to the camera. When we made a
second film together, *You Said a Mouthful*, he again ex-
pressed great interest and concern where I was involved.
(Although I thought my clothes in that film were terrible,
I was in no position to make a comment about them.) A
star actor who was willing to coach his leading lady was
very unusual. His great kindness to me is something I shall
long remember. It didn't surprise me to learn that during
World War II, he was the first actor to go to the front lines
on a USO tour.

For most of 1932 I was free-lancing, going from studio
to studio. I made the two Joe E. Brown films at Warner

Bros., *Hat Check Girl* with Sally Eilers and Ben Lyon for Fox, and *The Thirteenth Guest*, a suspenseful little murder mystery co-starring Lyle Talbot, for Monogram Studios; it was good experience, but it didn't seem to be leading anywhere. Then, at Mervyn LeRoy's urging, I took the role that gave my career its needed boost.

Warner Bros. was about to begin work on a new musical, *42nd Street*, directed by Lloyd Bacon with dances by the innovative Busby Berkeley. Warner's reached out to New York to find a fabulous tap dancing performer, Ruby Keeler. Bebe Daniels was the leading woman and Warner Baxter played the high-powered director. George Brent, Una Merkel, and Dick Powell rounded out the cast. My role was that of a chorus girl, Anytime Annie, and a humorous and often-quoted line from the film referred to my character: "She only said 'no' once and that was because she didn't hear the question!" As Annie, I assumed a broad accent and wore a monocle. The monocle was my idea, and it caught the public's eye.

42nd Street remains one of the great Hollywood "backstage" musicals, and I was part of it because I listened to Mervyn's good counsel. My one beef concerning *42nd Street* has to do with its effect on the subsequent interpretation of my career. Reporters who do little research about my background often refer to me as a former chorus girl. I haven't anything against chorus girls and I wouldn't mind if that were the reality, but 'tain't true!

42nd Street was a smash hit and received an Academy Award nomination for Best Picture of 1933, but it lost to *Cavalcade*.

Beginning in February 1933, I went from one film to another—seven in all—without catching my breath. Two of them were what I called "bread-and-butter" pictures. And thank God for the activity. They may have been B pictures, and not the most outstanding of the films I made,

but they allowed me to pay the rent and put food on our table. The viewing public took a proprietary interest in young talent and delighted in watching us grow up and following us into our maturity. These films were a necessary part of my training, for I was able to hone my skills and gain valuable experience.

Even though *42nd Street* was a smash hit, I didn't have time to bask in its success. I was hard at work on *A Shriek in the Night* with Lyle Talbot, directed by Albert Ray and filmed for Allied. With only a week's rest, I immediately began *Broadway Bad*, with Joan Blondell and ably directed by Sidney Lanfield. Oddly enough, this little "B & B" had one of Hollywood's top photographers, George Barnes, as its cinematographer.

Meanwhile, Mervyn LeRoy was assigned to direct Warner's next musical extravaganza, *Gold Diggers of 1933*. He chose me to play the role of Fay Fortune, a fortune-hunting chorine. This role was smaller than Anytime Annie, but it wasn't the size of the part that mattered, it was the content. The picture opened with a line of choristers covered in huge silver coins singing "We're in the Money." Harry Warren and Al Dubin of *42nd Street* were responsible for the music and lyrics. And Busby Berkeley was again the inventive dance director.

One day on the set, I was handed the opening song and told to learn it by that evening. The scene was to be shot the next day and we had to be up on the number. I pleaded with Malcolm Beelby, the pianist, to forsake his lunch hour to help me learn my lyrics. Malcolm kindly obliged. We went into a corner of the sound stage and started to rehearse. After about three hours, I started getting a little slap-happy, so instead of singing the lyrics as they were written, I translated them into pig latin:

> Er'way in-hay the oney-may,
> Er'way in-hay the oney-may,
> Ev'way ot-gay a-lay ot-lay of-way

Ut-way it-way aks-tay o-tay et-gay
a-lay-ong-lay . . .

In the middle of this nonsense, I felt another presence
besides Malcolm and myself. Out of the corner of my eye,
I could see a man standing at the left of the stage, wearing
a porkpie hat, with a big cigar in his mouth. It was Darryl
F. Zanuck, Warner's production chief. Immediately, I
stopped singing.

"What are you doing?" asked the observer.

"Oh, hello, Mr. Zanuck. I wasn't doing anything. I was
just kidding around a bit . . ."

"Well, show me what you were doing, Ginger."

"Mr. Zanuck . . . I . . . was just . . . just . . ."

"Let me hear what you were doing!"

I knew that I was going to get fired for fooling around
on company time, but I did as he asked. I sang the song
as it was written, and then lapsed into my pig-latin ver-
sion.

After I finished, Darryl paused, thinking. Finally, he
said, "You tell Mervyn I want you to sing it just like that
tomorrow." He walked out with the measured delibera-
tion of a producer.

I repeated the story to Mervyn and he said, "Darryl's
right. It's a great way to start the movie." The next day,
Mervyn brought in a big crane and started filming from
the back of the set. As I sang "We're in the Money," the
camera came in slowly for a close-up and the screen was
filled with my lips singing the song . . . in pig latin! It was
a sensational opening.

Now that I had fifteen films under my belt, I felt it was
time to move from our two-bedroom apartment at the
Garden of Allah into a larger house. Mother found a
wonderful three-bedroom, two-bath house on Dundee
Drive. This meant Phyllis could have a room of her own

and not have to share with Lelee. More importantly, it was a straight shot to Paramount and RKO.

Mervyn and I were dating steadily and spent many happy hours on the dance floor. Merv was a terrific partner. One evening, we went to a party at the Cocoanut Grove. The club had one of the best orchestras in town and it was a wonderful place for dancing. I was having a great time dancing with Merv and the other men at our table when I noticed a very tall gentleman on the dance floor, looking at me. His face seemed stern, mask-like, almost as though he was trying to keep his feelings hidden. The severity of his expression was alleviated by a half-smile that played around his lips every time his glance caught mine. I wondered at the time if this man was used to smiling or if it was hard for him. Mervyn and I were swinging around the floor as the band came to the end of a set. We stood on the floor with the other couples, applauding the orchestra, when the tall man came up to us, pulling a lady behind him.

"Hello, Merv," he said, "I'm coming over to your table in a few minutes," and walked on.

"Fine, Howard," Merv answered. "Now that's an odd fellow," he said to me as we were moving back to our table.

"Who do you mean?" I said.

"Howard. The man who just spoke to me. You don't know him?"

"No," I said.

"That's Howard Hughes," he said. "The Texas oilman who wants to be a movie producer. If he can produce movies as well as he can fly planes, he's got it made."

Our coffee and half-melted desserts were waiting for us as we sat down. Howard Hughes approached and borrowed a chair from an adjacent table, squeezing in between Mervyn and his mother. Over the noise, Mervyn

introduced him to everyone at the table. Mr. Hughes seemed impatient with introductions and barely said hello. When Mervyn came to me, however, a smile replaced that dour expression, and I must say, the relaxed expression made him appear almost handsome. Mervyn and Howard put their heads together and talked in low tones. I couldn't hear anything they said. When the music started up again, Howard got to his feet and said to Mervyn, "Do you mind if I dance with your date?"

"If you can keep up with her!" Mervyn smiled.

Howard Hughes was not a bad dancer. Although not creative or special in his style, he had no trouble keeping time with the beat. Because of Howard's height and the loud music from the orchestra, we found conversation impossible. He held me close to him as if to say, "Since we can't talk, we'll hug!" That he did! We finished our dance and on our way back to my table, he stopped at his table, where a man was seated. The man stood up and Howard said, "This is Neil McCarthy, my attorney." The table was set for four, and I figured the other two companions were in the powder room.

Howard Hughes made an impression upon me. As Merv drove me home from the Grove that night, I mused about the curious Texas oilman-flier. I wondered what he'd be like as a date.

Not long after that evening, I was quite taken aback when Mervyn LeRoy announced that he was going to marry the boss's daughter, Doris Warner. Everyone was shocked at the news. I couldn't understand why Mervyn had never bothered to tell his tennis and dancing partner about his forthcoming marriage! I didn't see Mervyn again for five years. When we did meet at a party, he didn't know where to turn to keep from facing me. But much water had gone under the bridge by that time.

 ❖ ❖ ❖

One day the telephone rang. Lelee said, "It's for you, baby. Do you know a Howard Hughes?"

"Yes, Mother," I called back. "I met him quite recently. What does he want?"

"He wants to take you to the Hollywood premiere of *Scarface* tomorrow night. He'll call back in five minutes for an answer."

When Howard called back, he told me that this was his own production. I was excited for him and by the expectation of attending my first Hollywood premiere. It was a good movie and the photographers were busy getting their coverage of this very important night on film.

14

MEETING MY DREAM MAN

COLUMBIA PICTURES WANTED TO MAKE A SCREEN TEST OF me for the role of a lady lawyer in an upcoming feature. This was my first Hollywood screen test. Although Harry Cohn, head of Columbia, paid for the test, he didn't sign me. He said my smile was too big. However, he liked me enough to make passes at me and give me a little chase around his desk. Harry Cohn's reputation as a ladies' man was deserved. I stood up fearlessly to his advances by reminding him that I knew his wife. His ardor dampened when I mentioned how certain I was that she wouldn't be pleased to know what was going on around his desk and behind her back. That's always a killer!

RKO heard that there was a test of me at Columbia and asked Harry Cohn if they could see it. Cohn was a professional and willingly showed it to them. After RKO saw it, they had a powwow and decided to sign me to a three-picture deal with an option for a long-term contract. When I arrived at RKO Studios in April 1933, they had just premiered their biggest film to date, *King Kong*. RKO had an impressive stable of stars including Irene Dunne,

Richard Dix, Ricardo Cortez, Constance Bennett, Ann Harding, and Joel McCrea. Even though RKO was a small studio, it tried to turn out quality pictures such as *What Price Hollywood?* and the 1931 Academy Award winner *Cimarron*. It was into this burgeoning activity with Merian C. Cooper as studio production head that I reported to work.

My first film with RKO was *Professional Sweetheart*, directed by William Seiter. One day I was in the hairdressing department, trying on some snazzy brunette wigs, when I had an irrepressible urge to have some fun. I've always been somewhat of a prankster, so I decided to play a little trick. Since we had been shooting for only three or four days, my face was not that well known around the lot to the staff and crew. Louise, my hairdresser, pinned a dark wig on me and accompanied me to the makeup department. I went into Mel Berns's office and put on a thick French accent to speak to the unsuspecting head of the department. "Excusez-moi, Monsieur Berns, I 'ave been asked to come to your office for ze make-oop for ze French maid in *Professional Sweetheart*."

Mel swallowed my story hook, line, and sinker. Not until I was seated in the makeup chair did I look straight at him and say, "Mel, it's Ginger Rogers."

With a mixture of a smile and a growl, Mel asked what I was up to.

I told him I was just having a bit of fun.

Now I wanted to see Bill Seiter. Mel went along with the ruse and called the director. "Bill, I'm sending you the young lady who is being considered for the maid in *Professional Sweetheart*. See if you like her makeup."

"Okay. Send her over," Bill said. Louise pinned down the wig even tighter and we hurried over to the directors' building.

On the stairway I bumped into screenwriter Glenn

Tryon, a close friend of Bill Seiter's. I decided to take him into my confidence. He offered to help me too, and brought me into Seiter's office himself. Louise stayed outside while Glenn and I walked in. My escort said, "Here is the young lady who's been suggested for the role of the French maid, Bill." After a few pleasantries were exchanged, Bill Seiter began to question me.

"Have you done many pictures?"

"No, not many."

"Well, are you from Canada or from France?"

"France, Paree."

"I see. You know this is not a very big part."

"Well," I said, dropping my accent, "why in the devil's name don't you give me a good part!"

He looked at me with his mouth open. "Ginger. You really fooled me."

Seiter had a tremendous sense of humor and tried to take me from office to office to trick some of the other staff. We might have done it all day had not one assistant director in Joe Nolan's office said, "Hello, Ginger."

Joe Nolan, vice-president of studio operations, looked at me and said, "Well, I don't think I would have recognized you either."

Professional Sweetheart was a pleasant working experience. My leading man was Norman Foster, the young man I flirted with in my first film at Paramount. This time, I got him—not Claudette! We had a wonderful supporting cast of skilled comedians: Franklin Pangborn, Frank McHugh, Allen Jenkins, Edgar Kennedy, of the "slow-burn" take (slow burn is a theatrical term for an actor's showing his anger slowly on his face), and ZaSu Pitts, with her famous fluttery hands. The story was a funny satire of a temperamental radio star (me), written by the talented Maurine Watkins. Even though RKO put it through three different titles—"Careless," "The Purity Girl," and finally "Professional Sweetheart"—it turned out quite well as my RKO debut. My only gripe was that my singing

voice was dubbed by someone else for my song, "My Imaginary Sweetheart." I was amazed and annoyed. I had been singing professionally on the stage and screen for years and thought it ridiculous to hear someone else's voice coming out of my mouth.

Bill Seiter was a super guy, with a charming, adorable, witty, and engaging attitude toward his actors. I simply adored him. Some directors play out their own problems with their cast; others, like Bill, put personal issues aside and are charming and encouraging. I've worked for both kinds and it makes a big difference when you're being directed by a caring person.

Shortly after I finished *Professional Sweetheart,* my agent informed me that I was up for the leading lady role in a Universal film, *Don't Bet on Love.* The star of that movie was Lew Ayres. Lew Ayres! I could hardly believe it. Imagine, I might be cast opposite my idol! Ever since I'd seen him in *All Quiet on the Western Front,* I'd been nurturing a crush on him. It's hard to believe that someone in the business can act like an ordinary schoolgirl, but it happens. I fell in love with Lew Ayres's image on the screen and the dreamy aura of the teenager was still with me. I had built a romantic fantasy about a man I'd never met. I was truly smitten with Lew's good looks and the smoldering glances he gave to the various females playing opposite him. Once I knew we'd be appearing together, I wanted to find out as much as possible about Lew Ayres and devoured all the fan magazines. Lew was newly divorced from actress Lola Lane and, according to one article, "sour" on women. I wondered why. I knew what it was like to go through a divorce, and despite the pain, I wasn't sour on men. I only hoped the magazine was exaggerating—as they often did.

I was having my hair done at Oddie's Hair Salon on Sunset, across the street from Schwab's drugstore, when

my mother telephoned and told me Lew Ayres had just called. She had given him the number at the salon and was certain he'd be calling.

My heart was pounding with nervous anticipation. Up to this moment, I had seen him only at a party given by Una Merkel (my pal from *42nd Street*). Our eyes met briefly, and I smiled shyly at him. The party was crowded, and I didn't see him again. I was there with Howard Hughes and had no chance to meet my dream fella. Many, many months later he told me that as soon as he saw me, he made some excuse to take his date home and came back to the party to find me, but by that time, Howard and I had left. Through our mutual friend, Bill Bakewell, he got my telephone number.

Just as Oddie had my head well soaped, the telephone at the front of the shop rang.

Oh, no.

Yes, it was Lew.

I put a towel around my head and went to the front of the shop to have my first conversation with my dream man.

"If you have nothing better to do tonight," Lew said, "I'd love to take you to dinner. Maybe we could drive up the beach and find a quiet little restaurant along the way."

My head was swimming with delight. "I'd like that," I said, trying not to show how breathless his call was making me. Then, searching for something to say other than "Yes, where shall I meet you?" I said, self-consciously, "I hope we can dress casually." Then, trying to be funny, I added, "I don't have to put on one of my dancing dresses, do I?"

"Not unless you want to go by yourself. I'm not one of the world's best dancers, but I do chauffeur a mean Packard," he said.

At his words, the room started to sway, the glasses on the shelf next to the telephone rattled, and the electric

light pole outside the large window of the salon started to wave at me. I thought, "This man has a terrible effect on me. If this is what his telephone call does to me, I might find he'll drive us into the Pacific Ocean before the evening is over."

"Did you feel that earthquake?" Lew asked over the phone.

"Oh, an earthquake? Is that what that was?"

"Either that, or you are a witch," he said in mock seriousness. With that he hung up.

Lew was there at seven and we drove up along the ocean road. The radio was full of news of the earthquake; most of the damage had occurred in Long Beach. The seismograph reading was of considerable importance. But then, so was our date.

He was easy to be with and we chatted like old friends. Initially, I'd been scared to actually meet this man. Would he be as wonderful as I imagined and wanted him to be? I knew he couldn't be the exact counterpart of his screen persona, none of us is, yet I did hope he would fulfill at least some of my expectations. And he certainly did. He was warm, interesting, good-natured, and as handsome as he looked in the movies. We were so engrossed in each other, we passed by a lot of cute little restaurants.

Finally, Lew pulled up and parked on a promontory overlooking a lean stretch of beach. A few other cars were parked nearby. We got out to view the crashing sea below us. Oh, to breathe some refreshing sea air and to smell that melon-like odor that comes from the strange combination of seaweed and salt water. I've always loved that fragrance and wished it would be made into a perfume.

As we stood there in the soft, cool sea breeze, our conversation turned to some nonsensical thing that left us laughing so hard we were leaning on each other to keep from doubling over. Slowly our laughter ceased as we looked into each other's eyes. The next thing I knew, I was being kissed, and I loved it.

During that earthshaking kiss, the ground beneath our feet started to move.

"You certainly have extraordinary powers to shake a fellow up," he said.

"And I was just thinking I've never been so rocked by a kiss before. Tell me, do you take lessons to get this kind of reaction?" I humorously queried.

Moving closer to me, he said, "No, but if you give me another chance I'll show you how it's done!" With that remark he took me again in his arms and planted a super kiss on my lips. At that very instant, the ground under our feet moved again, as if by command.

From a car beyond us, a female voice sounded out a note of hysteria: "THAT WAS AN EARTHQUAKE! LET'S GET OFF THIS EMBANKMENT BEFORE WE ARE ROCKED INTO THE OCEAN!"

Lew grabbed my hand, and with the authority of a ship's captain, he quickly guided me into the car, started the engine, and drove quickly away from that dangerous point of land. If our first date was any indication, the future was promising!

A couple of months after our earthshaking encounter, production started on *Don't Bet on Love*. It couldn't begin soon enough for me. Murray Roth, the director, was an angel. He knew that Lew and I had it bad for each other, and he didn't try to exploit the romance by playing tricks on us or humiliating us in front of the rest of the cast. I was wishing we could have filmed forever, but it was only a four-week shoot.

My option at RKO was picked up for another year; this time I was contracted for three pictures and would receive $550 per week. When RKO presented me with the script for *Rafter Romance*, to be directed by my friend Bill Seiter, I was delighted to do it. It was like old-home week again, especially with Norman Foster as my leading man.

After a week's rest, I was rushed into *Chance at Heaven*, again directed by Bill Seiter. The leading man was a good friend of Lew's, Joel McCrea, and actress Marian Nixon played the other woman. I played Joel's girlfriend, who gets left behind. But at the end of the film, I somehow get my man.

After fulfilling these obligations for RKO, I was loaned out to Paramount to do a musical called *Sitting Pretty*, with Jack Oakie, Jack Haley, and Thelma Todd. Harry Joe Brown was the director, and Charles R. Rogers was the producer. Songwriters Mack Gordon and Harry Revel were in the film, playing a pianist and a song publisher, respectively. The RKO brass was willing to lend me out to Paramount, right next door, because my role wasn't the feminine lead. I was working on one picture at RKO and then hastening next door to Paramount in my "spare time." The quickest way for me to go to and fro was by bicycle, and I spent the next few weeks wheeling from studio to studio.

In *Sitting Pretty* I had three songs. I liked two of them and had enough gumption to *say* I didn't like the third. I really stood my ground and refused to sing it. (I wish I'd been as firm about some other things during my career!) The producers gave in. I was told I could choose my third number from a stack of music in the corner of the room. This pile seemed to contain all the songs rejected over the past two years. I wondered if I'd find anything among the castoffs. I worked through the pile of songs and then saw a title that appealed to me. Scanning the music, I realized this discard was far superior to the one I'd originally been given. I sang it in the film and it proved to be a hit. In time it became a standard. I was proud of my choice, "Did You Ever See a Dream Walking?"

Sitting Pretty was the first movie I worked on with photographer Milton Krasner, a superb artist who really knew how to photograph me. Even when the camera "loves" you, there are angles and shots that do not show

you at your best. Stars are at the mercy of the cinematographer, and a good one can make all the difference. Some stars had what amounted to personal cameramen and wanted to work only with them; if you were a big enough star, you could get away with it.

I had no idea that the film I was making at the same time was going to be the start of something big.

15

\mathcal{S}OMEBODY CATCH THE BOUQUET

WHEN RKO WAS FIRST CONCEIVED, ITS FUTURE APPEARED promising. The deal was put together in, of all places, a Manhattan oyster bar, where, on October 23, 1928, Joseph P. Kennedy and David Sarnoff decided that a merger of the Radio Corporation of America (RCA), FBO (Film Booking Offices of America), and the Keith-Albee-Orpheum circuit of vaudeville houses would be just the thing to compete in the highly charged atmosphere of talking film production. The merger resulted in a $300 million corporation, Radio-Keith-Orpheum (RKO).

Although the first year was successful, Sarnoff's grandiose plans for RKO Radio (as the new corporation was now called) never really materialized. Over a period of twenty-seven years, RKO seemed to be a studio without a true identity. For one thing, the studio heads were constantly changing. The studio also went into receivership to the Irving Trust Company for ten years.

During my seven-year contract with RKO, there were seven different studio presidents, from David O. Selznick to Charles W. Koerner. You literally had to check the

name on the door so as not to call the new boss by the former boss's name. These changes were not good for morale. Each president had his own management style, which meant RKO never produced a predictable type of film. Instead, the studio's films ranged from *King Kong*, *Cat People*, and *Gunga Din*, to *Love Affair*, *Room Service*, and *Top Hat*. The lineup of films was constantly changing.

Perhaps the studio overextended itself because it was small compared to Universal or MGM. Although RKO was able to put out forty films a year, when George Shaffer came in as president in 1939, he demanded the studio turn out fifty-five! This was a great strain on the resources of the company, and as a result, the most creative producer on the lot, Pandro S. Berman, resigned to move to MGM. After Pearl Harbor RKO gave up the star system and hired its talent on a free-lance basis.

In July 1933 RKO decided to produce a big, splashy musical, *Flying Down to Rio*. Thornton Freeland was hired as director and Vincent Youmans, Gus Kahn, and Edward Eliscu were responsible for the score. The film starred Mexican beauty Dolores Del Rio, Gene Raymond, and Raul Roulien. Receiving fourth billing, I came into the project to replace Dorothy Jordan, who dropped out to marry the producer, Merian C. Cooper.

Several months earlier, David O. Selznick, current head of RKO, had seen Fred Astaire on Broadway. Selznick thought Fred perfect for the upcoming production and immediately hired him. *Flying Down to Rio* was supposed to be Fred's film debut, but RKO's production delays put the film on hold. Meanwhile, RKO loaned Fred to MGM to play a minor role, as himself, in *Dancing Lady*, starring Joan Crawford and Clark Gable. As a result, Fred's first film dancing partner was Joan Crawford.

When production finally started in September 1933, I was thrilled to see Fred again. He had sent me a lovely

letter after seeing some of my films. Alas, I had neglected to write back to thank him, and we lost touch. I must confess I never have been good at keeping up my personal correspondences. I love to receive letters, but I am terribly sluggish about replying. I hope my friends forgive me. I make up for my lack on the personal side by being exact on the professional. I kept up with my fan mail throughout my career and still do.

Fred looked the same but acted differently. He was not as open, far more formal. I felt I didn't even know him. As if to explain his behavior, he said, "I'm married now." It was weeks before I met Mrs. Astaire, the former Phyllis Potter, and I never became close to her. She was a society lady whose first marriage had ended in divorce. I think she was somewhat insecure in her new role as a famous dancer's wife. When we were introduced, she was a bit standoffish and greeted me as though she really didn't quite know who I was. I later learned that that was the way she affected everyone.

In *Flying Down to Rio*, Fred and I had secondary roles, and provided the comic relief. I played a band vocalist and sang "Music Makes Me"; our big moment together came during the full-scale production number, "The Carioca." Dave Gould was the film's dance director and his assistant was my old pal from *Top Speed*, Hermes Pan. Hermes and Fred actually met on the set when Fred had a problem with a solo and Hermes came up with a step. That, as they say, was the beginning of a beautiful relationship. Hermes also came up with a brilliant idea for "The Carioca." The lyrics talked about dancing head to head, and Hermes thought we should follow the words literally and suggested that Fred and I press our foreheads together as we went through the steps.

Ask me today if I had any notion of what would spring from "The Carioca" and I'd have to say no. Even looking at *Flying Down to Rio* now, it is hard to believe that our brief assay onto the dance floor led to a string of musical

films. I do remember the long, long hours of hard work that went into those fleeting moments on the screen. Of course, we had lots of fun, and most important, I truly enjoyed the dancing.

Flying Down to Rio established RKO as a leader in musical film production throughout the 1930s. The film helped to rescue the studio from its financial straits and it gave a real boost to my movie career. My professional life gathered momentum and the pace became frenetic. During 1934 I made seven films, starting with *Upper World* for Warner Bros. I knew very little about the star, Warren William, but I found him a very cordial man. I was sad not to work with his screen wife, Mary Astor; I would love to have had a scene with her. Unfortunately, my character was shot by a gangster who meant to shoot Warren William, but missed and shot me instead. That was the end of my activity in the film!

Pat O'Brien led the billing of another Warner Bros. musical, *20 Million Sweethearts*. Perennial Warner Bros. performer Dick Powell was my romantic interest. He was a young man I had met in Indianapolis, where he played a banjo in the orchestra. I thought he would make a very attractive leading man and was pleased that Warner Bros. had found him and pushed him to stardom. When this script came along, I was offered the feminine lead opposite him. I couldn't have been more thrilled, and enjoyed working in that film very much.

Then came *Finishing School*, back at RKO. Frances Dee and I had major roles. I was dating Lew, while Frances was romantically involved with Joel McCrea. Since Lew and Joel were very good friends, Frances and I shared a great deal of girl talk throughout the offscreen moments of the film. She told me how much in love she was with Joel, and I openly confessed my feelings for Lew. Now that I had been dating my flesh-and-blood dream man, Lew was everything I imagined him to be. I could sense his feelings toward me as well, and they were on the

same level as mine. It was truly heaven being with Lew.

At Fox, I made *Change of Heart,* playing the second feminine lead opposite James Dunn. Although not a great role, it did show me in a different light; I was a mantrap rather than a sweetheart. Handsome clothes and some very nice close-ups never hurt any second feminine lead. Janet Gaynor and Charles Farrell, a popular acting duo, were the stars of *Change of Heart,* and working with them was a real pleasure. Janet was adorable and Charlie was the handsome boyfriend every young girl coveted. I was surprised they weren't in love with each other. I got the feeling they might have had a thing for each other at one time, though now they were just friends. My feelings about them as a couple gave me insight into the way moviegoers felt about Fred and me. We were "together" on the screen, so naturally the fans assumed we were "together" off the screen.

Janet Gaynor was a gracious and lovely lady. Like me, she had a great affection for her mother and consulted her about most things, just as I did with Lelee. Janet and I became good friends. Among other things, Janet was very understanding about my personal beliefs and respectful of my religion. At a dinner party at her home, knowing that I shunned alcohol, she asked what I wanted to drink. I said ginger ale. A few minutes later, Janet brought a tray of glasses and handed me one, saying, "You did say ginger ale, didn't you?"

"Yes, I did," I replied.

I took a long drink and immediately felt an unaccustomed fiery sting in my throat. The next second I was spitting, sputtering, and choking like a Girl Scout who has run into some spiked apple cider!

When I could finally speak, I was embarrassed to say, "I think there's more than ginger ale in this glass." Janet went into the kitchen and discovered that the butler had confused her orders and given me ginger ale laced with

bourbon. My reaction only confirmed my feelings about liquor.

Whenever there was a lull on the set, I'd take out my pencil and sketch. I had been drawing for a long time and it seemed to come naturally to me. I found it challenging and relaxing. I never studied drawing or painting, I just did it. One time, Janet watched me as I sketched my sweet friend Jimmy Gleason. Jimmy's face was lined by humor and determination and I worked to capture his singular expression. Janet marveled at my ability and said she could never draw "in a million years."

"I'll make you a bet," I said. "Come over to my house on Sunday afternoon, and I'll prove it."

That Sunday, Janet presented herself with "How shall we start?"

I got pencils, charcoal, paper, erasers, and blenders. I sat Janet down in a comfortable corner that offered her good light and gave her a photo of an American Indian in his feathered headgear. I put stacks of great music on the record player—Beethoven, Brahms, Schubert—enough to last at least two hours. I said to her, "Now, copy that, to the best of your ability, then whistle for me. I'll be in the library."

After an hour and a half, I heard a whistle. "I'm finished. Come and see," she said, with the proper hesitation. "I told you I can't draw a straight line."

What I saw was a beginner trying to find herself, and it was a good beginning. Janet began to paint seriously. Eventually, her works were exhibited and sold in art galleries. I like to think I helped her get started.

While I was making my solo films, RKO was busily trying to get me and Fred Astaire back together. The studio wanted to capitalize on the success of *Flying Down to Rio* and realized that the pairing of Rogers and Astaire had moneymaking potential. Everyone was looking for appro-

priate properties for us. Pandro S. Berman, newly named head of production at RKO, was assigned the task of finding the right vehicle, and he did. While in New York, he saw Fred in the stage musical *Gay Divorce*, and bought the property for the screen as a co-starring venture for Fred and me. I heard through the grapevine that Fred was not happy with this proposal. He had been teamed with Adele for so long that he feared being identified, yet again, with any one female. While I could sympathize with his feelings about being teamed with me, I, on the other hand, had no apprehensions about making more films with him. Why should I? I had the opportunity to appear in nonmusicals by myself. For every film I did with Fred Astaire, I did three to four without him. Our partnership was a limited one only in his case, not in mine. Fred didn't have this luxury; he was a musical comedy star, period. Truthfully, though I loved the musicals because I could wear pretty dresses, I was just as happy appearing in comedies and dramas. Like a coin, everything has two sides, and our partnership was a two-sided blessing.

With a new contract under my belt, and a hefty raise, I began *The Gay Divorcee* in June 1934. More than just a successful sequel to *Flying Down to Rio*, this film was an affirmation of RKO's belief that "Ginger and Fred" were big box office.

This was the first time we were directed by Mark Sandrich, and we had a great supporting cast including Edward Everett Horton, Alice Brady, Erik Rhodes, and Eric Blore. These last two comedic actors were also in the Broadway show with Fred. Cole Porter, Mack Gordon, Harry Revel, and Con Conrad and Herb Magidson contributed to the delightful score that included "Night and Day" (our romantic pas de deux) and "The Continental," the *big* number, à la "The Carioca." Although "The Continental" won the first Academy Award given to a song, it didn't become a national dance craze like "The Carioca." *The Gay Divorcee* was nominated for four other

Academy Awards, including Best Picture, but lost out to a little film from Columbia, *It Happened One Night*.

About five days after finishing the musical, I was put into *Romance in Manhattan*, directed by Stephen Roberts. My leading man was a promising young actor, Francis Lederer. He was handsome, genuine, and very professional; I predicted stardom for him. Alas, it didn't come. The studio didn't know how to handle him or how to buy stories for him. His career never took off. Hollywood was (is?) a very parochial place, and once classified, actors could not easily break out of the mold. I faced the same problem myself. The bulk of my work was in light fare and I wanted to get some meaty roles. I fought like a tiger to get them to cast me in dramas, but it took a long time and a lot of effort to have my wish granted.

Meanwhile, my romance with Lew Ayres was in full bloom. He proposed, I accepted, and we set the date. Only after completing *Romance in Manhattan* did I have time to shop for my trousseau in New York City.

November 14, 1934, was a very important day. I was marrying Lew Ayres. A limousine was summoned to the house on Dundee Drive to drive me to the church. My agent, Leland Hayward, said he wanted to escort me and arrived with the limo. I opened the front door for him and when Leland took one look at me in my beautiful Chantilly lace dress and my Lilly Daché hat, he took me in his arms and embraced me as if I was leaving for Germany for an extended stay. Mother walked in on our embrace.

"I thought Ginger was marrying Lew today."

"You've got it all wrong, Lela," answered Leland, "Ginger's marrying *me* today. I'm going to convince her that she shouldn't be marrying an actor, but a very stable agent."

"Well," I said, "this is all new to me."

I thought Leland was kidding and so did Mother. She sent us off to the limousine and waited for her escort, Earl Eby, to pick her up. Leland and I got into the car and headed for the Little Church of the Flowers in Glendale.

Leland Hayward was one of Hollywood's major talent agents and one of the city's premiere bachelors as well. Though I knew he had a crush on me, I never thought of him as anything but my agent. But Leland had other ideas. The minute we got into the limo, he turned and said, "Now, let's talk seriously. You know you're making a mistake, don't you? Mrs. Leland Hayward is much more euphonious than Mrs. Lew Ayres. I'd make one whale of a husband, and I have never been more serious than I am now. Let's turn the car around and go to Santa Barbara. Will you marry me?"

I was so bumfuzzled by this turn of events that I really didn't know what to do. "If this is a joke, Leland, I don't think it's very funny."

"This is no joke," he said. "Take me up on it and you'll see."

"You mean, you'd let Lew Ayres stand there waiting for his bride, indefinitely, and never show up? You really have a dark side to your character, Leland."

As we were having this bizarre exchange, the limo stopped for a red light, in front of a Dolores' Drive-In. I happened to glance out my window and saw Lew and his best man, Ben Alexander, standing in their top hats, white tie, and tails, eating hamburgers; two handsome young men in their rented monkey-suits. I didn't want Leland to see them, so I didn't react. But as the light changed, he looked out my window and caught sight of them, too.

"How casual," he remarked.

"Well, that's better than having them standing at a bar getting a buzz on."

"Trouble with you, Ginger, is you're not serious about anything," he said.

"That's the pot calling the kettle black," I said. "And

when have you ever been serious about anything? Life is just a big joke to you, Leland."

"I am serious about you, Ginger. I've had a thing about you ever since I saw you dancing 'Night and Day' on the set with Fred. Ask Myron [Selznick—David Selznick's brother and Leland's agency partner]. He'll tell you. I talk about you all the time."

"This is no time to tell me about it, Leland. You're really trying to ruffle me, and you're doing a pretty good job of it. But I was in love with Lew before I ever met you. You're just going to have to put up with me as Mrs. Lew Ayres, because I intend to be Mrs. Lew Ayres for a long, long time."

The chauffeur announced that the church was just around the corner; Leland ordered him to drive around the block. Obediently, the driver continued around the corner while Leland continued his onslaught. I refused to listen and told the driver to take us to the front of the church, immediately!

Lew had already arrived, and twenty newshounds and cameramen had converged on his Pierce-Arrow for some quick prenuptial photographs. Lew disliked the attention of the press so I could imagine his discomfort. In trying to make a hurried exit from the car, he hit his top hat on the door frame as he flung open the door, and the hat slipped down and covered his eyes. He regained his composure and quickly strode into the sanctuary of the church.

The reporters flocked to my limo and I was besieged with requests for pictures. I told them to wait until after the ceremony, when Lew and I would be happy to pose. I raced inside the church and was greeted by my maid-of-honor, Phyllis Fraser, and my two bridesmaids, Mary Brian and Janet Gaynor. Mother was there, too, along with our good friend Earl Eby, who was to give me away.

My wedding gown was of pastel-green Chantilly lace with baby ruffles at the neck. The skirt was robe de style, with jeweled green buttons. The ensemble was completed

by a green quilted Lilly Daché hat, full veil, and plain green crepe pumps. The bouquet was fashioned of rare orchids and gardenias.

The ceremony went smoothly until the minister asked Lew to place the ring on my finger. Ben Alexander tried to reach into his pocket, but his glove was too bulky. There was a huge silence while he took off his gloves to search for the wedding band. The silence became longer and longer as he kept fumbling and fumbling, looking hopelessly at me, Lew, and the minister. Like an actor who has finally remembered his dialogue, Lew grunted and reached into the watch pocket in his own trousers, and there it was. He had forgotten to give the ring to the best man and had had it all the time!

The reception was held at the Ambassador Hotel where we had asked 250 of our most intimate friends to join us for the celebration.

We spent our honeymoon night at Lew's house. It was a cold November night and I was glad, because I could cuddle up next to Lew and be warm. We left the next day for the Del Monte Lodge in Carmel, California. If anyone wanted to see a happy girl, all they had to do was look at me. We sat around the pool at the lodge, hoping for as much of a suntan as the November sun could give us. Each of us had about a week before we had to be back at our respective studios, RKO for me, Universal for Lew.

We spent five wonderful honeymoon days in Del Monte, although each of us knew we soon had to return to the real world and leave all this blissful experience behind.

I was very much in love with a man who was, to my way of thinking, the handsomest leading man in the motion picture world. Lew was a natural when it came to acting; he always had a sixth sense about the right thing to do. I thought his acting talents never reached their full potential, but in watching many of his performances through the years, I've found it difficult to fault his technique or

emotional impulses. His intellectual side was a surprise to me and frequently made me feel a mite inferior. He knew something about everything. My mother had those same qualities, so I knew how to appreciate them.

Lew's enormous intellect was very appealing to me. He loved music and could read as well as write it. He played the piano, the organ, and the banjo. During the time he was acting, he also studied arranging and composing. This prodigious thirst for knowledge was a source of amazement to me. We always listened to classical music. Through Lew's love for the classics, I developed a taste for the three B's (Beethoven, Bach, and Brahms) as well as for many of the lesser known composers. He would put on a stack of wonderful classical records that encouraged us to dream away the hours listening to Tchaikovsky, Rimsky-Korsakov, Lalo, Holst—the list was endless. Lew gave me a deep appreciation for great music. I had had little time for listening, as my activities were such that the word ACTION better expressed the constant pressure I felt with my work. It was wonderful to hear such beauty, which I had never had time for, and we would dream away the hours.

He was always reading scripts. I too had to employ some of my time reading scripts when away from daily filming. He always learned his lines by himself, without anyone holding script for him. That was my habit too. I enjoyed the privacy of finding my own phrasing and had my own little way of keeping things in memory.

He never talked about gossipy things. I liked that. He was an avid reader. I envied that. He could read an entire book in the time I took to complete the first hundred pages of one. He loved to work with his hands, and I admired that. He could whittle, sculpt, draw, write a play, or compose a symphony: such an abundance of talents. I found that quite wonderful. These many qualities only made me be more in love with him. And his sense of humor was as ridiculous as mine.

· Lew and I moved into a house on Roxbury Drive, a lovely gray stone building with a garden and pool in back. One time, Lew drained the pool and photographed a story in which the whole family appeared. Mother, Phyllis, Lew, and I starred in a 1934 version of "Little Red Riding Hood." Phyllis has the only remaining copy of this domestic epic. I'd love to see it again.

Now that I was the proud wife of this wonderful new husband, I hoped to fulfill my role in every way. Like most brides, I wanted to win my husband's love and approval by cooking such mouth-watering meals that he wouldn't be able to wait to come home from the studio. One weekend Lew went hunting with a group of his buddies, and brought home a pair of birds. These birds had lived in the wild, open land with only Mother Earth to feed them.

I gave our cook the night off and I prepared the birds with loving care, soaking them with delectable spices. Then I placed them in the oven to bake.

As I moved about the house doing other things, the most terrible odor began to fill the house. I thought perhaps a polecat had left its lovenote near our house.

It became worse. Every room in the house was reeking of that burnt foul odor. Foul?

Fowl! The birds! I rushed to the kitchen, opened the oven door, and was almost overcome.

That was my first (and last) culinary failure! Lew wiped my tears away and enjoyed a good, bridegroom's laugh. "Don't you know coots aren't supposed to be eaten?" Now he tells me!

16

FINALLY, A CLASS "A" FILM

THE WEEK AFTER LEW AND I RETURNED FROM OUR HONEY-moon in Del Monte, I began work on another film with Fred, called *Roberta*, to be directed by my old friend Bill Seiter. I felt very much at home under Seiter's direction because of the sincere way he worked, and we got along splendidly. The musical score for this film, from the Broadway hit of the same name, was by Jerome Kern and Otto Harbach. I had the fun of working with the lovely soprano Irene Dunne, Randolph Scott, and Helen Westley. There was even a bit part for our rehearsal pianist, Hal Borne—as a piano player (what else?). A new RKO player was also in this film, as one of the models in the fashion show at the end of the film. Her name was Lucille Ball.

In *Roberta*, I was the Countess Scharwenka, a.k.a. Lizzie Gatz, an American singer posing as a Polish noble-woman. I relished doing accents and Scharwenka with her Polish accent was really up my alley. With handsome clothes by my favorite designer, Bernard Newman, and beautiful songs to dance to, I had the time of my life playing this role.

161

Bernard Newman's clothes in *Roberta* for me and for Irene Dunne were exceptionally clever and handsome. The gold lamé dress I wore for the "I Won't Dance" number was a dress I had bought while in New York as part of my trousseau. That was the first time I ever wore a personal dress in a motion picture, and it was probably because Bernard Newman had designed it. For the "Smoke Gets in Your Eyes" number, he created a long black satin dress, with a wonderful piece of faux jewelry on the chest. Men always commented on that gown; indeed, I never met a man who didn't like that dress. The song "Smoke Gets in Your Eyes" was a number I loved. It was romantic as well as ideal for dancing. I thought it was one of Jerome Kern's finest numbers. Jerome Kern was about the shyest, most unpretentious composer I'd ever met. He shunned photographers and resisted having his picture taken with Fred or me. Moreover, he seemed almost apologetic when anyone asked him to play his music. One of the most important composers of our time was probably the most self-effacing.

The engaging "I'll Be Hard to Handle" was the first number Fred and I did in the film. This was also the first time that a number was done direct; the taps were just as we did them, with no additions. Fred's and my laughter and giggling as we got into the throes of the dance were not added, either. They were real. The two of us enjoyed dancing together. The spontaneity was very real and it makes me laugh when I see it today. In "I'll Be Hard to Handle" we had a real wood floor, which caused each tap to come out distinctly from each dancer. What a pleasure it was to work on it. Alas, in the future, most of the surfaces we danced on were made of slippery and shiny plastic.

Many, many long, arduous hours of creative effort go into the preparation of a dance number. Fortunately, I love rehearsals. As a matter of fact, I had more fun rehearsing than in actually performing. Inspiration comes

during the preparation as you seek a better turn, step, or jump. In performance, you do it once and that's it! The time for improving is over. Like the rabbit in *Alice in Wonderland*, no time, no time, no time. Fred, often along with Hermes Pan and sometimes with me, spent days putting the steps together. Generally speaking, we practiced our dance numbers for eight hours a day for six weeks prior to principal photography. Because of my double work schedule, I was frequently unavailable. In those instances, Hermes would step in and dance my part with Fred. When I arrived, Hermes would teach me the routines. Hermes played "Ginger" often enough for some waggish writers to call him "Fred's favorite dancing partner."

Another rehearsal problem had to do with my shoes. I normally practiced in low heels and switched to higher ones when we were filming, which is exactly what I did for "Smoke Gets in Your Eyes." In choreographing the number, Fred forgot I'd be in high heels. When we did a backwards three-step turn-jump up the stairs, I nearly lost my balance.

Years and years later, a friend sent me a cartoon called "Frank 'n Ernst" from a Los Angeles newspaper. It showed Fred on a sandwich board announcing a "Fred Astaire Festival." A woman was standing near the sandwich board, talking to Frank and Ernst. The balloon coming from her mouth said, "Sure he was great, but don't forget Ginger Rogers did everything he did backwards . . . and in high heels!" I can't begin to count the number of people who have stolen that line from its creator, Bob Thaves, and credited it to themselves. In Ann Richards's opening remarks at the 1988 Democratic Convention, commenting on "women today," she used that same line. Now everyone thinks *she* created it. But now we all know the truth, don't we?

With less than a week's rest after *Roberta*, I was scheduled to start another Pandro S. Berman production. This

time I would be co-starring with Bill Powell in the 1935 *Star of Midnight,* a mystery melodrama. I had always admired Bill Powell and was quite thrilled to be making a movie with him. He was genuine and kind to me. The other members of the cast included Gene Lockhart, Paul Kelly, and J. Farrell MacDonald.

I was thankful to be going into a sophisticated comedy instead of rehearsing long hours and hearing the same song five thousand times. I had just finished one musical and after this film with Powell, I would have another musical to make. Happily, Bernard Newman had my measurements and could have all my gowns ready before lunch if necessary. He designed some lovely dresses; I especially loved my opening outfit, a white mink blouse with a black velvet skirt. It was so Fifth Avenue.

I had worked with director Stephen Roberts before, on *Romance in Manhattan.* Between shots, we engaged in long conversations. He and his wife had just come back from a fishing vacation on the Rogue River in Oregon. My talks with him made me yearn to go to Oregon to see for myself. It sounded like a perfect spot for getting away to relax and fish.

Lew and I loved fishing. One time, we went down to Santa Monica and rented a boat, complete with sea captain, to take us ocean fishing. That trip wasn't the most successful fishing expedition, but it was fun to be out in the fresh sea air. I hooked a huge fish and called the captain to tell me what kind it was. He said it was a shark. When I said, "Let's land him and save the fish," he asked, "What are you going to do with a shark?"

Because Lew and I had hired his boat, the captain felt that he had to do what we wanted. There was a strong metal cable running the length of his gaff and he tried to land my large shark from the bow. As he hauled the shark

on the deck, the boat and the shark lurched at the same time. The captain lost his grip on the gaff, and it turned in his hand, causing the cable to wind around one of his fingers. The next thing we knew, the captain had only four fingers on his left hand! Very heroically, he told us where to find the first-aid kit and how to help him. After tending to the first-aid needs of our captain, Lew took charge of the boat while the captain directed us to the harbor.

I never forgave myself for wanting to land that shark.

Just six days after I finished *Star of Midnight*, I began rehearsing another film with Fred, *Top Hat*, with music by the talented Irving Berlin. The score was nothing short of magnificent: "Top Hat, White Tie and Tails," "Isn't This a Lovely Day (To Be Caught in the Rain)?," "Cheek to Cheek," "The Piccolino," and "No Strings." The cast included Edward Everett Horton, Helen Broderick, Erik Rhodes, and Eric Blore. Horton was a very humorous fellow. I am always asked if someone is just as he or she seems to be in the movies. In this case, Horton was exactly the same as he appeared on the screen. He loved comedy, and behaved in a comical manner all the time. Consequently, we couldn't take our eyes off him, for fear of missing the topper to whatever he was doing. He had our undivided attention. Helen Broderick would pull laughter out of mannerisms, rather than lines of dialogue. Eric Blore's deadpan expressions were worth their weight in gold. On the other hand, Erik Rhodes, a line-man, extracted his laughs mostly from the idiotic lines of the character he was portraying.

Although *Top Hat* was a phenomenal success at the box office, Fred had a strong negative reaction when he first read the script. He wrote a handwritten three-page letter to the producer, Pandro S. Berman, outlining his objections, saying in part:

In the first place—as this book is supposed to have been written *for me* with the intention of giving me a chance to do things that are more suited to me—I cannot see that my part embodies any of the necessary elements, except to *dance—dance—dance*.

I cannot see that there is any real story or plot to this script.

The lead into "Cheek to Cheek" is hopeless as at present designed. It would be impossible to get a sincere note into that number out of the situation which precedes it. The fact that Rogers *slaps* me in the *face* in two different episodes is certainly wrong.

Please send for me immediately, so that we can start to fix things up as I think it vitally important that something is done immediately.

> Awaiting your call—
> Fred A.

One of our numbers was set in a public park gazebo. I had been horseback riding but found refuge in the park's gazebo when it started to rain. Fred finds me and starts to sing "Isn't It a Lovely Day (To Be Caught in the Rain)?" During rehearsals, Fred suggested that for the second chorus I get up from my seated position and follow him around the gazebo. I in turn suggested that I copy whatever Fred was doing with his hands; if he put his hand into his left pocket, I would follow suit. I thought my "shadowing" of Fred's movements added another dimension. Mimicry aside, neither Fred nor Hermes could come up with a way to close the number. I proposed that we go to the edge of the gazebo, reach out to feel the rain, sit down, and shake hands. End of number. Hermes and Fred also liked this idea. I had plenty of input in our routines and got to be known as the "button finder." In show business parlance, that means the one who puts the last word or the finishing touch on a scene.

Bernard Newman, again the dress designer, met with me to discuss the colors and shapes of the various dresses I was to wear in the film. Unlike a lot of designers, Bernie was open to suggestions. He'd say, "Tell me what kind of dress you want to wear and what color you'd like." Then he'd show me swatches of all sorts of beautiful materials—lamé, chiffon, velvet, and brocade. I was particularly interested in the "Cheek to Cheek" number and made my preference known.

"I want a blue dress," I told him. "A pure blue with no green in it at all. Like the blue you find in the paintings of Monet. I would love the dress to be made of satin with myriads of ostrich feathers, low in the back and high in the front."

Bernie sketched as I spoke. It's funny to be discussing color when you're making a black-and-white film, but the tone had to be harmonious.

Bernie's final sketch had an extremely low back, as I had requested. The watercolor he had used was just the color I wanted. The dress was form-fitting satin encircled by ostrich feathers, lots of feathers. A specialist would be hired to extend the feathers and make them a consistent length. Bernie said it would take roughly $1,500 worth of feathers.

He also showed me the sketch for the horseback ride in the park—a handsome pair of jodhpurs and a Harris tweed riding coat. It looked like the perfect outfit for the song.

The "Piccolino" sketch was very attractive, with sequins all over the little bodice with its semi-ruffled peplum. This dress now resides in the Smithsonian Institution. It is somewhat weatherbeaten from so many rehearsals and from perspiration. Also, the RKO costume department never dusted anything, causing the dust to be absorbed into the silk of the costume. (In May 1984, the dress was given to the Smithsonian by my good friend Paul Becker.)

Generally speaking, the steps for the designer were the same on every film lot. After sketching his concept of the character's clothes, he would submit his drawings to the producer, who would put his mark of approval or disapproval on each sketch. At that point, the producer would call in the actor or actress to see the designer's ideas. I had no time to go into Pan Berman's office and see the sketches. In fact, I had already seen them. From here on, they would have to be okayed by the producer.

The setting for "Cheek to Cheek" was supposed to be a Venetian canal. As designed by Van Nest Polglase and Carroll Clark, it was most extravagant and the biggest B.W.S. (Big White Set) to date. But however beautiful it may have been, it was about as Italian as Pat O'Brien. The Lido canal set occupied two sound stages, side by side, put together to make room for the canals and gondolas. Where that water went after filming was done, I never knew.

On the day of shooting we rehearsed in ordinary clothes to mark the various positions for camera. We rehearsed before and after lunch until director Mark Sandrich called for a take. My beautiful blue feather dress was still up at wardrobe for its finishing touches. Argyle Nelson, our assistant director, called to have it brought over.

As I headed for my portable dressing room, I saw Clarkie, the wardrobe lady, walking through the stage door. She held my dress high above her head as she marched toward my dressing room. Mark Sandrich, Fred Astaire, Argyle Nelson, cameraman David Abel, Hermes Pan, and the technicians turned their heads to watch this blue apparition go by.

"What is it? A bird? A plane?"

"No, it's Ginger's dress!"

Clarkie paraded past the crew and their jibes and into my dressing room where she put the gown on a rack. Almost immediately there was a knock at my door; Mark Sandrich wanted to speak to me . . . alone.

What was this, I thought?

"Ginger," Mark started out. "You know that white dress you wore in *The Gay Divorcee*? Well, I would like you to wear that because I think it is a much, much prettier dress than this one."

My heart sank to my knees. "Do you mean—you don't like this dress?"

"Well, I don't really think it's right for this scene." As Mark talked, my suspicions grew. He was acting as a spokesman for someone else. I knew who it was who didn't like the dress.

"Mark, the white dress has already been seen by the public. They wouldn't want to see it again."

"They won't remember it, Ginger."

"I disagree with you, Mark. To accuse an audience of being stupid is risky. The critics would be on my neck and yours for being so shortsighted."

"Well, to tell you the truth," he said, "as we saw the dress being brought in, all of us around the camera immediately disliked it. I really would like to send upstairs to wardrobe and get your *Gay Divorcee* dress."

With that, he opened the door and made a director's exit. I was stunned, broken-hearted, disappointed, and angry! Had I been the type of actress to show my emotions, I would have cried, thrown something, or disappeared into the ladies' room for a few hours. I decided to telephone my mother.

"Mother, come over to the studio right away, please."

"What's wrong?"

"It's better to explain when you get here. Please hurry."

I returned to my portable dressing room. In a short while, the frayed white dress was brought to me. It was soiled and stretched from being on the hanger. It was a mess.

When Mother arrived, I explained the problem to her and showed her the blue dress.

"I think it's beautiful. What do you think, Mother?"

"It's gorgeous," she said. "You mean Mark wants you to wear that worn-out white dress instead of this lovely blue feathered one? Why, what's wrong with it?"

"All I know is, Mother, what I've just told you. The dress barely got in the door, and suddenly I became a villain."

Again there was a knock on the door, and Mark reentered.

"Ah, Lela," he said. "I'm so glad that you are here. You can help me convince Ginger to wear this graceful white dress she wore in *The Gay Divorcee* instead of this, this, this . . . feathered thing."

I could see he was holding back some impolite remarks about the dress. Knowing the sketch had to have been approved by the producer and shown to the director, I was puzzled. However, it was not up to me to remind them of studio policy.

"Well, Mark, I'm sorry, but I agree with Ginger. This blue feathered thing, as you call it, is a lovely gown, and I think she should wear it."

"Lela, perhaps you could come outside and talk with McDonough, Joe Nolan, and all the executives about this."

Mark ignored me and directed his whole argument to Lela. I opened the door and saw ten men, five from the front office, waiting to change my mind about the dress. By this time, I could see my mother bracing herself as Mark continued to protest the dress.

"Lela," he persisted, "why don't we call upstairs and have them find another dress that she has danced in?"

The words flew out of Mother's mouth like seven boomerangs: "Why don't you just get another girl!"

She took my hand and we both stormed past Mark Sandrich and out the stage door. The voice of Argyle Nelson stopped us. "Miss Rogers, would you come back onto the stage? Mr. Sandrich suggests that you rehearse once in the dress . . . the blue one."

Mother and I looked at each other to try to guess where the next bed of quicksand might be. He held open the door, and Mother said, "Don't go back unless you really want to."

"This much, Mother, I'll tell you. It's either that dress or home I go. So wait. You may have to take me home yet."

"Never worry. I'm going to wait," she said.

We went directly to my portable dressing room and were silent for the next ten minutes while I got into my beautiful blue satin dancing dress. I wondered how I was supposed to go out there and dance as though nothing had happened and listen to a love song being sung to me? Fred didn't like the dress. That was the root of the problem. When he approached me for the trial run, it was written on his face.

Our emotions were high-pitched. He didn't like my dress and I didn't like being put to the test. First he sang and then we danced. In our rehearsal for camera, it's true, some of the feathers did flutter and annoy Fred. He muttered to himself as he plucked the feathers off his tailcoat. Instead of "Cheek to Cheek," the song should have been called "Horns to Horns." I was determined to wear this dress, come hell or high water. And why not? It moved beautifully. Obviously, no one in the cast or crew was willing to take sides, particularly not my side. That was all right with me. I'd had to stand alone before. At least my mother was there to support me in the confrontation with the entire front office, plus Fred Astaire and Mark Sandrich. My 105 pounds couldn't have gotten me through the first round without her. The rehearsal was over and it was time for the take.

After the first take, I could feel that for one moment, they had conceded graciously. Fred's attitude was still cool and aloof, but Mark was not taking his losing with any grace. I was sad that they didn't see that that lovely dress would add to the number.

I appeared for the rushes the next day and was greeted by a cold silence. Rushes (unedited film takes) were usually seen at 6:30 or 7:00. This day they were shown at 4:00. The lights lowered, and *no one* in the projection room spoke to me. *No one* acknowledged my presence. I'd never played a specter before. The dance began. As I saw my beautiful dress in motion, I was pleased and happy. I was enthralled, just watching it move across the screen. When the lights came up, everyone filed out, speaking to each other "sotto voce." I was the last one out of the room. As I reached the street, one of the assistants came up behind me and, as he passed me, said in a stage whisper while looking straight ahead, "I think it looks beautiful. So what's a loose feather or two." And he kept walking. That was the first kind word I'd heard from any of the group.

We returned to the set to film a few other scenes. Mark's attitude was stiff and businesslike. Fred's weather vane was aloof and cool. Everyone continued to ignore me. Only Argyle Nelson gave me a smile and wink at the end of the day. I didn't pout or sulk, even though I was bewildered.

Four days later, a small, plain white box with a tailored white bow was delivered to my permanent dressing room. I pulled off the lid and there was a note, which said simply:

Dear Feathers.
I love ya!
Fred

Underneath the cotton layer was a gold feather for my charm bracelet.

Irving Berlin had written "The Piccolino" for Fred to sing; when Fred heard the song, however, he said to Pan Berman, "I hate that song, give it to Ginger." That's how I got to sing the last number in the film. Fred and I danced

to it and the chorus kids' movements were choreographed by Hermes Pan.

Shortly before *Top Hat* finished filming, Leland Hayward came to me with an offer from Decca Records to record the songs from *Top Hat*. This sounded like a great idea, but I had Leland put a clause in my contract with Decca that I reserved the right to have the records destroyed if I didn't like the quality. They said okay. I got RKO's permission to make the recordings and everything was set. I went into their recording studio and did all these great Berlin tunes, but when I heard them on the album, I was dismayed with the quality. I therefore exercised my contractual right to have the recording destroyed. The Decca people were not thrilled with this turn of events, but after all, a contract is a contract. They said they would take care of destroying the recordings.

I should have included in my contract that Decca was to give me the destroyed masters, but I didn't. Instead, I found out later, they had secretly shipped the masters to England and put the recordings out on another label! Nice folks, right? I was really hot under the collar about this and Leland tried to get them to pay me the royalties due me, but no dice. This really cooled my interest in making records for several years.

During the final days of shooting Mark wanted a little something extra, dance-wise, at the end of the film. Fred and I were poised at the top of a flight of stairs and Mark said, "As you come down the steps, I want you to break into a little dance."

This request did not go over very well with either Fred or me. Mark knew we always had to rehearse a dance no matter how brief, before performing it for the camera.

But Mark was firm; he wanted a bit more dance, as a "Ta da!" before the fadeout.

I quietly spoke to Fred. "Anything you want to do is okay. Just whip me around with your hand, and I'll follow you."

Mark commanded "Camera—action!" and we came down the steps of the Lido set. As we reached the bottom of the steps, Fred whipped me into his arms and started making pivots. On the second pivot, Fred's top hat fell off and rolled down the floor, almost into the water of the Lido canal. Fred stopped in his tracks, his hands flew up into the air, and his head shook "No, no, no!"

"Cut!" came Mark's command.

Fred went over, picked up his top hat, and walked to the wall of the set and kicked it. Not once, not twice, but about five direct hits with his foot. Fred had never displayed his temper to us before and we were stunned at his behavior. I stared at him unbelievingly, until I saw what his tantrum was all about. He had failed to put on his toupee before shooting and the extra spins caused his hat to fly off. Fred never appeared without his hairpiece and was really just mad at himself for not taking that precaution. The *Top Hat* crew probably had a lot to talk about when they got home that night.

Top Hat received four Academy Award nominations— Best Picture, Best Song ("Cheek to Cheek"), Best Dance Direction, and Best Art Direction—but there were no wins.

WORK, WORK, WORK

OVER THE YEARS, MYTHS WERE BUILT UP ABOUT MY RELA-
tionship with Fred Astaire. The general public thought he
was a Svengali, who snapped his fingers for his little Trilby
to obey; in their eyes, my career was his creation. It just
so happens that when Fred and I came together for the
first time in *Flying Down to Rio*, it was his *second* film and
my *twentieth*. While our union had a special kind of magic
and produced a unique enchantment, it was not the be-all
and end-all of my career. Then there's the old story that
Fred and I hated each other and suffered through our
movies, with him ranting and me bursting into tears. What
nonsense! Fred said on more than one occasion that I was
the only one of his dancing partners who *didn't* cry. Fred
and I were colleagues, and despite occasional snits like the
blue feather dress episode, we worked together beauti-
fully. All you have to do to verify my statement is watch
us; we had fun, and it shows. True, we were never bosom
buddies off the screen; we were different people with
different interests. We were a couple only on film. Be-
cause we were so good together, the public tried to make

something bigger out of our relationship, even when we were married to other people.

I still believe Phyllis Astaire was a powerful force. You would never suspect it to see her. Demure and softspoken, she couldn't pronounce her "r's," an oddly appealing trait, it seemed, especially to Fred. I really felt, however, that Mrs. Astaire exerted pressure on her husband, subtly or unconsciously. She would come on the set with her knitting and sit on the sidelines clacking her needles. I found her presence disconcerting, especially during dialogue takes. Fred was uneasy at these times, too.

One thing's for sure, she never warmed up to me . . . and she surely didn't want her husband to, either. Other than on the dance floor, Fred and I rarely embraced in our films. Fred said he couldn't stand mushy love scenes and felt like a fool kissing for the camera. Frankly, I think Phyllis didn't want him kissing other women. When a script was released to Fred, the two of them would huddle over it for a few hours. Then he'd march down to the producer's office with a dozen reasons why it would be better if the protagonists never clinched. Thus, there were no love scenes with the leading lady!

Whenever people asked me why Fred and I never kissed, I'd blame it on the director. "Ask Bill Seiter or Mark Sandrich," I'd say, though I darned well knew the real reason. Anyway, our chaste behavior didn't affect our films at all, since, as the critics have astutely pointed out, we made love through our dancing. Take it from me, no matter what you hear, Fred and I were always friends and professionally compatible.

After almost twelve continuous weeks of work on *Top Hat,* plus making *Roberta* and *Star of Midnight,* I had been practically without any time off since my wedding day. Lew was also busy, making films at Universal. We decided to take some time for ourselves and get reacquainted. We went on a mini-vacation to a favorite spot, Willow Springs, near Boulder Dam.

During the six years that Lew and I were married, I continued to work at RKO. My next effort in 1935 was *In Person*, which had been turned down by a number of RKO stars. Those negative opinions never bothered me. If I read a script and could imagine myself playing the role, I was interested. Naturally, there were those who said, "You're foolish. Look who has turned *In Person* down: Fred Astaire for one, Kate Hepburn for another." If the leading character had been switched to a male, it would have been less humorous, in my opinion. But Kate Hepburn was right; she would have looked idiotic with the false teeth that the plot required. Neither Astaire nor Hepburn had my absurd sense of humor, which made it simple for me to look ridiculous, and I *did* look ridiculous in this film. The story line for *In Person* concerned a movie star who has recently had a nervous breakdown and is afraid of crowds. Anytime she wants to go out in public and not be recognized, she wears a disguise. Hence, the false teeth! Handsome George Brent comes to her rescue and helps her overcome her phobia.

We did location shooting for ten days in the mountainous Big Bear Lake region, just two hours from Los Angeles. One morning, director Bill Seiter said, "Now, Ginger, I want you to dive into the lake, swim underwater, and come up about thirty feet away."

"Bill," I said, "have you put your hand in this water? The crew are tying strings around their beer bottles and dropping them in the lake to keep it ice cold. That water is freezing, Bill!"

"Right, but you will swim underwater for about thirty feet and I'll have the camera right on you, and when you come up for air, the leading man will see you for the first time without your phony makeup on. Then you'll get out of the water and head for your cabin."

Of course, I obediently did the scene, freezing all the

way. Even though it was August, that mountain water was COLD!! The Hays Office made a fuss about the two-piece bathing suit I wore, claiming it showed too much flesh. I had to laugh. During the take, as I swam underwater, my bathing trunks were slowly sliding off. It was all I could do to keep them from coming off altogether. If the camera had picked that up, the Hays Office really would have had something to criticize!

George Brent, my leading man, was a love and a great straight man, as well as a joy to work with. Alan Mowbray, playing a pompous actor, was just hammy enough. Grant Mitchell, who was playing George's close friend, could do double-takes that cause me to laugh, even now, when I see the film.

This film was to be known as a musical. Dorothy Fields and Oscar Levant wrote the three songs I sang: "Out of Sight, Out of Mind," "I've Got a New Lease on Life," and "Don't Mention Love to Me."

The dressing room used at the end of the film was, in reality, my own portable dressing room. The set design department saved money by just dismantling one wall for its use in the filming. Naturally, I felt very much at home on this particular set, with the tufted walls decorated in blue satin (what else!).

In October of 1935, I was scheduled to appear with Fred in *Follow the Fleet*, which had another wonderful score by Irving Berlin. As we were about to start filming, word came that *Top Hat* had opened at the Radio City Music Hall in New York City to capacity crowds. We were told that the audience applauded each of the numbers.

These reviews helped to inspire us on *Follow the Fleet*. Fred and I were joined by Harriet Hilliard, Randolph Scott, Lucille Ball, Astrid Allwyn, Betty Grable, and Tony Martin. The script, based on the play *Shore Leave* by Hubert Osborne, was written by Dwight Taylor (Laurette

Taylor's son) and Allan Scott, who had also written *Top Hat*. My friend Bernie Newman designed the lovely clothes for me in this "seagoing" musical. Mark Sandrich was again the director. I hoped he would begin to see me in a more favorable light, since this was our third picture together, but unfortunately, that was not to be. To him I was merely a clotheshanger who could dance sometimes, sing upon occasion, and perhaps make the leading man smile at me. If I was talking to Fred or looking at Fred, Mark would take a long shot of me from behind, from my knees to the top of my head, to frame Fred's face. I know much has been written about what a splendid, supple back I had, but this was ridiculous. When we finished a take, Mark came scurrying over to Fred to tell him how terrific he'd been—and wouldn't bat an eye at me. Mark worshipped Fred's genius and thought he was the greatest thing since 7-Up. I was dismissed as a little bubblehead. He really tried to cut me down to size.

I didn't let Mark's attitude dampen my enthusiasm for this film, which has such great Berlin songs as "Let Yourself Go," "I'm Putting All My Eggs in One Basket," and "Let's Face the Music and Dance." Fred did two alone, "We Saw the Sea" and "I'd Rather Lead a Band." Harriet Hilliard also had two, "Get Thee Behind Me, Satan" and "But Where Are You?" This was an exceptional score.

In the opening number, "Let Yourself Go," Fred wore a sailor's uniform while I had a navy blue and white satin sailor-type outfit. This number turned into a dance contest and Hermes searched Hollywood for dancers to compete with our characters. This song was reprised later in the movie, when it afforded me the first chance I had had to do a solo dance number in any of the films in the musical series.

When Fred created routines, he always tried not to repeat steps from other dances. "Eggs in One Basket" was no exception. On the rehearsal stage, we asked Hal Borne

to play the number on the piano. Gradually, little by little, a goofy dance began to take shape from the silly things Fred, Hermes, and I were doing to the piano's rhythm. I suggested that it would be funny if I got caught in a step and couldn't come out of it. Fred should try everything to get me to the next step while I ignored him and continued doing what I was doing. Fred liked the idea, and we tried it out a few different ways. As the rhythm of the dance changed from waltz time to fast jazzy time, I suggested that Fred fling me out in a spin and let go of me on the return. I'd end up on the floor, doing an Edgar Kennedy slow burn as I sat there. Because the two characters we were playing, Sherry and Bake, were not sophisticated, we could get away with this type of nonsensical dance.

The number was done pretty much as we had mapped it out. The shooting started with Fred singing the verse and the first chorus of the song. As Fred sang to me, Mark had the cameraman photograph my left ear. Only when I started to sing my chorus did the camera swing around to show me in a full shot. This was one of the many times Mark went out of his way to set up the camera on Fred's face and the back of my head. Now, I'm not so vain as to think I should be the center of attention at all times, but Mark's lack of interest in me really was disturbing. I was sure he didn't like me, but I never had the nerve to ask him why.

For the final number, "Let's Face the Music and Dance," Bernard Newman created a pale blue beaded dress for me; it weighed about twenty-five pounds. Every time I whirled, the weight of the skirt would flare out and slap me, throwing me off balance. I had to learn to steel myself against the onslaught of the "third person" in our dance, my dress. Fred had to face a little music concerning my dress, too. On the first take, my bell sleeves slapped him in the jaw when I twirled. Fred winced and continued. I was completely unaware of what was happening. We spent several hours trying to get a take in which my

sleeves didn't hit Fred. Nothing worked and Mark finally used the very first take.

For all the activity that goes into filmmaking, there is an equal amount of inactivity, or passive activity. Waiting patiently can be a major part of a film actor's day, especially when you're being marked for the camera shots. I'd have to stand still while my footprints were scored; then I'd go to my dressing room while a stand-in stepped into my marks and stood still for the camera set-up and the lighting arrangements. When everything was ready, I'd be called back for the shot. This was done six or seven times a day and became very tedious.

"What is it you always mumble to yourself every time I mark your feet?" asked the camera assistant. "Would you please tell me, so I don't have to crawl up into your lap to hear it?"

Rather shyly, I said, "It's from the Bible," and I quoted it to him: "Mark the perfect man, and behold the upright: for the end of that man is peace." (Ps. 37:37).

A wonderful expression appeared on his face and thereafter, every time he marked my feet, he would look up with a knowing smile.

During one of these camera set-ups, I was seated in my little portable dressing room, reading. It was a rather warm day and my door was wide open, facing the back wall of the set. After reading for about a half-hour, I looked up and saw Irving Berlin seated in a chair next to the back wall. When he saw me looking up, he got up from his chair and walked toward my dressing-room door. He was wearing a gray fedora, and those smoldering black eyes of his looked at me intently. He said, "I've been watching you for the past twenty minutes, and that must be very interesting what you are reading, as you haven't taken your eyes off the pages. What are you reading?"

This sort of caught me off-guard. I hemmed and hawed a little and finally I decided to tell him. "I've been reading

Science and Health with Key to the Scriptures by Mary Baker Eddy."

Berlin said, "Oh, really? You're the second person I've ever met who reads that book. The first person was Ivan Lebowitz. I had gone to a little rest home to spend a week, trying to catch up with myself again. And as I was walking through their very palatial gardens, a voice called out to me, 'Hello, Oiving, how nice to see you here. This is just the place to come for a little rest and quiet. A friend of mine saw how ill I was, and he recommended a book to me. My friend gave me this book called *Science and Health with Key to the Scriptures* by Mary Baker Eddy, and told me to read it right straight through. And I did. It's a wonderful book. Look at me, Oiving. I feel a thousand percent better.' "

Irving said he thought it was kind of strange to hear this coming out of the mouth of a man wearing a yarmulke on his head.

Then, Irving continued, his friend told him, " 'Don't you think I look a lot better than four months ago when you last saw me? Oiving, I want you to have the same joy I have, so I'm going to get you this book, and I want *you* to read it right straight through. There's a lot of stuff in there about Jesus the Christ, just skip dat!' "

Irving told this story as though he were performing on stage, using an adorable Yiddish accent.

While I was working, my mother also found an outlet for her abundant energies and talent. Mother's long experience in Hollywood made her very knowledgeable about the business. For some time, she ran a workshop in East Hollywood called the Hollytown Theatre, where aspiring actors had an opportunity to train and to appear in plays. The RKO front office decided that it would be good for the younger contract players on the lot to have someone to guide them. Lela was asked to come to RKO and shift her

workshop activities to the Hollywood Playhouse. In no time she was casting and producing plays in the little theater on the RKO lot. The producers often dropped in to observe the new talent. After seeing a few of the plays she directed, I was very proud of her.

Mother contacted all the contract players to offer them acting lessons and asked J. R. McDonough, head of the studio, to use his authority to get the young players to respond. Most of them, including Lucille Ball, Betty Grable, Joy Hodges, Leon Ames, Anne Shirley, Tyrone Power, and Phyllis Fraser, did; only one person failed to answer, Joan Fontaine. Mother was sitting in her office with Al Nash, a writer, when she telephoned Joan to ask her why she had chosen to stay away.

"Lela Rogers," Joan said in a businesslike tone, "You can't teach me anything."

Mother gasped at this, hung up the phone, and repeated the conversation. Al said, "I guess you can't win 'em all."

Sometime later, Joan Fontaine called Mother's office and said, "Mrs. Rogers, if you have nothing better to do tonight, there's a preview over at the Fox Wilshire of my new movie. Maybe you'd like to see it." Mother said she'd be delighted. That evening she took Al Nash with her. The movie was Alfred Hitchcock's *Rebecca*. When Mother left the theater, she turned to Al and said, "You know, that kid knew what she was talking about. What a talent. She certainly didn't need me. All she needed was Hitchcock!"

Of course, not all good talent can have a Hitchcock. Those are the ones who needed a Lela Rogers. Mother was always reading plays and finding vehicles for these youngsters to show off their talent. She assisted a great many people and, in fact, literally saved Lucille Ball's career. The studio told my mother they were thinking of letting Lucy go. My mother said firmly, "You fire Lucy . . . then I'll quit. Lucille Ball is one of the most promising youngsters on this lot. If you're stupid enough

to do that, the minute you let her go, I'll snap her up and take her to another studio and see that she gets the roles she deserves."

One of my first recollections of Lucy was during the film *Finishing School*. The hairdressing department was right next door to the makeup room. My hairdresser had just finished fingerwaving my hair for the first shot that morning. There was a small pass-through opening with a wooden panel closure that slid up and down. I came around the makeup room door just in time to see Lucy lift up the panel and angrily toss her porcelain coffee cup through the opening into the hairdressing room. Mel Berns looked at me in surprise and shrugged his shoulders, as if to say "I don't know what that's about either." Kate Hepburn was there too and wondered what had happened. I've never known what prompted Lucy to throw that cup. Maybe it was her way of saying, "I'm here too, you guys." She made believers of us all, though Lela knew it far ahead of anyone else. I was immeasurably grateful that Lucy got the chance to prove that talent in her television series.

18

\mathscr{D}ANCING FOR THE PRESIDENT

WHILE I WAS FILMING *FOLLOW THE FLEET*, JOE NOLAN, the West Coast studio head, telephoned the set with an important message. He couldn't get through to me, so he did the next best thing and called Lelee. He told her the office of the President of the United States had called to ask if I would accept an invitation to be the *one* "motion picture star" to honor President Franklin D. Roosevelt's birthday ball on February 4, 1936. Apparently, no written invitations are sent from the White House until an affirmation is received; this way, there is never a record of refusal.

That evening, Mother came over to Roxbury Drive and told me I'd been asked to appear at the White House. As she entered the front door, the words tumbled quickly out of her mouth. I looked at her and she looked at me. Simultaneously, we said, "Wouldn't you think he would have asked a Democrat instead of a Republican?" I was honored by the request; but I wasn't sure I wanted to accept, and not because I was a Republican. There were two good reasons: first, I was scheduled for a six-week vacation

before starting my next film, and second, I really didn't like to travel. That's as true today as it was then; I had to do so much moving around as part of my theatrical upbringing that I'd do anything to avoid it. I delayed my response until RKO's president, B. B. Kahane, persuaded me to go. I had ten or twelve days to get ready, and my vacation was canceled! Since Lew was working, I asked Mother to go with me.

The minute Mother and I stepped off the train in Washington, we were hustled to the Mayflower Hotel. I had little more than an hour to get ready. We were to go to the Oval Office and listen as the President spoke over the radio. The network would broadcast the President's birthday party from the most popular hotels across the country. As part of the celebration, I was to appear on stage with an orchestra in three different Washington hotels. At each function, I was to tell the public that I was happy to be a part of FDR's birthday ball.

Mother and I arrived at the Oval Office and were seated next to the Secretary of Labor, Frances Perkins. The radio men were hovering around the President's desk, adjusting the microphone and wires. One of them said, "We have about ten or twelve minutes before you go on, Mr. President. We're piping in music from the different hotels."

The President nodded and checked his watch. Then he looked in my direction. Beckoning to his aide, he whispered something in his ear. The aide turned to look at me, nodded his head, and walked over to my chair. He leaned down and whispered, "The President would like you to dance for him."

I was dumbfounded. "But where would I dance?" I asked.

The Oval Office floor was nearly smothered in a two-inch sink-your-heels-into-it type carpet, beautiful to look at but impossible to dance on. Again I said, "But where would I dance?"

He pointed to a small section of exposed marble floor in front of the tall French doors. "There?" I said in a small voice. .

"Yes," he answered in a semi-whisper.

With a stunned expression on my face, I got up and walked over to the molecule of marble. I was wearing a form-fitting evening gown with eight-inch slits on either side of the skirt. Two straps supported the bodice. On my left shoulder I wore a corsage of orchids, given to me by the birthday committee. Underneath my gown were my silk stockings and a panty girdle.

The marble felt cold and foreboding under my satin slippers. It also felt slippery, which worried me most. I turned and faced the audience of about sixteen people. The anxious expression on my mother's face probably mirrored my own nervousness. I stood poised, and when the music from Oakland, California, was announced, I started to move in a graceful manner. Suddenly, the announcer broke in, saying, "And now we come to you from San Francisco." The slow waltz was immediately replaced by "Running Wild" at a breakneck speed. The rhythm truly was wild, and I couldn't possibly keep up with it. I thought to myself, "If this is dancing, I don't know how to spell it."

Striving to find a middle ground of rhythm, I came dangerously close to the two-inch rug facing me. In whirling, I lost my balance and though I didn't fall, the shoulder strap which held the heavy orchids on my left shoulder fell, dragging the front of the dress down with it. I grabbed the dress as fast as I could, to keep from standing half-naked in front of my audience. But I was not quick enough. Holding my corsage up, I curtsied and made straight for my chair. I was embarrassed beyond words. The applause from the mini-audience in the Oval Office made me even more embarrassed.

The President placed his amber cigarette holder between his teeth, lifted his head in the air, and clapped his hands in six noiseless pats. Within the next few seconds,

he began his speech. I was grateful that all eyes were off me so that I could regain my composure. When the President finished, the audience was dismissed. As Mother and I turned to leave, Mr. Roosevelt beckoned to me. He was smiling as I arrived at his desk. "Thank you very much," he began in his distinctive clipped tones. "I realize asking you to dance on the spur of the moment was an imposition. And you did it very graciously." The typewritten radio speech was on his desk, and as he spoke, the President scribbled a few words and then his signature on the bottom of the paper. Then he handed the speech to me. "This is for you." He smiled.

"My goodness. This is a lovely surprise. Thank you very much," I blustered.

I later learned I was the proud possessor of one of the few speeches President Roosevelt released from his personal files. The document has all of FDR's deletions and pencil corrections in the margins, as well as the hastily written dedication to me. That was a precious memento of a visit to Washington that I didn't want to accept and a dance that I didn't want to do.

From the White House, Mother and I were driven to the various hotels. As I got out of the limo at the curb of the first hotel, some people recognized me, and called my name. When the crowd pushed heavily against Mother and me as we entered the foyer of the hotel, the guards had to call for extra police to help. Eight policemen linked forearms and made a circle around Lela and me while we walked toward the ballroom. The screaming, yelling, laughter, joking, and music became louder. The pressure of people was so great that it knocked my mother down. I looked back and suddenly, she was gone. I had to yell loudly to get the attention of a policeman. "What happened to my mother?" I screamed over the continuous voice thunder.

He looked back and said, "I don't know."

One of the policemen yelled across the closed circle, "Here she is."

She was on the ground being stepped on. I saw her arms come up as if from the bottom of the sea. Next, her head came up, and she yelled to me, "Well, at least I found something while I was down there." She had retrieved a gold cigarette case off the carpeted floor. It was a beauty too.

Trying to hold together her dress, which by now was torn, we inched our way to the bandstand with the police beside us. From out of nowhere, someone reached into our circle of policemen and grabbed a handful of my hair, over a policeman's shoulder.

I yelled. One of the cops whacked the arm of the person who was clutching a handful of my blonde tresses. Some of my hair went with him.

Finally, the police moved Mother and me to the rear of the bandstand, where the master of ceremonies announced that I would say a few words. Of course, no one could hear anything above the din of that crowd.

After my brief words, the master of ceremonies told the crowd, "Here comes Mrs. Eleanor Roosevelt." I was surprised and pleased to meet our First Lady. She was a bit plain-looking, but had on an unusual necklace made of either claws or tusks in a semicircular shape. I couldn't tear my eyes away from her necklace.

I met her again at the third hotel, and she commented, "We're getting to be old friends." That was the second and last time I ever saw Mrs. Roosevelt. A wonderful quotation is attributed to her: "No one can make you feel inferior without your consent." She was truly a remarkable lady.

19

\mathcal{H}URRAH TIME!

In April of 1936, my agent, Leland Hayward, and I were negotiating a new contract with RKO. I wanted my rightful due, not only in money but in roles as well. By contract, I was not allowed to refuse the films I was being given. I knew I was capable of more and wanted to stretch my acting abilities. Unfortunately, the material I had to work with did not give me room to grow. Oddly enough, one of the obstacles to getting diverse roles was my very name! Reviewers loved to play around with it, throwing out phrases like "Snappy Ginger," "Ginger snaps," or "Does Ginger bite? No, Ginger snaps." Writers relegated me to the limbo of the lightheaded blonde, and most of my roles reflected this fact. I was delighted to do musicals; still, I longed for something to sink my teeth into.

Before the Screen Actors Guild was formed, an actor could be kept working until he fell down on his face! Actors' performances were often strained from lack of rest, something I constantly fought. When other female stars on the lot would take off two to three days during that certain time each month, I worked. Not once did I

ever take a day off for that reason—not once. I was never absent from a shooting schedule because of illness. The only absence that I had was during the controversy over my contract.

My films were making BIG money and I wanted a bit of the gravy. I had always been Miss Cooperation and bent over backwards to please. However, by not making de-- mands, I allowed myself to miss out on the financial rewards. That's when I decided not to report to the studio until something was done about my contract.

Some of my colleagues appreciated my situation and rallied to my cause. When RKO's files were presented to the UCLA archives in 1982, I saw a copy of a letter written by Pandro S. Berman to B. B. Kahane, president of RKO. In it, Pan's observations over the past year were noted quite eloquently:

> I must say that in spite of whatever difficulties you may have had with her over money, she has been a model of hard work. . . . She has spent all of her Sundays and holidays and nights rehearsing her dances, she has spent many nights after a very long and hard day's work recording her songs, and nothing has been too hard for her, even to the extent of going to the Wardrobe Dept. after midnight and staying there until 2:15 in the morning getting fittings on clothes which were necessary for the next day's work. I must say that nobody could have been as sweet and hard working as she has been. In fact, it has been beyond the request that one would be able to make of any star under any conditions, and I think this should be noted and called to your attention inasmuch as you are now considering certain problems in connection with her.

There is nothing more difficult than working on musical pictures. It is five times as hard as the work one ordinarily does on a dramatic story, and this ap-

plies even more strenuously to a woman than to any-
one else, and particularly to a woman who dances as
against an ordinary singer.

. . . There are so few assets in the picture business,
and she being one of them and one of the three
important personalities we have, I don't think it mat-
ters very much whether we give her an extra $500.00
a week or not when the figures are all added up at the
end of the year, and I would rather see the money
withheld from any of our other people than I would
from these three prime assets whose state of mind is
equally as important as their native talent. I must say
that I think IN PERSON could have been a better pic-
ture, in spite of Ginger's willingness and hard work,
if her mind had been at ease, because she has been
constantly emotional and working under a slightly
hysterical strain all through the picture, and I would
hate to think that we would start FOLLOW THE FLEET
with Ginger in this frame of mind as it might lead to
serious difficulties in a set-up where there is anyone
as temperamental as Freddie alongside of her.

. . . I know from things I have picked up around the
Studio that Ginger does not consider the offer which
was made to her to be an equitable one, and I am
sure takes it in the spirit of a very small increase;
whereas I think an extra $200.00 or $300.00 a week
above that figure might make her very satisfied for
another year or so.

Finally, after much foot-dragging, the RKO brass
agreed to negotiate. Still, I refused to come to rehearsals
until the new contract was agreed to by the New York
office. B. B. Kahane wrote me a formal letter demanding
that I come to rehearsals of the next picture. I said no. The
next day, a wire came from the New York office, approv-
ing my new contract demands. I had rightfully stood my
ground and won.

Although *Swing Time* was my sixth musical with Fred, it was a departure in a number of ways. First, Mark Sandrich would not be directing. Instead, George Stevens, whose work I greatly admired, was in charge. I considered this a real break. Also, I had more dialogue and didn't have to play the wide-eyed ingenue role with which I'd become so identified. The motion picture business was always a man's business, and the men repeatedly cast me in similar roles in film after film. An acting challenge was therefore most welcome. Happily, some things didn't change; Helen Broderick and Eric Blore were in the cast along with funny man Victor Moore.

Bernard Newman was my costumer, and once again I was able to realize my "dream" dress. The lovely gown for the "Waltz in Swing Time" number was a beautiful dress that photographed well. The pink organza panels had a one-inch ruffle falling from the center like rose leaves forming a rosette. The top of the dress was very tailored, with thirty self-covered buttons. When I put it on, I wanted to turn and whirl in it. Dresses always affected me that way. I can never emphasize enough how important clothing was to me. Fred could wear white tie and tails over and over, but I had to have different dresses and they had to be made for dancing.

Swing Time had a scrumptious score from Jerome Kern and Dorothy Fields. In a charming and intimate scene, Fred sang one of the loveliest numbers in the film, "The Way You Look Tonight." According to the script, I'm angry at him and go into the bathroom to wash my hair, leaving him alone in the living room. Trying to ease the situation, he sits down at the piano and sings the song. I hear it, get caught up in his mood, and open the door. I walk into the living room with my hair full of bubbly white soap. The shampoo was the problem.

George Stevens had ordered various kinds of soap and

we did take after take, trying first one soap and then another. Nothing worked. By the time I got to Fred at the piano, the soap would be running down my face, down my neck, down my back. It looked terrible and felt awful. Next we tried shaving cream, but that didn't work either. Somebody came up with the bright idea of beating the white of an egg, so we tried that. This time I had egg streaming down my face from the heat of the overhead lights, which were cooking the eggs as I stood there. Ugh! It was a mess. Then an inspiration came to me.

"George, why not try whipped cream?"

Someone ran down to the commissary and returned with gobs of freshly whipped cream. The stuff was piled on my head like a frothy cap. I went through the scene and this time, it worked! I was more pleased than anyone else during shooting that the cream didn't run. The minute the take was finished, I went to my dressing room and washed soap, eggs, and whipped cream out of my hair. I had to redo my entire makeup, which by now looked like a color television test pattern. That scene, by the way, was the inspiration for shampoo commercials throughout the next decade.

The last dance number in the film, "Never Gonna Dance," was difficult to film, because Fred was on one side of the screen and I was on the other. The dance started on the main floor of a nightclub. Then each of us whirled up eighteen steps to the second floor, where we danced and danced and danced! We did final work on this number into the wee small hours of a Saturday night, and more than forty-eight takes were recorded. Everything that could have gone wrong did during the shooting of this number: an arc light went out; there was a noise in the camera; one of us missed a step in the dance, where Fred was supposed to catch me in the final spins; and once, right at the end of a perfect take, his toupee flipped off!

I never said a word about my own particular problem. I kept on dancing even though my feet really hurt. During

a break, I went to the sidelines and took my shoes off; they were filled with blood. I had danced my feet raw. Hermes saw what had happened and offered to stop the shooting. I refused. I wanted to get the thing done. Finally, we got a good take in the can, and George said we could go home—at 4:00 A.M.

The managing director of Radio City Music Hall, Van Schmus, told Pan Berman that *Swing Time* played to capacity crowds during its entire run at the Music Hall, even breaking the records set by *Top Hat* two years previously. That was quite an achievement, since the Music Hall holds approximately 6,000 people. To add icing to the cake, "The Way You Look Tonight" received the Academy Award for Best Song that year. Our film was a success in every way.

I was told that upon being asked to name his favorite among his books, Charles Dickens answered, "I love them all—but in my heart-of-hearts, I have a favorite child and his name is David Copperfield." Well, though I love all the films I made with Fred Astaire, I, too, have a favorite child, and it is *Swing Time*.

Part of my feeling had to do with the opportunity it gave me to work with George Stevens. He had an incredible sensitivity to an *actress* playing a scene. He looked for nuances and was always delighted when I added something new. I was unafraid to express these acting variations with Stevens at the helm, and the results are evident.

HE WENT HIS WAY, I WENT MINE

AT THIS POINT IN MY PROFESSIONAL LIFE, I WAS NUMBER three at the box office with Fred; but with Lew, at home, I was zero. Our marital problems were coming to a head.

One of the things that caused the disintegration of the marriage was the prenuptial agreement that Lew had insisted we make. This proved to be a persistent cloud over my head. Having been raised in a society which silently demanded that the man be the breadwinner while the wife cared for the home and raised the children, I wanted my husband to be the head of the house, pay the bills, and dictate how his money was to be utilized. Even though I had put my name on such a paper, after thinking it through in the months that followed, this new concept of the marriage state caused me to have doubts as to the depth of real love that lurked behind such a document.

This was a new and unknown approach to marriage in 1934. Lew was just ahead of his time. To have each of us pay our own bills, each buy our own groceries, split the electric bill, and each pay the landlord half the monthly

rent was new to me. Perhaps I was embarrassed to be different from all my friends, who shared everything under the usual marriage arrangement. As I saw it, marriage should be a state of mutual trust, expressing mutual love through those loving qualities of cooperation, forgiveness, tenderness, unselfishness, kindness, and generosity of heart. This should be the starting point of a real relationship. What went wrong along the way, I wondered. Perhaps I gave the impression of someone who could not be wholly trusted? Maybe Lew felt no female could be trusted after his first marriage ended.

As it began to dawn on me what I had gotten into, I began to feel the sting of impermanence. Most women want a sense of home and family in their marriage. This signed paper kept me suspended in midair. With this document standing between us, I saw that I had unwittingly fallen into a pit of convenience.

Things that had been his would remain his, and what was mine would remain mine. Obviously he had been burned in his previous marriage. I was so in love with Lew that I would have built a pyramid for him if I felt he wanted it. He knew I was madly in love with him from the moment he appeared on the screen in *All Quiet on the Western Front*. I knew he was the man for me.

To be the wife of this wonderful-looking actor; to cook his breakfast; to exchange life's little problems; to choose his ties; to be his confidante; to listen to his compositions from the piano bench beside him; to exchange tennis strokes across the net; to be in his arms when the workday was ended and the lights throughout the house were turned off: this was a dream worth dreaming, but one that, sadly, would not come true.

Then there was another factor. We were in the heyday of the Hollywood scene, lots of parties and lots of drinking. I could not go along with the crowd, but Lew loved the late-night parties. My abhorrence for alcohol made this

difficult for me. Consequently, in May 1936, with a heavy heart, I decided to leave.

I moved into an apartment on Gregory Way with my mother. I shared the apartment with Lela because I didn't want the press hounds sniffing at my door. Phyllis, in the meantime, had moved out of the Dundee Drive house and was sharing a house with her friend Anne Shirley.

With these changes in my life, I asked Mother if she would like me to build her a house, and if she did, could I live in it with her. I can see now that she was torn between the desire to live her own life quietly, with her friends, and my request to her to wedge her life into that of a motion picture star, with its capricious demands. What was going to be hers was now going to be ours. However, she would see her daughter more frequently, and that usually makes any mother happier. After thinking it over, she agreed.

The next day she scoured the area for a suitable place to build. She found a wonderful lot high in Beverly Hills on 2.75 acres on Gilcrest Drive in Coldwater Canyon. It had a view that didn't stop; when the fog burned off late every afternoon, it was possible to see Catalina.

While the house was still in an unfinished state, a progressive dinner party was arranged by a group of friends. I drew the second course, the soup or shrimp cocktail. All of us laughed as we traveled on a bus from house to house. With a guitar and an accordion to serenade us, we had songs en route and a surprise at each stop.

The surprise at my house was the most interesting. As each guest entered the "front door," I gave them a flashlight and a place card for the table. Jimmy Stewart was my date that night, and we led the troupe over planks, nails, etc., to get to where the caterer had set up the tables on the makeshift floor. I put signs with large arrows to point the way from the front door, back through the solarium,

to the makeshift dining room. There were no walls, but who cared; food was food, the company was good, and the view was splendid. That was the first party ever held at my house.

The building took over a year because of labor strikes and material shortages. When the house was finished, it proved to have been worth waiting for. It had everything I wanted or needed in a house: swimming pool, tennis court, projection room, and my very own soda fountain. Who could ask for anything more? My studio, which could double as a guest house, held all the paraphernalia of my hobbies: painting materials, canvases, paint brushes, turpentine, pencils, and so on. I sculpted a bust of my mother, and what a chore that was to finish. She was a wandering "sitter" who disliked sitting still.

The style was an American farmhouse with Dutch doors opening to cool breezes. The large bay window in the corner of the living room had a view of Beverly Hills and a bit of Los Angeles. Off the living room was a patio for barbecuing on a flagstone area under a beautiful Australian pepper tree. It was a wonderful place to entertain on crisp California nights.

On a lower level was an outside entrance to the playroom. This room had big windows and comfortable cushions as did the solarium in the hallway to the patio. I read many a book, with apple in hand, buried in those downy cushions.

There were two bedrooms leading from the solarium, one for Lelee with a four-poster bed and one for me. My room looked out on the view of Beverly Hills and I had a beautiful hand-carved mantle for my fireplace.

On the way to the pool and tennis court were eight sculptured bay leaf trees. Next to the blue-tiled pool was my tennis court. This was my pride and joy. As a dancer, I really appreciated my "en-tout-case" court; it was a pleasure to be able to play on a soft surface that didn't wear your legs out. Although the rhythm was slower than

on cement, the cleverness of the game was not lost. The tennis association knew I had the only en-tout-cas court in Southern California, and before long they begged me to allow young hopefuls to get a taste of what they'd face at the championships in Forest Hills. I was delighted to open my court to competitors like Pancho Gonzales, Gussie Moran, and, later, Billie Jean King. Jennifer Hoad and Alice Marble slammed a few over the net too.

My home was made for entertaining and I gave party after party. Most of them were informal. I'd serve spaghetti and we'd play some night tennis. Alcohol was never served, just cold drinks. One, a mixture of finely crushed ice, 7-Up, and concentrated orange juice, was a real favorite with the tennis crowd. On one occasion, *LIFE Magazine* asked me to give a party for a soldier coming home to Hollywood. Private John Farnsworth was recovering from a bout with malaria. I invited a dozen beautiful girls, including Barbara Hale, Jinx Falkenburg, and Gloria DeHaven. We served hot dogs, hamburgers, and soft drinks. Private Farnsworth had the time of his life and it was all recorded in *LIFE*.

On another occasion, I was interviewed by Edward R. Murrow for his popular "Person to Person" television program. All went well except for one mishap. My new four-door Chrysler was delivered during the interview. The technicians asked the driver to move the car, and he left it half in the garage and half out. An electrician accidentally pressed the garage door button and down it came on my new Chrysler. I heard this horrendous noise and ran out of the interview to see what had happened. My car was sitting under the door with a huge crease in the top like you'd find in a Valentine heart. The poor fellow who did it, the poor man who delivered it and moved it, and the poor lady who owned it were all in deep despair. Ever since that episode, I have been wary of electrically operated garage doors. It only takes once!

* * *

Swing Time finished in July and I accepted an invitation
from Governor James Allred of Texas. Although I was
born in Missouri, I was considered a Texan and thus was
asked to participate in the Texas centennial celebration. A
train was put at my disposal, and I invited about a dozen
film folk to accompany me, including my RKO sidekick
Eddie Rubin; Lucille Ball, who was a laugh a minute with
her zany sense of humor; my hairdresser, Louise, and her
boyfriend, John Miehle, the still photographer at RKO;
Hermes Pan; my very good friend Florence Lake; and
Lela.

The big football stadium was colorfully decorated to
commemorate the centennial. I rode around the dusty
stadium in an open Cadillac convertible, and the crowd
stood up and hollered greetings as we drove past. We
made quite a group, and they put us up in the Hotel
Adolphus. After the festivities, we went back to the hotel
to collapse. The summer in Texas can be awfully hot, with
very high humidity. And in 1936 there was no air condi-
tioning. I telephoned Lucy's room to see if I could bring
her anything. She said to come on up. Lucy was in bed,
wrapped in a wet sheet, lying under the ceiling fan!

At the gala dinner that night, Governor Allred commis-
sioned me as the only woman admiral of the Texas Navy.
I never knew Texas *had* a Navy. So let's see a little re-
spect—salute me, on the street or anywhere—but salute
me, you'all!

After the hoopla of the Texas centennial celebration
was over, my next stop was New York City. I was a
guest at the Harvest Moon Ball at Madison Square
Garden. That night, there was so much traffic and so
many people that I needed a police escort to get through
the throng to my box seat. When I was introduced to all
these dance fans, the Madison Square Garden crowd
stood on their feet, stamping and applauding for several

minutes. They just wouldn't stop. Quite a thrill for a little girl from Texas.

During the two weeks I was in New York, Mother and I were invited by Howard Hughes to take a short trip on his yacht around Long Island Sound. We ended up at the Huntington, Long Island, estate of airplane manufacturer Sherman Fairchild.

When we stepped off Howard's yacht onto the dock, my mother turned her ankle and had to be carried into the house. Generously, Sherman asked Mother and me to spend the night in his charming Tudor house.

The next day, Howard and I played tennis on Sherm's en-tout-cas court. That was the first time I had played on that type of clay court, and I loved it. I promised myself there and then that when I got back to the West Coast, I would see the builder of my new house on Gilcrest Drive and tell him to make this type of tennis court.

That afternoon, Howard took me over to the Sikorski helicopter plant to meet the man himself. I had never been in a helicopter factory before, and found it very interesting. Howard was such a devoted aviator that seeing anything that could fly was a thrill for him.

On the drive back to Fairchild's house, Howard proposed to me, and asked me to fly back to California with him in his plane. I said, "But, Howard, I'm still married, you know. Lew and I have only been separated for a few months."

"Well, I'll turn it over to Neil McCarthy, my lawyer, and then you'll be free to marry me. What do you say to that?"

"I won't fly back with you, because I have reservations on the Chief to go with Lela. Then, when I get back to California, you and I will talk about this."

When I arrived home, Howard was on my doorstep, pressing me for an answer. My separation from Lew was

too fresh in my mind and I was not ready for any firm marriage commitments. Still, Howard was a persistent suitor and over the next three years frequently called me for dates.

21

${\mathscr B}$EGGING FOR A ROLE

AT A DINNER PARTY ONE EVENING, I CORNERED PAN BERMAN. "Pan," I said, "I know you're producing Maxwell Anderson's *Mary of Scotland* and that Kate Hepburn is starring. I've also heard that John Ford is directing. Now, Pan, you have tested everybody under the sun but Shirley Temple or me for the role of Queen Elizabeth. Why not let *me* test for the role?"

"You?" interrupted Mr. Berman. "Why would you want to play the role of such an embittered woman?"

"Oh, come on, Pan, you know I want to get out of those soft chiffon dresses and play something that has some starch in it."

"Dear Ginger," he said, patiently patting me on the shoulder. "You should be glad you do what you do so well. Why don't you just stick to your high-heeled slippers and be happy?"

With that, he gently brushed me off with a smile.

With that, I determined to devise a plan.

I called Leland Hayward. "You're my agent, why don't *you* talk to Berman about my playing the role of Elizabeth? He won't listen to me."

"Why don't you corner John Ford?" suggested Leland. "Catch him at the commissary during lunch."

I rarely went into the commissary while filming—unless I had to be there for a conference; I preferred to have lunch in my dressing room. Since I wasn't filming, I decided to follow Leland's suggestion. I found out the day and time that the tests were to be made and I went to the commissary. As Ford and some of his camera crew were leaving, I went up to him and told him what I wanted. I knew if I showed up as Ginger Rogers, I wouldn't get to first base. However, if I appeared under a false name, all made up as Elizabeth, the test I made would be judged only on the basis of my performance. John Ford loved a practical joke, and the idea of fooling Pan Berman tickled his funny bone. "Sounds terrific. Call me at home and we'll figure it out."

I called Leland with the good news and told him I thought I should pretend to be British so I'd even have the right accent. Leland loved the idea, and we decided I would become "Lady Ainsley." Listen, if I was going to be British, I might as well go all the way and be an aristocrat! Leland called Pan and told him he had a visiting British actress who might be talked into taking the role.

I got in touch with Mel Berns in makeup and Edward Stevenson in wardrobe. They were both sworn to secrecy. A lot of painstaking detail went into this charade; among other things, I had to get a studio pass under my pseudonym, Lady Ainsley.

The day of the test, I wore clothes different from any I had been seen in before, donned a brunette wig, and put a turban around my head. At the studio, I didn't go through the automobile gate but headed for the Gower Street door. The Gower Street entrance was the first test of my disguise. Studio pass in hand and my British accent at the ready, it worked like a dream. I galloped to Mel Berns's chair and he went to work. First, a plastic skull cap was put over my head. It reached down to my eyebrows,

and created the appearance of a very high forehead. Later, a faithfully designed eighteenth-century wig was put over the skull cap. The period makeup for Elizabethan times was a ghostly white, for men as well as women. You can't imagine how this white stuff changed my features. Mel gave my eyes a beady look by creating a narrowness around them and painted a slit-like mouth over my full lips. Eddie Stevenson found a period costume with the full regalia of queenly dress, including a huge stiff ruffle around my neck. If clothes make the woman, then I felt like the real Queen of England! As far as knowing that the queen was Ginger, I didn't think even Lelee would have recognized me.

Leland played his part well, too; he phoned John Ford and gave him the lowdown on my character. Lady Ainsley had been playing Shakespearean roles for the past five years on the London stage, where her name was well known. While her husband, Lord Ainsley, was on safari in Africa hunting lions, Lady Ainsley had accepted an invitation from Mary Pickford to stay at Pickfair for a fortnight. Though she was uninterested in making an American movie, Lady Ainsley was persuaded to do the test as a lark. She was a great admirer of John Ford's films, and would enjoy meeting Katharine Hepburn.

John Ford ate it up. Leland then advised John to call Pan Berman and give him the story. "If he doesn't buy it, tell him to call me. I'll convince him."

When the time came for me to test, I casually strolled onto the stage in this fantastic regalia and felt ten feet tall! Hiding behind character makeup was a new experience for me. Three other women in courtly costumes stood on the set waiting for the camera test. One of them was Anita Colby, a very good friend of my mother's and mine. Each of the ladies-in-waiting *curtsied* as the assistant director introduced them to "Lady Ainsley." Even Anita bowed; I could hardly wait to tell Lela. I moved off to the test stage and made a grand entrance. No one recognized me.

The entire crew stepped aside deferentially, giving me a wide berth. The rumor was that Lady Ainsley was doing this test as a favor to John Ford. I had a ball fooling all the folks I'd worked with month after month. There's nothing Hollywood loves more than a bona fide title, and Lady Ainsley had one . . . or so they believed.

John Ford came onto the set and went right to me. He played it straight but I could see the twinkle in his eye.

"Lady Ainsley, we have never met. However, I have seen you perform. I was in London eighteen months ago."

"Perhaps you saw me with Maurice Evans in *As You Like It*," I answered in my high-toned British accent.

"Yes, that must be it. My, that's wonderful makeup you're wearing. No one could possibly recognize you," he said audibly, and then, lowering his voice so only I could hear, whispered, "I *had* to tell Hepburn who you are. She'd kill me if she found out later, and I've got to make this film with her."

Katharine Hepburn came onto the stage dressed in her Mary costume. "Miss Hepburn, this is Lady Ainsley," announced the director. Kate looked at me as one does at an adversary.

"Hello," she managed. Kate looked at me again with an indescribable expression.

John placed us for the test and gave the signal, "All right. Camera, action. Don't just sit there. Talk to each other."

We were seated in high-backed oak chairs and a large mahogany table stood in front of us. I turned to Kate, and in my best British accent I said, "I've enjoyed watching your performances very much, Miss Hepburn."

Although everything looked normal above the table, below decks Kate swung her leg back and kicked me in the shins. Her expression was unchanged as she muttered in a stage whisper, "You 0#%&°$!! Who do you think you are fooling?"

I was surprised by her outburst and looked to see if the

sound boom was in place. If her remarks had been recorded, that would spoil the whole deal. Luckily, it was a silent test. I bit my tongue to keep from answering her back. My composure was slipping, but somehow I managed to offer another weak-tea type compliment. Her look was that of the cat ready to pounce on the canary, and I was the canary. History was reversing itself. "Mary" was going to behead "Elizabeth"!

Ford broke the spell. "Look to the left, then turn to the right. Just keep talking to each other." I moved my mouth as though speaking, as Kate continued to glare at me.

"Thank you, Lady Ainsley," said Ford. "As soon as the other tests are over, I'll come into your dressing room."

I got up slowly from my chair, and turned to Kate. "Thank you, Miss Hepburn," I said through clenched teeth. "Thank you *very* much."

As I headed for the portable dressing room, I ran smack into my old buddy Eddie Rubin. Eddie wasn't in on this ruse as he hadn't been around when this idea was hatched. He looked right at me as if I was a stranger and let me pass. I waited for the bomb to explode over my disguise. But nothing happened until John Ford burst into the room and said in a loud voice, "Lady Ainsley, thank you so much for your time and trouble. I knew we interrupted your holiday, but in a day or two, we'll get back to you. Leland Hayward is representing you—correct?"

"Yes, that's right, Mr. Ford."

"Good. I will speak with Leland after we see the test. Your Shakespearean ability is known to us, but we needed to see how you photographed opposite Miss Hepburn. Mr. Berman and I will be seeing this footage sometime late tomorrow afternoon. Thank you again." And he disappeared.

I returned to my dressing room, got out of the Renaissance clothing, and then went over to Mel Burns to get the makeup removed. I slipped out of the studio without being detected, and when I reached home, I called

Leland to describe the events. He roared at hearing how Kate had kicked me.

A couple of days later Leland called and told me Pan had seen the tests and liked them. Now he wanted them reshot in sound. My ruse was really snowballing!

Alas, someone leaked the story, and the next day Louella Parsons's column was devoted to the Lady Ainsley incident. Lolly sharply criticized me for spending the company's money on a practical joke. Louella loved to give me the "raspberry" whenever she could. Hedda Hopper, on the other hand, seemed to like me, and I liked her. I think this was because she secretly thanked Lelee for not accepting a job offer with the Los Angeles *Times*. They then offered it to Hedda—and the rest is history. But Louella was another story. Unfortunately, I was not Carole Lombard, who could get away with anything. Louella called it a "practical joke," but in my heart, it was serious. I wanted that part so much I could taste it. And I had no other way of getting a test for the role.

I raced to the telephone to call Berman's house, and spoke with his wife, Vi. She told me Pan had not seen the morning paper because he had gone to the races at Santa Anita early that morning. Shortly thereafter, a friend called and asked me to the races . . . at Santa Anita. To go or not to go, that was my dilemma. What if I ran into Berman? I decided to take the risk of bumping into him. With twelve thousand people at the races, that wasn't very likely.

So far, so good! I was standing near the betting window with my friend when I heard a familiar voice behind me. "You little devil! You know, young lady, you really had me going." I turned to face Pan Berman. "That was the best trick ever pulled on me. I had no idea that you were that 'lady' I saw on the screen. I never would have guessed it was you!"

I laughed and suggested that I do a second test. To his great credit, Pan Berman wasn't the least bit angry. His

sense of humor about this was far better than anyone
could have expected. But I didn't get the second test and
I didn't get the part. The role of Elizabeth was given to
Florence Eldridge. Maybe it was just as well, because the
film wasn't favorably received by the public. And if I *had*
played the role of Elizabeth, both the studio and the pub-
lic would probably have laid their complaints at my door!

Since I hadn't gotten the part, I had some free time and
left for a quick trip to New York. There I bought some-
thing I'd always wanted . . . a mink coat. When I returned
to Los Angeles, I put my mink coat on and went to the
studio, to show off a little, I guess. As I walked up the main
street of the RKO lot, I headed toward the directors'
building. George Stevens looked out of a second-story
window.

"Well," George called down, "you're finally back."

"Yes, and I had a swell time, too. How do you like my
new mink coat?"

A brunette head popped out from the window next to
George's. It was Katharine Hepburn. "You got a new
mink coat?"

"Yes," I said. "Isn't it lovely?"

The head disappeared into the room again. George and
I talked a bit and then Kate reappeared. She put her arm
out the window and the next thing I knew, she poured the
contents of a large glass of water on top of me.

Kate called down, "If it's real mink, it won't shrink!"

My only defense was to stand away from the building
and brush away this unexpected cloudburst.

22

*T*HE ROLLER SKATE CONNECTION

I started work on *Shall We Dance* on December 24, 1936, and once more was surrounded by familiar faces: Fred, naturally, and Edward Everett Horton and Eric Blore, and a new face, Jerome Cowan. The score was by George and Ira Gershwin and included "Let's Call the Whole Thing Off," "Shall We Dance," "(I've Got) Beginner's Luck," "They All Laughed," "They Can't Take That Away from Me," and "Slap That Bass"; who could ask for anything more? One face on the set was familiar but not so very welcome to me: Mark Sandrich. I'd been spoiled by working with George Stevens and was loath to go back to second-class status with Mark.

Speaking of faces, I had to go through a unique ordeal for this film: I had to have a face mask done. My old friend Mel Berns put me in his barber chair, gave me two straws to put in my nose, and began to apply plaster of paris all around my head. I had to sit there and not move for fifteen minutes, which was like tying ZaSu Pitts's hands down to her sides. I sat for what seemed like fifteen hours until Mel finally grabbed both sides of the mask at the cheeks –

and slowly pulled it away from my skin. My face felt like raw meat. He looked inside the mask and said, "Yes, this has worked very well. We will fill the inside of this mask with terra cotta to give us a whole group of Ginger Rogers face masks for the finale."

Everytime the scene with the girls and the masks comes on the screen, I turn away because I just can't bear to look at that horrible mask and its dozen copies.

The story opens with Fred, as Petrov, a Russian ballet star, falling in love with a famous Broadway musical star, Linda Keene (me). Linda thinks that Petrov's ballet dancing is too stylized, but when he breaks into a tap break, she changes her mind about him.

One number in the film really got to me, for I thought it was badly integrated into the film. To this day it drives me up a wall when I see what was done to "They Can't Take That Away From Me." Fred was supposed to dance with a ballerina so they imported Harriet Hoctor from the New York stage. In this number, she does a backbend on her toe and taps her head with her toe-shoe. I thought it was pretty awful, but couldn't say anything because people might have accused me of sour grapes. Decades later, I was on a television interview program discussing my films with Fred Astaire. After much talk, they showed a clip of Fred dancing with . . . *Harriet Hoctor*. The hosts turned to me and said, "We didn't know you could do that."

Fred, Hermes, and I got together for our rehearsals of "Let's Call the Whole Thing Off," and we sat around and gabbed a bit. Out of these gabfests came our dances.

"What shall we do this time?"

"The scene is in Central Park, New York, so whatever we do must be authentic."

"Let's see, what do people do in the park?"

"They bicycle, jump rope, play volleyball, and what else?"

Hermes murmured, "Say, I'll tell you what I used to do as a kid . . ."

"Wouldn't it be fun," I jumped in, "to do the number on roller skates? We might be able to do a tap or two with them. Did you ever try to skate, Fred? This would at least be a challenge for all of us."

Fred was hesitant. "Well, let's think about it, but in the meantime get the prop department over here and tell them what we need for us to TRY."

That last word he said in CAPITAL LETTERS, which meant he wasn't too secure about this idea. The prop department delivered a variety of skates, and the moment I put on a pair, I *knew* this was right. Soon the room was full of the rumble of rolling metal wheels on a hardwood floor as the three of us whirled around. The creative juices were flowing. Two hours later, after steps had begun to emerge, we concluded that the skates were a good idea.

The roller-skating number was a ball to do. We were free to laugh out loud at each other. Fred sang one chorus, and I sang one chorus, before we turned the wheels of our skates to the rhythm of the song and sped away into each other's arms. Both Fred and I enjoyed it very much.

That roller-skating number inspired me to give a skating party with my current beau, Alfred Vanderbilt. We rented the Rollerdome in Culver City for the night of March 6, 1937. We invited a lot of our friends. The guests included Joan Crawford, Franchot Tone, Sally Eilers, Kay Francis, Frank Morgan, Chester Morris, George Gershwin, Ira Gershwin, Harold Lloyd, George Murphy, Simone Simon, Johnny Mack Brown, Jack Oakie, Humphrey Bogart, Mayo Methot, Cary Grant, Phyllis Fraser, Anne Shirley, Johnny Green, Cesar Romero, Eddie Rubin, Florence Lake, Hermes Pan, and Lela, too.

Alfred and I hired the best band available for our joint party and served plenty of spaghetti, chili, tamales,

Boston baked beans, sliced ham, cheese of every kind, hot dogs, and hamburgers cooked to order. The food table covered practically one-quarter of the circle of the rink. You name it, we had it!

There never was a better party. Alfred and I agreed on that. Everyone dressed very casually and had a great time. We had some kooky signs painted and placed around the rink, such as:

"Never let your right skate know what your left skate is doing."

One sign on the ceiling said, "What are you doing looking way up here?"

"Whyareyouwastingyourtimetryingtofigurethisout?"

"Itsonlytocoveraholeinthewall."

Humphrey Bogart turned into the star of the skating party. About two hours into the party I saw chairs and tables lined up in the middle of the rink.

"What's going on?" I asked Joan Crawford.

"Well," she answered, "you'd better look fast while he's on his feet. Bogie's over in the corner and is preparing a running start to jump over those chairs or dance with them."

I looked just as he came out of the shadowy corner. Before you could say "Scat," he jumped over the first chair, headed for the second, and picked up the third en route to do a cartwheel with it. "Oh, Bogie," moaned George Murphy, "don't do that again. You'll break your neck!"

Paying no attention to anyone, he challenged himself again. This time, when he reached the third chair, his hands slipped off. He missed it clean and ended up sliding about fifteen feet on the seat of his trousers. Everyone gathered around him as he got to his feet. Bogie stood up to his full skate-height, brushed the dust off his suit, and said in that charming lisp, "I used to travel with a circus and did this for a living. I was pretty good at it then. I just haven't done it in a little while."

LIFE Magazine, recording and reviewing the party, said, "Unique among Hollywood parties, this one was so much fun, nobody got drunk!"

Alfred and I planned to make this party an annual event. Unfortunately, this never materialized. Alf was fun to be with, and we enjoyed each other's company. Our dates didn't go beyond that, although Alfred's mother expressed great joy that we were dating and hoped it would develop into a full-fledged romance.

The filming of *Shall We Dance* wasn't always a time of fun and games. One morning, during a break, my secretary, Bill Hetzler, brought me a letter encased in cellophane. I couldn't believe what I read. It was an extortion letter. The letter said I had to pay $5,000 or they "would fill my mother so full of buckshot that I wouldn't be able to lift her." I told the front office and they said to let it go, it was probably a malevolent prank. But I wouldn't do it. No one has the right to threaten another human being, and as far as I was concerned, it would have been un-American not to report this to the FBI—which is exactly what I did, much to the studio's annoyance.

The FBI agents told me there would probably be another letter, with instructions for the payoff. Sure enough, the next week, another letter arrived. I was personally to bring $5,000 in an unmarked envelope to a small café in San Pedro and give it to the cashier. The FBI went to the San Pedro café and arranged for the staff in the café to be replaced by FBI agents. Not wanting to be left out of this operation, I persuaded my friend Bill Bakewell to drive me down to the café to watch the whole thing. I decided to wear a disguise of a hat and dark glasses in order not to confuse the guilty party.

The day of the payoff arrived and everyone was in place. The FBI's "Ginger" delivered the envelope to the cashier as instructed. Inside the café, a sailor from the

U.S.S. *Texas* got up from one of the booths, went over to the cashier, and said he'd take the envelope. FBI agents had surrounded the area and were waiting for the sailor to open the envelope. When he was asked by the agents why he had picked me, he said he liked me in pictures! I received a letter from his mother before the trial asking me to help him. She said he was just a boy, and had learned his lesson.

I wrote her back, saying I was sorry but the case was out of my hands. Anyway, boy or not, he was dangerous; he had threatened to shoot my mother. The sailor was tried and sentenced to five years in prison. We never heard another word about, or from, him.

Often there would be visitors to the set. Fellow artists would drop by to watch us work. One afternoon, everything was set up for my song, "They All Laughed." I took my place beside the piano and saw my old chum Cary Grant standing next to the camera. Mark Sandrich said, "Okay, hit the playback," and the orchestra went into the introduction to the song. I looked straight at Cary. Now I had someone for whom to perform and Cary reacted beautifully. He was as good an audience as he was an actor. When I finished the verse and chorus I went over to him, and while we chatted, Cary asked me to dinner the next night.

I went back to the scene and Fred and I danced to the tune I'd just sung. Cary watched the dance number about three times, and then had to leave. He waved at me, pointed to his watch, and held up seven fingers.

The next evening Cary arrived on the dot to take me to dinner, and we drove to a favorite seaside restaurant. We both had a keen sense of humor and tried to top each other on the way to the restaurant. It was a wonder that the police didn't stop us, since the car was weaving all over the road, but laugh we did. He loved telling cockney

stories. Over dinner, I made Cary repeat a little poem that went something like this:

> There was a big molice-pan
> Who saw a bittle lum,
> Sitting on a wide-salk
> Chewing godda wum.
> 'Long came big molice-pan
> Who said to bittle lum,
> Simmie gum,
> Said the bittle lum to the big molice-pan,
> "Gaul I sot."

Cary just ate this up. He wanted to learn it himself and tried to repeat it. I'd correct him and then he'd go at it again. Some eavesdroppers tried to tell him where he'd made his error, until our half of the restaurant became embroiled in this stupid poem. Our sides were aching from the mistakes Cary made. Finally, the room applauded when Cary got it right!

Cary was as dear a gentleman friend as anyone would ever want. To be friends with a male who is not your husband is a neat trick that works sometimes! His friendship was one I always treasured. One time, to prove his unselfishness, he said, "She, whom I love, I would have free, even from me. I need space around me and I want that for you, too!"

When I first started going down to Palm Springs in the mid-thirties, Cary had a house in the desert. "Let's go horseback riding tomorrow, what say?" We'd get our horses from a horse barn (that still exists) and ride for hours through the desert, rarely speaking. We just enjoyed being together and gazing at the wonderful views one experiences from the back of a horse.

Cary was a wonderful date, one of many terrific men I was seeing at the time. Another special beau was the composer of *Shall We Dance*, George Gershwin. George

would call me from time to time and ask me out. We enjoyed each other's company, and he was always fun to be around. We'd go to dinner and see a movie or go for a drive on a warm afternoon to find some new little beach restaurant. We frequently went to these small out-of-the-way restaurants because George was not one who went out dancing every other night.

One evening, however, we planned to go the Trocadero with a group of friends. I was thinking about the upcoming evening as Fred and I were going through a rehearsal of one of our dances. Suddenly, I thought what fun it would be if Fred and I surprised George with a little "impromptu" routine at the Troc that evening. Happily, Fred agreed with the suggestion and we worked out the steps for that night.

Shortly after everyone arrived at the club and the party was going strong, Phil Ohman's orchestra played a noise-stopping chord and Fred and I went to the center of the dance floor. We made some brief little speech to George and then the music began.

All went as rehearsed as we danced across the floor until we came to one particular spot. There was some liquid on the dance floor and I slipped on it. Fortunately, Fred caught me before I hit the floor and we finished our dance. Dancing together in public was something we had never done before, and George was dumbfounded and pleased that Fred and I would dance for him.

One Saturday afternoon we drove to Pasadena to see a college football game. George was a big football fan, and so was I. We had excellent tickets for the big college game. We screamed, yelled, cheered, ate hot dogs, got mustard all over us, and had the best time.

On the way back to Beverly Hills, George asked if I would object if we stopped off at an art store to pick up some things he'd left there the previous week to be framed. I was delighted to have the privilege of seeing these Gershwin canvases before anyone else. While he

was in the back of the store, I amused myself by looking at the enchanting supplies. The wonderful smell of linseed oil and turpentine obsessed me. I gingerly (no pun intended!) lifted the lid of a huge brown box to see a magnificent rainbow display of pastels. I carefully closed the box, thinking that one of these days I must investigate pastels and buy myself a box of those gorgeous chalks. I walked to another aisle, getting dizzy with all the good things I'd like to own.

George came out and we packed his paintings in the trunk. He closed the back of his car and handed me a wrapped box. "Dear girl," he said, "this is for you."

"What in the world have you done, George? What is it?"

"You'll find out," he said as we sped away.

"George, what is it? Tell me."

"Well, I saw you admiring a large box of pastels while we were in the shop, and I figured you didn't have any of these or you wouldn't have lingered so long over them."

"George, you didn't. You read my mind." I was touched and thrilled with this thoughtful gift and sincerely thanked him. Pushing my luck, I told him that as much as I loved receiving the pastels, I would love more than anything to be able to watch him as he painted.

"Well, Ginger, come over tomorrow. We'll go out to dinner, and I'll show you my etchings!" and he laughed at his own dull joke.

I arrived the next afternoon and George led me to an alcove where he was working temporarily. George wanted me to watch him as he painted. After a while, I asked, "Does it make you nervous to have someone look over your shoulder while you paint?"

"Not in the least," was his reply.

After about an hour, I decided to do some painting too. I told George I wanted to sketch him and asked if he had a photograph of himself. He directed me to a table in the next room with a bunch of pictures on it and told me to

take any one I liked. I found a picture that I thought was striking, but, alas, it wasn't George or Ira. It was Irving Berlin. I sat on the floor in the room next to where George was painting a self-portrait and began a charcoal of Irving Berlin. This was fun.

When we went to dinner that night, George told his other guests that I had had the chutzpah to sit on his floor, in his house, and do a drawing of his rival, Irving Berlin. He added, "You can see that she's crazy about me!" I *was* crazy about George Gershwin, and so was everyone who knew him.

Six or seven months later, when the news came over the radio that my good friend George Gershwin had passed on, my heart went out to that wonderful man. Only then did I realize that I had never opened the package he gave me. There it was in my studio guest house, unopened on the drafting board. I pulled the string, undid the package, and lifted the lid of the box. On the reverse side of the 5 × 7 art store receipt was a colorful self-portrait George had drawn with these pastels, and he had put his initials "GG" in the lower-right-hand corner. And to think I never thanked him for it. What an empty feeling I had inside for not acknowledging his wonderful drawing, which he must have known I would treasure, as indeed I do.

23

I WANNA GO FISHING!

STAGE DOOR, AN RKO FILM MADE IN JUNE 1937, WAS A milestone in my career. Both Fred and I had been bombarding the head office with requests to do separate projects. There wasn't any antagonism on either his part or mine; we just wanted to grow in different directions and not be stereotyped. Fred went into a musical called *A Damsel in Distress,* with George Burns and Gracie Allen. His leading lady was the nineteen-year-old contract player Joan Fontaine. It was directed by George Stevens with music and lyrics by George and Ira Gershwin. My film was not a musical; rather, it was exactly what I wanted, a bona fide opportunity to show my acting ability. *Stage Door* gave me that chance.

The film was an adaptation of the Broadway hit by Edna Ferber and George S. Kaufman and told the story of a group of aspiring actresses living together in a theatrical boarding house. I was to share top billing in the film with Katharine Hepburn and the match-up was calculated to play our distinct personalities—Hepburn, the aloof; Rogers, the accessible—against each other. We were a

long way from Queen Mary and Queen Elizabeth, and thank goodness for that; *Stage Door* proved to be as much a hit as *Mary of Scotland* had been a flop. (Kate, although she had won an Oscar, had appeared in a string of movies with poor box-office attendance.) The character Kate played in *Stage Door* was a test to me. Would I overcome her silent ridicule of me or melt into the scenery like a chocolate bar? Kate always wanted her way and usually got it. I was surprised at her attitude about the *Mary of Scotland* test. She didn't have to behave as strongly toward me as she did. Pan Berman would have given her Vine Street if she really wanted it. I steered clear of her, not trusting what she might do if I in any way crossed her. I recognized she had little empathy for me.

One day, I learned of her coming birthday. So I went to a jeweler and found a dear little platinum suit pin, set with about twenty small diamonds. I sent it to her, but never got a reply from her about it. Years later, I went backstage while she was doing a Broadway play. I asked her what she'd done with my little birthday gift. "Oh, I don't really remember. I must have given it to someone."

In the cast were Adolphe Menjou, Jack Carson, and Constance Collier, plus an exceptional group of young women including Lucille Ball, Eve Arden, Andrea Leeds, Gail Patrick, and Ann Miller. Little Annie Miller (not so little at 5'8" tall) had told everyone that she was eighteen when she was only fourteen. We were supposed to do one dance number together, but I wanted to be paired with someone shorter. She begged, "I'll wear flats if you'll put on high heels and wear a tall top hat. Anything, but I want to dance with you!"

The story and cast were first-rate and so was the director, Gregory La Cava. Morrie Ryskind and Anthony Veiller brilliantly adapted the Ferber-Kaufman script, and in order to expand and enhance the dialogue, Greg would

take time out from shooting to sit around and listen to the
off-camera chitchat among us girls. He'd make notes on
our conversations and then incorporate these off-the-cuff
exchanges into the dialogue. That's one of the reasons
Stage Door remains so fresh and snappy and why the
dialogue rings so true. La Cava liked me and knew how to
get the best from me and the rest of the actors. I liked him
immensely, too, and felt great confidence in him. La Cava
had a drinking problem, and many times during the shoot-
ing there was a teacup in his hand. The Earl Grey was
liberally laced with gin. However, his alcoholism didn't
affect his competence. As a person, he was kind and lov-
ing; as a director, he was masterful.

There were no minor roles in *Stage Door*. Everyone had
a chance to shine, sometimes for unconventional reasons.
Eve Arden noticed a cat hanging around the set and got
friendly with him. The cat liked to drape himself over her
shoulders and sleep. La Cava saw this and included quite
a few shots of Eve wearing her living stole. Later, she was
singled out by critics and reviewers as "the girl with the
cat."

As for me, *Stage Door* vindicated my persistence with
the front office. Frankly, I was grateful that I didn't
have to dance nonstop in this movie. As a result, more
substantial roles were offered to me. My work as Jean
Maitland was singled out as the "finest performance in
the photoplay" by the *New York Herald Tribune*. *The
New Republic* commented, "When you think of Miss
Rogers' former song-and-dance appearances, it seems as
though this is the first chance she has had to be something
more than a camera object and stand forth in her own
right, pert and charming and just plain nice, her personal-
ity flexible in the actor's expression." (I just loved having
the word *actor* applied to me.)

I loved making *Stage Door*, and was sorry when it came
to an end. However, the minute it was over, I decided I
needed a vacation and would go fishing in Banff, Alberta,

Canada. Mother was involved with her theater at RKO, so I asked my cousin Phyllis to come along. I knew I would need a car when we got there so I arranged for us to board the train in Los Angeles and have my Dodge put on the same train. We arrived in Vancouver, British Columbia, and then Phyllis and I drove through the beautiful countryside to Lake Louise and Banff.

The pageantry of beauty was everywhere. Piercing the aquamarine skies were the snow-white mountain peaks, themselves reflected in the waters of the glacier. We felt like small sugar ants.

At the beautiful gray chateau, we expected medieval knights to gallop across the terrain. I was disappointed not to find a moat around it. Once in our suite, Phyllis beckoned me to the window. "What am I looking at?" she said. "I've never seen that before."

Up in the sky, I saw a perfectly round rainbow, looping through the overcast mist.

The next morning we started out to play golf with a gray gazelle staring at us and a huge brown moose staring at our putting strokes. Somewhere on the back nine a cloud-burst let go, drenching us both. Fortunately a car appeared near the cart path and rescued us. Our newfound friend, Kay Paris, invited us to come to her home for afternoon tea. We happily accepted.

During our tea, I told Kay and her mother that we planned to go fishing tomorrow. We asked about the best lakes or streams. When Kay's father appeared, he told us the exact spot for the best trout, a small mountain lake, which we would approach by horseback. At 5:30 A.M. the next day we started our journey. The mountainside was very wet and slippery as our horses made the long climb. After an hour's ride we reached a small, beautiful emerald lake. The minute I cast my line out into the deep clear water, something tugged. It was a beautiful two-pound bass. Phyllis and I both caught a fish in this beautiful pool.

Then another. Could this be true? Tug, tug, and another tug—and here we go again.

"Your father was right, Kay. This is a special place he has sent us. In twenty minutes, I have caught three beautiful fish. Phyllis has caught two."

After our picnic lunch, we headed back down the mountain and agreed to meet Kay at her home again for tea with her mother and father.

"Mr. Paris," I said to Kay's father over tea, "do you realize that we were fishing at the lake only about half an hour and in that time we caught five fish? I think that's remarkable."

Suddenly, I caught a wry smile as he looked at his daughter. "I can see you haven't told them," he said.

"No, Father, I think that is your prerogative."

"Well," he said, and took a long breath, "since Kay didn't tell you, I'm the Commissioner of Parks in Alberta and to ensure that you would catch some fish, I . . . I arranged for you to fish in a spawning lake."

"Oh, no," I said, laughing. "How will I tell this to my friends when I show them the pictures of me and my fish?"

"Just tell them that Canada is a wonderful place and that fishing here is terrific."

That evening a bellman delivered a telegram to me from Pan Berman. I showed Phyllis Pan's message.

Know you will be happy to know Santell went to work today on Having Wonderful Time. Stop. Have been reading your letters to Lela and want to know if I can engage you as comedy constructionist. Stop. On Stage Door think picture is so important and would so hate to bill it Katharine Hepburn Ginger Rogers Adolphe Menjou in Stage Door that am very anxious to say Stage Door starring Katharine Hepburn Ginger Rogers and Adolphe Menjou. Stop. Only thing standing in the way is your consent which

feel you will be happy to grant as believe it will result
beneficially for everybody concerned. Stop. What do
you think. Love and Kisses. Pan.

I was very pleased with his reaction to *Stage Door*. I
hoped this story about young girls going to New York,
hoping to become new Sarah Bernhardts, would be a
winner at the box office. I responded in a humorous way
so that he knew I was in Canada where I was supposed to
be and that some Moby Dick hadn't locked me up inside
some suspense story. So—I answered him:

Hope you warned Santell about time out for tea and
I said tea. Stop. Also that I've started more pictures
in the past year than I've finished. Stop. Considering
your offer as comedy constructionist if you can take
your scripts in letter form which might be a novelty
from cuffs. Stop. On the billing thing it's okey. Stop.
Goodbye I'm going fishing. Love and kisses. Ginger.

After seeing the Continental Divide, my vacation
time was over. I reluctantly left this beautiful spot for
Hollywood. I had a new film coming up, and I was anxious
to see a certain gentleman friend with whom my lips had
a nodding acquaintance.

After that glorious vacation in Canada, I was ready to go
back to work. In September I began *Having Wonderful
Time*, another adaptation of a hit Broadway play. The
director was Alfred Santell and filming was done at scenic
Big Bear Lake, outside Los Angeles. We spent two won-
derful weeks in this beautiful mountain location, far from
the noise of the big city.

Douglas Fairbanks, Jr., was my handsome leading man
and the cast included Lucille Ball, Eve Arden, and Jack
Carson. A very funny up-and-coming comic named Red

Skelton made his film debut; unfortunately, much of his antic inventiveness ended up on the cutting-room floor. At the insistence of the Hays Office, the ethnic Jewish story was played by a decidedly gentile cast. As a result, the film was not nearly as funny as the play and, understandably, was nowhere near as successful.

Doug Fairbanks was a very cooperative actor and our working relationship was fine. However, in later years, his attitude toward me changed. For some reason, he persisted in referring to me as a "chorus girl." Again, had this been true, I wouldn't have minded the label. But the range of my films and the breadth of my experience represented so much more that I was greatly disappointed by his view. Anyway, I knew it was a putdown.

If *Having Wonderful Time* ultimately wasn't such a wonderful experience, my next picture, *Vivacious Lady*, more than made up for it. I co-starred with Jimmy Stewart, and Charles Coburn, Beulah Bondi, and James Ellison were in the strong supporting cast. George Stevens directed. Jimmy played a professor and I was a nightclub singer. In the first twelve minutes, we meet and fall in love as we roam around New York City from midnight to dawn. (According to some viewers, those few minutes are among the most romantic ever filmed.) We get married, but before we have a chance to consummate the union, he takes me home to his college town. He wants to keep the marriage a secret until he can break the news without upsetting anyone. Although we keep making secret rendezvous, circumstances always keep us apart. We don't get together until the very end of the film.

In one scene, we arrange to meet at the boathouse late at night and it turns out to be a lover's hideaway for the entire campus population. Some boats were in the water, while others were strung up like cradles. We rehearsed the scene on a big stage at RKO. Dozens of other couples

were snuggling in the various crafts and Jimmy and I were to make a beeline for one of the low hanging boats. We went over the action and then George Stevens announced that we were going to do a take. We took our places and George called out, "All right. Action. Camera . . ." And then, for some unknown reason, he said, "Hit your crickets!" Somehow, it just struck everyone as hilarious. Jimmy and I began to giggle and the hanging boats shook with the laughter of the other smooching couples. For years afterward, whenever Jimmy and I met, we'd smile and say, "All right, hit your crickets!"

A high point of this delightful film is the confrontation between me and Frances Mercer, who plays Jimmy's ex-sweetheart. Frances and I get into a slapping/kicking fight over Jimmy. The entire scene came out of George Stevens's immense gift for comedy, and was choreographed as carefully as any ballet. It starts with words, moves to slaps and kicks, and culminates in a pseudo-wrestling match. Since I was on the receiving end of the kicks, the prop department wrapped my legs with boards. When Frances Mercer slammed her high heels against my shins, I was protected by the padding, though you wouldn't know it by my pained facial reactions. As we shot the scene, I wondered how it would turn out on the screen; so much depended on the cutting. I needn't have worried. George edited this brief moment into a miniature masterpiece and audiences watching it today react with the same pleasure as they did over fifty years ago.

24

\mathcal{F}IGHTING THE FRONT OFFICE

By THE MID-1930s I HAD BECOME AN IMPORTANT MONEY-maker for RKO, yet the front office continued to dismiss or ignore my contractual demands. Despite my box-office value, I had to fight for my rights every inch of the way. It wasn't considered "ladylike" to talk about money, but when you're a lady earning her living, the subject becomes exceedingly significant and well worth discussing.

In April 1933, when Lela and I signed my first contract with RKO Studios for *Professional Sweetheart*, I received $1,600 for three weeks' work, with a three-picture option. The option was picked up, and in May 1934 I signed a year's contract at $1,100 per week and went into rehearsals for *The Gay Divorcee*. In 1935 my salary was increased to $1,550 during the shooting of *Top Hat*. In May 1936 I was *commanded* to appear at the studio to begin filming *Swing Time*. I said I wouldn't show up until my new contract went into effect. I got $2,625 per week and by May of 1937 was receiving $3,000.

My salary was much less than that of my co-star, Fred Astaire, which was bad enough, but when I realized that

character actors like Edward Everett Horton and Victor Moore were receiving *twice* as much per week as I, I made my stand. Don't get me wrong. I didn't begrudge Eddie and Victor their fees; they were fabulous performers and deserved everything they got. However, I put in many, many more working hours on our films and my name above the title brought in the customers. There's something terribly wrong with a system that awards *less* to its stars. In my case, there's no question that the discrepancy in treatment and remuneration was due to my gender. When Fred Astaire made his demands to the front office, his requests were honored, while mine were attributed to "greed" or "ego."

It was tough being a woman in the theatrical business in those days (and probably still is!). There was no one to turn to for real assistance; agents were mostly male and treated you in somewhat the same manner as the studio heads, the producers, and, in general, the directors. At that time, women were not allowed in the production department or in the directorial field. We had script girls, dress fitters, costume designers, and stand-ins, but no women were on the cameras or operating the sound boom or, indeed, working on any of the sound equipment. There were no women set designers, nor were females allowed to act as assistant directors or directors. There was one exception, Dorothy Arzner. Miss Arzner directed me in *Honor Among Lovers*, which was made at the Astoria Studios, and I found her to be a very competent and imaginative professional. The fact that she was a woman made no difference; male or female, she was the *director*. I wish I could have worked with this clever lady again; alas, I didn't reach the point where I could ask for her in time to utilize her services.

Yes, the Hollywood industry was a man's world. An actress who needed to argue a point had no leverage unless she called on a male to represent her. My agent, Leland Hayward, fell in love with actresses, but the deals

he made for them were never as beneficial as the ones he negotiated for his male clients. Like the rest, Leland was pro-male. Despite my knowledge of his prejudice, I naturally turned to my agent for help. Actually, I now had two representatives. Leland had combined his New York agency with Myron Selznick's West Coast organization. A charming Hollywood anecdote came directly out of this unification. The merger went through and clients from both agencies were asked to sign new contracts. Leland told his executive secretary, Pat Rankin, to have Margaret Sullavan come in and fill out the papers. Maggie arrived at the office and was handed her new contract. "I'll sign," said Maggie, "if you write into it that Leland has to marry me as part of the deal." Pat laughed and typed in a clause to that effect. Later, when Pat handed the contract to Leland, he saw the clause and was very amused. He signed it even though he was dating Kate Hepburn at the time. Several weeks later, a group of us, including Jimmy Stewart and Johnny Green, were down at my beach house in Malibu when Maggie telephoned from Connecticut to tell us she and Leland had gotten married. Well, you'll have to say that Leland certainly lived up to his contract!

I wasn't as fortunate as Maggie; despite my contract with them, neither Leland nor Myron could get me a fair shake. When I pleaded with them for help, I was dismissed with advice like, "Let sleeping dogs lie," or "Don't upset the apple cart." They smiled at me and patted me on the head, as you would a three-year-old. When the bell rang for the fight to start in the ring, they were miles away. Believe me, if I had been a man, those same agents would have beaten down the doors to the front office.

I felt completely justified in wanting my contract revamped. I not only wanted more money for my work, I also desperately needed some time to rest, read, and be quiet. My life was packed with professional activity and I went from one film to another with barely enough time for a good night's sleep. The fact of everyday living wasn't

included in this package. Theoretically, I had five days of free time between ending one movie and starting another; actually, my work never stopped.

In November 1937, when I completed *Having Wonderful Time*, the wardrobe department was already making clothes for *Vivacious Lady* and scheduled two more fittings for each outfit. The fittings would take a couple of days at least. In addition, I had to pose for portrait gallery shots in a day and a half to two days time. So much for those five days of rest. I couldn't make up the time at the other end, either; on March 5, 1938, when filming ended on *Vivacious Lady*, I was pushed right into retakes on *Having Wonderful Time*.

Besides the studio demands, I had other personal and professional necessities to consider. I never seemed to have the time for a dressmaker to measure the hems of my dresses, or to buy the right shoes for a newly purchased gown, or to have a much-needed manicure or to pluck my eyebrows, which seemed to grow like weeds. I'd have to do these things on the run. Throughout my career, especially in the beginning, there were appointments with a voice coach, rehearsals for a newly purchased tap routine, photo sessions, or interviews with newspaper or magazine writers. Somehow, these things always got done, but not always to my satisfaction.

When the retakes to *Having Wonderful Time* were completed, I was so exhausted that I didn't want to look at a set, step on a stage, dance a dance, or talk to anyone in the theatrical business. I knew I had to get out of town. I chose to visit Sun Valley, an area I'd always wanted to see. Mother was in New York and I called and asked her to join me in Idaho.

That night, Mother went to the Stork Club with Anita Colby, Quentin Reynolds, and several other friends. There she met Steve Hannigan, who was the PR man for Harriman Railroads, which included the Sun Valley Ski Project. Steve offered to make all the arrangements for me

and Mother. Mother would travel by train from New York, and I would come from Los Angeles, via Salt Lake City. Ordinarily, Bill Hetzler, my secretary, made my travel arrangements, and I could always count on Bill to make sure everything went smoothly. But this time, Mother's new friend, Steve Hannigan, had done all the planning, so I was a bit in the dark about my connections. I was looking forward to this time away from Hollywood and gratefully boarded the train for Salt Lake City.

As it turned out, there was a mix-up about the train to Sun Valley from Salt Lake. When I got off the Los Angeles train, with bag and baggage, there was no connecting train. It was 1:00 A.M. There were no porters, no ticket sellers, no taxis, no nothing! I was stranded.

Mother had registered at the Challenger Inn the day before and I immediately called and told her about my situation. Mother tried to call Steve Hannigan, but got no answer. So she just called the president of the railroad at home and got him out of bed. That's my Lela, never take "no" for an answer! The next thing I knew, a Mr. Jefferies, the president of the railroad, came down to the station and put his private railroad car, complete with cook, maid, and butler, at my disposal. He had the car put on a siding and it was attached to the proper train the following morning. Lela met me at the station in Sun Valley, and we had breakfast in Mr. Jefferies's private car.

The vacation was perfect for a much-needed rest, and I was learning to snow ski. I was quite determined to stay in Idaho until my new contract was worked out to my satisfaction. Nothing was going to make me budge.

The position I took against the studio lasted a very short time. Leland attributed this whole upheaval to Lela, which I felt was unforgivable. Obviously the male rules excluded them from being on your side. Naturally, my mother was on my side. Had I been Lela, I would have been on my side, too. She saw firsthand what it was doing to me to work those long hours day after day without any

let-up. Leo Spitz (RKO's corporate president at that time) didn't know. He never saw me, except in the finished product, nor did J. R. McDonough (a production head). But Lela did. She sided with me as any normal mother should. Leland, however, got 10 percent of my salary all the while he was condemning my mother.

It was during these negotiations that my mother made a very valid suggestion. At a party, she had been introduced to one of the top men in the experimental field of something called television. This gentleman invited Mother to come to his laboratory to see for herself. Mother returned home full of enthusiasm for the newfangled invention. Lela called Leland and suggested an addition to the contract: he should add a clause that would entitle me to receive 3 percent of the money made from any of my films transmitted through the medium of television.

Leland laughed. "Television is nothing, Lela, and it's going nowhere. Do you think I want to jeopardize this contract by asking RKO for a stupid hang-nail addition, such as television? Lela, you and I will be in our grave before television is ever an actuality."

Many years later, when I could have been receiving residuals from the television showings of my films, I would occasionally see Leland at parties during my New York visits. He would put both elbows in the air to cover his face when he saw me come into a room. This always got a rise from me: "There is my great friend, Leland Hayward."

And he knew what I meant, and so did anyone who knew me.

The general public has always believed that Fred Astaire and I were raking in television residuals from the films that we made together and that I received residuals from the seventy-three films which I made altogether. When agents take their 10 percent or more of your earnings, they sometimes do not fight to get you some of the

things that rightfully should be yours. Fred and I had the same agents, and neither one of us ever received one penny from the worldwide exhibition of our films.

My salary was raised to $4,000 per week and I also managed to work in some other particulars. Ordinarily, costume fittings were done after the day's shooting; consequently, I never got home before nine in the evening. The studio agreed to have the fittings done on the set during the shooting. Even this turned out to be too hectic for me as I had to rush off the stage into my portable dressing room. There, a wardrobe lady whipped me out of my filming costume into another one that had to be fitted. Because I had to *stand* and be tugged and pinned all the while, this broke my train of thought for the character. Then I'd change back into my filming dress to return to the set, where the director was tapping his pencil against his script, waiting for me. Again, my resting time had been eliminated.

After about three months of doing the fittings while shooting, I made another suggestion to the front office: I asked them to find someone with my measurements to stand in for me. That way, I could sit and watch while this person was fitted. Plus, I could make objective suggestions and corrections. However, even this improved idea did not eliminate the last fitting on each gown, for although measurements may be identical, shapes are not.

Another problem loomed as *Carefree* began shooting in May 1938. Mark Sandrich was the director, and ever since the feather dress episode, I had felt a strain in our relationship. Although relations appeared normal on the surface, there was an underlying feeling of an iron hand, but no velvet glove. After working all day Saturday and most of the night on *Top Hat*, I was still at the studio on Sunday morning to do a close-up. I wanted in the worst way to tell

Mark I was too tired and wanted to go home, but I didn't. But, I said, "Where's Fred?"

Mark said, "Oh, we sent him home thirty minutes ago because all we have left to do is a big close-up of you."

"But Mark, it's 6:30 Sunday morning!"

He looked at me and said, "You look marvelous, darling!"

For a split second, I thought of telling Mark Sandrich exactly what I thought of him and his methods. I was not one who enjoyed a fight, particularly when I was completely exhausted from a grueling day's work. Not unless I was truly cornered in a situation would I fight my way out. The crew were looking at me to see if I would be the temperamental actress.

After twenty-four hours of continually performing in front of the cameras, they wondered how I would react. True, they had been there just as long as I, but the hot lights weren't shining directly on them, nor were they constantly assailed by members of the makeup and hairdressing departments. The makeup person was constantly tapping me on the face with a powder puff until I thought I would scream if she did it again. At the same time that I was being powdered to death, my locks were being sacrificed to the curling iron. The heat from my body made my hair uncurl, and Louise, my hairdresser, was constantly at my back trying to coax my hair into place with a comb. I looked like Dracula's sister. I decided I'd rather get home to bed than anything else in the world, even at the cost of a horrible close-up. I took the close-up and left. I knew the crew was clearly sympathetic.

Actors really were at the mercy of the studios in those days, and the treatment accorded me was typical. RKO had the right to put me into four pictures a year, *any* four pictures. After the four to five weeks of rehearsal, once shooting began, directors and producers could keep us as late as they pleased. Thank heavens the Screen Actors Guild now protects performers from tyrannical directors

and unreasonable working schedules. On *Follow the Fleet*, not only were my hours performing, rehearsing, fitting, and portrait and fashion sitting longer than anyone else's, Mark treated me in a downright deprecatory manner. Now the same thing began to happen on the set of *Carefree*.

I had hoped that one day, Mark Sandrich would accept me, but he didn't. I kept my cool as best I could and, believe me, he tried my patience. In one conversation, he actually said, "Ginger, why don't you take some dancing, singing, and acting lessons?" Imagine, I had been making my living dancing, singing, and acting since I was fourteen years old and he had the audacity to make such a suggestion. Overwhelmed by his inconsiderate treatment, I finally complained to Pan Berman. Pan wrote to Mark, hoping to alter his attitude toward me:

> Ginger has every right to believe that she is as valuable and as important to RKO and to the picture as any other person in the set-up . . . she is sometimes made to feel that her opinions, her clothes, her dancing, and her parts are to be given less consideration than those of any other member of the cast. . . . Let me assure you that I am very sincere when I say that consideration from all of us has been her main issue in the series of discussions, and it seems wrong to me that any business which is so dependent on so few outstanding personalities, should fail to give that consideration, which is so cheap to give and so important to receive.

So what happened? Mark went to London and was quoted in the press, in less than flattering terms, about Fred's and my performances. When Mark returned to the States, he immediately contacted Fred and apologized to him for what he had been quoted as saying and claimed he never said anything of the kind. The European press

does have a very creative pen, and it's quite possible Mark *was* misquoted. True to form, though, he made much ado about contacting Fred to explain what had happened, but he never once made any effort to explain to me.

When I read the script of *Carefree*, I was elated. The role of Amanda was better than anything I had seen before in the RKO musical scripts. (My assessment of the role's importance proved correct; in Europe, *Carefree* was called *Amanda*.). Pandro Berman wrote to me, "We have a script which has a beginning, a middle, and an end and in my opinion, this is the best part for you that has been present in any of the Astaire-Rogers pictures to date."

Another happy note was sounded when Robert de Grasse was assigned as cameraman. A musical usually didn't rate a top-liner like de Grasse because RKO did not like to spend any more money than was absolutely necessary. However, changes in film speed, technology, and lighting were proceeding at a dramatic pace and made it imperative to use the most skilled practitioners. Film was now recorded at a higher speed, so the lighting on the set could be reduced. A cinematographer had to be unafraid to use less light, and capable of controlling its variations. De Grasse was an expert, and though I did not feel he had done his best work on my behalf in the first film we made together (*Stage Door*), by our third film (*Vivacious Lady*) he understood the kind of lighting that produced a better quality of close-up for me. Bob was a very pleasant gentleman, too, willing, kind, generous to any of my suggestions, and the first cameraman who took the time and effort and care to make me look as photogenic as possible. Bob's good nature and, indeed, his talent were an important asset to any film. I felt great confidence knowing that Bob de Grasse was behind the lens, and my heart was broken when I couldn't have Bob photograph me in the 1941 film

Tom, Dick and Harry. This film broke the chain of the
nine films we did together.

Amanda was the first in a series of girls I would play
who couldn't make up their minds. (Is it any wonder that
I would be chosen to do the song "The Saga of Jenny" in
Lady in the Dark?). Amanda couldn't decide whether to
marry the man she was engaged to or give her heart to her
psychiatrist, Tony Flagg. Her fiancé was played by Ralph
Bellamy and the psychiatrist was Fred Astaire . . . so, you
guess whom she marries. Everyone assigned to this film
had a great sense of comedy; Luella Gear, Jack Carson,
Clarence Kolb, Franklin Pangborn, and Hattie McDaniel
were experts at getting laughs, and with Irving Berlin
providing the music we were home free. As far as I
was concerned, the only fly in the ointment was Mark
Sandrich.

A few weeks before we started shooting, Pan Berman
told us *Carefree* would be filmed in Technicolor. Fred and
I were thrilled. Except for an occasional studio portrait,
neither of us had yet appeared in color. Irving Berlin was
so excited he went home and put more color into his
Carefree lyrics. Irving's color-word palette was certainly
put to use when he wrote:

> That semi-circle that was always hanging about,
> Is not a storm cloud, It's a rainbow,
> You brought the colors out.

After the many rehearsals of this particular number, I
was more eager than ever to see one of our musical films
in Technicolor. Alas, a few days prior to actual shooting,
Pan announced that the extra cost of a cent and a half per
foot made the use of Technicolor film out of the question.

We were shocked and dismayed. The disappointment
was felt by everyone, from Robert de Grasse to the art
directors, Van Nest Polglase and Carroll Clark, and our
set decorator, Darrell Silvera, who had planned color

upon color for RKO's first Technicolor musical. Suddenly, everything had to be reversed. In the flick of an eyelash, we were back in good old black and white. *Carefree* was made that way, and that's the way it should remain. I don't think *Carefree* or any black-and-white film should suffer today's colorizing process.

I had my own song in *Carefree*, "The Yam." Actually, it was another hand-me-down from Fred. He didn't like it and suggested they give it to me. I sang "The Yam" in front of the guests at the country club while Fred sat at the table with the rest of the cast, grinning and enjoying his relief from that ordeal. For this scene, I wore a smashing costume designed by Howard Greer. The dress was chiffon panels of red flame and steel gray, and it looked scalloped at the bottom because each panel was cut in a semicircle and accordion-pleated in half-inch pleats. The belt was silver and gray bugle beads with occasional brilliants sprinkled throughout the beads. It was a special thrill to pick up the skirt as we danced and see it flutter like a silken kite.

While we were in the throes of dance rehearsals, prior to principal photography, Fred and Hermes had still not found a happy or interesting way to close "The Yam." There were sixteen bars of music that needed filling.

"Hey," I said to them, "I've got an idea. Fred, put your left heel up on this table and keep your other foot on the ground. While we're still in the ballroom dance position, let me leap over your extended leg."

"What do you mean?" he said.

"Hermes, come here. Let me show Fred what I'm talking about." I described my idea to Hermes. "We could put the tables in close enough together to form a semicircle, I can execute a series of leaps at each table, and it will fill the sixteen bars with a flying-in-the-air routine."

Fred was less enthusiastic than Hermes, probably because it meant Fred had to lift me over his leg each time we came to a new table. Undaunted, Hermes and I gath-

ered enough flat surfaces to represent tables in this empty rehearsal hall. We asked Hal Borne, our rehearsal pianist, to pick up the tempo for the remainder of the dance. Then Hermes and I performed it for Fred. For the first time since my suggestion, when he actually saw it performed to the music, a wee smile appeared on Fred's face. Then Hermes and I took it from the top and danced through the whole routine, including the "over-the-tables" ending. It worked like a charm and Fred went right into it. Years later, Hermes used this "over-the-tables" idea in a film with Betty Grable called *Moon Over Miami*, where he and Betty danced over a stone wall.

The inspiration for the dance in the garden between Fred and me to the tune of "Change Partners" was a difficult one to work out. Should boy chase girl, as we had done in some of the earlier film dances, or what? After trying and rejecting several ideas, I had a flash. As the psychiatrist Tony Flagg, Fred, at one point in the script, hypnotizes me. I am powerless to change my mental or physical condition except under his influence. We experimented with this as a concept for the dance. Fred gestured his orders to me and, trancelike, I did his bidding, by lifting my arms or whirling in place. Little by little, the number began to unfold and the enchanting finished product is in the film. I was grateful for that inspiration. For this number, Howard Greer created a beautiful black marquisette gown, with a picoted bodice with silver threads, which caused a slight glimmer of reflected light as I danced around the floor.

"I Used to Be Color Blind" was conceived as a dream sequence, and Howard Greer created another lovely gown, this one of white marquisette with picoted edges. The dress made me feel like the fairy godmother in "Cinderella." The dream dance was in slow motion—but Fred and I danced it to our usual tempo. In slow-motion photography, film runs through the camera at faster than normal speed. Later, the film is played back at normal

speed and looks slowed down. The music was reorches-
trated so that everything sounds normal in the finished
product.

As I've mentioned, one of the quirks in Fred's film
behavior was his unwillingness to give his leading lady a
kiss, a peculiar fetish fostered, as I've also noted, by his
wife, Phyllis. In *Swing Time*, Fred and I step behind a
door and when it's opened, he has lipstick on his mouth.
Did we kiss off camera? No sirree. A makeup artist came
and *painted* the imprint on Fred. In the six movies we'd
made together so far, I remained the great unkissed lead-
ing lady. Then (in slow motion), along came "I Used to Be
Color Blind." Whether it has any bearing or not, Phyllis
Astaire was not on the set when we shot this sequence. In
the closing four bars of music, I fell into a backbend with
Fred's right arm supporting me. Fred was to lean over me
and touch my lips with his as my arms came quickly over
his shoulders to complete the picture of an embrace. He
hated every minute of those last four bars. Fred had no
idea what was going to happen when we went to see the
rushes. Like everything else in the number, the brief
"peck" was now in slow motion and had been trans-
formed into a full-fledged kiss! I laughed out loud. Fred
moaned and squirmed, but, bless his heart, he wound up
laughing too. How funny, I thought. When is a peck not a
peck? When it's a slow-motion kiss.

Before I leave *Carefree*, I'd like to answer those who
insist there was a number produced and filmed called
"Let's Make the Most of Our Dream." They claim it was
deleted from the final cut. I'd like to say, if there was such
a number, I must have shot it while dreaming. The only
numbers that were ever done for the film *Carefree* are in
the released film.

Carefree was Mark Sandrich's swan song with me. We
never made another picture together and I didn't miss
him. Getting Mark out of my hair was a relief, but in my

next film with Fred, I found another antagonist to contend with . . . a lady by the name of Irene Castle.

On its August 22, 1938, cover, *LIFE* magazine paired Fred and me in a sweeping dance pose. This was the first of my four *LIFE* covers and marked the period between the end of shooting of *Carefree* and rehearsals for our upcoming musical film based on the life of Vernon and Irene Castle. The Castles popularized ballroom dancing in the years before World War I. While in the British Air Corps, Vernon was killed in an airplane crash. His widow tried to keep his memory fresh and herself in the public eye by writing about him. Her two books, *My Husband* and *My Memories of Vernon Castle*, formed the basis of RKO's script for *The Story of Vernon and Irene Castle*.

This film was our first period musical and I looked forward to wearing the costumes of the early 1900s. Vernon and Irene's dance routines—among them the fox-trot, the one-step, the maxixe, the Castle Walk—were delightfully old-fashioned and called for a less sensational kind of dancing than Fred and I had been doing. I liked dancing to some of those catchy old tunes like "Darktown Strutter's Ball" and "Waiting for the Robert E. Lee." Edna May Oliver and Walter Brennan made a fine supporting cast, too. This was a movie I really looked forward to doing.

Before shooting started, Mrs. Castle called Pan Berman and asked if she could talk with me. Pan arranged to have us meet in *his* office so he could keep an eye on the proceedings. I was sitting inside the office when Pan's secretary announced Mrs. Castle. What an entrance she made! There was a knock on the outer door, and I could hear the rustle of taffeta and the swishing of her dress. Then the door opened and in she swept. Irene Castle was tall, at least 5'10", I guess. Her towering presence reminded me of Hedda Hopper, another grande dame

whose height intimidated 5'4½" me. Irene wore a stylish dress of gray Italian silk taffeta. Indeed, everything she wore was gray: gloves, shoes, hat, and purse. She must have really spent a bundle to put on this show, but it was worth it. She looked as if she had stepped out of a *Vogue* magazine from the early 1920s.

Pan introduced us and Irene proceeded to drag her chair over to where I was seated. She sat down and, after looking me over, began to give orders.

"Mr. Berman, since I am a brunette, I should think Miss Rogers should dye her hair to give a more accurate impression of my persona."

I felt invisible as Mrs. Castle proceeded to discuss me with Pan. He gave me a helpless look.

"We'll discuss that later," he said. "I would like to discuss the costumes right now. The sooner we get them under way, the easier it will be for our wardrobe department. This isn't the only film RKO plans to make this year."

Apparently Pan had met the formidable Mrs. Castle before and didn't want to haggle with her again. Pan was used to dealing with stars, and he was ready to do battle with her if necessary. I'm sure she was concerned that the studio would start shooting without consulting her. Pan deftly turned the conversation to costumes. Relieved, Mrs. Castle's voice mellowed. Pan went over certain details and alleviated her fears.

I felt that Irene Castle looked down her nose at me; I was certain she didn't want me in the film. Since signing the contract with RKO in 1937, she had hounded the studio about one thing or another. Among other requests, she wanted RKO to conduct a nationwide search for just the right actress to portray her, like the Scarlett O'Hara business at Selznick International. I'm sure this was an annoyance to the front office, for RKO had bought the rights to this film as a project for Fred and me; they already had their Irene.

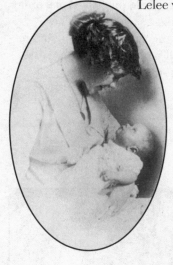

Lelee with the newborn me.

At one year old, 1912.

At 18 months, with
William Eddins McMath.

This photo publicized one of my earliest stage appearances: singing in "The Motion Picture Ball" at the Fort Worth, Texas, Arts Club in 1921.

Dancing "The Valencia" in a 1926 vaudeville set.

My first professional photograph, 1926.

Vaudeville, 1927—my first encounter with ostrich feathers.

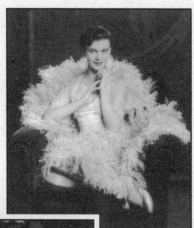

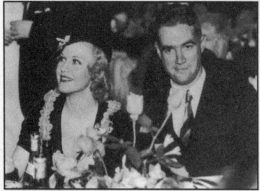

With Howard Hughes, 1932.

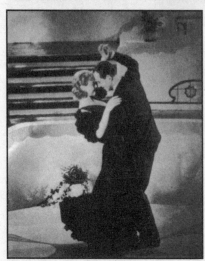

With Fred Astaire in *Flying Down to Rio*, 1933.

FRED ASTAIRE

FILM FESTIVAL

SURE HE WAS GREAT, BUT DON'T FORGET THAT GINGER ROGERS DID EVERYTHING HE DID, .. BACKWARDS AND IN HIGH HEELS.

One of my favorite cartoons. (Reprinted with permission of NEA, Inc.)

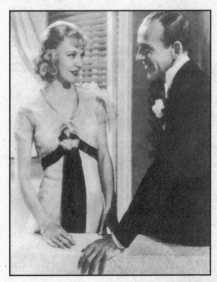

With Fred Astaire in *The Gay Divorcee*, 1934.

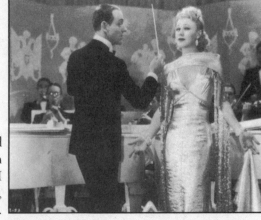

With Fred Astaire in *Roberta* ("I Won't Dance"), 1935.

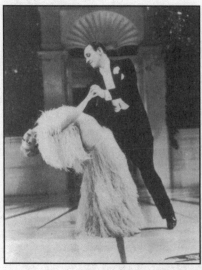

Dancing with Fred in the "Cheek to Cheek" number in *Top Hat,* 1935.

Mr. and Mrs. Lew Ayres in 1935.

With Lew Ayres and Lela Rogers, 1935.

With Lucille Ball and Harriet Hilliard on the *Follow the Fleet* set, 1936.

A birthday luncheon for me with Katharine Hepburn and Gregory La Cava, costar and director of *Stage Door*, 1937.

With Alfred G. Vanderbilt and George Gershwin at our roller skating party in 1937.

Making an ice cream soda at my home soda fountain, 1938.

With Ronald Colman in *Lucky Partners*, 1940.

With Dennis Morgan in *Kitty Foyle*, 1940.

Oscar night: February 27, 1941. I win Best Actress for *Kitty Foyle*; Jimmy Stewart wins Best Actor for *The Philadelphia Story*.

With Burgess Meredith and Phil Silvers in *Tom, Dick and Harry*, 1941.

Jimmy Stewart goes off to war, 1942. He gave me his Air Force pilot's wings.

A September 1942 stop in Corpus Christi, Texas, on a War Bond tour with Lt. Buddy Rogers. I sold $500,000 in bonds that day.

With Henry Fonda and Cesar Romero in *Tales of Manhattan*, 1942.

With Cary Grant in *Once Upon a Honeymoon*, 1942.

Feeding Frank Sinatra at a 1943 radio broadcast. (Photo by Gene Lester)

Mr. and Mrs. Jack Briggs. (Photo by Dick Stotz, U.S.M.C.R.)

A victory leap over my tennis net, 1949.

Trout for breakfast
with Jack Briggs (left)
and Jackie Cooper,
1947.

With Judy Garland in the
early fifties.

My house in Beverly Hills.

With Jacques Bergerac in *Twist of Fate*, 1954.

With my twin sister in the TV pilot for "The Ginger Rogers Show," 1961.

With Mother in the early sixties.

With Harry Truman in 1964, breaking ground for a new electrical system in my birthplace, Independence, Missouri.

My first anniversary party for *Hello, Dolly!* with, from left, Phyllis and Bennett Cerf, Bill Marshall, myself, Michael Stewart, Bob Hope, and David Burns, 1966.

With Lucille Ball backstage at *Hello, Dolly!* (Photo by Tony Rizzo)

My painting "Moon Over the Hudson," oil on canvas, 1967.

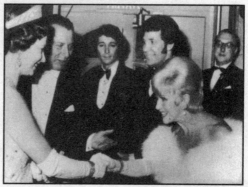

At a command performance at the London Palladium with Queen Elizabeth II, Herb Alpert, and Tom Jones in 1969.

With Lela Rogers in the early seventies.

With Ron Steinbeck, Jeff Parker, Michael Cody, and Jim Taylor in *The Ginger Rogers Show,* which opened in Oklahoma City and ran from 1975 to 1979.

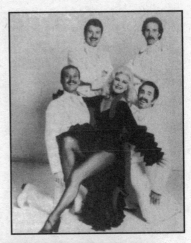

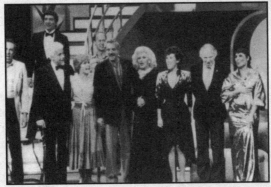

At the 1983 Tony Awards with Jerry Orbach, Sergio Franchi, Peter Nero, Bonnie Franklin, Hal Linden, Melissa Manchester, and Lena Horne.

With Sir Laurence Olivier at "Night of a Hundred Stars II" in 1985.

With Hermes Pan and Fred Astaire in 1982 at an RKO/UCLA luncheon.

Me in the nineties.

Irene had something to say about everything; making me look exactly like her was a good case in point. She not only wanted me to dye my hair but to chop it off to the short bob, which she claimed to have originated. I certainly wasn't ready to have my hair bobbed for this lady, when I could easily pin it up to look more in the period of that day. Her antics didn't bother me too much, because the producer was on my side. Though we had minor skirmishes, in many ways I sympathized with her. This was her life, yet she must have felt overpowered by these studio people. Luckily, we also had a very nice and well-balanced individual as director, Hank Potter. He was easy to work with and handled potentially explosive situations with care and tact.

For a while Irene hung around the set. One day Fred and I were rehearsing a dance she'd taught Hermes based on the steps she'd done with Vernon to "The Missouri Waltz." After about ten minutes a squabble developed off-camera. Irene was complaining bitterly to Hank Potter that the ribbons on my shoes did not match the ones she had worn. "They," she said, "must be gray!" I was wearing a gray dress with the fur on the sleeves, a recreation of an original Castle costume. I must say, this costume, like all the clothes Irene insisted upon copying, looked wonderful in the film. However, the gray ribbons on the shoes appeared washed out. I asked the wardrobe department to put on silver ribbons instead because they made my feet stand out. Now Irene was berating poor Hank Potter and sending him into a spin. He asked if I would change the ribbons on my shoes, and I politely refused. I wasn't an Irene Castle clone any more than Fred was a carbon copy of Vernon. We were just emulating them. I was doing my "imitation" of Irene, and Fred was doing his conception of Vernon. Fred got off the hook because Irene focused all her attention on me!

In time Irene disappeared from the set. She became

involved with other activities, including an antivivisection group, and devoted her time to her causes.

For only the second time in the musical films I did with Fred, I was given a solo dance number. This time I imitated Irene Castle (née Foote) imitating Bessie McCoy doing her famous "Yama Yama Man" dance routine. Dressed in a baggy clown suit, I had great fun doing this number. I've mentioned that *The Story of Vernon and Irene Castle* had a more dramatic plot than our other films; for one thing, Fred's character had to die. This fictional demise led to much speculation about the fate of our real partnership, and RKO was abuzz with rumors. This truly looked like the last picture Fred and I would do together. It seemed as if that feeling permeated the whole RKO lot and beyond. "The Missouri Waltz" was the last number filmed for the movie, and people were coming from far and wide, even nearby Paramount and Columbia, along with employees from the front office and other stages in production, to see this last dance. It even got to me—I sort of teared up as we were dancing our last waltz together. This was a very dignified way to end our musical marriage at RKO, climaxed by *Time*'s cover photo of me on April 10, 1939.

25

A FINE ROMANCE

Eight weeks into the new year of 1939, I was given a first draft of the script for my next film, *Bachelor Mother*. After reading the script, I wrote a three-page letter of protest to Pan Berman, stating my deep reservations about the thin story line and cardboard characters. Basically, the story is about an abandoned baby thrust upon a working girl, a *single* working girl, and her encounters with the boss's son. To me, the characters had no life and no tender emotions for each other, which made me feel as though I was being used for box-office purposes without any regard for dramatic honesty. Pan replied immediately and defended the script. RKO believed it was a good vehicle for me. He assured me that my character, Polly Parrish, had warmth, humanity, and believability—all the qualities my public wished to see in me. I took his word for it, though I did fight a bit. Pan was right. *Bachelor Mother* turned out just fine; in the end, the characters had dimension and feeling and my early apprehensions about the movie were put to rest, especially when the public responded favorably.

I loved working with David Niven and the precious baby, and Garson Kanin was a lively director. Gar was imaginative and spontaneous and his good humor and lively sense of comedy smoothed out any problems along the way. One day he was standing in front of the fireplace on the set, telling me how he felt the next scene should be played. He read my lines, and very well, too.

"Gar, would you do the scene again, please?"

He performed it a second time, and I said, "You know, that's so good. You don't need me to do it. I'm going home. You do the scene." And I started out the door.

"Hey, come back, you crazy woman," he said.

I returned and laughingly chided my director. "No, Gar, you play scenes much too well. I don't think I can live up to what you have performed."

According to film historians, 1939 was arguably Hollywood's greatest year, with the release of classics like *Stagecoach*, *Gunga Din*, *Wuthering Heights*, *Dark Victory*, *The Wizard of Oz*, *Ninotchka*, *Goodbye Mr. Chips*, *Mr. Smith Goes to Washington*, and, of course, *Gone With the Wind*. The list includes three of my own films. I'd have to say, considering the special company that "she" kept, that *Bachelor Mother* came out very well. It was one of RKO's biggest box-office winners in a year of champions.

Besides *The Story of Vernon and Irene Castle* and *Bachelor Mother*, my other 1939 release was *Fifth Avenue Girl*, which reunited me with Gregory La Cava. I had been very impressed with his innovative direction in *Stage Door*. Greg brought a humanistic feeling to everything, and in *Fifth Avenue Girl* he adroitly contrasted the spoiled rich with the simple sincerity and warmth of the less fortunate.

Walter Connolly, the leading actor in the cast, was a warm and understanding man who would meet you more than halfway in a scene. He played a very rich man, who was ignored by his wife, Verree Teasdale, and children,

Tim Holt and Kathryn Adams. Walter isn't having any fun until he meets me, a poor, breezy girl, in the park. We cook up a scheme to make his wife and family notice him again and everything works out fine.

When *Fifth Avenue Girl* finished shooting in June, I had completed fourteen months of work with no significant vacation time. RKO owed me four weeks and I wanted to hide out somewhere where I could have quiet without interviews or theatrical demands. If I was going to have a vacation, I had better get about it. When you're a movie star, hiding out isn't that easy, unless you alter your appearance. I decided to go incognito. I took Jacque Parsens, my secretary, with me and had my dressmaker make us two identical traveling suits. Jacque had raven hair and I donned a black wig. In my suit and dark glasses, no one could recognize me. Jacque booked passage to Hawaii on the *Lurline* and ordered a suite at the Royal Hawaiian Hotel under the name of "Jacque McMath." I called my mother to inform her of the masquerade. She was the only one I told and I asked her to keep it quiet.

The first week in July, a pair of twin brunettes walked up the gangplank of the *Lurline*, without fanfare. Jacque headed for her cabin and I went to mine. It was heaven not to be photographed and interviewed. I planned to spend the five days of the cruise away from the ship's well-orchestrated social activities, have dinner in my cabin, and wear my lounging pajamas to read and sleep.

One morning after breakfast, Jacque came back from her usual morning walk around the deck and described a private area for sunbathing. "There were only three people in this huge area, so put on your wig and your sunglasses and let's start our Hawaiian suntan."

I changed into my shorty terrycloth sunsuit, black wig, and large sunglasses and followed my "twin" to this un-populated spot. We placed a couple of pillows on the

nicely scrubbed deck and lay down with our heads at the base of a huge pole, anchored to the deck by four heavy-duty guy wires. The warmth of the sun and the rocking motion of the ship created a nice drowsy feeling. Before my eyes closed, I noticed that our ranks had swelled; there were now about fourteen people on the "private" deck. They must have seen us and figured it was a comfortable place to tan. I could feel ol' Sol painting a sea-toned tan on me, and sleep suddenly overcame me.

Suddenly, without any warning, a tulip-shaped horn above our heads blasted me awake. "VIRGINIA MCMATH, COME TO THE RADIO ROOM." I jumped out of my skin. Jacque popped up like she was sitting on a hot bed of coals. Almost immediately another announcement followed: "EH, EH, . . . GINGER ROGERS . . . YES . . . GINGER ROGERS, COME TO THE RADIO ROOM."

Because Jacque and I had behaved like two Mexican jumping beans, we now had the attention of the sun-worshippers. Not wishing to be discovered, I quickly got to my feet, slipped my terrycloth robe over my bathing suit, and started in the direction we had come, replacing my glasses securely on my nose.

With my head bent forward, I couldn't see, and walked straight into the guy wire! It hit me right in the wig and off it flipped. I retrieved the brunette part of me from the deck while the blonde part of me briskly flew in the breeze. I ducked into the ladies' room and carefully put the wig back on.

How in the world had anyone known to call me on this ship? And why would they use my name? I rearranged my disguise and proceeded to the radio room. I walked in and was told to wait while the call was reconnected. The two radio men looked slyly at me. The dark wig and dark glasses went for naught. From now on the jig was up. They knew exactly who I was. Finally, one of them turned to me and said, "Your call's come through, ma'am, you can take it in that booth."

In I went and lifted the receiver. "Hello."

"Well, hello to you!" came the reply. "I suppose you're wondering how I found out where you disappeared to?" The voice was unmistakably that of George Stevens.

"Yes," I laughed. "There's only one keeper of this information."

"Yes," he said, "I know. I called her. I prevailed on her to tell me. Believe me, she was reluctant. She said you didn't want anyone to know where you had gone. She figured I knew and that you told me."

"I did that intentionally, George."

"Yeah, I figured. There was a preview of your picture last night, and I hear it was very well received. Hope I'm the first person to tell you this."

"Yes, you are. I'm just sorry Mother didn't tell you that I'm traveling under another name. I felt I needed the quiet, so up to now I have been incognito, but with the announcement that was made throughout the ship, thanks to your loving thoughtfulness, my mask has been removed."

"I guess now I'm in double jeopardy."

"Not really," I answered quickly. "It is nice to hear from you."

"So, when are you coming back? Don't you have retakes coming up, that's what I heard," he said.

"Yes, that's right. Until that time, it will give me approximately three weeks in the sun."

"I wish I could be there. You know I miss you, don't you?"

"That's good," I said. (That *is* good, I thought. He had to go to some trouble to find me by asking my mother and that was probably, for him, the most disquieting adventure possible.)

"I'm really sorry I had to blow your cover, but I miss you!"

"And that's what you called to tell me?"

"How about you?" he asked.

"I always miss you, George." (Maybe I always will, I thought.)

"That's what I called to hear. Now that I've heard it, I'm satisfied. Don't forget page 62," he said.

"Don't you!" I said.

"Is it still page 62?" he questioned.

"Yes, yes, it is."

"That's great, darling," he said. "Talk to you later."

With a "Bye," we both hung up.

That little code had a meaning for both of us. One day on the set, George had a book in his hand while seated in his director's chair. I saw him put a slip of paper between two pages and as he closed the book, he looked up and saw me looking at him. He grinned that attractive boyish grin and, with his index finger, beckoned me. As I walked over, he stood to his feet.

"I've just been reading this book," he said. "I like it. Especially this part . . ."

He opened the book to the place he had marked, put his finger on a line of dialogue, and saw to it that I read it. Before he closed the book again, I caught the number of the page.

"That was on page 62," I said, smiling at him.

"Yep . . . page 62," he answered as he grinned at me.

"Great," I said, wanting to hug him and not being able to. Very businesslike, I said, "Here's to page 62!"

The line of dialogue he had pointed to read, "I love you." Thereafter, anytime in public during our romance, that's all George and I ever had to say to one another. "Here's to page 62!"

We arrived in Honolulu a few days later and I held firm to my resolve of no interviews. The *Honolulu Star Bulletin* was not very pleased:

Ginger Rogers Shy; Ducks Interviewers
Suffering from a severe attack of self-inflicted
anonymity, Ginger Rogers arrived from the main-
land on the *Lurline*, today, behind her locked cabin
door. . . . When asked where and when Miss Rogers
might be found, the ship's personnel, including mem-
bers of the purser's and steward's staff, talked about
the weather and baseball.

Having put up such a stiff front to the press upon my
arrival, I obviously irritated them and was put on their
"dark purple" list. Although unfortunate, it did meet my
need for privacy. I got to do all the things I wanted:
sunbathe, swim in the soft Pacific in front of the Royal
Hawaiian, and enjoy the fresh Hawaiian fruits, especially
a whole fresh pineapple every morning.

After a week of sleeping as late as I wanted to, I re-
ceived a call from Alfred Vanderbilt's brother, George.
He and his wife, Lucille, invited Jacque and me to a luau
the next evening. Never having experienced this type of
feast before, I eagerly looked forward to it. The spicy raw
fish, lava-cooked pork, and coconut dessert were delicious.
However, I was not so enthusiastic about poi, three finger
or four finger; I decided watered flour would have been
just as interesting.

After dinner, some of George and Lucille's friends play-
fully taunted me. "Now that George and Lucille have fed
us, it's up to you to entertain us."

I had never been taught to do the hula, so after much
persuading, my meager offering was to balance a tumbler
full of water on my forehead. I started from a standing
position, tumbler on forehead, and slowly lowered myself
to the floor. Then, with great care, I put my back against
the floorboards. Arriving at that point without having
spilled a drop, I reversed the entire procedure and re-
turned to my original standing position. Ta-da! Maybe I
don't have to sing and dance and act anymore. All I have

to do is balance a glass of water on my forehead. The next day, someone told the press about it and did they give me the raspberries.

Before leaving the luau, George and Lucille suggested a swimming outing for the next day at a semiprivate beach at Makapu Point. Jacque arranged for an excellent picnic lunch from the hotel, and on July 16, we were swimming on Oahu's north shore beach. While chewing on a chicken leg, I asked Lucille if she had seen Jacque. "No," she said, "but maybe she went up to the car to get something."

The car was on a shelf of land above us and was not easily seen. Her answer satisfied me for a while. We went on talking and eating our picnic lunch. Suddenly, a man appeared on the edge of the shelf and yelled, "Somebody's in trouble out there!"

We three looked at each other. It was Jacque. She was caught in a riptide, and we hadn't even known she had gone into the water. The yelling gentleman was running down the beach and into the water, on his way to her. It seemed forever before he was able to grab her and push through the force of water, swimming toward the rocks to the left of the beach. Finally, he dragged her up onto the beach and administered mouth-to-mouth resuscitation. Jacque told us later that her screams against the wind and waving her arms to attract our attention had exhausted her. She knew she was dying, and gave up trying to fight it. However, a Bible quotation kept her thoughts turning to God: "For he shall give his angels charge over thee, to keep thee in all thy ways. They shall bear thee up in their hands, lest thou dash thy foot against a stone" (Ps. 91:11–12). We were all very grateful to the angel who appeared at the beach that day.

The conclusion to the Hawaiian vacation would also mean the end of a three-year romance that had really had no

chance to blossom. That romantic telephone call aboard ship was the promise of something wonderful. But for a variety of reasons, it was not to be. I was still married, if in name only, and so was he.

\mathcal{D}UMPING HOWARD IN THE PACIFIC

BACK IN CALIFORNIA, NOW RESTED AND READY TO GO BACK to work, I did two radio broadcasts before my next film project began. The first was with my *In Person* co-star, George Brent, in a delightful comedy, "She Married Her Boss," for Cecil B. DeMille's Lux Radio Theatre. The next radio broadcast was done with an actor whom I'd never worked with before, Clark Gable. It was a fun little story, "Imperfect Lady," and since I never had the chance to work with Gable again, I was grateful for this delightful opportunity.

In November 1939, I began production on *Primrose Path*, once again under the sensitive direction of Gregory La Cava. Joel McCrea was my handsome leading man, and I always loved working with him. The supporting cast was equally wonderful: Marjorie Rambeau, Miles Mander, Queenie Vassar, Joan Carroll, and Henry Travers. The film was based on a rather trashy novel and play about a wayward mother and grandmother from a lower-working-class area. La Cava and Allan Scott adapted the story for the screen and changed the location

from Boston to Monterey. They also sympathetically shifted the focus to the granddaughter and her struggle to break out of her environment.

When I accepted the role of Ellie May Adams, I knew I was saying goodbye to a fancy wardrobe and all the glamorous trimmings. I was playing a poor teenager and chose not to wear any makeup. In a further attempt at realism, I dyed my hair brunette, which I thought more appropriate for my character. I wanted to keep this color change a secret from the press and refused to give any mention of it to the magazines or newspapers. However, right in the middle of shooting *Primrose Path* came the Los Angeles premiere of *Gone With the Wind*. I had a beautifully designed gown for the occasion but was concerned about revealing my dark hair. I asked Walter Plunkett to create a turban for me, and that's exactly how I appeared. No one suspected what was going on underneath my hat, and when *Primrose Path* opened, everyone was very surprised to see my dark locks.

Primrose Path provided me with my first substantial dramatic role after Fred and I spread our individual wings professionally. Fred went over to MGM and made another musical, *Broadway Melody of 1940*, with the wonderful Eleanor Powell. I remained at RKO, and after two delightful light comedy roles, went happily into the role of Ellie May Adams, which gave me an age range to play as well as an opportunity at character development. Though La Cava and Scott cleverly tried to write around the fact, Ellie May's mother and grandmother were obviously prostitutes. Some critics felt I might have picked up an Academy Award nomination had the film not run into trouble with local censors.

There was one actor in Hollywood whom I had long adored from afar. Everything about him, from his voice to his gentlemanly manner, thrilled me. When I was at last

introduced to Ronald Colman, he turned out to be as fine in real life as he was on the screen. His wife, Benita Hume, knew I had a crush on her husband. She decided I was harmless enough, and invited me to their home for many enjoyable evenings. Benita always seated me on Ronnie's right and I'd sit there gazing at him with a perpetual grin of pleasure on my face, just like a fan. No wonder I jumped for joy when RKO assigned me to *Lucky Partners*. Ronald Colman was the male lead, and I took the film without hesitation. Lewis Milestone was to direct *Lucky Partners*, with George Haight as the producer. Once again the talented Allan Scott was the scenarist, along with playwright John Van Druten. The supporting cast included Spring Byington, Jack Carson, and Harry Davenport, and we all had a wonderful time.

When I reported to the set, the front office at RKO was shocked to see that I had dyed my hair even darker than it had been for *Primrose Path*. They thought it wasn't glamorous enough for me and that the public would be disappointed. I told them I was more interested in portraying the character correctly than in the glamour. Actually, my hair color did come out darker than I wanted, but by that time shooting had begun. Ronnie was a perfect performer and a perfect gentleman on the set. If ever he made a correction or a suggestion to me, it was always done in an inoffensive manner. I never minded receiving criticism from him, though there were rumors of conflict between us. (To set the record straight, I adored Ronald Colman and there never was any friction between us.)

Another gentleman began to feature more and more in my personal life. Shortly before Lew and I were officially divorced, Howard Hughes began to romance me. Naturally, the wooing was a bit unorthodox. Howard would call my house early in the morning and say to Mother, "Wake up Ginger and tell her we are going for a ride in my new

plane over the desert. I want her to see the wildflowers because they're so pretty this time of year. Then we will have lunch at the Hotel del Coronado in San Diego and maybe play a round of golf before we come back to L.A."

I loved to watch Howard play golf; he was terrific. I was fairly good at the game, but after he coached me, I became fifty times better. He had a terrific eight-iron shot, which I would try to emulate. He was a great teacher and a good companion. Furthermore, Howard had a keen sense of humor, at least in those days.

One morning my mother woke me and said Howard was expecting me to meet him at the corner of Coldwater Canyon and Sunset to go sailing.

"But, Mother, you know I don't know a thing about sailing."

"Howard is going to instruct you."

So I put on my bathing suit under a shift-type dress, met Howard at the designated place, and was whisked off to the harbor. A motorboat waited to pick us up and we zoomed out to Howard's yacht. We walked up the folding gangplank, but the yacht was not our destination.

Howard gave some orders to his crew, and almost immediately, we were going down the gangplank to a star sailboat. At Howard's command, I climbed into the star sailboat, which was the size of a matchbox. He took the tiller and explained what its function was while I listened. Soon, the breeze caught the sail, and we were clipping right along at possibly three knots an hour, which felt like forty miles an hour. When we got to the end of the breakwater, Howard turned to me and said, "Take the tiller. But remember, keep the sail full of breeze." With that terse instruction, I tried my best to keep the sail full of wind. Before I knew it, he started to teach me how to "turn about."

I had no idea what that phrase meant. "Keep the sails full of the oncoming breeze and turn the tiller like you were rounding a corner in a car," he said.

That was too much to learn for a novice. As I rounded the imaginary corner he'd just spoken about, a mighty gust of wind came up and tipped us over. I laughed so hard I almost swallowed the coastline of California's waterways.

Howard and I were bobbing up and down and I could see the crew of his yacht lined up around the aft of the ship, watching through binoculars and laughing! I couldn't stop laughing because Howard was trying to hold on to his upturned sailboat and his fedora was still firmly clamped onto his head! When his crew came to rescue us in a tiny motorboat, I was weak from laughter, not from capsizing. Unfortunately, I'm afraid, they never let him forget that dunking.

Howard really loved calling my mother and telling her what the activities for the day were going to be for him and me. Once he phoned and said he was taking me for a spin in his new plane and we would have lunch in San Francisco. When Mother relayed the message, I asked her why she didn't put *me* on the phone and let me say whether or not I could make it. She figured Howard told the plans to her because he considered her his ally and didn't want to allow me the opportunity to refuse his invitations.

That trip to San Francisco was a bit more exciting than most. As we were coming into the airport, Howard shouted a command to his co-pilot. Because of Howard's attitude toward him, I became quite nervous, especially at the tone of his voice and the swear words coming from Howard's lips. Howard asked his co-pilot to wait before he let down the flaps. I vividly remember his co-pilot saying, "I've already let the flaps down." As difficult as it was for Howard to hear, he heard *that* and then uttered, "#$96&°! You've done what? Couldn't you wait until I gave the command?"

Later, Howard told me we could easily have flopped over and into San Francisco Bay, for we were going at too

great a speed when the flaps were lowered. Fortunately, Howard found out in time to lower the speed.

Howard and I saw each other steadily, but my divorce from Lew lagged. Frankly, I wasn't sure I wanted to divorce him. I thought a lot about trying to patch things up with Lew, and felt that he too must be deliberating. I think if he had made a move in my direction, I might have gone back to him. It seems, however, that we outwaited each other. I had walked away from the marriage, claiming incompatibility, and obviously I would have to be the one to request a reconciliation. I was occupied with my work, though, and doing one picture after another. Also, to be absolutely candid, I found it quite interesting to be a single girl again.

After all, I was truly working long hours, rarely leaving the studio until after 8:00 P.M. and rising again the next morning at 5:30 to be on the set, ready to shoot, by 9:00 A.M. Now, as a single girl, I could do what I wanted with my spare time and began accepting social invitations. I should have stayed home and rested, but I, who never thought of myself as a "party girl," began to enjoy this change of pace. The invitations invariably led to my meeting new directors, writers, producers, actresses, and actors. Not infrequently, after such dinner parties I'd receive a telephone call from one of the male guests of that evening, asking for a dinner date. If the gentleman was as stunning as his films, I'd accept. This kind of popularity would be enough to turn the head of any grown-up female.

One of these attractive gentlemen was James Stewart. Jimmy was a charmer and a joy to be around. He loved to laugh, and was a smooth dancer. Whenever Jimmy asked me for a date, I was delighted, and we often went dancing at the Trocadero or Ciro's. At the time that we were dating, Jimmy and Henry Fonda were roommates. Hank

was seeing Lucille Ball and the four of us often double-dated. The boys took us dancing at posh places like the Cocoanut Grove or the Trocadero, but they were too cheap to stay there for dinner. Instead, we ended up for dinner at a little hole-in-the-wall called Barney's Beanery on Santa Monica Boulevard.

One night, after a hearty meal at Barney's, the boys took us back to their apartment. Everything appeared very romantic, as the lights were turned down low and soft music played in the background. Before Lucy and I knew what had happened, we were danced into the kitchen to wash a week's stack of dirty dishes. So much for romance; maid duty was uppermost in their minds. But still, two nicer men you couldn't hope to meet.

Incidentally, I was invited to make another film many years later with Jimmy, called *It's a Wonderful Life*. However, the woman's role was such a bland character. I sacrificed this kind of role for ones that would give an audience a change of pace. Real characters, that's what I was after. Anyway, I declined the offer. Foolish, you say?

Caught up in work and socializing, I continued to drag my heels about divorcing Lew. Howard was eager for me to be free and insisted that his attorney, Neil McCarthy, handle my divorce. On March 13, 1940, I filed the necessary papers. By now, Howard completely dominated my personal life. Within a short while he presented me with a five-carat square-cut emerald engagement ring.

27

\mathcal{K}ITTY FOYLE

I HAD BEEN MAKING FILMS FOR ALMOST TEN YEARS AND THE head men at RKO thought of me only in terms of musicals. I found no fault with that, except I just couldn't stand being typed or pigeonholed as only a singing and dancing girl. I wanted to extend my range. I hoped and prayed to be handed a serious role that would be both romantic and dramatic, like Ellie May in *Primrose Path*. The RKO front office knew absolutely nothing about me, and hadn't from the time I first came to them. No one had any idea about my theatrical background. Once, I talked to an assistant producer of an upcoming musical who told me, "We're looking for a girl who dances and still can read lines." He wasn't kidding!

RKO didn't know what to do with me and dropped me into comedienne roles. Eventually, they gave me leading lady roles. I almost became confused as to whether I was a comedienne or a leading lady. So I became a dancing–leading lady–comedienne. I don't know how long I'd have continued in this vein had not producer David Hempstead sent me a copy of a best-seller recently purchased by

RKO, *Kitty Foyle* by Christopher Morley. David sympathized with my desire to do something other than froth and thought the role of Kitty was tailor-made for me.

I had the book with me when Howard picked me up at the studio's Gower Street entrance one evening to take me to dinner. He'd told me that he had a great new cook "and you can judge for yourself, if I'm right."

"What's she preparing for dinner tonight?" was my immediate question.

"Country fried chicken, mashed potatoes and gravy, and also vegetables like petits pois and creamed little onions."

I had a regrettable lack of appreciation for most vegetables. But through eating with Howard at his home on various occasions, I had learned to like vegetables. His cook used a lot of melted butter, which I think made all the difference to me, and increased my affection for the lowly vegetable.

As Howard and I were driving toward his residence, I glanced at my copy of *Kitty Foyle*. There were explicit love scenes in it that were quite disturbing to me. As I read these passages, I found myself passing judgment on them. "That could never pass the censor board. So what good is it for me to spend time reading it?" I was really embarrassed that RKO would send me something like this. I snapped the book shut and, quite deliberately, threw it in the corner of Howard's car.

"What's wrong?" asked Howard.

"I'm just not flattered by having this submitted to me as a future film. It's highly suggestive and too lurid."

"Call the producer and tell him," said Howard.

"I intend to!" When I got to Howard's house, the first thing I did was call the studio, only to find that Hempstead had already gone home.

When Howard took me home after dinner, I handed the book to Lelee and explained my hesitancy about accepting the role. Mother, wise to the ways of Hollywood, said,

"Darling, don't worry. They can't possibly make a film with things like that in it. You'll see, they'll have to rewrite the whole thing. Then, maybe you'll want to do it." (Wouldn't my dear Lelee be shocked at what's being filmed today? I know I am!)

I considered that, and, as always, Lelee was right.

The next morning before breakfast, David Hempstead called. "How did you like the book?" he asked.

I told him my feelings about it, and he replied, "Ginger, for heaven's sake, don't tell anyone at the studio you disliked it. I'm having it rewritten and when that's done, I'll submit it to you again. If you want to turn it down then, okay, but remember, RKO bought this book as a starring vehicle, expressly for you. So DON'T TURN IT DOWN until you have read the rewrites." Hempstead assured me that we would have a good script because scenarist Dalton Trumbo was working on it. That sounded hopeful. I was obedient to David's warning and kept my own counsel.

During the wait for the revised script, I faced yet another crisis in my personal life.

Howard Hughes was extremely possessive and terribly jealous. He always wanted to have his own way, whether it was in outlining a trip or in ordering a meal. He liked to call the shots. I began to get the feeling that someone was reporting to him on my doings, particularly my phone calls. He brooded when I talked to other people on the telephone and lapsed into a morbid silence, even if I was conversing with someone as innocent as my Aunt Jean. And his cold attitude extended to my mother. He didn't like it when I telephoned her, and I called her at least once a day. This was too much for me. I wanted a boyfriend, not a policeman. Things were coming to a head.

One evening I was eating my dinner when Howard called. "Princess, I have to go to the dentist tomorrow at 10:30. I want you to go with me. The doctor says you need

a cleaning anyway, so I'll come by your house at 10:00 and we'll go together." A typical Howard Hughes phone call.

"No, Howard," I said.

"Why not?"

"I'll tell you in a few days."

At that moment, though I didn't know exactly what I would tell him, I knew I had to let him know his behavior was peculiar. Ironically, within the hour I received a phone call from writer Alden Nash which cleared up some of the mystery of Howard's attitude. Only a few of my very best friends, Alden included, knew that Howard and I were engaged.

Alden was blunt. "You're not going to like this, but you're my friend and I want to warn you. Your boyfriend, Howard, is spending the night with that little actress who lives near me. His car is out in front of her apartment most nights and I've seen him walk into her place. You can come and see for yourself. I realize it is none of my business but I don't like to see a friend of mine being two-timed by this big lug Howard Hughes."

Well, now I had good reason not to go to the dentist with Howard. I can laugh today, but at the time, I was very upset. The next morning Howard called. "I'm coming to pick you up. Will you be ready in ten minutes?"

"No! A thousand times no!"

I telephoned the studio and said I would not be coming in today for a scheduled interview. I begged the publicity department to bear with me and reschedule it. I knew I couldn't face anyone, especially if the interviewer mentioned Howard's name to me. I probably would have bitten the interviewer's head off. I hung around the house.

Late in the afternoon, the phone rang again. It was one of Howard's assistants.

"Miss Rogers," he said, "Mr. Hughes asked if you would come to the hospital." He told me the name and address of the hospital, with Howard's room number.

"What happened? Why is he in the hospital? Did Dr. Hollenbeck take him there about his teeth?"

"No," his assistant said, "he had a head-on collision with another car today as he was on his way to the dentist. The doctor had to take seventy stitches over his eye. He's all bandaged up, but he asked for you to please come and talk with him."

I didn't want to talk with him, but I thought I should go to the hospital. I was ushered into his room and saw him lying in the bed. His head was swathed in bandages and his brown eyes were at half-mast. I asked how he was feeling and he told me he was miserable. In fact, he'd been so angry with me, he swerved his car into oncoming traffic. Naturally, the accident was my fault. I wasn't giving in to any feeling of sympathy.

"Howard, you have been acting very distantly to me these past ten days, and though I didn't seek out why, I have inadvertently found out you have been dividing your time between me and someone else." Howard groaned. I took out a small box which I'd packed before I left the house. "Here, Howard, is all the jewelry you have given me over the past fifteen months, including the emerald engagement ring. I am returning them *all* to you. We are no longer engaged."

There was a silence you could cut with a knife. Howard looked at me from under his bandages; his soulful eyes were like those of a bloodhound puppy. Then I turned and walked toward the door. With a dramatic turn of the head I opened the door, slamming it as I left. That was the last time I ever saw Howard. I later heard that Howard's right-hand man, Noah Dietrich, had come into the room shortly after my exit and found Howard crying. Noah asked him, "What's the matter?"

"It's Ginger. She's left me!" Howard cried.

I knew I was right, and time proved it. Howard wanted to get himself a wife, build her a house, and make her a prisoner in her own home while he did as he pleased.

That's what happened to Jean Peters. Thank heavens I escaped that.

A little more than a month after I walked out on Howard, I received the rewritten script of *Kitty Foyle*. I also received a telephone call from David Hempstead urging me to read it immediately. "The wolves are after this script, read it immediately, and only tell *me* if you do or do not like it. Promise?"

I hurried to my bedroom to my chaise lounge, the most comfortable place I knew. For the next two hours I sat reading, laughing, and crying. I realized it was one hell of a script, and was convinced that whoever played the role would end up with an Oscar. I saw it that vividly. (Sorry, Olivia, you didn't get this one! Olivia de Havilland landed some very good roles that I turned down.)

David called back. "So, what do you think now? You can see that Donald Ogden Stewart has done some additional dialogue work on it. Well, what do you say?"

"I say, the lights are green all the way. I love the script."

Truthfully, as I read it, I felt all the emotion that I hadn't felt while I was reading the book. "When do we go into production? Don't forget I have a vacation coming up after *Lucky Partners*. But I like your script so much, if you tell me I have to forgo my vacation, I will do that. Who do you have in mind for the leading man?"

David told me the possibilities, who included David Niven, Robert Montgomery, Ray Milland, Laurence Olivier, Franchot Tone, Douglas Fairbanks, Jr., George Brent, and Melvyn Douglas.

None of the names on the list seemed to fit the role. "Who do you have in mind for the second male lead, the doctor?"

"Well, there's Randolph Scott, Joel McCrea, Dennis

Morgan, Jeffrey Lynn, Patric Knowles . . . Sam Wood will be the director. I think that should make you happy."

Indeed, I was happy at the prospect of working with a first-class director like Sam Wood. Sam was responsible for films ranging from *A Night at the Opera* and *A Day at the Races,* to dramas like *Goodbye Mr. Chips.*

Lucky Partners took longer to film than anticipated because our director, Lewis Milestone, became ill. The delay stretched to eighteen days and changed the starting date of *Kitty Foyle.* Right after the Fourth of July, *Lucky Partners* was finally finished, and I had to begin work on *Kitty Foyle* without any time to rest. This violated my contract, but I was so grateful to have a swing at such a good woman's story, I couldn't be bothered with contractual agreements. I plunged into the new film.

By the time we started *Kitty Foyle,* my very dark hair had washed out to a tone I felt would be acceptable. After I had digested the script, I concluded that Kitty couldn't possibly be a blonde. She was the daughter of a proud Irishman, and had to look and act like one. Dark hair, blue eyes, a quick wit, and a stinging tongue . . . that was the way Mr. Foyle saw his offspring. She could take care of herself, "come hell or high-water."

I felt the casting of this film couldn't have been better. The role of Kitty's boss, Wyn Strafford, was made for Dennis Morgan. Dennis was the personification of the Arrow Collar man. He was extremely handsome, intensely romantic, without manufactured overtones. James Craig played the doctor and seemed born for the part.

The two girls who played Kitty's friends were happily suited to their roles: Katharine Stevens, the daughter of Sam Wood, and Mary Treen, who really knew how to treat a comedy scene. Gladys Cooper, Odette Myrtil, Ernest Cossart, and Eduardo Ciannelli rounded out the ensemble.

Sam Wood was friendly, but firm in his direction. However, I found him very receptive to little suggestions along the way. He knew how to hold a film together and bring out the nuances in the script. We had very few disputes, though I remember one minor incident. There was one scene with which I had trouble; it takes place in the hospital just after Kitty has given birth. I had asked Sam if I might have a few minutes to go to my dressing room to listen to some sad music to get into the mood. Sam okayed the request and off I went to the portable dressing room to hear Tchaikovsky's "Romeo and Juliet." Tears were ready to well up in my eyes when I returned to do the scene. Sam had a bad habit of jingling the coins in his pocket just before a scene. I never thought to speak to him about this very disturbing habit, especially before this scene, which would turn the audience to their hankies.

Then the words came from the mouth of this veteran director. "Lights . . . camera . . . action . . . now Ginger . . . excited and happy."

At that moment, he jingled his coins in his pockets. It was all I could do to keep a straight face, let alone think of a baby I'd given birth to only minutes before. The take was a disaster.

I went back to my dressing room to hear my sad music again, trying earnestly to get myself into the mood. When I came back to the set, I got back into the hospital bed and prepared for the new take. This time Sam omitted his "excited and happy" remark. Thank heavens some sensitive friend got to him and told him to stop jingling his coins. The scene proceeded without a hitch, and the rest of the picture followed suit.

In *Kitty Foyle* I had an opportunity to create a three-dimensional portrait of a young American woman, and when the picture was finished, I felt I'd met the challenge.

A wonderful P.S. to the release of *Kitty Foyle* was a cover story in *LIFE Magazine* on December 9, 1940, detailing everything about the filming of the picture. My second cover!

28

\mathscr{G}INGER'S BIG SURPRISE

AFTER FILMING WAS COMPLETED ON *KITTY FOYLE*, I WENT to New York to do some publicity interviews, and while there went to see a few Broadway shows. One, Rodgers and Hart's *Pal Joey*, had just opened on Christmas day, 1940. A young man in the chorus caught my eye. He was tall, blond, and handsome. I thought he'd be perfect in pictures. I called Leland Hayward and asked if he'd seen this show. He had, but hadn't noticed the young man I thought was movie material. "I'm getting two tickets and taking you to see this young man, because in my opinion he'd make a great leading man."

The date was set. Leland and I sat in the third row center, and I pointed out my "discovery" to Leland. "That's the one," I said. "Don't you agree he's movie material?" He gave me a wry look. "No, Leland," I protested, reading his mind, "I just think you and I should put him under contract and bring him out to California to test."

"You know, Ginger, sometimes I wonder about you. This boy is just another chorus boy. He'll always be just another chorus boy."

"Well, if you can't see his potential, how about helping me put him under contract?"

"Ginger, dear, do you know what people would say if you put a chorus boy under contract?"

"No, Leland, what would they say?"

"Well, because he's handsome, young, and tall, they'd say all kinds of suggestive things because you have him on salary."

"But, Leland, you've just admitted he's handsome, and he has an attraction for women. You're saying exactly what I'm sure the public will see when they look at him on film."

"I will not be a party to such intrigue, Ginger."

"Intrigue, my eye. He's got what it takes, and I know it, and you know it too. Wake up, Leland, we could both have a star on our hands here."

"No, no, no," Leland said, "I will not go along with you."

Unfortunately, I let Leland's attitude sway me, and I didn't even go backstage to meet young Van Johnson, but I just knew we were both missing the boat by not sponsoring him. A few months later, I heard that Van Johnson had been signed by Warner Bros. and was then given a long-term contract at MGM. Three months after that, I met Van at a party. I told him the story of my desire to put him under contract, which had come to me during his performance in *Pal Joey*.

He said, "The whole cast was so excited when we knew you were outside. We danced our little hearts out. You looked like you really enjoyed the show, and when you came the second time, we were hoping you'd come backstage, only you didn't."

One of my habits of dress at that time was to wear large-brimmed hats with suits. Whenever Van saw me at a party or luncheon, he would lovingly yell, "Hi, Pancho," because of my wide-brimmed chapeau. To this day, whenever we see each other across the room or across a

theater or restaurant, he greets me with, "Hi, Pancho! What's new?"

Shortly after the New Year of 1941, producer Robert Sisk sent me the script of *Tom, Dick and Harry*, the story of Janie, another working girl. This was a lighter look at working life since Janie's biggest problem was deciding which of three suitors to marry. I was delighted that it was to be directed by Garson Kanin. We had had a wonderful time working together on our previous picture, *Bachelor Mother*, and after having seen a couple of other films he had directed, *The Great Man Votes* and *My Favorite Wife*, I knew this would again be a happy experience. I was right. Gar's sense of humor swung 360 degrees, and he always managed to see something humorous in whatever came up. One sweet habit we had started during *Bachelor Mother* was continued on this set. Each morning, as Gar and I greeted each other, we recited a nursery-rhyme verse: "How do you do, my partner? How do you do today? We will dance in a circle, I will show you the way." Smiling and locking arms, off we'd go onto the set for the day's filming.

The cast was well chosen: George Murphy (Tom), Alan Marshal (Dick), and Burgess Meredith (Harry). George Murphy played the car salesman who expected to be engaged to Janie; Alan Marshal played the rich boy vying for Janie's hand; and Burgess Meredith played the poor boy who worked as an automobile mechanic and found Janie to be an interesting prospect as a future wife.

The days of shooting this film were filled with laughter and happiness. The cast and crew loved the hilarious ridiculousness of the plot, and so did I. During the first week of shooting, Burgess Meredith, in his cute and charming way, started cosying up to me and decided to go to any length to capture my attention.

In his first attempt, he sent me a box of candy. The card on top said, "To Janie, Candy Woo, Love, Harry."

I laughed at the card, and opened the box to find beautiful chocolates. When I bit on one, I found it was made of chocolate paper, used in window displays. I had to chuckle, and passed the candy around to see who would bite on the impossible toothbreakers.

When I thanked Burgess for them, he said something to the effect that "I always try to be considerate of my leading ladies. You see, these chocolates are not fattening."

"No," I said, "they just break your teeth."

Affectionately he said, with a twinkle in his eye, "Oh, you'd look good even without teeth."

The next day I arrived in my dressing room at 6:00 A.M., and could barely get through the door. There were flowers everywhere—of all shapes, sizes, and descriptions. And as my hairdresser walked in, she said, "Aren't they beautiful? Who are they from?"

There was a large card, which said, "Flower Woo, Love, Harry."

"Wait a minute, Louise. These are phony flowers."

The next morning a lovely jewelry box was delivered to me. There, nestled in plush red velvet, was a string of huge, fat pearls, larger than any ripe olives. The card at the bottom of the box said, "Pearl Woo, Love, Harry."

That morning, in a rehearsal scene with Burgess, I decided to wear them. Seeing me with those cockeyed pearls on, "My dear," Burgess said, "contrary to what people say, you *do* have good taste."

With that, I took them off and tossed them at him, laughingly. Gradually, the crew on the set discovered that it was Burgess who had sent them to me for a laugh.

The next day, a huge box was delivered to my portable dressing room. It contained the tiredest fur coat I have ever seen, made of rabbit skin and a little bit of everything else. The card said, "Fur Woo, Love, Harry." What next, I thought. What is he going to do next?

Naturally, I put the fur coat on and walked out on the set to parade my "fur woo" in front of the crew, who by this time were pouring joke suggestions into Burgess's ear. The only thing that could be next would be an engagement ring, I thought. I must soon expect that. And I was not disappointed. He must have driven the prop man crazy looking for "Diamond Woo," which was next. It was a huge ring that you could have put on an elephant, with a diamond that must have been a headlight off some automobile.

One morning I had to be on the set a little earlier than usual, though I did not have to be completely made up, because I was to do my voice, over close-ups of other people in the cast. I walked out my front door only to find, parked right at my door, a hand-painted red, white, and blue Model T Ford.

How in the world did that ever get up that steep hill to my door? The card, on the steering wheel, said, "Car Woo. Love, Burgess."

I called RKO and got Fred Flock, our assistant director, to help me in a plan when I arrived at the studio. I got the gate man to call and say, "Miss Rogers had just driven in the gate." As prearranged, the huge stage doors opened like magic, and I triumphantly rode onto the set in my red, white, and blue chariot called "Car Woo." I hung the card on the side of the windshield, so everyone could see who had invented this new four-wheeled American flag. The day started off again with great laughter and fun.

By this time, Burgess had probably exhausted his inventiveness because he said, "I couldn't think of anything else that was as good. You have now been wooed by a champion wooer."

"Indeed, I have." And I kissed him smack on the lips and thanked him for the fun he had brought to me and to all of us.

The crew really missed it too. "No woo today?" they'd ask.

No, but no one else "wooooed" have done this but Burgess Meredith. Burgess never asked me out to dinner, we never dated, but this was a delightful remembrance of his adorable sense of humor.

However, I did have a few dates with the appealing French actor Jean Gabin during the making of this film. His longtime girlfriend, Marlene Dietrich, was hot with fury when she found out.

During the production of *Tom, Dick and Harry,* my first seven-year contract with RKO came to a close and my agent negotiated a new seven-year free-lance contract. RKO would submit four scripts a year to me for consideration, and I would be free to say yes or no to any of them. As a free-lance actress, I was able to claim a higher salary for each picture because the bidding for my talents sent the fee skyrocketing beyond what it had been in the past.

While we were in early production of *Tom, Dick and Harry,* RKO asked me to attend the 1940 Academy Awards presentation at the Biltmore Hotel. *Kitty Foyle* had been nominated in five categories: Best Picture, Best Director, Best Sound, Best Screenplay, and Best Actress. I agreed to attend the ceremony, although I did have some reservations. I'd be out late in the evening, which would make getting up at six the next morning a real chore. I was very pleased to be one of the five actresses nominated for an Oscar. This sent chills up my spine, but I was emotionally reluctant to go for the fear of being at the race and not winning haunted my unsporting heart.

The 1940 Academy Awards presentation was unique. The Academy was fed up with the newspapers announcing the winners before the awards were handed out, so this time, for the first time, no one would have any advance information about the winners. Only the accountants from Price Waterhouse knew who the winners were,

and they weren't talking. The secrecy factor really heightened the excitement of the evening.

Although my early intuition had been that *Kitty Foyle* was Oscar material, I knew I was up against pretty strong competition: Bette Davis in *The Letter*, Joan Fontaine in *Rebecca*, Katharine Hepburn in *The Philadelphia Story*, and Martha Scott in *Our Town*.

Kitty Foyle was popular, and so was the heroine I portrayed. The *New York Daily Mirror* had given me a rave review, saying, "Thrilling is the amazing development of the one-time Interstate Circuit hoofer and Broadway musical-comedy dancer who gives a spirited top-flight dramatic performance here, the equal of anything seen on the screen in years." In January I'd gone to New York as guest of honor at the annual Stenographer's Ball. Kitty Foyle a.k.a. Ginger Rogers had become the symbol of the white-collar working girl. Still, the very talk of an Oscar nearly split my eardrums and set my heart a-pounding.

The night of the Academy Awards, I dressed in a black lace and gray peau-de-soie gown designed by Irene and was ministered to by Louise, my hairdresser. Eddie Rubin, my dear friend and publicist, also helped prepare me for the ordeal by bolstering my morale. I wished deep inside me that I didn't have to be a part of this parade. However, I bit my tongue and pulled up my long silk stockings, along with my courage. I asked Lelee to accompany me, and together we went to the Biltmore. All the way to the hotel, I kept wishing I could be home in bed. I was exhausted from my full day's working schedule. Having to remove my film makeup and replace it with color makeup for the party, and redoing my coiffure with curling irons, made me feel this day was never going to end!

Mother and I were seated at the RKO table next to George Schaefer, RKO's president of the week. Mother was seated across the table from me. The excitement of the evening was high-pitched because of the surprise ele-

ment. I remember sitting on pins and needles while trying to carry on intelligent conversation.

The ceremony began at 8:45 p.m. with a radio address from President Roosevelt, followed by the presentations. I was excited and very pleased when Alfred Lunt and Lynn Fontanne were announced as presenters for the acting awards. Well, whether I won or not, at least I'd been nominated. The big moment arrived, and Lynn Fontanne read the names of the nominees. I just sat there coolly, expecting one of the good old favorites, like Katharine Hepburn or Bette Davis, to walk up to accept her prize. I was shocked when George Schaefer elbowed my ribs, shouting, "Ginger, it's you! Ginger, it's you!"

I couldn't believe *what* Lynn or George Schaefer had said. By the third time he said, "Ginger, it's YOU!" (this time in capital letters), I came to. I looked down the RKO table to see the smiling face of my mother and my producer, David Hempstead.

I walked to the presentation table where Lynn Fontanne was standing with Alfred Lunt, waiting for me with the golden statue, arms outstretched. I was still in shock, truly dumbfounded! I stood in front of the radio microphone and the applause slowly subsided. Now what do I say? I hadn't prepared a speech. Dear God, give me some words. The first thing that came from my lips was about my mother. I said what a wonderful mother I had to guide me, and then I began the well-known theme of thanking all the people with whom I had worked. I really can't accurately recall the words, but believe me, I was deeply grateful for God's love being with me at this momentous hour.

As I was returning to my seat, the announcement of the Best Actor, Jimmy Stewart, came over the microphone. I jumped with joy to think my sweet friend Jimmy and I

were in the same bivouac together. I was as thrilled for him as I was for me. What a wonderful night!

Harry Evans of *Family Circle* described the evening this way:

Mr. Betts handed Miss Fontanne an envelope; she opened it, then hesitated a moment. "For outstanding performance given by an actress in 1940 . . . Miss Ginger Rogers."

That's all you could hear. No doubt she also said, " . . . in 'Kitty Foyle.' " I wouldn't know. All I remember is that every person in that room seemed to be clapping, cheering, and yelling at once. Three gents from Universal reached over and grabbed at me. I grabbed back, and we screamed at each other. "Wonderful! Perfect! Great!" At the table in front of me Darryl Zanuck, Annabella and Tyrone Power were applauding madly. They hail from the 20th Century–Fox lot. As you know, Ginger works for RKO.

Everybody at my table was standing as Ginger started toward the platform as if she were in a dream. Lynn Fontanne, both arms outstretched, was waiting for her. As they embraced, Lynn kissed Ginger on the cheek, and she wept openly. She was still weeping as she tried to speak into the microphone. "This is the greatest moment of my life," she said, trying to control her shaking voice. "I want to thank everybody in Hollywood who has given me my chances. Especially a person who has stood by so patiently and faithfully—my mother."

Looks a little cold in type. And well, you know—sort of the old stuff. But if you had seen the mist in the eyes of dozens of hard-boiled Hollywood players and cameramen and executives, you would know that it wasn't old stuff; it was something they had never heard before. They were listening to a girl who had

been named No. 1 screen star in America—a kid who had done it the hard way. Dear little Ginger—always in there pitching, having to battle every inch of the way up the ladder. Climbing up a couple of rungs. Slipping down one. Dancing lightly upward for a short period. Struggling hand over hand for the next spell. And now, on this night, at this very moment, her feet had touched the top. The success every screen actress dreams of—the sort of success Hollywood loves and takes to its bosom.

When Ginger returned to her table, Lela was waiting for her. Lela is her mother. According to Hollywood, Lela Rogers is a cement-coated realist. Tough and matter-of-fact, they tell you. I watched her. She was trying not to be the adoring parent. But in her eyes was that light which does not have to be described to any reader who is a mother.

Lela was indeed proud that night. She had predicted my success long before I even thought in those terms.

As I got to my hilltop home, I couldn't wait to clear a place on my mantle for my Oscar. However, the people in charge of the festivities that night told me they would bring my golden man after my name had been engraved on the plaque at the foot of the statue. I couldn't wait to have it. Three days went by. Finally it came, and I proudly placed it on my mantle. In retrospect, I was aware of how thrilling the whole evening was, especially because Alfred Lunt and Lynn Fontanne had been there. What a precious compliment the Lunts gave to me that evening.

Over the next few days, I received many telegrams and letters of congratulation from friends in the industry: George Murphy, Harriet Hilliard and Ozzie Nelson, Janet Gaynor, Mervyn and Doris LeRoy, Irene Dunne, Carole Lombard, Frank Capra, Lucille Ball and Desi Arnaz,

David Niven, Eleanor Powell, Rosalind Russell, Joan Crawford, Jerome Kern, and Martha Scott.

Kate Hepburn wrote, "Many, many congratulations. I am very jealous, but most happy for you. Affectionately, Kate."

Screenwriter Nunnally Johnson said, "You earned it."

David O. Selznick, whose film *Rebecca* won Best Picture that evening, sent: "I am sure you must know by now how delighted everyone was over the award that you so justly won. Throughout the industry there was great satisfaction and pleasure over your recognition, and also the charming way in which you received the honor."

Charles R. Rogers summed it up: "So happy all my predictions proved true. Love . . ."

Of the many congratulatory letters I received, I treasure one that actually came the week before I was given the Oscar:

Hello Cutie:—
Saw "Kitty" last night and must write this note to say "That's It!" Yes—yes—a thousand times yes! You were *superb* Ginge—it was such a *solid* performance—the kind one seldom sees on stage or screen and it *should* bring you the highest honors anyone can win!!

> Hope to see you soon—
> As ever your—
> Fred

The morning after the Academy Awards, the studio called to say that my early call had been changed to 11:00 A.M. How grateful I was for those two extra hours. When I arrived at the studio, the gate man congratulated me on the wonderful win. From there on, everyone who saw my car put up their hands to stop my chauffeur, so that a word of joy could be expressed.

My studio dressing room was half a block away from the stage where our film was shooting. After preparing myself, I walked to the set. One of the crew members was outside the huge sound-stage door and, with a flourish, opened the door, saying loud and clear, "Madam, at your service."

I opened the second door to the set and there, directly in front of me, were fourteen men, seven on the left, seven on the right, with evening jackets and top hats, which they crossed over the top of my head to form an archway. They were the electricians and crew, who had dressed up for my entrance in top hats and black tuxes, and were wearing their electrician and carpenter tools on their hips!

What an adorable way to celebrate a win, and a fantastic moment for Virginia Katherine McMath Rogers.

29

1800 ACRES OF PEACE AND QUIET

IN EVERY WAY, EXCEPT FOR DECISIONS OF THE HEART, I looked to my mother for advice and counsel. When it came to romances, however, it was useless for her to try to influence me; I had to follow my own path. In all other matters she would eagerly pitch in and give me chapter and verse as to why I should do this and that or why I shouldn't do thus and so. She was generally accurate in her summations.

For a long time, I had been thinking about getting a place where I could escape from the Hollywood scene. I decided I wanted to buy a ranch somewhere near a river, where I could look at the scenery, go fishing, walk in the woods, hear a river flow, and even fall in if the weather was hot, or simply enjoy the quiet. I recalled what Steve Roberts had told me about the Rogue River in Oregon, and it sounded exactly like what I wanted. I spoke to Lelee with enthusiasm.

"Mom, I want a ranch on the Rogue River. There's fishing, scenery, beauty, and it's green. Oregon, Mom. Oregon on the Rogue River." Mother, ever practical,

bided her time and waited for my sigh to come to a full stop.

"Why Oregon, dear? Why don't you let me pick up four hundred acres or so in the San Fernando Valley? You could build a nice home, ranch style, a couple of horses, pool, and all that good stuff."

"That's too close, Mother, too close. People can stop there at anytime and surprise me at the door, just like they can here. I need to be away. I'd love to start a dairy or something that's real country."

Reluctantly, my little mother gave in to my preference.

Once again, Lela Rogers proved to have a better notion of economics than her movie star daughter. Her investment advice was always designed to give me a faster return on my money and she thought California real estate was more valuable. Mother was right on the button, for San Fernando property soared after World War II.

Despite her personal beliefs, Lela was a good enough sport to go up to Oregon and scout for me. She photographed six different ranches on the Rogue River and described each one in great detail. I looked over the pictures and listened carefully to the narrative.

"From what you've brought me, Mother, I like the looks of this one here." A cute smile came across her face; this was the first time I had noted a smile of appreciation for Oregon.

She said, "Yes, that's the one I like too. But I didn't want to persuade you."

And so, in 1940, I bought 1,800 acres of Oregon land on both sides of the Rogue River between Eagle Point and Shady Cove. My purchase may not have turned into the financial bonanza of a comparable piece of property in the San Fernando valley, but it has been my beloved home for fifty years and I have no complaints. *LIFE Magazine* was interested in my ranch and came up for a photo session; the result was my third *LIFE* cover!

Being the daughter of a contract builder, Mother felt

she knew enough to attempt the designs herself. Accordingly, she prepared blueprints for the ranch house, dairy complex, sheds, barns, and chicken house. The carpenters who put together the buildings couldn't believe my little mother was the one who laid out the plans.

Frequently, Mother drove up to open the house for me. On one occasion, she heard a knock on the back door. Mother was thoroughly surprised to find one of my handsome leading men, David Niven, standing in the doorway. They had never met, but she recognized him from his screen portrayals. David said he had expected to find me and had planned to challenge me to a fishing contest. Mother informed him that I wouldn't be arriving until the following afternoon. The two of them had a good gabfest before the sun set, and she invited David to stay in our ranch house that night. He was delighted. The next morning, David and Lela went on a fishing expedition. When I arrived at the house in the afternoon, nobody was at home. I heard singing from the road leading to the river and ran to the deck to see who it was. Mother and David were on their way up the road singing a duet, as if they had done this for years.

Later, David told me, "It's a good thing I went fishing with your mother, as she would have been down to the Pacific by now if I hadn't caught her."

Mother had lost her balance and the river current started to sweep her away, but David caught her right after she'd fallen in. The only casualty was David's fishing rod, which was swept off during the rescue.

On October 13, 1941, I began work on *Roxie Hart* for Twentieth Century–Fox. The film was based on the play *Chicago*, by Maurine Watkins, which in turn was based on newspaper reports of a murder. *Roxie Hart* was really a satire, and way ahead of its time. William Wellman was the director and Nunnally Johnson was both the producer

and scenarist. Both of these gentlemen were real pros. Bill Wellman treated Nunnally's offbeat script exactly as it should have been treated, by keeping the pace lively and the sentiment at a minimum. I wish I could have made more films with this director, sadly, this was the only one. I did have the good fortune to make two more films with Nunnally.

Roxie Hart is a gum-chewing, wise-cracking dancer who confesses to a murder committed by her husband, just so she can get publicity. I later learned that the part of Roxie was intended originally for Alice Faye, but she had a date with the stork. That's why you saw not her, but me, in the role. Again I was surrounded by a superior cast. Adolphe Menjou really was superb as the lawyer who defends me. His main ploy was to make sure I showed my legs to the all-male jury. George Montgomery, a gorgeous hunk of man, was a newspaperman, and Phil Silvers brought fun to a film that was already a burlesque. Lynne Overman, George Chandler, Nigel Bruce, Spring Byington, and Sara Allgood were also in the cast, and we all had a great time.

In trying to fill out my character, I decided this girl had to have dark hair. The papers used to write articles saying that the studio forced me to become a brunette for this or that movie, but in truth, except for my initial blonding, no studio ever told me what color my hair was to be for any movie. It was always my decision, based on my understanding of the role. Right or wrong, I made the decision, and the one time I found it to be a mistake was in the film with Ronald Colman, *Lucky Partners*.

Since Roxie was supposed to be a dancer, I thought I should work a little tap routine into the proceedings and found a perfect spot for it. Roxie is in jail and I wanted to do my dance on metal stairs. Truly, I'd always wanted to do taps on a metal staircase, because I knew the taps would have a good, resounding sound. Twentieth Century–Fox didn't have a metal staircase on hand and

had to go to a good deal of trouble to locate one. It was finally found in the wreckage from a demolished building in downtown Los Angeles. It was worth the effort; the tap sequence was a pure joy to do and, I'm happy to say, a pure joy to watch. The stairs tempted everyone on the set. You'd hear clicks and clacks at odd times, and when you looked, you'd see a cameraman or a propman or a production assistant trying out the staircase. Years later, when *Roxie Hart* was turned into the stage musical *Chicago,* Gwen Verdon told me how sad she was that she was not going to be able to dance on a metal staircase.

Roxie Hart has become a cult film in recent years. I know of one theater in Philadelphia that runs it frequently. The manager told a friend of mine, Sidney Luce, "We practically sell out the house for the entire run." Not bad for a film released in 1942.

30

\mathcal{T}HEN CAME BILLY WILDER

I WAS WORKING ON *ROXIE HART* WHEN THE JAPANESE AT-
tacked Pearl Harbor on December 7, 1941, and the United
States entered World War II. With our country now at
war, whether we wanted to be or not, the sound stages
were filled with radios giving out fresh information. The
sound booth had to block out the squeaking from midget
radios in the middle of a take, and much film was wasted
during that time because we were so eager to hear the
news.

The same day as the Pearl Harbor attack, I received a
call from a friend who had contacted the sculptor Isamu
Noguchi for me. I wanted to commission a bust of myself
from this gifted artist. I called Noguchi and arranged
for him to come to my house the next day. I was very
impressed with this gentle, distinguished Japanese-
American and was delighted when he agreed to sculpt
me. We had all his materials and tools moved up to a
specially prepared floor above the tennis court and the
pool. For a month, Noguchi worked so quietly around me
that I hardly knew he was present.

At the time, I was readying myself for Roxie, and was wearing the pageboy bob hairstyle Louise Miehle had designed for me in 1937. I loved the style's simple lines, and so did all the secretaries in America, who began sporting the pageboy. It was this hairstyle that Noguchi sculpted.

One afternoon, after he finished a session, Noguchi told me he would not be returning.

"The United States government is putting me in an internment camp." I was shocked to hear that this fine artist could be treated in such a way. He seemed to accept his fate. "I'll take my sculpture with me," he continued, "and by the time I'm released, it should be done. You wanted it finished in pink marble, didn't you?"

"Yes, that's correct, but how can you complete the job in an internment camp?"

"Don't you worry about that, I will get it done, you'll see."

And as soon as World War II was over, Noguchi telephoned me to say he was out and a free man again and to ask when he could bring the pink marble bust over to my house. Two days later, he arrived and unveiled his work. I was thrilled to have my likeness captured by a brilliant sculptor. And I was mightily impressed that he had the tenacity and courage to finish his work while living under such deplorable circumstances. Besides his famous portrait sculptures, he did the landscape designs for parks and sculpture gardens such as the UNESCO garden in Paris in 1956.

In January of 1942, Twentieth Century–Fox announced *Tales of Manhattan*, a series of unrelated stories connected by a man's dress tailcoat, which falls into the hands of various owners. Boris Morros and S. P. Eagle, as Sam Spiegel called himself in those days, were the producers. Boris, a friend from way back in the presentation theater

days, called and asked if I would act in a segment of this film. I couldn't have been more pleased to hear from him again after so many years, and it seemed like a good idea to me.

I had a few weeks free, so I accepted, partly to make a few dollars and partly to have the opportunity to perform with longtime friend Henry Fonda. Hank was an easy actor to work alongside—it was almost like working with my own brother. Our story line was a bit thin, but still, it was entertaining for me to be with Hank, Cesar Romero, Gail Patrick, and Roland Young.

Tales of Manhattan was squeezed in between *Roxie Hart* and my next assignment, a special favorite among my films.

During a lunch break on the set of *Roxie Hart,* I received a telephone call from the guard at the automobile gate. Arthur Hornblow, Jr., and Charles Brackett wanted to talk with me. My agent had alerted me to expect them, but he didn't say when. I had figured that they, being film producers and writers, wouldn't come to visit a working star on her lunch break. But that's what they were doing. I asked Charlie Brackett if I could see them at another time.

Charlie said, "All we need is five minutes to tell you the outline of this story, and if you like it, we will tailor it to fit you." I reminded them that I would have to return to the set the moment the assistant director telephoned. They agreed, and within minutes, Brackett and Hornblow were in my dressing room.

Actually, this dressing room had been built expressly for Fox's biggest little star, Shirley Temple, and it was more like a small house. For years, she had kept that company in business with her films.

Charlie and Arthur got right to the point, and related the first fifteen minutes of *The Major and the Minor*. The

heroine, Susan Applegate, is desperate to leave New York City and go home to Iowa. She hasn't enough money for her train ticket, so she disguises herself as a child in order to ride half-fare. I loved the story the moment I heard it. I told Charlie and Arthur that I had had similar experiences as a child on the Interstate circuit: when Mother and I didn't have enough money to ride the train at full fare, I used my stuffed-doll Freakus as a ploy and a pillow. The story they were telling me was, in a sense, the story of my life. At this point, the telephone rang and, of course, it was the assistant director calling me to the set.

As I was leaving, Charles Brackett said, "Now we would like to talk to you about the director. We have someone in mind and he has a great sense of humor. Though he's never directed a movie in this country, I've worked with him on screenplays and he's terrific. His name is Billy Wilder."

Though I respected their opinion, I asked to meet with their choice and judge for myself. I made a date to meet the prospective director at Lucy's, an Italian restaurant across the street from RKO.

When Billy Wilder and I met, I began to see why he had been selected. He had a wonderful sense of the ridiculous, and I concurred with Brackett's evaluation of his talents. After talking with him for an hour, I could tell what type of director he would be. At my earliest convenience, I telephoned Brackett to inform him that I was sold on Wilder, too.

As promised, the role of Susan Applegate was tailored for me, and I can't tell you what a good time I had making *The Major and the Minor*. This was the first film I made for Paramount under a new three-picture deal.

Billy Wilder was a wonderful traffic cop for this film and couldn't have been more enchanting. From the very beginning, he had the nicest attitude toward me and all the other actors. The "Major" in the story was played by Ray Milland, Rita Johnson played his snobbish fiancée, and

Diana Lynn was her little sister, the only character in
the story who recognized that I was putting on an act. We
also had many fresh-faced young talents playing the
cadets who were constantly after "Susu," among them
Raymond Roe and Frankie Thomas, Jr. The main source
of our off-camera laughter was the very talented Robert
Benchley. One of his lines to me, written by Charles
Brackett—"Why don't you slip out of that wet coat and
into a dry martini?"—became a standard. Benchley's on-
stage humor was the antithesis of the backstage Benchley
I came to know. His innocent type of humor was very
different from his own nature, for he was far more serious
and complex. He would arrive at the studio in the morning
punctually, carrying with him a stack of books, and would
read, on average, four books a day. I was amazed at his
literary accomplishments.

Filming had begun, but we were faced with a hole in
the cast. We needed someone to play my mother in a brief
scene at the end of the film. Billy tried to hire Spring
Byington. She had recently played my aunt in *Lucky
Partners,* and we had a definite family resemblance. Un-
fortunately, Spring had already been offered another
movie.

Charlie, Arthur, and Billy approached me and asked
who I thought would make a good parent for me.

"What's wrong with my mother?"

"Do you think she would consider such a thing?"
Charlie said.

"Well," I retorted, "there's only one way to find out,
and that's to ask her."

Arthur Hornblow, Jr., contacted Lela at RKO. When
she heard their request, she did not hesitate to ask, "What
are you willing to pay?" After much back and forth, she
said "yes" to the figure they offered.

Later, the group laughed over her first reaction. They
agreed to pay her $3,000 for her work as an actress. I
believe she had to join the Screen Actors Guild before she

could appear on the set in costume. This was a big change for her; she had been directing young folks in her little theater on the RKO lot, and to change from director to actress can sometimes be a devastating experience. There was no need to worry about Lelee, though, she never needed a retake and remembered her lines perfectly. In addition, she got along splendidly with Billy Wilder and gained a great deal of respect for his work.

And it was great fun for me to have the joy of acting beside my mother.

When Billy finished a scene, if he liked the way the actors had played it, he'd yell out, "Champagne for everybody!" Sometimes the crew would anticipate his accolade and would chime in, and the sound would reach up to the president's office. Our set was known around the lot as a very happy and joyous one to visit, and we had many visitors. I believe I had more fun playing this role than any other, with one exception . . . *Kitty Foyle*. A lot of my enjoyment had to do with Billy. I would love to have made another movie with Billy Wilder, but it was not in the cards.

Sam Goldwyn sent me the screenplay for *Ball of Fire*, and I turned it down, even though Gary Cooper was the male lead. Goldwyn didn't want to take no for an answer and asked me to come over to his office. When I arrived at the Goldwyn studios on Heyward and Santa Monica, I went directly to the mogul's inner sanctum. He was glad to see me, and after a hearty greeting said, "Ginger, as the Lord God liveth on this earth, I have a film I know you'll love to do." Then Goldwyn began to praise the fine points of *Ball of Fire*. I had previously read the script and felt it was a piece of fluff.

Without pausing for a breath, Sam said, "Here, let me show you the dressing room that you'll occupy." He took me to the dressing room for the "star of the lot," whoever

that might be. I was mighty impressed. It was twice the size of my RKO dressing room, and had a kitchen to boot. Also, there was a couch, which could be used for the lunch-break nap I always took.

At each turn, Sam would say, "As the Lord God liveth on this earth." This phrase preceded everything he said. It was funny to hear a Goldwynism in person. He was very proud of his studio and loved showing people around. He also loved to run the show. One evening, I was a guest at a small dinner party in Frances and Sam Goldwyn's home. After dessert, Sam asked me to play backgammon with him. I threw the dice and Sam counted the number and moved my men on the board. From then on, I would roll the dice, and Sam would count the numbers I'd thrown and move my men. My only contribution to playing the game was to throw the dice, and I was getting bored with that. Finally Frances came over and said to her husband, "Sam, you've got to let Ginger play her hand."

He said, "Dear, she doesn't know this game as well as I do."

"The more reason you should let her play her own hand."

"But can't you see I'm helping her to win."

I wanted to laugh at that, but after all, I was a guest in their home.

Sam liked to get his way, whether it concerned a game of backgammon or a movie, and he really wanted me to do *Ball of Fire*. I stuck to my guns, though, and refused.

As for the film, Goldwyn gave the role to Barbara Stanwyck, who always said she got the parts I had turned down. She claimed RKO gave her a rough time. Yet I think any female star who was awarded the role of the original Annie Oakley can't complain. When I saw *Ball of Fire*, I realized I'd made a mistake. It was light fare, but so what.

<div align="center">° ° °</div>

That was one of several films that I stupidly let slip through my fingers. Leland Hayward told me one evening that Paramount wanted me to play the leading role in its new film *To Each His Own*. I read the script and asked myself if I wanted to play the mother of a twenty-year-old man who is preparing to go off to war. My answer to myself was NO! Olivia de Havilland accepted the role and, to add salt to my wound, Olivia received an Academy Award for her portrayal.

Another film that I turned down was *The Snake Pit*, about a women's psychiatric ward. Who played the tragic woman's role? Olivia de Havilland. And she received another Oscar nomination! It seemed Olivia knew a good thing when she saw it. Perhaps Olivia should thank me for such poor judgment.

Speaking of poor judgment, I really must have been unconscious when I was invited to make the film *His Girl Friday* and turned it down. Cary Grant was the co-star in this, but he hadn't been cast when they sent me the script. Another fine actress, Rosalind Russell, grabbed it after I rejected it and played the part of Hildy Johnson.

Of course, there were also roles I wanted and wasn't offered. When MGM was looking for a star for the musical *Annie Get Your Gun*, I told Leland to go after it for me and not to haggle about money. Money wasn't the object. In fact, I would have taken just one dollar, to make it legal. Leland returned after a talk with Louis B. Mayer and reported what Mayer said: "Tell Ginger to stay in her high-heel shoes and her silk stockings, she could never be as rambunctious as Annie Oakley has to be." They turned me down, and after Judy Garland dropped out, Betty Hutton got the role.

At one point, Warner Bros. wanted to borrow my services from RKO and offered Paul Muni in exchange. A long and complicated contract loan agreement was worked out between the two studios. In effect, the con-

tract said that RKO would get Muni, and Warners would get me or $75,000, if I failed to do their picture.

Warners thought that Dick Powell and I had done so well in the 1934 film *20 Million Sweethearts* that they wanted us to repeat that success in a new film called *Hollywood Hotel*. They sent me the script, and after reading it, I gave them a resounding "No!" I did not want to do any musical off my home lot, and certainly not this one. Much later I saw the film and it was a real dawg, so my judgment was vindicated. Warners began sending dramatic scripts over for my perusal. Again, I didn't feel they were right and refused them too. Warners constantly complained to Sam Briskin at RKO about the lack of interest RKO was showing in getting me to do one of the Warners films.

RKO was very supportive and never pushed me to accept any of the Warners scripts. Of course, they preferred to keep me at my home studio, working for them and making more money for RKO, even if they had to pay off Warners. As a result, I was put into RKO films that were already on the studio's shooting schedule and more were lined up for the future. Finally, Jack Warner was fed up and suggested that the deal be cancelled. Warners felt that RKO was stalling, and they were probably right. RKO did have to pay Warners $75,000 in the long run. I do remember, with a tinge of regret, turning down a Warner Bros. film with Humphrey Bogart, *It All Came True*. In hindsight, I should have done that one, just for the opportunity to work with Bogie.

Another time, Warner Bros. sent me a script that I really wanted to do. It was originally intended for Bette Davis, but she had gotten into a contractual-legal mess with her bosses and had walked out of the studio. She'd been on suspension for a few months, and they'd demanded that she return to make this film. She refused. When I read *Now, Voyager*, I telephoned Leland Hayward and said, "I'm in love with this script. I most

certainly want to do it." Apparently the rumor machine went to work and the news reached Bette. One thing that really irked her was that I was getting more money per film than she was. Bette went back to work, and I lost the part. I would have given anything to have played Charlotte Vale . . . even if I had to let Jack Warner beat me at tennis!

31

\mathcal{T}HE HALLS OF MONTEZUMA

WHEN JUNE OF 1942 ROLLED AROUND, I WAS SCHEDULED TO do *Once Upon a Honeymoon* at RKO. Working with Cary Grant was the best assignment any actress could have, and I had the good fortune to work twice with this fine actor. Cary's comic timing rated a ten. His gentle humor was infectious. I admired and adored him. Walter Slezak, also in the cast, a pro from the word go, was perfect as the Nazi sympathizer.

And as for director Leo McCarey, you felt you had struck it rich to work with him. He was full of good ideas and directorial nuances. Any American actress was thrilled to work with this superb director. *Once Upon a Honeymoon* was the first film I appeared in that dealt directly with the war. It was a romantic story played against the reality of the Nazi menace.

During World War II, I was asked, like many others, to make USO appearances, do bond drives, and visit Army camps and hospitals. We were all proud to do our part, and I met many wonderful people, from generals to captains to privates, on the stops I made. In September 1942,

the USO requested that I travel to several southwestern cities, including Corpus Christi, El Paso, Albuquerque, and Tucson, and then back to California, over a ten-day period. I had appeared before the Army, Navy, and Air Force when Mother began lobbying for the Marines; after all, she was a Marine veteran from World War I. The first Marine Corps base I visited on this trip turned out to be the last stop on the tour, Camp Elliott in San Diego, a far cry from the Halls of Montezuma.

During my visit there, Private First Class Jack Briggs, a very charming Marine, was assigned to escort me around the camp. Private Briggs told me he had a stock contract at RKO and had even appeared briefly in *Tom, Dick and Harry*. He told me that he had taken his parents to see the film, only to discover that his part had been cut. With his face on the cutting-room floor and with the war on, his chances of getting back into the film industry were slim indeed. Jack had a super sense of humor and an easy manner that appealed to me. Upon leaving the base, I told him that if he was ever in Los Angeles on a weekend pass, he should give me a call, and maybe we could play some tennis. The invitation was extended spontaneously, almost as a courtesy, and I really didn't expect to hear from him. Two weeks later, the Marine landed.

Jack Briggs called and asked me out for an ice-cream soda. I thought he must have read in the press about my home and soda fountain. But I gave him the benefit of the doubt, figuring he might be an ice-cream soda fanatic, too. I invited him over on Sunday afternoon for some tennis. He arrived and joined in with me and a few of my regular Sunday tennis "customers."

Later that evening, Jack and I drove to an ice-cream parlor and sat there giggling at the sophisticated taste we had.

"Next time I come up, may I call you again?"

"Yes, Jack, please do."

Over the next three months, we saw each other regularly. This was the budding of a romance that caused the press to say I was aiding the war effort by going out with servicemen. Little did they know, I wouldn't have gone out with him if he hadn't liked to play tennis and hadn't favored ice-cream sodas instead of daiquiris.

One Sunday afternoon, when Jack and I had just come into the playroom from a hard-fought game of tennis, that tall Marine in uniform said to me, "What would you think of being married to a man in the Marine Corps?"

"Who have you in mind?"

"Me, you silly little dope."

"I didn't read the whole script, but are you proposing to me?"

"Well, if you answer in the affirmative to my question, then I am."

"You know that I'm a few years older than you are and still you ask me that question? You realize that we've only known each other for three months."

"Well, I couldn't love you any more if I had known you for three years."

"If that is supposed to make me melt and run into my shoes, you've won your case, Mr. District Attorney."

I had never realized how much this young man had come to mean to me in this short span of time. We mortals seem to measure things by the sundial or the weather map or by the opinion of others. But when we are honest with ourselves, we begin to see different-colored lights on the road we are traveling. When there are no lights telling us to follow the little white line, and we have to use our common sense in finding our way, we discover that we do have an opinion of our own, and it takes us just a few seconds to find happiness in that opinion.

So Private First Class John Calvin Briggs II and I informed our immediate family of our intentions. Without any disagreements or crying eyes, we went to Pasadena

on January 16, 1943, to announce our vows to the world.

Jack Briggs seemed so right for me. After my brief teenage marriage to Jack Culpepper and the sad breakup with Lew Ayres, I was ready for a new partner and hopeful it would last.

Just prior to taking this big step, I spent Christmas with my immediate family, as Jack was spending most of his holiday leave with his folks in Los Angeles.

Despite the dreadful shadow of war, my house on Gilcrest was full of the Christmas spirit, as well as bulging presents waiting to be opened. My mother, whose birthday was December 25, squealed with delight at having her father, Smokey, as our guest for the day. Family and friends gathered around the Christmas tree, and I was the master of ceremonies for this part of the presentation. When the presents from under the silver-tip pine dwindled to nothing but empty space, Smokey's face became very long and very sad. He must have thought we'd forgotten about a present for him.

I drew my mother's attention to the clouded expression on his face, and she nodded to me that we had better take him outside before he pouted. Mother and I planned his present and its presentation together. I reached down to the base of the tree and picked up a huge ball of red string. I announced to Smokey, "Here's your present but you'll have to follow wherever it leads you."

He immediately caught the humor of it, saying, "This is just what I needed." He wound the string into a red ball and he repeated his remark each time the string would be wrapped around a lamp or a book. The whole group got caught up in his search and as soon as the string stopped at any item, in unison they would repeat with him, "This is just what I needed."

The string led us outdoors to the parking space in front of my three-car garage, and, as planned, there was a

brand-new Ford. When the crowd saw this shiny new car, they let out an audible "Oh, no!" since the string had just stopped at the radiator on the front of the car. In his amazement, Smokey again repeated, "This is just what I needed!" Smokey sat down on the runningboard of his Ford and began to cry like a baby, he was so overcome. Everyone in the crowd got caught up in the emotion of the moment, and there wasn't a dry eye in the group. Lelee and I presented him with the right gift, and it *really* surprised him. It was a thrill for me to know that. He took my mother into a corner later that evening and said, "You two didn't have to get me such an extravagant present."

Mother rightly answered him, "But, Daddy, you are the most important man in our lives."

With that, Granddaddy cried again. He was an emotional Welshman. Bless him!

In December of 1942, Paramount began shooting the film version of Moss Hart's *Lady in the Dark,* which had music by Kurt Weill and lyrics by Ira Gershwin. I had seen the show in New York with Gertrude Lawrence, who was elegant in the role, never dreaming that several years later I would be fortunate enough to play her role of Liza Elliott. The press razzed me unmercifully for running away with someone else's role. However, Howard Barnes of the *New York Herald Tribune* stood up for me in his wonderful and inimitable way. So I guess it wasn't *all* in vain. The studio, not I, bypassed Miss Lawrence. Was I supposed to turn the role down?

Mitchell Leisen was the director as well as the producer. I had never met Mitch and didn't know what to expect. Everyone speculated as to how I would blend with, or should I say bend to, his attitude toward women. From all reports, it seemed that he had a dislike for the fair sex that was quite a departure from the attitudes of the directors I'd had the privilege of working with in the

past. I thought of an idea for breaking the ice right away.

Before we started actual shooting, I went to a pet shop and bought a darling black-haired dachshund. I had a collar made with the name "Lady" on it and attached a note, saying, "Here is your new leading lady. I hope she will behave herself and keep you amused as she has me these past five days, awaiting the right time to receive her as a loving gift from me. Looking forward to making a smash of a movie with you, Ginger Rogers." I put Lady in a basket and arranged to have her brought to Mitchell Leisen's office.

The following day the RKO publicity department told me to call Mr. Leisen's office immediately. I telephoned, expecting to hear how amusing he had found my present. Was I ever wrong. "Ginger, whatever made you buy a dog for me?" were the first words out of his mouth.

"I don't know, Mitch, it seemed a good idea at the time."

Perhaps it was presumptuous of me to assume he'd like the animal; still, I had given the puppy with love and found his reaction most frigid. Then, when I learned he'd left the poor thing at his office overnight, I became angry. How could he let the little creature go without food or water for so long? Well, that was the beginning of a beautiful friendship. His treatment of the four-legged Lady showed the same amount of heart as he invested in the film's direction. Mitch's interest was in the window draperies and the sets, not in the people and their emotions. As far as I'm concerned, he made hash out of Moss Hart's original, very meaty story.

Lady in the Dark was my first Technicolor movie. I truly resisted and disliked the way the film opened, with my character's unattractive hair-do. But everyone convinced me that that was how Liza would look, because she wasn't competing with other women and would be as stark as possible. Apparently, Liza loved to be the plain little nobody, except when somebody crossed her. Then she

longed to be the center of power. Ray Milland played the assistant to the editor in a most convincing manner, and Jon Hall was the movie star who piqued Liza's interest for a while. Edith Head designed all of my clothes for the film. Since my character was editor-in-chief of *Allure* magazine, my clothes were for the most part of the pinstriped business suit variety. I did have a chance to wear some spectacular garments in the dream sequences, but problems arose when I was attired in these elaborate dresses.

"Lean-tos" or "slant boards" were created for actresses, all dressed up in their finery and face, to rest against during delays in filming. Many times during the shooting of *Lady in the Dark* I was told by the assistant director to stand on the lean-to while the scene was prepared. "We'll be ready for you in a few minutes," I'd be told, and then I'd be left "leaning" for hours. Then, of course, there are times when nature calls. Then the company just has to wait for you to remove the dress, get into a robe, and find the nearest ladies' room.

One afternoon I grew tired of waiting and told an assistant that I was going off to the ladies' room and would be back before I was missed. I went to my Paramount dressing room, got out of my fancy dress, put on a robe, and hopped on my bicycle to pedal over to my dressing room at RKO. People made great fun of me because I insisted on using the bathroom facilities at my home studio instead of those at Paramount. Since I was willing to pedal the city-block distance, I didn't think it was anybody else's business. I returned to the set to discover that Mitch had called for me at precisely the moment I was on my way to RKO. I faced Mitch, ready for whatever chastisement leading ladies get from their director based on the human need to go to the W.C. Mitch was angry because of the fifteen-minute delay and made some crack about the bathrooms at Paramount not being good enough for Miss Rogers.

Lady in the Dark was not one of my happiest assign-

ments. There were too many problems, physical and emotional. In a dream sequence, I did a dance with Don Loper. We devised a little routine that we had to execute through a fog, created by dry ice. For over two and a half hours I worked on the dream dance. To keep the dry ice from melting too rapidly, all the outside doors were shut. Inside, I was groping through the fog and inhaling the overwhelming dry ice. It was like swimming underwater on one breath. I went outside and took big gulps of the fresh air. I'm sure there are modern techniques for creating fogs which aren't as hazardous to the performers. I know I wouldn't waltz through a dry-ice stage again, ever.

Next came the grandiose production number "The Saga of Jenny," an elaborately costumed circus number with lots of extras. Edith Head designed a beautiful gown of red sequins and mink. There are two weights of mink, male and female; female is more prized because it is lighter. Naturally, my dress was constructed of the male skins and must have weighed about fifteen pounds. Heavy or no, the dress was truly spectacular and, according to the public relations department at Paramount, cost $30,000. Because of the price tag, my gown received sensational press coverage and can now be seen at the Smithsonian Institution.

The set for "The Saga of Jenny" was designed around the circus theme, and the set decorators covered the floor with a basket-weave hemp rug. I didn't know I would be doing "Jenny" on a hemp rug until I arrived on the set, wearing four-inch stiletto heels to match my gown. Trying to maneuver on this rug had its drawbacks, for halfway through a turn, the dress had turned me! No one ever checked with me to ask, "Is it all right with you if we put down a hemp rug for your 'Jenny' number?"

Don't I have the right to say, "Hey, wait a damn minute!"

You're darned right I do. The dress length had been measured with these shoes and the production would

have had to wait for the $30,000 mink skirt to be altered or new shoes to be dyed to match the dress. You can't do those things at the last minute on a movie set. And now it was too late to redesign the set to accommodate my high-heeled shoes.

After a three-month shooting schedule, I was grateful when *Lady in the Dark* was finally over. Because Jack was stationed in San Diego at Camp Elliott, it was hard for us to spend much time together. But now, with no film in the near future, we had that opportunity.

32

\mathscr{S}AYING GOODBYE

WITH JACK ON DUTY IN SAN DIEGO, LIKE MOST WAR BRIDES, I saw my husband when he was home on leave. I remember what a shock it was on December 7, 1941, when the Japanese attacked Pearl Harbor, and my heart went out to anyone who had to be involved in any way, anywhere, in a war, and in particular to our American troops. And now, two years later, I knew someone who was really headed for the Pacific, and my heart nearly stopped. My marriage to a serviceman brought me closer to prayer and to understanding, as best I could, the Bible quotation "Love your enemies and bless those that curse you, do good to them that hate you" (Matt. 5:44). As a very dear friend of mine said to me, "You can measure how much you love God by thinking of the person you like least. That tells you what percentage of love you are missing for God."

I reminded Jack, after we were married, of the great need for constant prayer. I took him to church with me on Wednesdays and Sundays to give him some idea of what was needed, beyond being a good Marine. It was impor-

tant for him, as well as for me, to stay close to God in thought and deed, which would indeed remove some of the paralyzing fear that would beset a soldier. Gradually he began to understand this, and I gave him a Bible and a copy of *Science and Health* to take with him to read and told him to pray daily.

As the summer of 1943 was winding down, I was cast in a picture at RKO entitled *Tender Comrade*. I looked forward to working opposite the charming leading man, Robert Ryan, and Ruth Hussey, Kim Hunter, Patricia Collinge, and Mady Christians in a story about women defense-plant workers who share a house. The movie addressed problems related to the home front, but the story was like a Valentine out of season.

To my great surprise, some of Dalton Trumbo's dialogue had a Communistic turn, which upset me deeply. I complained to the front office and sent notices to those in authority, including director Edward Dmytryk, that they would have to make a finer sifting of this script if they wanted me to continue with the film. In order to satisfy me, David Hempstead, the producer, gave the other actors the dialogue, "Share and share alike!" that I was unhappy about. I still hold strong feelings against communism because it is atheistic and anti-God.

Meanwhile, Jack was awaiting his orders and we continued to see each other on a catch-as-catch-can basis. I bought a little gray Studebaker for him and each time Jack would drive back and forth from Beverly Hills to Camp Elliott, he would send the word to other Marine friends, and his car would be filled with servicemen like Tyrone Power, Glenn Ford, Bill Lundigan, and Jack's best friend, Al Flanagan. When the men got a weekend pass, they would leave Camp Elliott immediately after inspection on Saturday morning, and return after sunset on Sunday. They'd drive down the Pacific Coast Highway without

headlights because lights were forbidden during black-outs. Many times they would hit heavy fog pockets, making their trip very difficult and tense. Not only was the journey perilous, it was also costly. Gas was at a premium and you had to have coupons to buy it. Irma Scheid, my precious German housekeeper, gave Jack her gasoline coupons. Without her gift, they would not have been able to make their weekend trips. As Al Flanagan said, "Irma was always able to prove, during the period of rationing, that you *could* have butter and guns at the same time."

Tender Comrade had finished shooting at the end of October and I decided to rent a house in La Jolla so I might be with Jack, as rumors were flying that his battalion was to ship out soon. Weeks passed, and during that time he was involved in marching, training, running, jumping, climbing, and crawling in the hot sun of San Diego. One day someone at the base telephoned me to tell me that Jack was in sick bay and might not be able to come home that night. I saw that there was some praying to be done. About 7:30 P.M. Jack arrived home.

"It's been a rough day," he said. "We marched for four straight hours in the broiling sun, and that is all I remember until I woke up in sick bay." He told me that he fainted and he described how his feet were just killing him and his socks were full of blood.

"From what?" I asked.

"Ever since childhood, I've had hundreds of warts on the bottom of my feet and toes. Whenever I have to be on my feet for a very long time, they start to bleed and now they want me to go into sick bay for maybe three weeks. I'm sure, in that time, my battalion will be shipped out, and I'll still be here. I want to go at the same time with Al."

I explained to him that with God all things are possible and asked him if he would consider having a Christian

Science Practitioner take up the case. We talked along these lines for about an hour, and he finally agreed, in the hope that it would get him overseas with his battalion.

I gave him the number of a Christian Science Practitioner who had helped me during the past three or four years, and suggested he call her to explain our conversation and ask her if she would consider taking the case. She requested that he memorize certain passages from the Bible, such as the 91st Psalm, the 23rd Psalm, and the Lord's Prayer. He promised to comply with her request, and she in turn told him that she would be happy to pray with and for him.

He told me the next evening, when he returned home, that he would certainly be sent into sick bay in the next forty-eight hours, and they didn't know how long he'd have to be there. He talked again with the practitioner, and she told him that God was in charge of him and of everything and everyone. "You will see," she said. "You will not have to go into your sick bay."

The next evening, he seemed quite calm. He'd been thinking a great deal about what the practitioner had said to him and spent much of his lunch hour reading the pocket-sized Bible, studying and memorizing and thinking about the deep, pure meaning behind the words. The look of anxiety had disappeared, and he seemed more content.

Four days later came a night I shall long remember. After giving me a rousing welcome after a long day, Jack went to take a hot shower while I prepared our meal. The lamb chops had been in the broiler for about two minutes when I heard the most horrendous scream from the bathroom. My blood ran cold! My first thought was that he'd slipped in the shower and hit his head. To heck with the lamb chops. I ran screaming, saying, "WHAT is the matter? What is the matter?"

He was repeating over and over, "I don't believe it, I don't believe it, I don't believe it."

"What is it? What's happened?"

He had a towel wrapped around his loins as he sat down on the edge of the bed and started to cry, but not painful tears. Joyous tears poured down his cheeks and fell upon the towel below. With one foot up over his knee, he said, "LOOK, LOOK, LOOK!"

I looked.

"They're gone," he said. "Can you see? They're gone."

He was right. There wasn't a trace of a wart on his toes or the soles of his feet. His whole foot was as clear as the palm of his hand. "Now I know what you mean when you say God is here and everywhere, throughout all space. Where did they go?" he said, as a question to me, but said in outspoken wonderment.

"Where does 7×7 is 41 go? It doesn't go anywhere. It never existed. It has no basis in existence. It's a false concept of the rules and laws of mathematics. 7×7 is 49. That's the truth. That's the law, and that's the rule. You are God's beloved child, and there is no separation between you and your Creator. Your obedience, Jack, in striving to learn more about God by studying the 91st and 23rd Psalms, is following the rule and the law. You have witnessed the results in the biblical quotation, '. . . all things work together for good to them that love God . . .' (Rom. 8:28). Let us now, both of us, pray a prayer of thanksgiving for opening our eyes to see more of His ever-present goodness, here and now."

With that, we held tight to each other while quiet sobs of gratitude punctuated that prayer. At this point, I lovingly reminded Jack that when he was shipped out, to wherever that should be, he should study daily the weekly lesson that is given in the "Christian Science Quarterly." This healing had proved something to him. He had never thought much about God or God's ever-present goodness, or that Jesus' teachings were given to us to prove our Christianity by working through prayer, as he admonished us to do.

Jack's religious training had been more or less zero, but

now he was seeing clearly, for the first time, that his Creator was supplying and meeting his needs. This spiritual element that allows us to see through the veil of tears is purity of thought expressed in gratitude to Him "who made all things." (And I always add, "all things good.")

A few weeks before Christmas 1943, Jack came home with an expression on his face that I had never seen before. "The look on your face is . . . is causing me to question you."

"I'm sure you know," he said, "that none of us really knows when we are going to be shipped out. It just happens—like a sudden squall of rain. But today the attitudes of the various officers I met make me believe that the time is imminent. Who knows, it just might be tomorrow."

"Oh, I see," I said. "Then, this feeling must be very strong."

"Yeah," he said, "even Al thinks that this just might be it."

We spent that evening after dinner quietly in front of a small fireplace, staring into the embers, wondering what tomorrow would bring. I reminded him that if the mails worked, I would see to it that he was never lonesome for me, as I would write him each day and would keep him up to date on everything that happened on this side of the Pacific.

"You know, of course," he replied, "I can't make you that promise. I wish I could. But I'll do my best to see that you have word from me as often as possible."

"Oh, I hate to see you go!"

With that, I buried my head in his neck in the hope that hanging onto him tightly would keep him from escaping into the far, unknown reaches of the South Pacific.

The next evening, upon his arrival home, he took me by the shoulders and looked me square in the eye and said,

"I was right. It could be any minute. If the telephone rings in the middle of the night, don't be too surprised."

That ominous night I waited for the phone to ring. I hardly slept, thinking that I wanted to be alert and awake if he had to tear out of the house. There was a possibility that I might not see him for many months or ever again. But I mustn't look at it that way, I argued with myself. That way is defeating. I prayed that God would show His child what was right and correct to do. And if Jack was needed, His Creator would be right with him all the way, there and back.

That night we were spared the telephone call. The next day, Jack called me from the base. "How would you like company while I'm away?"

"Well, it's according to who it is. What have you in mind?"

"Well, Effie Lou, Al's wife, has decided to stay in California to find a job, instead of going back to Alabama. It occurred to me that since you two seem to get along fairly well, maybe you'd like company."

"That's an interesting thought. It would be nice, since we both have a Marine going to war together."

He interjected, "We hope together. We don't know for certain whether we're going out on the same ship together or not."

"Well, God knows about that. Of that, I am certain."

Each day we were together was like a reprieve from the governor, a stay of execution. I decided not to let it hang over my head like a black cloud and to just enjoy the minutes we had left together.

"You know, you're a pretty good cook," he said. "I'll bet that is something no one has ever told you before. I love your spaghetti sauce."

"How about my untroubled eggs?" I asked.

His laugh was wonderful to hear as he added, "Yeah, but truthfully, I never ate a troubled egg. So maybe I don't know the difference." (My untroubled eggs are two eggs

whipped in a mixer with a quarter of a cup of milk per person. Place this in the top of a double boiler, being sure not to have too much water in the bottom pan, maybe only an inch. Cover the eggs and time for three minutes per egg. When the timer goes off, take a wooden spoon and *gently* scrape the bottom of the pan holding the eggs. If there is still too much moisture, cover again for another minute. After three minutes per egg has been tallied, look at the eggs again—they should look like a custard, as if they've never been troubled. Spoon a helping onto each warm plate and announce that salting and peppering is to each person's desire. Alas—you have untroubled eggs.)

With Jack's gentle gauntlet thrown down, I decided to fix him a feast he'd never forget: untroubled eggs with spaghetti sauce, green salad, refried beans, French garlic bread, and Chapman's ice cream with fudge sauce.

At 5:30, I heard the car door slam outside. I took the sauce off the fire while the bread was in the warmer. The only thing left to do was whip the eggs and pour them into the omelette skillet. Then, let him tell me whether I'm a good cook or not!

He came in and gave me a long, solid kiss. He held me close. After coming up for air, I said, "Come on into the kitchen, it's practically ready to eat. My favorite dish is going to be your favorite dish, too."

He wouldn't let me go. "I can't stay."

His eyes were saying goodbye.

"But haven't you just fifteen minutes?"

"Wouldn't you know, just when you've gone to all this trouble."

"And ice cream too."

"What kind?" he said as he held me tight.

It's hard to believe people talk about nothing, really, when they don't know how to say goodbye. He kissed me quickly this time and said, "I've got to go. Just remember one thing, I love you. Remember that."

He opened the door and dashed to the car. "I'll try to call you on the base from a pay phone, if I can."

He started the car, and down the hill it went. I stood there, numb, not knowing what to do. Should I watch the car go down the hill? Was that a goodbye? I did watch the car as it went down. . . .

Why have I been living in such a wonderland, I thought. Did I really think that in these war years, I could keep my man from going off to war? Well, here it is. The moment you thought would never arrive—or did you think of it at all? Now you have plenty of time to think of it. Just imagine how many women are feeling exactly the way you are, how many G.I. husbands have kissed their wives and gone to an unknown destination.

They, too, have said, "Goodbye, darling. Remember, I love you."

Knowing you're not alone in your emotion doesn't make that hollow, empty, alone feeling go away. Hundreds and thousands of women were trying to hold back their tears over that inevitable separation.

It was 2:00 A.M., and the telephone still hadn't rung. I put my head down to try to sleep a little. I didn't even take a shower the next morning, for fear of not hearing the phone if it rang. The pans in the kitchen were still full of the uneaten food. If I ran the water to clean up, I couldn't hear the phone. It was 8:00 A.M. and no word. At 8:30 the silence was broken. The telephone rang and I skidded across the hardwood floor onto a throw rug. Quickly I lifted the phone to my ear, for the first breath of his "hello." A high-pitched southern voice greeted my ear. "Is that you, Ginger? This is Effie Lou. Have you heard anything?"

"No, I haven't."

"Neither have I," she said. "I think that means they're on their way. Al said they ship out in the middle of the night. At least, those are the rumors he has heard."

I found out later that they had shipped out that night,

leaving the harbor without the lights burning. With the ship so laden with Marines, it was deeper in the water than it should have been and Jack and Al were up on deck all the night and morning. It was sneaking across the Pacific, going through perilous water lanes to reach New Caledonia.

I invited Effie Lou to come and share my house with me while Al and Jack were away. Effie Lou said she had to get up early every morning to work and didn't want to disturb me. I had to laugh.

"Effie Lou, what do you think I do for a living? Do you think I live off the income of my grandfather's pistachio farm in South India?" People never seem to realize that an actor's life is mostly work and rarely privileged.

I wrote to Jack every day and sent him packages of Irma's homemade chocolate chip cookies and salami, strange bedfellows to be sure, but good snacking food. To keep the salami from influencing the cookies, I dipped the salami in hot wax and set them on the sideboard to dry before packing them in the carton. I shipped out a box every fifteen days or so. Jack told me that the minute my care packages arrived, his friends lined up for a handout. Knowing this, I sent perhaps a hundred in each box so there was plenty to go around.

The war effort continued to take up much of Hollywood's time and energy. Some of the things we did—like selling bonds, performing in shows, and putting in time at the Hollywood Canteen—we knew we were doing; later, I was told many stories about how I had affected servicemen's lives without realizing it. One soldier, James Carrington, had been captured by the Japanese and interned in the Bilibit Prisoner-of-War camp in Manila. American movies were shown as a special treat and the first film screened was one of my pictures, *Tom, Dick and Harry*. All the men in the camp, from prisoners right on up to the guards and officers,

were seated on long narrow benches to watch the film, just as darkness came over the camp. James Carrington settled in to watch the film when he noticed that the guards were engrossed in the antics of the leading lady and oblivious to the surroundings. He decided to slip out, and in a short time was through all the barricades. His freedom was gained, I was later told, "because the guards were busy watching Ginger Rogers."

This letter appeared in a London newspaper and the clipping was sent to me by a friend:

There were twelve of us sappers seeing our first action in Italy during the war, and it was a hellish baptism by fire, with mortar shells and machine guns going off all round us. We were constantly challenged by our own infantry. I'll never forget our vital password, as long as I live. It was "Ginger Rogers." That name saved many a soldier during that terrible battle.

A World War II bomber had "Ginger Rogers" scrawled on each side of the fuselage. Letters came to me during the war from some of the boys who flew that bomber. They told me how well "she ducks in and out of the shells thrown up at us, like the dancer she is." The original plane was scrapped; however, when a British television company made a film about the air war, they took a B-17 and put my name on it as before, and a photograph of the reborn "Ginger Rogers" appeared in *Air Force Magazine*.

Members of a tank division in Burma saw a lifesized cut-out of me in a dancing dress at a theater and gained possession of it. Since it was about five feet tall, they couldn't bring it into the tank with them, so they took some heavy wire and wired it to the outside of their tank. That mascot advanced them safely throughout their Burma campaign. When they were shipped to India, they arranged to ship their mascot with them. Again, they placed the cut-out on the front of their tank and the cardboard me led the way!

33

A BEAR ESCAPE

WITH JACK OVERSEAS FOR ONE YEAR, I WAS GRATEFUL TO BE kept busy shooting films, making radio broadcasts, and helping out in the war effort with personal appearances and selling war bonds.

One of the myths about actresses is that we're too self-centered to be friends with other actresses. Well, Maggie Sullavan and I certainly disproved that theory. We had met at a party and became good friends long before she married my agent. I always welcomed Maggie's company and her conversation. Maggie and I both loved oil paintings, and occasionally we'd go to an art show together. Our expensive tastes led us to bemoan the fact that we never had six-digits in cash to buy a certain oil painting we loved. Later, we'd learn that a painting we admired had ended up in the collection of that fine actor Edward G. Robinson.

During February 1944, before I started work on a new film, Lela and I had enough gas ration coupons to drive to my ranch in Oregon. From my living-room window, I looked out to hear that impeccable silence that follows a heavy snow. I said to Lela, "Maggie would love this."

I finally reached her by telephone and invited her up. She said, "I'll come if I can ski."

"Well," I said, "it would be hard to play badminton. There's so much snow you couldn't see the bird, so skiing it is. Get here before the snow turns to ice, and we'll head up to Crater Lake."

Thirty-odd hours later, Mother and I picked Maggie up at the airport, toting her skiing gear. We had great hopes for the following day and for practicing our jump turns, stem turns, snowplows, and herringbone, uphill walks. Mother and I decided to prepare a hearty lunch to take with us, to obviate the need to search for a roadside restaurant. After all, wasn't it skiing that Maggie and I wanted more than anything? Too bad Lela didn't have our love of the sport.

After a hearty breakfast, Maggie, Lela, and I set out for Crater Lake, one of the wonders of the world. There had been a heavy snowfall and the two-lane highway looked like the route to fairyland. The air was so crisp and clean, and the snow glistened in the sun. The sixty-mile drive north of my ranch was a photographer's dream of silence, white chocolate, and beautiful arched branches. Lela was at the wheel of my station wagon, a Chrysler "woody," and I sat between Lela and Maggie. Suddenly Maggie cried out, "Stop the car!" She had spotted a group of bears on the side of the road. Mother pulled up.

"Let's watch them for a minute," Maggie playfully continued. "Maybe we could get a closer look at them if we gave them a cookie from our lunch." Maggie reached behind the front seat, taking a handful of cookies and sandwiches in one hand, while grinding down the glass window with the other.

"I don't think that is wise," Mother warned.

"I'll throw a sandwich out the window, and we can take a photo of the bear eating."

"Just as long as it's only the sandwich he's eating," Mother gently cautioned.

"Oh, Lela, they're only cubs. Wait until one gets up close." Maggie let out a whistle to catch the bears' attention. She sailed a sandwich out the open window, and through the air it went. Unfortunately, as she flung the sandwich it came apart and the meat fell onto the snow right below the open window.

In a second, the itty-bitty three-hundred-pound baby-bear was on top of the ham, eating away, and Maggie aimed her camera out the window. As her head touched the ceiling of the car, she dropped the cookies and sandwiches to the floor. Before she could click the button for her picture, the brown furry head of the bear and the face of the actress were slowly moving until they were only inches apart for a fraction of a second.

"Maggie, shut the window, hurry, shut the window!" I yelled. By now, the long talons of the brown bear were on the windowsill of the car and all the weight of his three hundred pounds was hanging on for more ham. Mother slammed her foot on the accelerator, but the rear wheels were embedded in the snow and the tires began to spin furiously.

"Margaret," Mother said firmly, "roll up that window."

Maggie couldn't move the bear-weighted window. The car was rocking back and forth like a kite caught in cross-ventilation. Maggie grabbed more sandwiches from the floor and tossed them out the window. Again, the ham fell to the snow below the door, and the bread went three feet farther. The bear was not interested in bread. During the ten seconds it took the bear to grab the meat, Maggie pumped the window three turns. Then he returned to put his grubby paws back on the glass. I tried to help Maggie get the window up, but it was no use.

"Cookies, cookies," Maggie said, as though she was announcing what was next on his menu. Grabbing cookies, she flipped them like playing cards out the window, and by golly, chocolate chip cookies saved the day. The

bear grabbed them and in one leap jumped up on the hood of the car, while Maggie finished rolling up the window.

Maggie's itty-bitty bear was now standing on the hood, looking at us through the windshield. He could no longer follow the scent of the ham sandwich, but what he saw through the windshield could have created a postscript to any bear's latest book of "Great Things to Eat" or a "Three in One" sandwich. He was greatly interested in looking each of us over.

"If only he'd move to the very back of the roof," Mother said, "instead of sitting there staring at us, we might get some traction on the tires."

As if by command, he jumped up on the roof and sat directly over our heads for about two minutes. We didn't have to wait too long. Mr. Bear obliged by walking to the rear of the car. His weight was making the strong roof of the car crackle. Mother hit the accelerator. Zoom! There went one wheel. When he moved to the left, again she pressed the accelerator. She quickly turned on the engine, put it in gear, and gave it some gas, all in a split second. That was just the trick we needed to get going. The bear came tumbling off the roof as we took off down the highway. Thank heavens Lelee used her cool and got us out. She was a bit miffed at Maggie for acting so foolishly, and so was I. Maggie was very apologetic and asked us to forgive her for underestimating the size and the appetite of the little "cub."

The rest of our stay was far more relaxing and we returned to Los Angeles, refreshed and revived . . . the way I always felt after a visit to Oregon, and the way I *still* feel after a stay in the Rogue River Valley.

In between radio broadcasts and my film commitments, I found time to do another recording. In March 1944, the Walt Disney Company asked me to make a recording of the Lewis Carroll classic *Alice in Wonderland* for the

Decca Records Personality Series. I had read this story as a youngster, and it was one of my childhood favorites. I was thrilled to make this recording, and it was a rewarding experience.

The sales of this recording were excellent, and I received many nice fan letters. One letter in particular that I remember very well was from a little boy who asked me to come to his house and play. I guess I sounded as young as he. Over the years, the letters have still come in, asking if I have a copy of *Alice* as they want to give it to their grandchildren. (This time Decca lived up to their agreement—no under-the-table recordings.)

I began work on *I'll Be Seeing You* for Selznick International in March of 1944. Working for David O. Selznick, even though he was not the producer on this film, was a great pleasure. We had another D. S. as producer, Dore Schary. William Dieterle, the director, always wore pigskin gloves while he worked. The cast included Joseph Cotten, Shirley Temple, Spring Byington, and Tom Tully. I had worked with Spring Byington before, but I had never had the chance to work with Joe Cotten, whom I considered a very good actor. The film was to be shot at the Selznick studios in Culver City with exteriors at Warner Bros. or at the Universal Ranch; the Selznick studios didn't have exterior locations. I thought it was an excellent dramatic story, based on a radio play, "Double Furlough," about two people who meet and fall in love during World War II.

One week, night shooting was scheduled for two or three nights. In one scene, Joe Cotten and I walk down the street and are attacked by a barking dog as we pass by his house. We didn't get the shot the first night because of a problem with the camera, and the wind and dust blew so hard that the sound couldn't be recorded properly. Now, on the second night, the cast and crew had to wait again for some technical problems to be fixed. If every actor had

a nickel for every minute he had to wait before shooting a scene, we'd all be millionaires.

I watched them try to set up the shot for a while and then went back to my dressing room. Joe Cotten came in and said, "Gee, I don't think they're ever going to get this shot done. We may be here for another couple of nights."

I kiddingly pretended to be drunk and said, "Well, I'm not going to go out there and shoot anymore tonight because I'm tired of waiting for this ridiculous scene to come up."

"Oh, you're funny," said Joe. "Why are you playing a drunk? You don't drink, do you?"

"No, I don't drink. I'm just kidding; but I can see why some actors turn to drink because of these long waits. They have nothing else to do, and then things get out of hand."

Suddenly, the practical jokester in me came out. "Hey, Joe, let's play a joke on Bill Dieterle. Go out and tell Dieterle maybe he'd better cancel tonight's shot because you've just come from my dressing room and found me three sheets to the wind."

Joe didn't think Dieterle would fall for it, but at my request he went out to the director to set up the joke. "How soon is the shot, Bill?"

"Well, another thirty to forty-five minutes before we can get this shot set up correctly," Dieterle answered. "The camera was wobbling too much so I'm having the crew set up dolly tracks."

Joe set the scene. "I wonder if you should consider working anymore tonight. I was just in talking to Ginger and I don't think she's in any condition to shoot."

"What do you mean?"

"Well, I was of the opinion she didn't drink, but by golly, she's really kind of gone."

"You're kidding!" Dieterle called to Victor Stoloff, the assistant director, and told him to bring me a batch of strong coffee and make me drink it.

Soon a great big pot of coffee arrived in my dressing room. Joe was amused when he saw the attempt to sober me up. "You know, Joe," I said, "this is not going to make me sober. I wouldn't be sober for anything in the world at this point. Do you realize how long we've waited?"

"Well, actually, we may not get to shoot the scene anyway, so your joke may have gone for nothing."

Ten minutes later, Victor came to my door. He eyed me closely, to see if anything was wrong. "Ginger, I ordered some coffee, but I haven't gotten it yet. Did you get my coffee by mistake?"

"Oh, there's some coffee here. You can help yourself." I continued to primp drunkenly in front of the mirror.

"How's it going? We're going to be ready to shoot in a few minutes . . ."

"Oh, sure, sure, that's what you've been telling me for hours, ten minutes, ten minutes . . ." I gave him the whole scene from top to bottom as though it was the usual thing for me to be alcoholed at this time of night. Victor couldn't believe that his friend, whom he knew so well, and who did not drink, was now in this impossible condition. He went back to Dieterle with this information, and immediately we were called to the set, for a rehearsal of the dolly shot.

Wiping the smiles from our faces, Joe and I walked out of my dressing room to our marks to begin our walk down the street. We had just started when I walked out of the camera blocking, waving my arms, saying, "Who cares, it's too late. I don't feel like shooting the scene anyway. Who cares."

Dieterle was so stunned at my behavior that he became red in the face. He was on a tight schedule and had to get this shot tonight. He asked us to try it again. "Okay," I mumbled, "but it's too late."

Joe and I walked down the block again, and once more during our dialogue I said, "You know, I don't think this is right. Are you sure this is right, because it doesn't feel

like it is right to me. And it's too late anyway to be doing this," carrying on further as if humorously drunk.

The whole crew stared incredulously at me, because they knew I didn't drink. Dieterle hurriedly walked up and said, "Let's try this again from the beginning, and maybe we can get a take, okay, Ginger—Joe?"

Under his breath, Joe said to me, "I think you better straighten up."

"No, they're getting their rehearsal, and this is fun," I said between my teeth.

We took our marks again, and at "Action" I started in again. Just as I was getting good, I saw Dore Schary, our producer, walk onto the set. The fake drunkard sobered up real fast. I went over to Dieterle and said, "I have to go to my room and fix my face."

Almost behind me came Dore. "Ginger."

"Yes," I said soberly.

"I understand you don't want to do this scene tonight."

"Dore, I'm only kidding. We have been sitting here for over three hours waiting to do this scene." I explained to him that just for these two rehearsals, I was swacked. Dore wasn't so sure. Finally, I walked over to the director and crew and told them of my practical joke and that I was just having some fun during the rehearsals. "But now I'm ready to shoot the scene, so let's go."

Dieterle looked at me as if he didn't believe one word I had said. Later he called Joe over and asked him if I was kidding. Joe reassured him that I was indeed kidding, and didn't drink. However, if Dore Schary hadn't walked in at that moment, I probably would have continued.

This was the second time I had worked with Shirley Temple (the first was *Change of Heart*), but now she was more grown up, all of fifteen. Edith Head was the costume designer and she sent the sketches for our costumes. My character, out on furlough from the state penitentiary, had only two costumes, a lovely navy blue chiffon evening gown and a basic two-piece traveling suit with a couple of

different blouses. Shirley, on the other hand, had several changes. In one scene she was supposed to wear a skirt and sweater. Dore Schary came on the set and asked why Shirley wasn't wearing the sweater he'd okayed. It turned out that Mama Temple didn't want her little girl wearing a sweater in a movie. I'm sure she thought it would delineate her daughter's figure too much. Schary convinced Mama, and the next thing I knew Shirley was wearing a sweater. The film was released in late 1944 and immediately, teenagers across the U.S.A. began wearing sweaters.

The nostalgia of war and romance in this film mirrored my real-life story. The agony of being separated from someone you love, coupled with the threat of losing him, was unbearable.

34

MÉLANGE

In October of 1944, Arthur Hornblow, Jr., called me from MGM. The studio was planning to do an updated version of *Grand Hotel* with Robert Z. Leonard directing, and I was offered the Garbo role. "You'll have lots of pretty clothes to wear designed by Irene, and Sydney Guilaroff will be doing your hairstyles," Arthur told me, piling on the inducements. Wearing clothes by Irene, how could you go wrong? And with Sydney caring for my hair, *Weekend at the Waldorf* was going to be a breeze.

This was the first time I had worked for the giant, MGM, and the studio really pulled out all the stops. The sets were so convincing that I really thought I was at the Waldorf Hotel in New York and not on a sound stage in Culver City.

MGM used plenty of its star power, too. I had never met Walter Pidgeon before, and I found him delightful and easygoing. His war correspondent was very convincing. I was just sorry I didn't have a scene with Lana Turner, who played the public stenographer, and more of one with Van Johnson, whom I just passed on the stairs.

Both of them were so darling in the film. And I was particularly pleased since I had said Van would be a star in movies. For the musical interludes, Xavier Cugat was along with his wonderful orchestra. Although we didn't work in any scenes together, Edward Arnold gave his usual "bad guy" character lots of life. Robert Benchley filled out the cast as the know-it-all newspaper columnist who lives in the hotel.

When the day came for Walter and me to do a particular scene, however, the dress I was supposed to wear wasn't finished. Rather than hold up production, Arthur Hornblow asked if I had a dress of my own that might be suitable. I never expected to hear a question like that from MGM! I did have a black silk grosgrain dress designed by Irene, and I sent Irma home to get it. It must have been somewhat embarrassing for the producer to ask the star to dip into her own wardrobe to help costume the film.

In June 1945, I was contacted by RKO and asked to appear in a film. It was a welcome call, for I had not worked on the RKO lot for almost two years. I wondered if, because of the many changes at the head office, the atmosphere would be different. Charles Koerner was now head of production and catering to independent production deals, one of which was my next film.

Robert and Raymond Hakim, producer brothers, had bought the American film rights to a French picture, *Battement de Coeur*, and sent me the script adaptation, *Heartbeat*. I found it a charming, different kind of comedy. My character, Arlette, was a homeless waif who's brought into a school for thieves and trained to pick pockets. Because Arlette was a simple street girl, I decided not to wear too much makeup; as in all my films, I was willing to appear less than perfect if it suited my character. Consequently, my face shines like a polished apple. *Heartbeat* gave me another opportunity to work with Sam Wood as

the director, and I was grateful to have the excellent photographer Joseph Valentine. Jean Pierre Aumont played opposite me and was as charming a leading man as you could imagine. Basil Rathbone played the instructor of thievery, and my friend from *Roxie Hart* and *Stage Door*, Adolphe Menjou, played the diplomat for whom I had to perform this newly learned ability. The plot was paper-thin but the audience was kept in suspense and I think they enjoyed it, even if the critics didn't.

The first day of shooting was July 12, and as usual, I was tired after a strenuous day. I came home and planned to spend the evening relaxing with a book and catching up on my mail. There was a knock at the front door and—"Surprise, surprise!"

There was Jack, standing on the front step. I fell into my husband's arms. I couldn't hug him enough. He was home from the war.

We talked all night. He told me what had happened on the front lines. "The guys nicknamed me 'Lucky,'" he said.

"Lucky? Why?"

"Because you gave me a Bible and *Science and Health*. I studied it every day like you told me, and nothing ever happened to me," he whispered softly.

As we talked in the dark, my eyes filled with tears.

"Every time there was an air raid, the guys said, 'Where's Briggs? Jump in the foxhole with him. He's always safe!'"

My heart nearly burst with gratitude to God for keeping him protected.

The only mishap he had was shrapnel in his leg, but that was as far as we got in this first session of our rediscovery of each other. Our reunion was sweet, and I had rehearsed it over and over in my thoughts during his absence. The war had changed him; he was a different person, but it was great to *have him home*!

The next morning I could hardly tear myself away from

him. Now that my husband was back, it was a real chore to have to go to work. Irma Scheid, my housekeeper-cook, couldn't do enough for him and stuffed him with home-cooked meals.

Fortunately, the war in Europe had ended in May and now, in July 1945, there was a light at the end of the tunnel. V-J Day was only a month and a half away.

Shooting on *Heartbeat* was finished in October 1945, and now I had time to devote to my husband and my home. I noticed that something new had been added to Jack's behavior when he returned from the Pacific, and I decided to talk to him about his drinking. He said, "It's not a permanent thing."

So now all I could do was pray, but even in prayer there's a need to recognize and cease the temptation that is knocking on our door incessantly.

I did a few radio broadcasts, but basically I was free as the breeze until April 1946, when producers Jack Skirball and Bruce Manning contacted me about playing Dolley Madison, the wife of President James Madison, in an adaptation of Irving Stone's historical novel *Magnificent Doll,* for Universal. They sent me a copy of the book, and I was greatly flattered that they wanted me to portray Dolley Madison.

Dolley Payne Madison was a forerunner of that most distinguished Washington hostess, Perle Mesta, who learned which Republican to sit next to which Democrat in order not to create a brawl. That was not an easy diplomatic task, and history recognized Dolley for her skill in mixing opposite forces with taste and grandeur.

I had the joy of working again opposite Burgess Meredith, playing James Madison, and David Niven, cast as Aaron Burr. One terrible event marred this production. The night before we started shooting, David and his wife, Primula, attended a private party. Game playing at parties was the rage and that evening the guests were involved in a hide-and-seek diversion. Primula ran to hide

and, going through what she must have thought was a closet door, fell down the stairs to the basement, to her death. David and Primula had been one of Hollywood's happiest couples and he was devastated. The producers did everything to make it easier for David, as did all of us on the film. We pushed him to continue working to keep him occupied. Though David looked particularly handsome in the period costumes and gave a fine performance, in conversation he always gave this film a zero. His attitude and memory were affected by his loss.

Burgess Meredith was perfectly cast as Dolley's thoughtful and loving husband. We enjoyed all our moments in this film, even if there wasn't any "woo," as there had been in *Tom, Dick and Harry*.

Frank Borzage, the director, was a nice man; however, his drinking interfered with his attention to the script.

As we worked through the film, much of the dialogue left an empty feeling in the pit of my tummy. One scene at the end of the film finds Dolley confronting an angry crowd, reminding them that they must reject the mob mentality, which favors hanging Aaron Burr, now that he is a free man. As I was memorizing this scene the day before we shot it, I realized it was like an empty box: nice on the outside, but nothing inside. It really didn't go anywhere. When I got home that night, I told Mother over the telephone my deep feelings about this scene. It had no life or fervor and yet should be the denouement of the entire film.

Mother came over after dinner, and we sat up until 6:00 A.M. the next morning, discussing the scene and writing and rewriting it. That morning on the set, I presented my newly rewritten scene to Borzage and the producers and they readily accepted the revised version. In my opinion, it couldn't have worked any other way.

✦ ✦ ✦

After finishing *Magnificent Doll*, I was invited to the White House to see the actual portrait of Dolley Madison and I happily accepted. While I was viewing the portrait, someone asked if I wanted to meet President Harry S. Truman. "Yes, I would," I said. "We are both from the same state."

Inquiries were made, and in a short while I was ushered into the President's office. He was busily working on some papers, which he took a moment to finish, and then looked up and said, "Now I'm ready to meet the young lady."

"Mr. President," I said in a teasing tone, "you and I are from the same city in Missouri, and I am here to register a complaint. No one realizes I'm from Independence and everyone knows you are. I'm jealous."

"Oh, you are?"

"Yes. I'm proud to be from Missouri and Independence."

With a twinkle in his eye, our thirty-third President said, "Well, we'll have to do something about that."

Almost twenty years later, on July 23, 1964, something *was* done; Independence, Missouri, had a "Ginger Rogers Day." Mother and my good friend Shirley Eder, a journalist from Detroit, joined me for the festivities. On the grandstand with me was former President Harry S. Truman. After the ceremony, Mr. Truman and I were given shovels to break ground in Independence for a new electrical system. Then he invited us to tour the Truman Library, where we spent three wonderful hours with the former President as our guide. Before we left, he tried to reach Bess, but she had spent the afternoon at her favorite sport—fishing. So Harry Truman has his library in Independence, and I had my "Ginger Rogers Day." That seems fair enough!

Before, during, and after the war, I was working steadily on one film after another. Although I didn't work at the

back-breaking, back-to-back pace of earlier days, I had steady employment. During the summer of 1947, I made *It Had to Be You* for Columbia. Don Hartman and Rudolph Maté co-directed, with Hartman producing. Norman Panama and Melvin Frank came up with a very amusing script about a girl who backs out of four marriages. In the end she finds the answer to her dreams and the reason for her vacillation. The "answer" was played by Cornel Wilde, who usually appeared in robust adventure roles. I must say, he marched into this picture as though he had done farce all his life. Spring Byington played my mother this time (Lela wasn't available), and I got to act for a few moments with Anna Q. Nilsson, a silent film star.

It Had to Be You was a cute picture. Don Hartman even tried to rent the Hope Diamond for me to wear, but he was unsuccessful. I loved the multi-wedding aspect of the film because I could wear *four* different wedding gowns, all of them designed by Jean Louis, who was under contract to Paramount at that time. Each gown was prettier than the one before, and I also had a number of stunning suits to wear. I remain partial to Jean Louis's styling, and I've called upon him and his designing ability quite frequently.

In 1947 my mother was asked to appear at the hearings of the Committee on Un-American Activities of the House of Representatives. Concerned about the Communist infiltration of the motion picture industry, Lela had become a founding member of the Motion Picture Alliance for the Preservation of American Ideals.

In her testimony, she was asked why it was formed. She answered,

"The organization was formed in an attempt to combat the threat and the menace that we saw arising in

Hollywood, the Communist infiltration in Hollywood in our unions and the guilds, and in our scripts and stories and direction and all avenues and all departments of the motion-picture industry. We felt that if we could bring this to the attention of the men in power, who had the right to hire and fire these people, and try to show them what these people were doing to their industry, that we could possibly save them from what we saw ahead, it would have to come out into the open and be dealt with summarily as is now being done."

"Do you think the alliance has done effective work since its formation?"

"Yes, sir. I feel that the alliance had been right effective in that it has brought out the menace so that it could be looked at by other members of the industry, so that they would recognize it and feel it, and then learn what it was and how it worked."

"Why are some of the persons in Hollywood who have been very successful in their lives, writers, actors, businessmen; why would they follow the communist line?"

"I have often asked myself that. When a man sits alone with his soul and sees what we have in America, and if he is an intelligent man he has looked around to the rest of the world and has seen the condition that the rest of the world is in, under their forms of government, I often wonder what in the world he is thinking about. . . ."

I was very proud of my mother for having the fortitude to go to Washington, D.C., and speak in front of the Committee. Do you think Lela was a Russian hater? NO! She took time to explain that she saw through that veil of deceit. Their ignorance of what freedom really is made her blood boil. Gary Cooper, Robert Taylor, and Adolphe

Menjou were in step with Mother's views and also testi-
fied as friendly witnesses.

Many years after the hearings, I was touring the coun-
try giving some interviews. One radio talk host asked to
meet me for a Chinese dinner before the broadcast. He
was quite late and in an alcoholic fog when he arrived at
the restaurant. Our meal was quite good and he was
friendly, I remember that. When we finished dinner, he
stumbled to his car and I walked to my limo. At the radio
station, he turned into an angry interviewer and hurled
sharp questions at me. "Why did your mother testify in
Washington against her motion picture friends?"

I wasn't prepared for this. I am often unprepared when
so-called hosts unexpectedly attack my religion or my
mother. I said a quick prayer before I answered this inter-
rogator. "Have you read the text?" I asked him.

"No," replied the host.

"How can you possibly ask such a question when you
haven't read her complete testimony?"

That was the end of that! And I would give the same
answer today.

ONE MORE TIME

DURING A WELCOME BREAK IN THE SUMMER OF 1948, I WENT
up to my ranch in Oregon with Mother. She loved the
ranch as I loved being there, away from the "madding
crowd." On a beautiful June morning, I was seated in the
awning-covered swing on the front lawn. Everything was
calm and lovely; the sunlight filtered through the oak
trees and the air echoed the constant song of the Rogue
River in its icy rush to the Pacific. Suddenly, the serenity
was shattered by a shrill ringing. Our housekeeper, Mrs.
King, called me to the phone and I reluctantly left my
tranquil haven to answer.

The man on the other end of the wire introduced him-
self as an executive at MGM. After apologizing for break-
ing into my vacation, he came right down to business.

"Would you have any objections to doing another film
with Fred Astaire?"

"What kind of a question is that?" I exclaimed. I was
irritated at the manner in which I was asked; how ungra-
cious to assume I *wouldn't* want to work with Fred. We
had parted as friends and maintained a cordial, if distant,

relationship. I think it's ridiculous for anyone to corner me in such a way! I *never* felt that way about it. In the past, I had wanted to do something on my own, but never anything against Fred—ever. "I would adore to make another film with Fred," I told the fellow, adding, "What have you in mind?"

"We've lined up a property called *The Barkleys of Broadway*, with Chuck Walters directing. Now that I know you're interested, we'll contact your agent."

The next thing I heard, it was a fait accompli and I *was* going to make another film with Fred. I was delighted! My next move was to start exercising, limbering up, stretching, and getting my breathing even and unlabored. To get back into your dancing shoes after ten years is not the simplest thing to do. It doesn't happen overnight. But it felt good to be putting myself through these rigorous activities. I began to feel like I could jump to the moon. It was a delicious feeling. When rehearsals began, I was ready.

When I reported for work, I was taken to the costume department, where Irene showed me some sketches. She designed some absolutely exquisite evening gowns for me. The first number in the film was the "Swing Trot," and I suggested that I wear a gold lamé dress to contrast with the purple chorus gowns. My dress had a very full skirt and when I whirled, it filled with air because of the way it was sewn—balloon-style at the hem. Another favorite gown was made of white marquisette, which is soft and floats like a feather. A white dress in a color film is supposedly outlawed, but cameraman Harry Stradling was willing to risk it for this one. At that time, I had quite a good suntan, and my back was black from sunbathing in the Oregon sun. Needless to say, my white dress with its soft, full skirt was smashing. With Sydney Guilaroff to supervise my hairdos, I was all set.

The supporting cast included Oscar Levant, Billie Burke, Jacques François, and Gale Robbins. Billie Burke,

a great beauty, had been married to Florenz Ziegfeld. She specialized in playing dizzy society ladies, though her most memorable screen role was as Glinda the good witch in *The Wizard of Oz.* Oscar Levant, the actor-pianist, was, next to George himself, the greatest exponent of Gershwin's music. Oscar's acerbic personality was the same on and off the screen. His biting dialogue appealed particularly to intellectuals. Although he had a notable career and a successful marriage, he never struck me as a very happy man. His seemed to want to live the day after tomorrow while he was still living through today. He couldn't wait for the next two or three days, but anticipated them in dread. Oscar, Fred, and I were a strange combination, but in this film it worked well. And for the first time, Fred and I were being filmed in Technicolor!

On the first day of work, I went down to the rehearsal hall to see Fred. He was sweet and friendly, but I could see he was slightly disappointed. I had learned that Judy Garland had originally been signed as his co-star. They'd just worked together on *Easter Parade* and I knew Fred had a slight crush on her. When Judy Garland was taken off *The Barkleys,* I was pressed into service.

Harry Warren and Ira Gershwin were responsible for the music and lyrics. They played the whole score for me and I was a little disappointed; I didn't hear anything that resembled a hit. Harry and Ira said they were about to write one more song for Fred to sing to me. It was supposed to bring the protagonists, a husband-and-wife dancing team, together again. As they described the situation to me, I had an inspiration. "Why write another song, when you've already got one that's never really been used?" I said.

"What do you mean?" they asked.

"In *Shall We Dance* Fred sang a gorgeous song to me, only we never danced to it. The melody is beautiful and the lyrics really fit the circumstances." I was describing "They Can't Take That Away from Me." Of course,

George Gershwin, not Harry Warren, was the composer, and that could have created a sticky situation. But Harry was big-minded and agreeable, and after listening to the lyrics, he conceded that they couldn't have found a more suitable song. It had a double significance for Fred and me, because we had done nine previous films together and this was a reprise from one of them, a real musical memory for us, and the audiences who knew us, to savor.

A week after rehearsals began, I bumped into Arthur Freed, our producer. He was quite excited and asked, "Did you hear the news?"

"No, what news?"

"Well, I just came up with the most wonderful idea for *The Barkleys*. I just told Harry and Ira we should use 'They Can't Take That Away from Me.' Remember? . . . the song Fred sang to you in *Shall We Dance*. Don't you think that's a beautiful idea I had?"

My mouth fell open. I didn't know what to say. Obviously, Arthur had spoken to Ira and Harry and they'd told him what I'd said. Now he had turned around and made it *his* brainstorm. I believe in giving credit where credit is due, and was crushed that my idea had been usurped. I didn't say anything to Arthur, and when I told Fred the story, he waved his hands as if to say, "What can you do?" Sometimes Fred had a laissez-faire attitude, and would wave things off with a toss of the hand, whereas I would wade into things with both fists up and ready.

Once Fred and I began rehearsing in earnest, the ten years fell away; honestly, it seemed a matter of mere weeks since we'd been on the dance floor. One song, "Bouncin' the Blues," was a very energetic tap number, which I loved doing.

I love it, too. I was very pleased he felt that way as well. Fred's solo, "Shoes with Wings On," was choreographed brilliantly by Hermes Pan. The scene was originally photographed against black velvet, in front of which danced people dressed in black and wearing white shoes.

This filmstrip was then integrated into Fred's number to provide the illusion of Fred dancing with shoes that are "alive." I watched Fred while he did this number and knew it was going to be spectacular!

One day, Judy Garland came on the set; we were shooting "They Can't Take That Away from Me." She looked daggers at me as though it was my fault I, not she, was dancing with Fred. The fact that she was not in the film had nothing to do with me. I was an innocent bystander. I knew the studio worried about her stamina and didn't want to take a chance. Her track record wasn't good; she'd be on the set one day and then off the next two or three. This kind of erratic behavior cuts right into the heart of motion picture production—the financial structure. Though I had nothing to do with her being ousted, I could tell she blamed me for her dismissal.

I had a quirky relationship with Judy Garland; she tried to be friendly, yet something always went amiss. Once, a few years earlier, she invited me to a cocktail party at her home. I arrived at her house on the appointed day and was greeted by the baby nurse, who told me Miss Garland wasn't there but would be back any minute. I waited, figuring she might be bringing the other guests back with her. After more than an hour of cooling my heels, I left. I asked the nurse to tell Judy I had been there and that I was sorry to miss her. Perhaps I had the wrong date? I never heard from Judy, and actually hadn't spoken to her again until the day she came on the set.

Judy, Fred, and I had a few photos taken together and then she wandered off. I was waiting on the sidelines when Chuck Walters called me over. "Ginger, I think you'd better go into your dressing room and wait until I call you. Judy is acting so strangely. I don't want you to get upset." I did as he asked. I later heard that Judy was

fooling around with the crew and holding up the shoot. In the end, she had to be physically removed from the set.

The Barkleys continued. Although everyone at Metro did all they could to make my dresses and coiffure look correct, shooting in Technicolor was very hard on an actor's eyes. In many of the shots you'll notice that our eyes are at half-mast because we were squinting from the glare of the bright lights. Sometimes you couldn't even see the actor you were playing opposite. *The Barkleys* opened to quite good notices and the public responded positively. Even if some reviewers were overly critical, I still like the movie myself, though I recognize the weakness of the score. Not surprisingly, the biggest hit was the recycled "They Can't Take That Away from Me."

In December 1948, my second seven-year free-lance contract with RKO was mutually cancelled. For the time being at least, I could enjoy the luxury of relaxing without any undue pressure from the studio.

My personal life also had another kind of cancellation. Jack Briggs and I made a pronounced decision to call a halt to our marriage. He was full of grandiose schemes about producing movies and making fortunes, overblown plans that were often the result of late-night drinking sessions with his pals. Jack's opportunity to be somebody in the show business world, if he wanted to, was right there. We could have worked together very well, and very happily, but the war had changed him and he was drinking a lot (maybe, a little is a lot for me). In reality, he was no longer married to me and certainly was not the young man I had met many years before. No matter what I said, no matter how I talked to him about it, it made absolutely no impression on him. He was lost to me. He couldn't keep a productive thought in his head. It was my hope that he'd

work out his problems. Later, Al Flanagan, his Marine buddy, told me that Jack had quit drinking completely, remarried, and become a successful salesman. I've never heard from him since our divorce, but was happy things had worked out better for him.

Six months into the new year of 1949, I started shooting *Perfect Strangers* for Warner Bros. The first-rate script was based on the play *Ladies and Gentlemen* by Ben Hecht and Charles MacArthur and the film was directed by Bretaigne Windust. Dennis Morgan and I had fine support in the persons of Thelma Ritter, Marjorie Bennett, George Chandler, and Paul Ford. It was a good story of a sequestered jury during a murder trial. As the story unfolds, the leading characters fall in love, even though he is already, but unhappily, married, and each wonders how their relationship will fare after the trial ends. This script gave me a chance to work again with the very handsome Dennis Morgan. We had wanted to work in another film ever since *Kitty Foyle* and this was the perfect opportunity.

In November of 1949, Warner Bros. sent Leland Hayward a script, asking him to get it to me as soon as possible. *Storm Warning*, a melodrama about the Ku Klux Klan, offered me the kind of challenge I wanted. I told Leland to say "yes" immediately. The casting of this film was very good and offbeat for another actress as well: Doris Day played a nonsinging role as my kid sister. I didn't really know Doris, but I liked her. She was open-faced, honest, and straightforward and I was looking forward to meeting her. Steve Cochran was outstanding as her husband. After reading the script two or three times, I realized that Steve could steal the movie from the other actors by playing his character sympathetically. The district attorney desperately working to halt the Klan's murderous progress was played by Ronald Reagan.

When shooting was finished and I saw the rough cut of the film, it was evident why Stuart Heisler had been chosen to direct this melodrama. Heisler knew his craft and understood the pace necessary for this type of movie. I was impressed. In one very dramatic scene toward the end of the film, Steve begins to follow me around menacingly. Before he corners me, his wife walks in and surprises him. Heisler photographed it almost as Hitchcock would have done. Unfortunately, now the television stations have cut that scene to mere seconds, losing the full impact Heisler wanted and leaving some unexplained story points.

Toward the conclusion of the story, the members of the KKK are furious with me for telling the district attorney that the killer I saw *was* wearing a hood. That description has only one meaning to the authorities. As the trial ends, I am grabbed and taken to the place where the KKK is holding its meeting. There they whip me with a leather whip, of the type once used on slaves. I was amazed how authentic this whipping looked on screen. In reality, it felt like a dozen shoe strings lashing at me, and never for a moment really hurt.

Reviews of this film were quite good. Without exception, the critics found everyone in the film to be dramatically sincere. Since the fourth estate usually has a few unkind words to bestow, this was a wee bit unusual.

In March 1950, the Academy Awards ceremonies were held at the Pantages Theatre in Los Angeles. About ten days before the event, the Motion Picture Academy asked me to present Fred Astaire with an honorary Oscar. I said I would be delighted to be a part of the presentation. It was great fun for me to present an Oscar to my longtime dancing partner. "For his unique artistry and his contributions to the technique of musical pictures," was engraved on his Oscar. He seemed very happy to receive it. But I

knew that deep down, it was hard for him to accept anything from anyone; he never knew how to react to a gift. But he was very convincing that night, even if he was 3,000 miles away in New York, and accepting the Oscar by a cable hook-up. I couldn't have enjoyed it more if they had handed the honorary award to me.

From May through August 1950, I was shooting *The Groom Wore Spurs* at Universal. It was a lightweight bit of fluff—cowboy style—which I did with Jack Carson and Joan Davis. Jack plays a rich, not too bright, cowpoke, and I'm the lawyer who tries to keep him out of jail. Joan Davis provided the broad comic relief. One bit player in this film, Ross Hunter, went on to glory in later years as a producer.

The live stage seems to be a "first love" for most actors and actresses. I was no exception.

The legendary and mysterious Sarah Bernhardt is the role model for many aspiring actresses. Almost every actress secretly waits for some producer to say to her, "You, my dear, are just the ideal one to play the life of Sarah Bernhardt."

So I was delighted to be contacted by a gentleman named Louis Verneuil. Mr. Verneuil wanted me to return to the legitimate theater in a play he had written and in which he could "envision only Ginger Rogers as the star." Verneuil had written a number of successful novels and plays, but his chief claim to fame was his association with Sarah Bernhardt. He wrote the last two dramas in which she appeared, *Daniel* and *Regine Armand*. Indeed, Verneuil claimed he was the one author/director whom the great Bernhardt really trusted.

I met with Verneuil in the Polo Lounge at the Beverly Hills Hotel. He handed me the script of *Love and Let Love*. He tried to explain a little by saying, "Eet ees a comeede avec sees deeferont speekeng roolz."

"Only six actors in your play? That cuts down some of the overhead too, doesn't it," I added.

I patiently waited for the other shoe to drop. Finally, I just couldn't wait any longer, I had to ask the major question. "Mr. Verneuil, does this play have something to do with the life of Sarah Bernhardt?"

This question evidently took him by surprise. "Why vood you aask zot?"

Through blushing pink cheeks, I mumbled something like, "You spoke so incessantly about her on the phone, I thought this play had something to do with the life and loves of Sarah Bernhardt, I guess."

With Anthony Farrell producing, and the writer as director, the project caught my fancy, so I signed to do it and got in touch with Jean Louis to design the costumes.

The final cast included Paul McGrath, Tom Helmore, Helen Marcy, and David F. Perkins. In an enticing second role, that of my own sister, I was billed as Virginia McMath. We went into rehearsal and planned to play on the road for four weeks, starting in San Francisco, and then to open on Broadway at the Plymouth Theatre.

The costumes were splendid—as it turned out, they were the best part of the play. The problem was the dialogue. This was a comedy with unfunny lines. At an early rehearsal, Lelee sat out front and came back afterward to speak with me.

"Darling, there's a need for a few more jokes in such and such a place in the script."

"Yes, Mother, I know. I wish you would talk to Mr. Verneuil. I mentioned it to him this morning during rehearsal." We both spoke to the playwright before the next rehearsal, pointing out a dull, dead spot that needed to be shored up in the first act. Furthermore, there was a huge crater in the second act that needed surgery.

Upon my telling him these things, Mr. Verneuil would take my hand, kiss it, and look into my eyes as if to say "I weel feex eet."

Well, he didn't "feex eet."

Love and Let Love opened on October 19, 1951, and lasted fifty-one performances. During the first weeks of the show, I dared to do something I never really liked to do—*look* to see where Verneuil was sitting. There, in the first five rows, I located him. When the joke lines got only chuckles instead of real laughs, I looked for his reaction. I could see he was listening. At least *he* was paying attention.

One night, during the performance, I saw a gentleman and a lady cross over in front of him to get to the aisle. I never saw that couple in their seats after that. Later, after that night's performance, I asked Mr. Verneuil if he had noted that people were somewhat discouraged by the lack of comedy in his show. "And what about those two folks who crossed over in front of you as you sat there? They must have HATED the show," I said.

He looked at me and said, "What people?"

Oh, no, I don't believe it, what have I gotten myself into?

I was so disappointed. I had returned to Broadway after twenty-one years, but in an inferior vehicle. To this day, I'm convinced that if Verneuil had sharpened the dialogue instead of kissing my hand, it might have worked. The only positive aspect of my brief Broadway return was my appearance on the cover of *LIFE Magazine*, my fourth, on November 5, 1951.

Two weeks later, Twentieth Century–Fox asked if I was available to do *We're Not Married*. The movie had a mischievous premise: a justice of the peace marries five couples during a period when his license is invalid, and the rest of the film follows the adventures of the unknowing un-weds. Fred Allen and I had a good time doing this wacky comedy, in which we were cast as a couple who have an early morning radio program. We ignore each

other in real life, but when we're on the air, we bill and coo and simper. Fred's dry humor cracked me up during the reading of the script and I found him terrific to work with once the shooting began. Victor Moore played the unlicensed justice of the peace with all his charming skill at bumbling. The film was a hit, and our segment received the best notices.

Two weeks after finishing this film, I was scheduled for another comedy at Twentieth Century–Fox, *Dreamboat*. Clifton Webb and I played two yesteryear silent-screen stars. Clifton was really funny in this film and played his stodgy professor role with his customary artistry. This movie was alive with wonderful character people like Fred Clark and Elsa Lanchester, and featured two young, bright, up-and-coming stars, Anne Francis and Jeffrey Hunter. Gwen Verdon has a tiny spot on a television screen in the film, but more important, she helped to choreograph the harem dance I did, in costume, in one of the silent-screen segments. I was embarrassed at being clothed in such a skimpy harem costume, complete with black wig; I was never at ease wearing too little. The way things are on the screen today, with nothing left to the imagination, I don't think I'd be making movies. One day, Marilyn Monroe dropped by the set for a visit. I was wearing a wonderful gold lamé evening dress and Marilyn liked it. Moreover, she told the front office she wanted it. She got it and wore it in a brief scene in *Gentlemen Prefer Blondes*.

All any producer ever had to do was to tell me his proposed film had Cary Grant as the male star, and I'd be there with bells on! Then, if the director was Howard Hawks, it was a certainty I'd say yes, because I've always loved Howard's films. I knew he would bring out every comic detail of the Ben Hecht/Charles Lederer/I. A. L. Diamond script of *Monkey Business*.

Cary played an absent-minded professor whose employers want him to find the fountain of youth. I played his long-suffering wife, Edwina. She and the professor unknowingly drink some of a potion mixed by a laboratory chimp, and they revert back to childlike behavior.

Even though it had been almost ten years since Cary and I had worked together, it felt as if we had been together only yesterday. When you know somebody that well, it's easy to pick right up again.

One day, while the crew was lining up for a shot, the frisky chimp got away from his handlers and scampered up onto the catwalk above the set. It took a long time for the crew and handlers to capture the chimp, and it was quite a sight to see grown men running back and forth on the catwalks, climbing up ropes and ladders, trying to catch a monkey!

Marilyn Monroe had a role in *Monkey Business;* she played the secretary to Cary's boss, Charles Coburn. There is a delicious moment in the film when Coburn hands Marilyn a paper and says, "Find someone to type this." Marilyn exits and Cary looks at Coburn quizzically. Coburn replies, "Anybody can type!"

36

I LOVE PARIS!

IN EARLY 1952 I WAS ON THE BRINK OF ANOTHER SERIOUS relationship. Working with Cary Grant again, after almost ten years, made me even more enamored of this joyous fellow and his wonderful sense of humor and charming ways. When we were dating in the late thirties I found Cary totally captivating, but my heart was elsewhere. Sensing this, Cary did not press me any further for a more serious relationship.

When my romance with George Stevens ended, Cary was involved with someone else, and by the time we made our first film together in 1942, Cary had married Barbara Hutton. When his marriage broke up, I was already married to Jack Briggs. When my union with Jack ended, Cary was remarried, albeit unhappily. And now in 1952 we met again and the smoldering embers were ready to be rekindled.

Knowing that Cary had traveled a great deal, I asked him where a novice traveler should go on her first time out of her own country. My vacation was due, and I wanted desperately to find some place that would be different,

interesting, and exciting. Since I had never been to Europe, he suggested it was high time I went. What's more, if I were to time it right, he, too, could possibly meet me somewhere on the Continent, which conjured up "an exciting adventure."

Cary made some inquiries for my trip and gave me the names of friends I should meet and the best places to go for a good time. He knew I was not big on cocktail parties and that active sports, such as tennis and swimming, were much higher in my priorities than party life. The more we talked about the trip, the more people he wanted me to meet once I got there. He was getting excited for me. I planned to go as soon as filming on *Monkey Business* was finished, which meant mid-July. He checked which ships were leaving around that time and had comments on each one. He highly approved of the *Ile de France* and told me what kind of accommodations I would want. Cary apologized because he couldn't get away at the same time to show me some of his old familiar haunts and see them through my eyes. I felt as though I was in the hands of a great admiral who knew his way across the pond. I was indeed right!

His enthusiasm set me to work to decide exactly where or what in Europe I wanted to see first. Where do I want to go? Why, France, of course. Certainly to begin with *Paris* sounded like the right plan. Cary recommended that I stay at one of the best hotels there, the Meurice. Trusting his judgment, that's where I stayed. Since then, I have always stayed there.

Mother turned down my invitation to accompany me. She wasn't a great traveler and preferred to read about other places than to visit them. "I know more about that country than you'll ever know, though you may have traveled through it for months," she'd tell me when I tried to induce her to join me. Lela was a student. She would read till dawn, while telephones were silent and the world was quiet. Her light was always on hours after everyone else's

had been turned off. Without my mother to accompany me, Irma, my housekeeper-cook, would be my traveling companion.

On July 25, 1952, I boarded the beautiful *Ile de France* to sail to France. In those days, you sailed across the Atlantic and reveled in the chance to relax and enjoy shipboard life. Alas, like the train, the oceanliner has been overtaken by the airplane. This was a beautiful ship, and my thoughts were filled with the hope of being met along the way by my tall, dark, and handsome leading man.

Illustrious people invariably appeared on the passenger list, and this voyage proved no exception. Dolores Gray was aboard, headed for London to perform at the London Palladium. That was a theater I really wanted to play and I envied her chance. I consoled myself by considering the joy I would realize in visiting the Louvre, breaking in my new French accent on the natives of France, and possibly encountering my charming tour guide somewhere en route.

Also on board were the Duke and Duchess of Windsor. When they found out I was a fellow passenger, they invited me to a private dinner in their stateroom. What a handsome man he was, and what a charming, precise lady she was. Their devotion to each other was very apparent. Our conversation centered around dogs. We were all animal lovers. They had two adorable little pugs with them. Since I was missing my own dog, I couldn't stop fussing over their two. Guiding the conversation, the Duchess asked me what breed of dogs I had had and what kind I wanted in the future. Because the Duchess was very fond of the French couturière Chanel, we chatted briefly about clothes while the Duke listened patiently.

Then they politely inquired about my movies. Of the ones they had seen, they wondered which one was my favorite. As they named them, I could truthfully say *Swing*

Time. The Duke became quite animated and said that he enjoyed Eric Blore's role as the mumbling waiter in *The Gay Divorcee*.

After our very pleasant dinner, I occasionally saw the Windsors walking together on deck, and we nodded pleasantly to each other with typical British reserve.

Those five days went quickly. In the dark morning hours, with the buoy bells and shouting voices punctuating the silence, we touched the shores of England. My heart stopped. I could hardly believe I was finally across the ocean as a lone adventurer. Well, not really alone, Irma was with me, but still alone and a little scared. I could hardly wait for the dawn to break, so I could see the land I had seen only in films. I wished Dolores Gray well as she left for her opening in London.

The ride across the channel was choppy—probably it always is. Would we ever get to Le Havre? The next morning, before we docked, I received a cablegram:

> Would you like to have me meet you and take you to a showing of Schiaparelli at 5:00 P.M. after you arrive. Looking forward to seeing you. Signed, Earl Blackwell.

Though I didn't know Earl Blackwell personally, friends of mine were close to him and had told me he was a charming man. Sure enough, when the ship docked in Le Havre, Earl was there to meet me. I recognized him by his outgoing smile and warm, friendly laugh. He took Irma and me onto the train and soon we were on our way to Paris.

"I knew you didn't know France," he said, "so I'm here to take care of you."

I couldn't have heard better words. I felt at home and looked-after in a foreign country. Earl told me everyone knew I was in town.

"When you come to Paris for the first time, everyone is

bound to hear about it. Your movies have had such warm acceptance. Schiaparelli is delighted you're coming to her show and I am pleased to have the joy of taking you." Earl was easy to be with and such a pleasant companion. We went to the Meurice Hotel and while Irma began to unpack, I tried to figure out what to wear to a couturier showing, as I'd never been to one before.

The Parisians with their olive skin, dark hair, and brown eyes were an interesting contrast for a blonde. There were very few blondes there, and I'm sure that if Old Glory had walked into the room, it could not have drawn more attention. Schiaparelli's clothes were beautiful. I just couldn't let the day go by without making a purchase or two.

Earl introduced me to Schiaparelli herself, and she invited us to dine with her at her home. Earl was an excellent guide and took me to all the special Parisian places, from the couture houses to Les Halles, the wonderful vegetable market. Late that evening, after the dinner party, we watched the produce people bring their vegetables to market and place them in fascinating and artistic shapes. Mounds of tomatoes were set one beside another like soldiers of the Red Army. White onions were arranged in diminishing rectangles, like miniature pyramids of Egypt. Green peppers, cherries, red strawberries—this was all too much to behold.

After walking through Les Halles for over an hour, we stopped and had a steaming-hot bowl of onion soup, covered with a half-inch of hot, soft, gooey cheese. It's not unusual to spend your first night, or even first few nights, in Paris going to bed at dawn. Back at the Meurice Hotel, in my fourth-floor apartment with its balcony high above the Rue de Rivoli, I looked out onto the Tuileries and the beautiful old architecture of the Louvre. *I'm in Paris.* I had to pinch myself to be sure it wasn't a dream!

Earl insisted that I have my portrait painted. He arranged for me to meet a Monsieur Beren and I agreed to

pose for him. I went to Beren's studios and sat in a love-seat while he worked at his easel. I wore a royal blue linen dress which blended nicely with the green upholstery on the loveseat.

"May I see it?" I asked after the first day.

"No, not yet, mademoiselle."

I went for two more sittings and still hadn't seen his work. At the third and last sitting, I again asked to view it.

"Yes, mademoiselle, I am ready."

As I faced the canvas, my face paled and then turned bright red. To my absolute horror, he had painted the strap of my blue dress off the shoulder and exposed my left breast.

"How could you do this to me?" I exclaimed. "I'm so embarrassed!"

"But this is Paris, mademoiselle."

"Well, this is not what I arranged with you, and I can't pay for it this way."

I left the studio distraught and found someone to nego-tiate the purchase of the painting because I didn't want it displayed anywhere. Beren must have photographed it, though, because a photograph appeared in a French mag-azine. I have the painting in storage; it's a grim reminder of artistic license. For the record, I never did and never would pose for anyone except in a discreetly clothed con-dition.

On my second night, Earl called to announce plans for dinner that evening with friends. As I was getting ready, I received a phone call from a friend who was in Paris for a few days, and hoped he could sightsee with me. Mike Cowles and his wife, Fleur, were having some marital difficulties and he was searching for a way out of his present relationship. If I saw him for more than a cocktail

hour, I could be considered a corespondent in divorce proceedings.

So I said, "Yes, Mike, I'd love to have you come and have a cocktail, though I have a dinner appointment." Mike arrived around 5:00 P.M., and it was apparent that he was searching for someone to hold his hand. Mike and Fleur had given a lovely dinner in my honor in New York a few weeks prior to my sailing, and though I adored him, I found it difficult to answer his unspoken call for help. His magazine, LOOK, had run various pictures of me over the years and I knew he had more than an editor's interest in photogenic ladies, myself included. He was crestfallen and said to me that he would stay in Paris if I would find the time for him. That was not the direction in which I wanted to go. He was an attractive man, but his appearance here spelled trouble. My reply to him was, "Why don't you look me up after your divorce?" He never did.

Thankfully, Mike stayed only for his one cocktail and then left. At 6:30, Earl arrived with six friends and announced that we were going to Maxim's for dinner. One gentleman in the party was a young lawyer from Biarritz, Jacques Bergerac. He was extraordinarily handsome and totally charming; we flirted throughout the evening. Jacques took me to lunch the next day to La Coq Carde and we spent an animated afternoon filled with laughter, jokes, and the joy of correcting his English. I wouldn't speak my cracked French to him, for fear he would laugh at me. But then Jacques laughed gleefully at most things.

"I wish you would come to the south of France," he said.

"I am."

"When?" he asked.

"Over the weekend. I am going to Cannes. I've made a reservation, and Earl tells me it's a very pleasant place to stay . . . L'Beach Hotel."

Since Earl was going to Cannes a few days later, Irma and I boarded our flight for Cannes and arrived in the semi-darkness of early evening. Disembarking, I could see only some silhouettes standing around the tarmac. As I walked toward the reception gate, one of the silhouettes spoke to me. "Well, hello. Were you going to just pass me by like that?" How could I miss seeing this tall, handsome Frenchman?

"I didn't know you were coming to meet me."

"I know. I drove all the way down from Paris without stopping so that I might be here at this moment to greet you." I realized at that moment that I was smitten with this Basque Adonis.

Jacques suggested that we go to dinner and visit a Brazilian friend of his who had a lovely house in Cannes. I was tired from the trip, but sleep, go away. This was much more interesting. I showered and changed, and away we went. Jacques was right. His Brazilian friend had a house full of beautiful antiques. But instead of staying at his home, they both wanted to go to a place called Whiskey à Go Go.

"It's great," Jacques's friend said. "You'll like it."

Upon entering this world of noise, we heard loud music coming out of the nails in the wall and saw lights whirling overhead in various colors on a postage-stamp-sized dance floor. It seemed as if a police car and fire engine were in the room with you. We danced. Jacques had never quite learned the American style of ballroom dancing, but he made a sincere attempt, as did his Brazilian friend.

Over my club soda and their crème de menthes, we must have spent two hours trying to hear each other. I did not like the crowded room, the cigarette smoke, the ice-cream-cone-sized table where we were seated, or the push of elbows. But what could I do? Here I was. And I really must get back to the hotel and make that important telephone call to the United States. It's 6:00 P.M. California time. Would he be in? What am I going to say?

No, I don't owe him or Jacques anything, except what I want to owe either of them.

My thoughts traveled back to 1936 when that American charmer entered my life like a beautiful Rembrandt painting, ready to be hung on the vacant walls of my life. Even though we had a dozen dates, Cary sensed that someone else was occupying my thoughts at that time. I couldn't make up my mind, and therefore lost him. Circumstances caused me to lose the other man, too. I knew Cary would not allow himself to experience such a fate a second time. I had to telephone him before the newspapers spread the story about my keeping steady company with this attractive stranger.

As I walked into my hotel room, the telephone rang, almost in answer to my thoughts. It was my handsome leading man calling from America to say that he was delayed and didn't know exactly when he could be there, and what was I doing?

Now I had to tell him. My mouth seemed to be full of marshmallows. I couldn't make my way around the words. I don't know exactly how I said it. I really adored Cary and realized this would end his fascination with me. I could feel our friendship disintegrate over the overseas telephone. The emotion was unpleasant, but I felt I had been backed into a corner and there was no way out. Frankly, I didn't want to be separated from this charming man. But there you are. Oh, dear, I did not want this to happen.

He spoke kind words as though picking up a little girl after a bad spill that had messed her Sunday dress. "This is too bad," Cary sighed. "I'd looked forward to showing you France, but who better to do that than a Frenchman."

He was so adult about this situation, and never crowded me with words. As I hung up, I melted into steamy tears.

That was the loss of a friend I had always wanted to keep, no matter who enchanted me to the altar. I had always wanted him to like me and still to love me a little.

Thereafter, whenever I saw him, Cary remained my handsome lothario, although he was involved with someone else. I have often wondered what our life together might have been like. So, you see, dreams are never really over, are they? Whenever we met after that, Cary greeted me as one who might start whistling an old tune, only half-remembered.

Jacques and I were the target of photographers everywhere we went. Whether we were high on the rocks above the Mediterranean or basking in the sun, the paparazzi pointed their telescopic lenses at us. The pictures ended up in magazines and newspapers, and the south of France was alive with Ginger and her new beau, Jacques.

"Does this go on all the time?" he asked.

"Not exactly, but then I've never been out with a French beau in the south of France before."

And what fun it was to be in France with a Frenchman, to swim, play tennis, dance, and visit all the quaint little towns in the company of this vibrant and loving man.

From Cannes, Jacques drove me to Spain. We stopped in San Sebastian, "the Pearl of the Sea," and strolled along looking in the shop windows. As I looked in one window, a group of Spanish men stopped at the other end of the window, also to look. I went to the next boutique, and so did they. They kept muttering something. When we reached the third shop window, they repeated the same phrase, but a little louder.

To me, it sounded like, "Haun-Hey, Roo-Hey; Haun-Hey, Roo-Hey."

They didn't look directly at me, except through the reflection of the window.

Finally, I asked Jacques, "What are they saying?"

"Your name."

"What?"

"Your name—Ginger Rogers."

"That's my name?" I said. "It sounds like the bray of a donkey."

We smiled at each other and headed for a restaurant to eat, with our body of Spaniards following us. After lunch, Jacques turned his car around and headed back to Cannes with Haun-Hey, Roo-Hey!

My six-week vacation was coming to a close and I booked return passage to America on the *Queen Elizabeth*.

At the beach, the day before I was to go, Jacques begged me to stay.

"You can go home anytime," he said. "You don't have a picture to make right away, do you?"

No, I had to admit, I didn't. But I had meetings to attend at the studio about film possibilities. Then he made the big pronouncement with the word "Marriage" in it. That had never yet entered my thoughts. Was I crazy enough to consider this? Yes, I said to myself, I am.

"We could get married in France or Switzerland or Spain," he said. "Think how exciting that could be. I could take you down to Biarritz and introduce you to my mother and father and brother. What do you say, Pinkie?" He called me Pinkie because I loved pink so much.

Well, we both knew that we were truly in love, and he would never let me out of his sight, which was indeed a new experience for me, to have someone I loved care that much for me. We laughed a lot. And he was constantly correcting my use of his language.

After a refreshing dip in the Mediterranean, we walked back to the huge towels and the warm sand, and spotted ourselves with oil to protect our skin from peeling. As he rubbed my back with the fragrant almond-scented lotion, he said, "You haven't answered me, Pinkie."

"I'm thinking, Jacques, I'm thinking."

He added, as though I had given him an obstacle to jump over, "We'll not get married in Europe, I'll come to

America. I could be there in a month, at the most two."

My head was whirling with the enormity of this decision. As a child, I used to pick petals off a daisy and say, He loves me, he loves me not. He loves me, he loves me not. Now the mental petals of my daisy were saying, Is it right? or is it not? Is it right? or is it not?

My heart said "yes," but my head said "no." If he comes to America, then I'll know for sure. There will be that space of time and distance between us. He agreed that the next move was for him to come to California.

On September 10, I took the *Queen Elizabeth* out of Le Havre. I had a few months to get my balance, catch my breath, and examine my inner desire, free from any pressure. I truly missed him on the ship going back, where my thoughts were still on the sunny beaches of France, or on driving on the open road down the Appian Way with the top down, or on the out-of-the-way restaurant that served bluefish from the adjacent stream. This whole romantic episode was something that Ernst Lubitsch could turn into a marvelous film, leaving his audiences breathless with wonder at what will happen next. But this was not a motion picture. This was for real.

I could hear him saying, "You haven't answered me, Pinkie." I guess I was too afraid to let my head know what my heart was saying.

The *Queen Elizabeth* certainly must have missed the romance we could have showered on her decks and dance floors. It was a melancholy trip for me, as was the Southern Pacific train ride home. I wished that Jacques had been along. Well, you'd better think about this, Pinkie, I told myself. After all, he is younger than you are, and people are going to say . . . I stopped myself and said, the heck with people.

Why is it, I said to myself, that a man can marry a younger woman, but people frown on a woman who mar-

ries a younger man. I've always been puzzled by that. Whose business is it, except the two people involved? Jealousy of others may be one answer. Those who are jealous sometimes wish they could find that exhilarating happiness with anyone.

37

\mathcal{T}HE FRENCHMAN

When I arrived back at my hilltop home, Mother was delighted to see that I was so brown and healthy looking, and she was surprised to find that I had met a stunning young man. Hiding behind my fan, I told her, "I think I'm in love with him."

Mother was never one to take that phrase lightly. The eye of suspicion glowed intensely at me. Like everyone else, she'd been following the reports of my romance in the papers. I'm sure she assumed it was just a fling.

"Greg Bautzer has called a number of times, wondering when you were coming home," Lelee said, brushing right over my declaration of love. I had met Greg at a party shortly after my divorce from Jack Briggs, and he was one of my special beaus; we'd gone out together for several years. Greg was bachelor number one in Hollywood. Not only was he tall, dark, and handsome, he was also a prominent lawyer and a superb athlete, one of the best tennis partners I'd ever competed with or against. He was a terrific dancer, too, my social Fred Astaire. We spent many evenings on the dance floors of the Trocadero,

Ciro's, and the Cocoanut Grove. Greg was a wonderful conversationalist and could amuse me for hours. And he was just about the best-dressed man I knew. I liked it that he was so sure of himself. I'm not really assertive myself, so I like someone who is and who's able to handle any situation. On the screen I always said the right thing because the dialogue was written for me; in private life, I'm much more of a listener. I think it has a lot to do with being Lela's daughter. When you have a mother who talks well and fascinates people, you do become a listener. Greg's self-assurance was very much like my mother's and I responded to it. It's funny, besides my mother, only a few people called me Virginia, and Greg was one of them. Yes, Greg Bautzer had everything, including a temper. He liked to get his own way and if he didn't, he'd flare up. I had had a few experiences with him when he lost his cool and these episodes stuck in my mind.

I was unpacking some of my French treasures when the telephone rang and the crisp, deep-throated voice of a lawyer said, "Virginia, when did you get back?" (As if he didn't know.)

"Well, the Santa Fe brought me into Pasadena this afternoon at four, on time."

"Did you have a good time?" he said coolly.

"A wonderful time, and I met some charming people."

"So I read," he said. "I know you must be tired, I'll drop up tomorrow afternoon. Will you be home, say around 2:00?"

I told him I would be staying put and not moving because there was a script for me to read. We agreed that he would come over the next afternoon.

It was too much for me to think about anything, the script or anything else. Irma was glad to be home, too. Fudger, my dog, had given me the kind of welcome that is beyond the capability of human beings. Dogs are so glad to see you that they don't hold back their generous affection in letting you know. "I thought you were never com-

ing home," their tails signal. Fudger jumped up on my four-poster bed to take one side while I slid into the other. Her general routine was to sleep in the pantry, but tonight she wouldn't leave my side. Dizzy with fatigue, I was in bed by 10:00.

The next day, as I sat in the solarium reading, the soft chimes of the door bell were followed by Fudger's barking. There was Greg Bautzer, smiling and handsome. I greeted him with a kiss as usual and we walked out onto the patio. We made some small talk for a while and I told him about my trip. Finally, he looked me squarely in the eyes and said, "What about this fellow, Bergerac. Is he important?"

I said, "I don't know exactly, why?"

"Look," he blurted out, "do you want to get married? Is that it?" It took me a second to realize that Greg was proposing to me.

Well, well, well, I thought to myself. I was pleased, but somewhat confused, by this sudden mention of marriage. I'm going to have to make yet another life decision. I held this moment like the underwater swimmer who thinks the end of the pool is closer than it really is. "Well," I said, gasping, "Greg, you're just three years too late."

Greg's reaction to my outspoken response caught him as much by surprise as his disjointed proposal had caught me off-guard. He waited a very long second before replying.

"You've changed, Virginia. Yes, you've changed. That episode with that, that . . . [I could see he was about to say "frog" before he said Frenchman] . . . that Frenchman, had more meaning to you than appears on the surface."

I didn't answer. There was a tangible gap between us now, widening every second. His offer of marriage and my cool reception gave him nowhere to go. When a lawyer runs out of words, a recess is in order. "Well," he said, feeling his time was up, "I hope you will be very happy."

As he flipped his hat onto his head, he walked through the living room and slammed the front door after him,

which dramatically punctuated the end of our relationship. I was shaken by this encounter, and it took a few days to digest what had happened.

Greg's generosity in sending flowers to commemorate every important event, giving candy to remind you that someone cared, and myriads of other niceties were all happy remembrances. However, once in a while Greg's jealous nature came out.

One night Fudger, my dog, heard a scrambling noise outside my bedroom and woke me up by racing from one window to another. As I looked out the window, I could see one leg of an intrepid stranger swing over the fence, twelve feet above the small edge that separated my house from the sloping hill that went down to Lloydcrest Drive, some three hundred feet below. When my face appeared at the window, he saw me. He quickly jumped three feet below and disappeared into the bushes. How did I know it was Greg? I had seen him wearing that same hat for many months. Besides, burglars don't wear hats. Why was he there? I can only guess that he wanted to see if someone was with me other than Fudger.

I often speculated on what marriage would have been like with this fascinating, erratic, and sometimes highly angry individual. However, I recalled that our dates would go from pleasant to tepid to cool to argumentative, until I gradually felt that if we had married, I would always have suffered the disadvantage of being an adversary to one who earns his living by winning arguments. I always hated to see Greg angry. It changed his handsome demeanor. Now he had made the grand gesture, and I had refused him. As much as I adored him, I wouldn't be sorry.

I had been home for a week and still hadn't heard from France. Lela's reaction was typical of a mother's concern. She thought Jacques would be out of place in these sur-

roundings. He certainly wouldn't be able to practice law unless he passed the bar exam in California. She suggested that the reason I hadn't heard from him might be that he realized he'd bitten off more than he could chew. I wanted to call him, but if I were to reach him, what would I say? No, the best thing to do was wait and see. At 4:00 A.M. one morning, I was awakened by the telephone. Jacques's voice boomed loudly, "Pinkie, how are you?"

Before I could wipe the sleep from my eyes, he rattled off his plan. "I'm coming to California in three weeks and I'll be able to stay about three months. Has anything changed, Pinkie?"

"No, no, no," I said. "Nothing's changed. I've been wondering what happened to you?"

"I'll explain when I see you."

Meanwhile, a script that I liked awaited me. *Forever Female* was an adaptation of James M. Barrie's *Rosalind*, and Paramount was filming it with me, William Holden, and Paul Douglas. The studio was pushing a young actress named Pat Crowley; I think they spent more money publicizing her than they did on the entire production.

The two leading men, William Holden and Paul Douglas, were both very good actors and were fine in their roles. However, when the press reported my romance with the very handsome, younger, leading man–type Jacques Bergerac, the daily response to me from Bill and Paul was one of indifference and downright belligerence. They would go to lunch and imbibe their share of manhattans or daiquiris. Upon returning to the set, they sat beside each other as if glued together, and behind their hands they would whisper to each other, look at me, and laugh, slapping their thighs. I felt this was a personal dig. They never spoke to me unless I spoke to them.

Unfortunately, Irving Rapper was not my type of director. His behavior was cold and unfeeling. Because of the

attitudes on the set, I was sorry I ever became involved with this film. However, I refused to let these belittling attitudes invade my personal happiness, for within a month, Jacques would be in California.

September 1952 went by very quickly, and soon I was at the airport, helping Jacques to gather himself and his suitcases.

I asked Mother if it was all right if I put him up in the guest house. "I don't see why not," she said. "Isn't that what a guest house is for?" Basically, I wanted Mother's approval and was pleased that she consented. For the next three months, Jacques and I enjoyed each other's company. We played tennis and golf, swam, went to parties, and danced. Jacques wasn't a great dancer but he loved music and wasn't in the least intimidated at having to partner me. Jacques's exuberant, loving nature was never cowed by such things. One thing I did insist upon. I told Jacques that he must never put black shoe polish on the shoes he wore when we went dancing. I've had more expensive satin slippers ruined by good and bad dancers. I told him to polish his shoes with a neutral color and have them highly buffed; that way, nothing rubbed off.

Four months after Jacques arrived in America, we were married in a quiet private ceremony in Palm Springs, California, on February 7, 1953.

In December of that year I received a special movie assignment; British Lion Film Corporation asked me to do a film. For the first time, I'd be making a film in England. Jacques would have a "first," too; after reading the script, I decided he should play the leading man and told the producers I would do the film *only* if my new husband was cast in the role. This was one instance where I threw my weight around and director David Miller agreed with me. I felt completely justified; no one had been cast in the part and Jacques was perfect for the role.

The movie was called *Beautiful Stranger* in England but was released in the United States as *Twist of Fate*. Stanley Baker, Herbert Lom, and Coral Browne were in the supporting cast and I enjoyed working with them.

Our first day's work on the film was actually in the wardrobe department, for even though the costumers had all our measurements, the clothes required final fittings. Then we returned to the hotel to learn our lines for the first day's shooting. Jacques had an early call for his first day of work as a movie actor, because of a strenuous fight scene chasing the villain through muddy water. The action scenes delighted him. He was full of nervous anticipation and wasn't resting comfortably in the king-size bed that night. Suddenly, he turned to me and said, "Pinkie, I can't sleep because these darn boils hurt."

I sat bolt upright! "What boils?"

"I didn't want to have to tell you about this, but if I'm going to have to be in muddy water all day tomorrow, these darn boils are going to hurt worse than they do now." Then he proceeded to locate them for me. One boil was on the inner side of the leg and there were two on his derriere. "That's why I'm not able to sleep, they hurt so much."

"Do you want me to call the hotel doctor?"

"No, thank you. He'll only want to lance them and then dope me up, and I don't want either of those things to happen to me before I start to work tomorrow."

I then offered to call a Christian Science Practitioner and Jacques readily agreed.

I reached for my "Christian Science Journal" and found a name that appealed to me, Pearl Beresford. I talked to her on the telephone and explained the situation. Pearl asked to speak with Jacques. They talked together for about ten minutes, and Jacques said to me, "She said she'd help me, but to go to bed and just be quiet, but repeat the Lord's Prayer and telephone her tomorrow." He thanked her and agreed.

In the middle of the night, he tapped me on the shoulder and said, "Pinkie, would you get me a towel? I feel these darn boils are draining."

I brought the towel and turned on the light. He was absolutely correct; they were draining. It was as though a sharp razor had made a slit down the center of each of them and the accumulated fluid had dispersed.

"Have you been sleeping?" I asked.

"Oh, yes. What woke me was this darn fluid, and I'm ready to go back to sleep. I only have two hours before I have to get up to go to the studio."

If an actor falls ill during shooting and the production is held up for a number of days, the financial costs can be devastating. However, if the film is properly insured, the production can lay off and not incur too much of a loss. The next day, Jacques met with the insurance doctor, who told him that if he had boils, they would have to be lanced. Jacques said, "It's already happened."

"Let me see," the doctor insisted.

Jacques showed the doctor the remains of his boils. "What doctor did that?"

Jacques told him the events of the previous evening, and that his wife had asked a Christian Science Practitioner to pray for him. "Well," the insurance doctor said, "that is certainly a neat job. I will give you some wrapping gauze and rubber inner-tubing, so when you are in the fight, that muddy water won't get to you."

Jacques telephoned Pearl to thank her profusely for her metaphysical help. In a very few days, the only remains of the boils peeled away, like a patch of sunburnt skin, leaving his skin as smooth as ever. Jacques was able to work long and hard hours on the film, doing his fight scene with no after-effects whatsoever.

38

\mathcal{R}IO! RIO BY THE SEA-O!

We returned to California immediately after filming was completed, in February 1954. Jacques and I were deciding where to go for a brief holiday when I received an invitation to go to the Carnival in Rio de Janeiro from my friends Jorge and Dolores Guinle.

Having just completed a ten-week shoot on a motion picture, with its early calls and working late into the evening, I was in the mood just to sit for a week or so by my swimming pool and watch the world go by. Therefore, I was reluctant to accept any invitation that took us more than two hundred miles away, especially this one at such a long, long distance. Jacques spent most of his time trying to persuade me, telling me what we would miss if we didn't accept the Guinles' lovely invitation. He did everything to fire my enthusiasm.

I know how easy it is to wallow in negative, unproductive thoughts. I thought I could justify my desire to stay home and rest by my fatigue. But after talking with a practitioner, I decided I should change my thinking and pray for a fresher, more absolute outlook, as the Bible tells

us to do. At that point, I was willing to give up my human will and go to Rio for whatever reason. As it turned out, the trip was a very meaningful one. After I felt the calmness that prayer brings, I informed Jacques that I truly felt better about accepting the Guinles' invitation.

The flight took seven hours from California to New York and then another eighteen hours from New York to Rio, with stops in Port-au-Prince, in Puerto Rico, and in Trinidad for refueling.

The view from over the eastern bulge of Brazil was like a glorious Walt Disney drawing of greens and cobalt blues. The white-plumed mountains pierced the heavens, as if to hold back the sunrise colors of orange-red and aqua in this postcard wonderland. Viewed from 35,000 feet, Brazil's winding rivers looked like shiny silver ribbons, dropped carelessly over miles and miles of moss-green velvet by some giant's hand. These silver ribbons seemed endless. I was fascinated by what I saw. Suddenly, it dawned on me . . . I actually was "flying down to Rio."

Dolores and Jorge met us at the airport and whisked us off to the Copacabana Hotel. That evening, after a bit of shut-eye, we went to a cocktail party that our hosts had arranged. Among the guests was Elaine Stewart, a lovely young woman who had just arrived from California with her friend Ibrahim Sued, a very good-looking Brazilian chap who was in the newspaper field. Elaine was an up-and-coming actress in Hollywood and I enjoyed talking to her. She was as charming as she was beautiful.

After a day of rest, Jacques and I left for a visit to São Paulo. Flying out of Rio was, if possible, an even more glorious sight than flying into it. We took off under the towering shadow of Calvo Cristo, and headed directly into the mountain. The plane veered, allowing us to look back and see Rio and the mountain trail, leading to the white Christ atop the peak. The stewardess began handing out newspapers and Jacques took one. Over his shoulder I saw on the front page the name "Elaine Stewart." Although I

wasn't fluent in Portuguese, I recognized words that looked like "serious" and "hospital."

I asked Jacques if he could translate and he asked one of the stewardesses over to translate the article. Elaine had been rushed to a hospital in the middle of the night and was in very serious condition. I held my breath in disbelief. I was now uninterested in the view, for my thoughts were on Elaine. I couldn't believe the vibrant woman I'd spent the evening with was now lying in a hospital bed. As we flew, I prayed in the way that my religion teaches me.

We spent the day in São Paulo, though truthfully I had Elaine Stewart in my thoughts and could not enjoy the visit to the fullest. Back in Rio, when I stepped onto the tarmac, a young Brazilian gentleman came up to me. "Miss Rogers?"

"Yes," I answered.

"Miss Stewart is asking for you at the hospital."

I was struck by the fact that Elaine Stewart had asked for me; we had met only two nights before. Not only that, no one knew Jacques and I were going to São Paulo except Jorge and Dolores. How could Elaine have known?

Jacques and I were now due at a big gathering at the Guinles'. Jacques looked at me and said, "Now, don't think you can go to the hospital *and* to the party. We'd never make it."

As we drove to the hotel to change, I reflected on what would be the wisest thing to do. I decided that I certainly must go to the hospital. The moment we arrived in our suite, I changed clothes at breakneck speed, because I vowed that even though I might miss some of the party, I most certainly would go and see Elaine. I had to find out what she wanted me to do to help her. Jacques insisted on accompanying me and we took a cab to the hospital.

A forlorn-looking nurse was stationed at the door to her room. "Oh, you are a friend? She very bad, she very bad." She ushered us in and hastily exited. Jacques headed for

the balcony and stood looking out. I picked up a chair and brought it over to the side of the bed. Elaine appeared comatose. Her face was waxen white and various tubes were hanging overhead. I was unused to hospitals and hospital visits, but I wanted to be of service to my friend. I turned my thoughts away from the whole picture of this ghost-like figure and pulled my chair up to the head of her bed.

I leaned over with my lips close to her ear. I shut my eyes to this tragic picture and I spoke into her ear every word I could remember spoken by our master Christian, Christ Jesus. Every truth I had ever gleaned from reading of his healings in the Bible, I addressed to this situation. I said the Lord's Prayer and then thought of Mrs. Eddy's scientific interpretation of it in *Science and Health*, which helped me to see more of the depth of its meaning. All the precious spiritual truths about God and His love for His children that I had learned from my childhood to the present, I brought to this altar of gratitude. My prayer was to see this lovely child of His as whole, healthy, upright, and complete. I stated the Scientific Statement of Being from *Science and Health*, along with the definitions of God and man from the same book. I repeated the Ten Commandments given to Moses and the Beatitudes of Jesus.

My inner heart began to have a greater sense of peace and freedom, which dispelled the fear and anxiety I had felt upon stepping into this room. My inspiration had reached a higher plane and was refreshed. I slowly opened my eyes and looked again at my friend. Though her eyes were still closed, her skin was radiant. Her cheeks were as rosy as if someone had rouged them. Her pale, dry lips were now cherry red. She turned her head in my direction and slowly opened her eyes.

"When did you get here?" she asked in a faint little voice.

"Never mind," I said. "Dear one, don't talk. Just listen.

What I am about to say is very important. Now, Elaine, since you have to be on this bed looking up at the ceiling, I want you to promise me you will do something. I want you to write your thoughts of gratitude up on that ceiling and every thought of good that has come into your life. After each one, declare to God that you thank Him. Thank Him for the sun that shines and warms you, thank Him for the stars that beautify the night, thank Him for the love your family has brought you, thank Him for every good thing. Now I want you to fill that whole ceiling up there with thoughts of your gratitude to Him. When it is full, I want you to tie thoughts of beautiful pink bows of ribbon to decorate it at each corner. Will you do this for me, please?"

She looked at me for a long second and slowly nodded.

"And don't you dare go to sleep until you've done this, promise me that."

"Okay," she said.

"Remember, that's a promise."

Meanwhile, my patient husband had practically worn out the soles of his shoes from pacing up and down on that balcony for more than ten minutes, and his shirtcuff had become wrinkled from his looking every few seconds at his wristwatch. I got up from my chair, beckoned to Jacques, and threw Elaine a kiss from the door.

Jacques's only comment to me was, "Boy, did you see the difference when we left?" I smiled at him, grateful that he could see the hand of God working in the brief encounter.

The next morning, I went back to the hospital. As I entered her room, the doctor was leaving. He said, "Are you the American lady who was here yesterday at Miss Stewart's critical hour?"

"Critical?" I said.

"Yes," he said. "If she had not made it past that hour, she would not have survived. She had an acute case of appendicitis complicated by peritonitis. It's amazing, it's

just amazing, because I didn't think she had a chance, but," he hurriedly added, not knowing exactly what to say next, "when two Americans get together, something extraordinary always seems to happen. The proof is, she's on the mend."

I was anxious to see Elaine. I pushed my way past him with a smile to find her sitting upright in her hospital bed, looking lovely and animated. She was giving directions to the nurse. "Move that bouquet over here, set that chair over there . . ." and when she saw me, a healthy, happy smile came across her face.

"I'm so glad to see you!" she said joyously.

"Now, I want the answer to the promise you made me, did you do as I asked?"

"Oh, well, it was hard to do at first. I seemed unable to think of anything to be grateful for, but little by little, one thing, then another thing, and before long, so many good things came to mind that I could hardly write them on the ceiling fast enough. It probably took me an hour before I got under way, and then I really went like a house afire. I even put the pink satin ribbons on the corners," she added, without my asking.

I could tell that she was grateful for the freedom she was feeling. I told her that I couldn't stay too long as I was expected to lunch with our hosts.

The night of the ball was Mardi Gras. Amid the screaming and yelling, music came from every corner. Dancers were twirling in the streets, there were brilliant costumes of every color and description, beautiful women were half-naked in this warm climate. The cacophony of sound was a mincemeat of animal cries, set to music. Passersby delighted themselves by spraying each bare back they encountered with freezing cold liquid from a spray can. One jokester aimed a spray can at my back, but at that moment I turned around, and both my eyes were splashed by this

crazy liquid. I shall never forget that half-hour of tears, red eyes, and mascara-covered handkerchiefs.

Several days after the Carnival, a formal invitation arrived from President Juan Perón of Argentina, inviting me and Jacques to come to Buenos Aires as his guests. Full of thanks to the Guinles for a wonderful Rio visit, we accepted and took off for Argentina. We were met at the airport by Pepe Macoco, an old friend of mine, and were taken to the Plaza Hotel. The next morning, the president's personal car picked us up and took us to the Pink Palace. I wasn't prepared for the extraordinary beauty of Perón's residence, though I certainly approved of the color! We were ushered into a huge, tastefully decorated lounge and waited for the president's assistant to take us to his office. We had been seated for only a few seconds when four very attractive young women walked in, looking for "something." They glanced at us with a broad smile as they continued to "look." Chattering to each other in their native tongue, they disappeared. I said to myself, "Those little dolls came in here not to look for some *thing* but to see some *one*—and I think the someone was *us*." Finally, the gentleman arrived to escort us to the president's office.

"Our Presidente speaks two languages," explained our escort, "Spanish and French."

Perón's office was massive. A motion picture set designer couldn't have devised a more spectacular background for this tall president of a South American country. Behind a huge mahogany table covered with mementos, pictures, books, pencils, papers, emblems in gold, and small Argentine flags in sapphires and diamonds stood a dramatic armoire. Atop it was a bird, a condor with outspread wings—a masterpiece of taxidermy. All the furniture had been made oversize to fit the stature of this large man. I was so absorbed by the grandeur of the room that

I failed at first to see the man we had come to meet. There he was at his desk. His dark hair blended into the color of the mahogany armoire. His dark eyes watched our every move, and as we approached, he suddenly stood to his feet. Perón didn't speak English, but he spoke French with a decidedly Spanish accent. What I wasn't able to understand, I asked Jacques to clarify for me. He was delighted to meet me, declared the president, and for at least one good reason.

"My wife saw every movie you made," he said, "and showed them in the palace projection room. She would call in her dressmakers to copy dresses you wore. I remember her hairdresser had great difficulty trying to duplicate the various hairstyles you used with each gown." He told us of his great love for her, and how much he missed her. Did he? I wondered. After the pretty young girls I saw trying to glimpse a Hollywood movie star, I questioned in my own mind if he really did love and miss Eva.

I asked the president about the bird on the armoire. "The condor is indigenous to my country. This particular bird was captured by the people of the village where I was born. They each contributed pesos to have him prepared, as you see. The bird came with a note reading, 'A condor is capable of flying higher than any other known bird, and he never gets dizzy. Don't you!' signed, The People of Your Village. I was very touched by this," he said, "and have given it the place of honor in my office, and I will never get dizzy."

Although it was a touching story, history would later report that he did become dizzy—from power! Politics aside, I must say he was more than gracious to Jacques and me. The following day, he arranged a sightseeing schedule for us, which included a limousine and a guide. After we had spent nearly an hour touring the city, the car stopped in front of a florist shop. "We must get some flowers to take to the shrine," our guide said.

"What shrine is this?" I quietly asked Jacques.

Jacques hushed me and said, "Don't you remember? We were going to the Eva Perón memorial."

He had heard something I hadn't. We bought two dozen roses with a lovely white ribbon and took them to a fourteen-foot obelisk with Evita's picture at the top. It appeared to be a temporary shrine, but nevertheless, wreaths of green with faded flowers were all around. I thought it was strange to ask us to do this, but then we do this at the Tomb of the Unknown Soldier. This was Argentina's female representative. Known and obviously loved, this lady certainly left her mark on her country's laws and attitudes.

We next stopped at a children's hospital, where the guide described the former first lady's love of children and how she especially tried to help the sick ones. As we entered, I saw rolling hangers of brand-new children's clothes on both sides of this huge hall.

"Where are the children?" I asked.

"Oh, well, this is a brand-new building, and we haven't put the children in yet."

I later found that no children ever were in this hospital. But at the time I was afraid to ask too many questions, which was the message Jacques picked up also. After lunch we visited Perón's horse arena. Our guide informed us that the president had one of the finest collections of Arabian horses in South America. The horses and their masterful riders performed for us and it was a dazzling show. A beautiful gray dapple with huge black spots (one of the loveliest horses I've ever seen) pranced and went through five different stepping routines, press to the left, press to the right, prancing, kneeling, and rearing. The "Oohs" and "Ahs" that came from me were appreciated by the rider.

"You like him?" Perón's assistant said to me.

"That is a beautiful animal." I turned to Jacques and said, "I'd love to own a horse like that."

A wide smile of pride and possession spread on the face of Perón's assistant.

Though I saw quite a few other horses, I could think only of the beautiful gray dapple horse with the black spots. His confirmation, footing, the manner in which he held his tail, the length of his neck, everything about this horse was beautiful. As the horse show concluded, the riders and their horses took a bow.

Jacques and I applauded loudly.

The riders reacted to us as though we were a group of one thousand. I whistled my taxi-stopping whistle, and Jacques shouted his "Bravos." It was indeed a wonderful show.

Next on the agenda was the theater in the Pink Palace, where motion pictures from all over the world (including mine) were shown. This day, Peron was giving us a special showing of *The Life of Evita*. Jacques and I were not quite sure what to expect, though I felt that at last I'd get to meet Evita, if from a distance. But I was sadly mistaken.

Everything that came on the screen had to do with her illness and death. I was stunned to see footage of the day she collapsed on the balcony while broadcasting to her many thousands of admirers. "I can't go on, I can't go on," she cried as her aides rushed to her side. They carried her from the scene. The next film clip was shocking to me. The camera closed in on a great hall where Evita lay in a glass-covered casket. Thousands of people lined up to pass by and look at her, crying and reaching down to her. Even when the rains came, the lines of people outside the church were undaunted as they carried candles under each umbrella.

Jacques looked at me and said, "Why, why would he want us to see this?" I was asking myself the same question. These scenes were beyond sadness, they were morbid. Perhaps Perón wanted to keep her fame alive in the hearts of the Argentine people. Still, I remained con-

vinced that his thoughts were preoccupied with dancing
with the little sixteen-year-olds around the Pink Palace.

This was not the end of the president's hospitality to us.
He put his private plane at our disposal and arranged for
our hotel in the fascinating seaside town of Mar del Plata.
Flying over the long, tall, fine silvery-white pampas grass
and seeing the cattle graze was a peaceful change. Our
stay in Mar del Plata with its sea breezes was truly a rest.
Jacques and I made our way to the beach in our bathing
suits and sat under the bright-colored umbrellas, loving
this part of the trip. We spent two days in the sun—and
promised ourselves that we must revisit this charming
place.

Promises, promises, promises. I've never seen it since.

Back in Buenos Aires, Pepe Macoco called to invite us
to visit the cattle ranch, or estancia, of one of his friends
for a barbecue. We were guests of some prominent
Argentinians at high noon in the grassy dining area. The
huge open barbecue could have accommodated food for a
hundred, but was taking care of only twenty guests. Fresh
beef was the main course.

Ten gauchos on horseback brought the meat for the
barbecue. The Argentine cowboys were wearing large
hats with chin straps, brightly colored shirts, and leather
chaps (larger than those you see in Texas) that had silver
decorations down each leg, directing your eye to high-
heeled boots with huge silver spurs that clanged and rat-
tled. Jacques and I were amazed at the parade and at this
enormous amount of food for so few people. It was lavish.
The smell of burning flesh, the clinking of glasses, and the
raucous laughter of the gauchos was part of the life.
Jacques's laughter twenty feet away from me was so con-
tinuous that I had to get in on the joke.

"What's so funny?" I asked Jacques.

"Guess what we're having for lunch?"

I looked at the barbecue with chunks of beef on it.
"That's what we're going to have for lunch."

"Yes, but do you know what that is?"

"No, Mr. Bergerac, I don't know what that is."

"Those are bull's testicles, a delicacy in this country.
And what's more," he said, bordering on hysteria again,
"they're making a gift for me of a cane."

"Odd," I said, knowing there must be more to this.

"They're going to make me a cane of a bull's penis.
They sell them in the stores, I'm told, but they're going to
make one up, specially for me."

My eyes rolled to the heavens, finding it hard to under-
stand this custom. When he received the cane, the stick
closely resembled amber that comes from Russia, and its
handle was made of metal.

When the food was served, everyone wanted to know
how I liked the meat. For some reason, my appetite had
disappeared, but to satisfy the onlookers, I began chewing
the peppers, olives, and other relish. This whole thing was
too bizarre for me.

Arriving back at the Plaza Hotel, we were surprised by a
gift from President Perón as a token of his friendship. I
hurried to open my package, which contained a beautiful
initialed alligator-covered traveling vanity case with glass
jars and silver tops. It was about six inches high, twelve
inches long, and ten inches deep and weighed a ton be-
cause of the glass and silver inside. I adored my alligator
case and wondered if customs would let me in the country
with it. Happily, they did.

\mathcal{O}LÉ!

WHEN WE REACHED LIMA, JACQUES AND I DECIDED TO STAY a few days in this interesting capital. I later wondered at the wisdom of this decision. "Tickets, tickets, we've got to get tickets to the bullfights!" an excited Jacques insisted. I had never suspected that my husband was a bullfight enthusiast.

After leaving our taxi, we had a long, long walk through deep layers of red brick dust and throngs of excited Peruvians, who pushed and shoved to the left and right of me. I wore a thin cool dress and a large picture hat to shade me from the intense sun, plus the latest style in three-inch high-heeled Italian shoes, not what a sensible female should wear to attend a bullfight!

Jacques walked two feet in front of me, full of breathless anticipation of viewing his first South American bullfight. Needless to say, it was my first of firsts. We could hear the crowd in the stadium cheering and found that climbing the stadium stairs was a feat in itself. It seemed like miles up, and up some more, and then across. No, not there! Here!—No, not here, over there! Finally we arrived. Phew! Was it hot!

For Jacques, our tickets were superb. I will never understand how Jacques was able to acquire front-row seats. But that was Jacques. He could talk a pig out of the screw in his tail! I, unfortunately, was squeezed into a seat next to a young boy and his father. The four of us were jammed together on a bench that should rightly have accommodated only two. Wherever Jacques bought these tickets, in my opinion, the seller got the better of the deal.

The young boy next to me liked being squeezed together, to benefit from the shade of my hat. However, in his excitement he plunged his fist into the sky to give the picador his approval, and punched my wide-brimmed hat. The only way I could keep my hat from falling to the floor of the bullring was to hold it to my head like an empty taco shell, pushing the brim snugly to each cheek. Finally, Jacques came to my rescue, saying something in Spanish to the father that convinced them to trade seats. The poor father was pleased only when I held tightly onto my hat; otherwise he had its brim in his eye, which erased the smile at our first greeting.

Our seats were directly above one of the bullpens, to provide a view of the bull before he saw his enemy, the picador on his horse. The picadors entered the ring as if they were on parade. The horses wore heavy protective armor and the cheers of the crowd were deafening as each man came into the ring to show his pride, his costume, and his bravado! Jacques explained that the role of the picadors was to lance the bull's neck muscles, so it would keep its head low for the subsequent stages of the fight. With this terrible torment, I knew *my* head would be very low in order not to see this staged bloodbath.

After the show of costumes and horses, there was a hush. Those who knew this sport understood the moment—the bull was entering! As he charged into the ring, you could sense that the animal knew this was his "swan song." After the bull had made his "debut," he saw the horse and charged. The blood-thirsty crowd screamed

with excitement. You didn't have to understand Spanish at that moment, for you could feel the crowd cheering the bull to attack.

"Attack."

I was filled with unhappy feelings, wondering why I had ever agreed to come to a thing like this. With cheers and applause, the crowd punctuated every stabbing attempt of the picadors. My hands felt better over my eyes. Jacques was involved with the show and unaware that I was sick at heart.

A huge round of applause greeted the matador as he entered. I had to look to see this famous "killer" star. He was a handsome young man who bowed again and again to every section of the stadium, beginning with the president's box. After he had made a full circle, he turned to the seats where Jacques and I were sitting, and bowed.

"He is bowing to you, Pinkie," Jacques said.

My face, flushed with heat, now became even redder for burying my head at every "Olé!" Mr. Matador, why do you have to waste yourself and that proud bull? I asked him silently. Does that large torture weapon behind a bright red cape really make you more of a man? Isn't life difficult enough without killing for the joy of killing? Only a fool would deceive and corner a creature, or an individual, and make him submit to such a slow and cruel death.

As the bull made his first pass, I couldn't look. I was frozen. I wanted the world to stop, so I could get off.

"Don't you want to see this?"

"I can't look, Jacques."

"You'll get used to it," he said. "A toreador has to be very clever. It's his talent you're watching. You'll soon be able to tell which one is the best of the toreadors." And then he rattled off the names of star toreadors from Spain, Portugal, and Mexico.

Directly to our right was the sun-protected Royal Box. Many Peruvian pennants decorated the inside, while the outer edges of the box were peppered with streamers. The

national flag was at the center; it featured two bright red bars divided by one white bar, in which was a coat of arms. Under the national flag sat the country's most important man of that day, President Fernando Belaúnde Terry, and his entourage.

I was definitely uncomfortable and much too hot in the sun, when Jacques said to me, "Their president is looking this way. I'm sure he sees you. Turn to him."

Having focused on the shaded box, I saw the man who must be the president, sitting in the center of the front row. He nodded in recognition, and I nodded back. He smiled at me, and I smiled at him. Oh dear, I thought, now I must behave like I'm enjoying this. How I longed to be in my little hill-top home in Beverly Hills. Appreciating the president's gracious recognition, I turned back to the task of pretending to watch this gruesome bullfight. Fortunately, all eyes were on the center of the arena.

Even with my eyes averted, I could tell from the crowd's reaction what must be happening. I never picked so much lint off a dress in my life as I did during this performance, for my eyes just would not look at the scene below. Thank heavens for my hat. A sound of disagreement swelled from the crowd. I said to Jacques, "What's happening, what's happening?"

"This is something no one else but you will appreciate—this you *can* look at."

His tone made me feel that he was in earnest and that I could look, without weeping. The bull was running. But he was running *away* from the center of the arena, *away* from the toreador, *away* from the many threats to his life. He ignored the red cape and the matador, and was on a heated run to find an exit.

The crowd went wild, chanting, "Catch him, catch him."

Before anyone could arrest the bull's attention, he somehow discovered an unguarded exit of the arena and disappeared. I quickly jumped to my feet and applauded.

Jacques caught me by the skirt of my dress and instantly pulled me down to my seat beside him. "You can't do that, you can't applaud a loser. That, my dear Pinkie, is a cowardly bull."

"That bull, my dear Jacques, is a hero."

I made few points with the citizens around me because of my enthusiastic delight at the turn of events. The masters of the bullring had been told I was sitting in the front row of the arena, facing their president. Within two minutes, the next toreador made his appearance, bowing to the box of the president and then, as an afterthought, to us.

This young toreador was now swirling his red-cape enchantment and the sound of the crowd's "olés" were reaching to high heaven. Very soon our toreador had the bull in his power, and Jacques, knowing I *wasn't* looking at the action below, said, "Now comes the coup de grace."

I wouldn't look. I couldn't look. "Tell me when it's over."

"Pinkie, you're a real sissy," he said, using an American slang word he had only recently learned.

I kept my head down and thought what stupidity it was for a grown woman to be in a place where she doesn't want to be, watching a thing she doesn't want to watch, and having to smile across a crowded stadium at a president she doesn't even know. There was a three-minute period when I felt things had been resolved in the arena. I still refused to see for myself. I knew Jacques would tell me when we could go.

"Look down there. Look down there!" Jacques said breathlessly. "Look, Pinkie, look!"

"I don't *want* to look!" I insistently groaned.

"You've got to look, they are paying you an honor."

I peeped over the edge of the stadium rail to see the toreador just below our box. He bowed graciously, looking up at me for approval. Not knowing what else to do, I waved at him.

"No, no," said Jacques, under his breath. "No, no, no, applaud him, applaud him."

I unwillingly followed Jacques's directive. It was very difficult to put my two hands together and make a noise. But I dutifully did it and grudgingly smiled. I noticed our toreador extended something in his right hand in my direction. It seemed that all of Peru was yelling "Bravo, bravo, bravo."

He yelled something to one of the aides, handing him that "something" and pointing in the direction of our seats. The next thing I knew, this young emissary came racing up the stairs and, before the "bravos" had subsided, was standing breathlessly beside me, smiling as he extended his cupped hands in my direction. I could see by his face that handing this gift to me made it a red-letter day for him.

I innocently reached out to take the gift. I could not tell what it was, as his hands were closed around it. He proudly placed the contents in my extended palms. I looked down: No, no, no, I don't believe it. He had just handed me the ears of the sacrificed bull, plus a thing that looked, to my uneducated eye, like a small black whip. It was the tail of the bull, with the root of the tail still bloody! It seemed that everyone in the stadium was staring at me!

"Jacques, Jacques," I pleaded under my breath, "tell me, what do I do now?"

Suddenly the whole scene became a comedy to Jacques. He started to laugh. Here I am at the crossroads of emotion, and Jacques is laughing. Something about my reaction to the prize I held in my hand, my agitation, my utter repulsion at the whole event, plus the pressure put upon me publicly, tickled Jacques's funny-bone.

"Bow. Bow to the six thousand people watching you, then acknowledge the toreador who is standing there awaiting your expression of thanks. That toreador is giving you his 'medal of honor,' the ears and the tail of his bull. Bow. Any one of those people would give the gold in their

teeth to have what is being given you this afternoon,"
Jacques said, through his retreating laughter.

"Oh, Jacques, this is so embarrassing. What am I sup-
posed to do? Put this gift around my neck and wear it like
a fur piece?"

Obediently, I bowed to the toreador. Then I bowed to
the six thousand noses and six thousand mouths, to the
twelve thousand eyes and twelve thousand ears and two
ears plus one tail. I was ready for home. The youngster
sitting next to his father was excitedly yelling something in
Spanish, which translated as, "The ears, the ears, the tail,
the tail. What a gift. Congratulations."

What was my next move? Was I supposed to put these
prizes, which everybody in this stadium would love to
own, in my purse and take them with me? "Oh, oh,
Jacques." My tone pleaded for understanding.

"This is a great honor," he said. "A *great* honor."

And looking over at the president's box again, I saw him
looking at me with his two arms in midair, applauding me.

My blonde hair was totally tucked under my sun-
umbrella-type chapeau. I stood up to face the presidential
box, and in reverence to their "man of the hour" I took off
my hat to him in a gesture of appreciation. My blonde hair
cascaded down over my shoulders, causing some of the
surrounding spectators to give me the same
"Aaaahhhhhh" that had been delivered to the now ear-
less, tailless, gone to "bull-heaven" animal. What chance
would I have to escape from that hymn of destruction?

Reverently, I placed the two ears and the tail carefully
on the four-inch ledge directly in front of our seats. I
noticed the eager eyes of the youngster watching me
with wonder, while simultaneously saying something in
Spanish to his father.

"Jacques, this youngster would like these, wouldn't
he?"

"I didn't know you understood Spanish. Yes, he would.

He was just asking his father to ask you for them, if you didn't want them."

With that, I turned with the intention of giving them to the young man until Jacques stopped my forward motion. "Don't let anyone see you do that. That would be grossly insulting."

In Spanish, Jacques said to the father, "My wife wants your son to have these, but don't let anyone see him take them as we leave."

We got up and headed for the stairs. Being way ahead of the crowd, we found a taxi to take us to the hotel. Our plane didn't leave until the next afternoon, which gave me time to get my mental equilibrium. I had to take a cold shower to wash the whole memory out of thought. Jacques decided to refrain from speaking about the "afternoon of the bull" until many days later, knowing I had really suffered enough without having to ruminate over it again. I was indeed grateful for his sympathetic attitude.

The next morning we decided that the Lima Museum with its artifacts and tools was the place to spend the three hours before boarding our plane for Panama. We planned to stay in Panama City for one day because I wanted to go through the locks of the canal. Jacques also was excited to see this engineering feat up close. According to family history, my father had done some work on the canal, as an electrical engineer. We explained to airline representatives about our desire to see the canal and visit the locks. They couldn't have been more cooperative and the airline wired ahead. Before we knew it, we were ushered into the private office of the Master of the Locks. After a very cordial chat, we were led to one of the overseers of a lock who answered our thousand and one questions. This kind gentleman was delighted to meet a "moovieee star." He took me by the hand, showed me around, and told me that a combination of numbers would have to be pressed to

open or close the locks. He asked me if I would like to see the next ship that was to go through. He pointed to the ship that was getting in line to go east into the Atlantic side. He said, "In just a very few minutes, I'll let you press the button, and you will have opened the locks for her."

"She" was a Liberian tanker, and I wondered whose lives I was touching (from a distance) by freeing them into that magnificent body of water in their quest for some far-distant shore. Little did they know who was opening the locks. Not that it mattered who was aboard the ship; the fun was saying that I had opened the locks to the Panama Canal.

After that excitement, Panama City was our next attraction. Jacques and I walked the trail through the thicket that was supposed to have been walked by one of the famous Spanish conquistadors, who had left the sea on one side only to view another sea ahead of them. I was shaken out of my reverie by a voice saying, "Come on, Pinkie, I'm hungry, let's go."

After the root beer, cheese, and wine for my exploring husband, we checked our reservations for the return to California. Home never looked so good to me. I was glad our travels were over for the time being, and we could settle happily into our abode.

Soon after returning, Elaine Stewart called and asked to see me. She had a new boyfriend she wanted me to meet. I invited them to come over. After an affectionate reunion, I seated them on my couch in the living room. Elaine told me the young man with her was a doctor. She had told him the story of the healing in Rio, but he didn't believe prayers had cured her.

"The healing needs no explanation," I said. "It speaks for itself. By the way, I meant to ask you how you knew to send that man to the airport in Rio to tell me you wanted to see me at the hospital?"

"What man?" she asked, dumbfounded.

"You didn't send anyone?"

"No."

Silently, I thought to myself that this man was indeed one of God's angels. I was acknowledging what the Bible says, "For he shall give his angels charge over thee, to keep thee in all thy ways" (Ps. 91:11).

This was a piece of the story I would never have known without our visit. To others, this might seem miraculous, but to me, it was a normal outcome of Elaine's desperate need.

40

*M*ADAME ANTOINE WAS RIGHT

IT WAS NICE TO BE HOME AFTER SO MUCH TRAVELING. Relaxing by the pool and enjoying the quiet was even more restful than a vacation. With no firm film commitments, I kept busy professionally by doing an occasional radio show. Jacques, on the other hand, constantly wanted to do something or go somewhere. After being away for over two years, he wanted to go back to his native France for a visit.

April in Paris! It was fun being back in Paris, this time with my French husband. Visiting the out-of-the-way restaurants and little places he took me to on my first visit was even more enjoyable this time around. One morning at our hotel, Jacques said to me, "Pinkie, your hair is so long. Why don't you cut it?"

"Cut my hair!" I cried. "It's taken me over ten years to get it this long. Why should I cut it?"

"Because it always takes you forever to get it fixed before we go out anywhere, and besides, you'd enjoy the beaches near Rome much more without the bother of your long hair."

393

Jacques's idea made some sense. I was a bit reluctant, but the more I thought about it, cutting my hair didn't seem such a tragic idea. The next day, I made an appointment to see Antoine, the celebrated hair stylist. I arrived at the hair salon and told Antoine my desire. "But, Miss Rogers," said this darling Frenchman, "your hair is so important to your performances. We love to see you throw your hair around. I don't want to cut it."

"But I'm tired of it."

"Oh, but, Miss Rogers, I can't do that. I can't cut your hair."

"I'm willing to pay you to do it."

"BUT I CAN'T DO IT!" pleaded Antoine. He was adamant and refused. "Let me call in my wife. She always has such very good ideas."

Madame Antoine was a huge woman, weighing 240 pounds, but with a very smiling face. She spoke French to me, and I explained to her what I wanted.

"But, Miss Rogers," she echoed, "you can't do that!"

She gave me the same argument her husband had given me, but I insisted.

"Well, all right, all right, if you insist, I will cut your hair. But I will tell you, I DO NOT WANT TO and I want you to remember this as a protest from me."

Whereupon he took out the scissors and proceeded to cut my hair. When she finished, my hair was about four inches long all over my head; I looked like a blonde French poodle. That was not the way I had intended it to be, but that's the way I looked. I was very dissatisfied, but it was too late now, my tresses were all gone.

We left Paris and headed for Rome. On our way to Rome we stopped in the south of France for a few days. While there, Noel Coward telephoned and invited us to lunch. We accepted. I was especially curious to see his decor. Noel's Georgian-style home was full of lovely French an-

tiques, and everything at lunch was beautifully served on bone china.

Soon, Jacques and Noel were rattling away to each other in French. My French was fair, but I was quickly left far behind. In fact, I was left out completely. Such a display of bad manners was disappointing.

After lunch, the two of them left me alone while they disappeared to take a tour of the house. When half an hour passed, I summoned the butler and told him I was ready to go and would be in the car. Jacques appeared sheepishly in ten minutes, but nothing would soothe my ruffled feathers.

Because of this incident, Noel Coward the man was lessened in my eyes, but my professional regard for his work as a composer and playwright has never changed.

Coming to this glorious city for the very first time, I was receptive to every visual experience it offered. Little did I know that my dear cousin Phyllis and her ever-loving husband, Bennett Cerf, were to be in Rome at the same time. (After appearing in a few films, Phyllis opted for a career in journalism and moved to New York. She was introduced to Bennett by my mother at a party and immediately fell in love. Soon after, they married and had two wonderful sons, Christopher and Jonathan. After Bennett's passing, Phyllis met another wonderful man, the former mayor of New York, Robert Wagner. They were happily married for nearly twenty years.)

One evening, the four of us, the Cerfs and the Bergeracs, decided to try the spaghetti palace of Alfredo's. Jacques and I ordered spaghetti with marinara sauce. When our dish came, Alfredo took the beautiful golden fork and large spoon given to him as a gift some years before by Douglas Fairbanks and Mary Pickford and dove into this mound of pasta like a small crane. When he raised the pasta to serve it, he found,

much to his consternation, that he had severed the head of the fork and spoon. He began to weep openly. We were at a loss as to what to do. His wife came over to the table and the two of them wept over their great loss. I guess one doesn't have a solid gold spoon and matching fork given to them every day. I assume the utensils eventually were soldered together. Still, I hated to be the one whose spaghetti caused all this trouble.

On a trip to the beach at Ostia, some twenty miles from Rome, Jacques and I were searching for a quiet strip of sand to sun ourselves and swim. We saw a very tall, very handsome man by himself. It was Rock Hudson. We were happy to see each other and Jacques and I spread our things alongside him. Naturally, our conversation turned to Hollywood, talking shop. Then we discussed Italy and shopping.

"Rock, did you ever notice the shopkeepers in Italy?" I asked. "They watch you as if you're going to steal something."

"I guess I did notice," replied Rock.

"Let me show you," I said, and proceeded to imitate some of the Italian shopkeepers, ending with a funny face.

"Hold it," said Rock. "I want to take some home movies of this." He took out his camera. "All right, Ginger, do the whole thing again."

Somewhere in Rock Hudson's estate, there is an 8 millimeter film of me on an Italian beach mimicking the tourist trade.

While we were in Rome, I received a long-distance call from Darryl Zanuck. Not only did he want me for a film, he also wanted to cast me against type. "Ginger, this is the opposite of the nice lady you usually play."

"Tell me more about it," I said.

Darryl wouldn't say any more except that the movie would be made in CinemaScope. "I'll send you the script.

Let me know right away if you will do it. But I recommend it, Ginger. As a matter of fact, I demand that you do it!"

Our relationship had been one of warm affection since the time he insisted I do "We're in the Money" in pig latin. I was a good friend of his wife, Virginia, and had spent many enjoyable evenings as a guest in their lovely home in Santa Monica.

The script of *Black Widow* arrived, and I read it. The story concerned the murder of a young actress and the efforts of the police to find the killer. My character was an actress and I discovered that she/me had committed the murder. "That's why I want you to play the part," Darryl told me over the phone. "No one will ever suspect *you* of being a killer. It will be a nice shock for the audience."

Jacques and I talked it over, and I decided it would probably be an interesting thing to do, from a career standpoint. Finally I had an opportunity to play a villainess. Nunnally Johnson was the producer and director. I loved working with him, though I have to say, I think he was much more articulate as a writer than as a director. Reginald Gardiner played my husband, and the cast included Gene Tierney, Van Heflin, George Raft, Otto Kruger, and Peggy Ann Garner. Aaron Spelling, the television producer, had a small part, too.

At the time I was filming *Black Widow,* Marilyn Monroe was busy shooting *There's No Business Like Show Business* for the same studio, Twentieth Century–Fox. One day she wandered onto our set and dropped by my dressing room. We had done *Monkey Business* together two years before, and had become friends. Not close friends, but friends. She had been married to Joe DiMaggio earlier that year.

"How's Joe?" I asked casually.

Before she could reply, her eyes clouded over, and the tears were very close.

I looked directly at her and asked, "You're not planning to leave him, are you?"

She nodded.

"But he's a darling man. You shouldn't."

Without a word, she shrugged and went back to her set.

Another remembrance of Marilyn is of a Sunday morning when I was attending my church on North Crescent Heights Boulevard in Los Angeles. I happened to look back and saw her sitting in the last row. It was the only time I saw her there. Perhaps if Marilyn had become seriously interested in this way of thinking, the tragic end to her life might have been avoided.

When *Black Widow* was released, the reviews were mixed, but Darryl was absolutely right about my casting. The whole film community was shocked that I played such a role. Even today, people walk up to me and say, "I saw a film of yours and couldn't believe you were the murderess. How could you do it?"

"Very easy," I tell them, "they paid me."

When Leland Hayward told me I was wanted for a television special, I was surprised, but even more surprised when Leland told me the material that had been suggested: *To-night at 8:30*, a group of short plays by Noel Coward that included *Red Peppers, Brief Encounter,* and *Shadow Play.* Originally the plays had been performed on the London stage by Noel Coward and Gertrude Lawrence. Laurence Olivier had done a production of *Red Peppers* several years before in New York City. I was to take on the three leading female roles and play opposite three different leading men: Martyn Green, Trevor Howard, and Gig Young.

Jacques and I flew to New York in October 1954 and settled in at the Waldorf as I began a week of rehearsals

at the NBC studios. Otto Preminger was the director. He was very gracious toward me, but he was a very picky man and nearly drove Gig Young crazy. Otto was constantly on his case—pick, pick, pick—unnecessarily. I was embarrassed by Otto's constant fault-finding and Gig was nearly in tears. How he stood Otto's behavior I will never know.

In the first episode, *Red Peppers*, I played a very cockney gal who worked London's West End with a partner, played by Martyn Green. It was mostly song and dance and cockney dialogue. The role I most enjoyed was the one opposite the British actor Trevor Howard, in the second episode, *Brief Encounter*. He gave the whole production such reality. The third and final episode, *Shadow Play*, had an excellent cast: Ilka Chase, Gloria Vanderbilt, Estelle Winwood, Gig Young, and Margaret Hayes.

You must remember, this was *live* television in 1954, and I was frozen stiff at the thought of being on a television stage with a live audience and no chance for a retake if anything went wrong. But once I started the first few lines of the show, all the so-called panic left me, although it was difficult to concentrate, knowing I had to play three different characters during this ninety-minute show. I was certainly grateful when the final fadeout came, and we were finished!

I wasn't taking any chances with live television and had a clause put in my contract that this show could be broadcast only once, in the United States. Well, NBC was a bit piqued about this, but asked, if that was the case, could they at least show it overseas to the U.S. Armed Forces. That I agreed to, but as the only other showing. Actually, I didn't even see "To-night at 8:30"; Leland Hayward never found the time to get me a copy. Thank you, Leland Hayward.

Whenever Jacques and I were in New York, we loved to frequent El Morocco, with its postage-stamp-sized dance

floor and wonderful music from its equally wonderful or-
chestra.

The mood was romantic and mystical. Against each
wall were black-and-white zebra-covered banquettes
with stately white papier-mâché palm trees extending al-
most to the ceiling. This stark but stunning black-and-
white decor with marvelous blue-colored lights shining on
the palms created the effect of a balmy night in Florida.

John Perona, the owner, had a great affection for me,
and every time I came into his club, he treated me in a
queenly fashion, giving me the best available table. If the
club was crowded, Perona would have a table placed on
the edge of the dance floor, which was like "sitting in"
with the orchestra. Loving music as I do, this only created
a more cha-cha atmosphere for someone who loves to
dance. As the music began to play for the dancers, multi-
colored ceiling lights would whirl overhead while the
music grew louder. I'm certain a number of marriage
proposals went unheard, with the fellows never getting up
the courage to repeat those tender and dangerous words
again.

Returning to the big screen, my next film was *Tight Spot*
for Columbia. It gave me my first opportunity to work
with Edward G. Robinson. I had always loved him, and
we had known each other for a long time. I also liked
Brian Keith, and working with him for the first time was
a joy.

I found *Tight Spot* a very interesting film, because it
gave me a character I could really sink my teeth into.
Being directed by a friend of mine, Phil Karlson, was a
bonus. The producer was Lewis Rachmil. As a prison
inmate on leave from prison, I did not have many changes
of costume, but Jean Louis came up with a very pretty
polka dot dress.

This picture was adapted from a stage play, *Dead*

Pigeon. I played a small-time hood's girlfriend who is taken out of prison and put under very tight security because she is turning state's evidence against a gangleader played by Lorne Greene, pre-"Bonanza." Although it was not a big hit, everybody seemed to enjoy the show. As the *New York Times* reviewer wrote, "If Academy Awards aren't in order, neither are apologies."

The First Traveling Saleslady was supposed to be a vehicle for Mae West, but she was unable to do it. Taking the role of Rose Gillray, the corset/barbed-wire saleslady, I was able to return to my old haunts at RKO. I hadn't done a film for that studio since 1946, and it was good to see some familiar faces. I even had the use of my old dressing room.

Some new faces were on the screen with me in this western. Carol Channing made her feature film debut and there was a small part for future megastar Clint Eastwood. Barry Nelson played his role with his usual affableness, and "Gunsmoke" star James Arness was in the saddle again.

At the time this film was made, January 1956, RKO was one of the busiest studios around. The new RKO Teleradio Pictures was cranking out films one after another, for television. Indeed, *The First Traveling Saleslady* marked the end of RKO Radio Pictures. Well, I'd been in at the beginning and I was there at the finish. *Sic transit gloria mundi* (Thus goes the glory of the world)!

In March 1956, Richard Rodgers invited me to join a star-studded benefit performance at the Metropolitan Opera House. I was asked to sing two songs and I chose "It's So Nice to Have a Man Around the House" and Cole Porter's "It's De-Lovely." When I arrived on the night of the benefit, Richard Rodgers handed my music directly to

the conductor. I was introduced and came out on stage to a wonderful round of applause. I bowed graciously as the orchestra launched into my first song. I started singing the first verse, then looked at the orchestra leader, greatly puzzled. I stopped singing and said, "Something's wrong. Can you start again?"

The second time it was still wrong, and I asked him again if he wouldn't mind starting over. There were fifty or sixty men in the orchestra, and the sound reached the stage in a conglomeration of unrecognizable noises. It was like nothing I had ever heard. On the third try, I still couldn't tell what was the matter. I begged the audience's pardon and said, "Believe me, I don't know what's the matter, but I'm going to find out. Thank you for your patience and good night."

The next day, I found out what had happened. Rodgers had handed the conductor the charts for my second song *first*. As a performer, I expected the music of the verse I intended to sing to fill my ears. I had the lyrics all ready in my mouth, but they didn't go with what was being played. It was a melange of sounds.

The day after the benefit, a beautiful bouquet of flowers came from Gloria Swanson, who had been sitting in a private box just above the stage. When I called to thank her, she said, "None of us knew what was the matter. It didn't sound like any song I'd ever heard."

P.S. Richard Rodgers never again asked me to perform at a charity concert!

In mid-1956, I received another call from my old friend Charles Brackett at Twentieth Century–Fox. He wanted me to play the mother in *Teenage Rebel*, based on the Broadway play *A Roomful of Roses*.

This was a marvelous script with just the right mother-daughter emotions. It was a role I found personally rewarding. Betty Lou Keim was the daughter, and Michael

Rennie played my husband. The ending of the film was unusual in that, instead of ending in a clinch between husband and wife, it ended with a clinch between mother and daughter, and was a very moving moment.

Only a month after I completed *Teenage Rebel*, Nunnally Johnson contacted me with another of his scripts, this time, *Oh, Men! Oh, Women!* from the play by Edward Chodorov. The analyst's couch is populated with all sorts of characters including Dan Dailey, Barbara Rush, Tony Randall, and the analyst himself, David Niven. I had great fun playing the neglected *Doll's House* wife of actor Dan Dailey, and telling my problems to David Niven. Fortunately, David was in a better frame of mind in this film than in the last one we had done together, for he had been remarried to a lovely lady for almost eight years.

Just before Christmas 1956, Bob Hope asked me to join his show to travel to Alaska to entertain our troops. I was delighted to accept. Mickey Mantle, Jerry Colonna, Peggy King, and Hedda Hopper were also part of the acting and singing troupe. The December weather in Alaska was not the best. Looking out the window, I could see only white on white—white clouds on white snow. The pilot was looking for a break in the clouds to find the landing field of Ladd Field in Fairbanks. He made three tries, dipping and circling. We lurched and bumped. Everyone on the plane was silent. The landing gear would not come down. Finally, on the third try, he came in for a relatively smooth landing. The relieved applause was loud inside the plane.

An amusing sideline to this Alaskan show was a scene in which I played a vampish golddigger. I was supposed to break a bottle over one actor's head three different times. The bottle was a prop, and had been scored, ready to break on contact. This had worked perfectly in Hollywood during rehearsals, but Alaska was cold, and the bottle had

frozen. When I hit his head, I had to strike twice to break the bottle. The same thing happened with the second bottle. Not wanting the third bottle to fail me, I really wound up, and WHAM, down on this poor man's head it came. It nearly knocked him out, but the force of my hit cracked all of us up on stage. We stood laughing for a few minutes before we could get on with the skit.

It was quite a privilege to perform for all those soldiers, braving the arctic cold for the Alaskan Command. I salute them all and all our Armed Forces, everywhere.

Although Jacques and I had a happy marital relationship, it was not to last. We were divorced in mid-1957. The reasons were personal and I was deeply hurt when I discovered his unfaithfulness. However, he was always very friendly and affectionate to me whenever we met in public after that, which was rarely. The truth is, for a few lovely years, Jacques Bergerac was my knight in shining armor and, bless his heart, that's the way I'll always see him.

THEATER AND POLITICS

IN 1957 I WORKED ON TELEVISION WITH SOME REGULARITY, from guest spots on "What's My Line?" to appearances with Perry Como and Steve Allen. I did not, however, get my own show, although a number of series were considered and even a few pilots shot. In one I played twin sisters, but the show eventually was made with Patty Duke playing identical cousins. I couldn't sit around waiting for the occasional call, and began to think about what I *could* do, on a regular basis. I always came up with the same answer, the live stage. Since there was so much music in my life, I decided to put together a nightclub act. I had my agent get me some bookings, and opened on December 10 in Havana, Cuba.

The first night of any show in front of a live audience is a nerve-wracking experience. The jitters come and are dispelled only when you begin. In this instance, my personal nervousness took a back seat. The room where I was playing was new and had acoustical problems. To top it off, an unexpected cloudburst raged for hours and left the lobby flooded with four and a half inches of water. My

audience practically had to swim to see me. The show went on, of course, and the reviewers in the various newspapers gave me the same reviews they gave the cloudburst. Shirley Eder ranted in her column, "How dare Ginger not dance a step." I had chosen all kinds of songs that I loved and enjoyed hearing. Shirley to this day reminds me that the four singers in my show had the nerve to sing "Red Sails in the Sunset."

Undaunted by Shirley's review, I took a similar act to the Riviera Hotel in Las Vegas in January 1958 and played there for four weeks. Peter Matz was my conductor on both occasions and Stephen Sondheim wrote some specialty material for me, including a song entitled "The Night Is the Best Part of the Day." I truly enjoyed playing Las Vegas, but it was almost twenty years before I returned.

When I closed in February, I was booked for more television appearances. I thought it was high time I had my *own* special, and my agent arranged one with CBS. I had a wonderful time doing this show, and invited Ray Bolger to be my guest and dancing partner. As a coincidence, that same week in October 1958 Fred Astaire did his first "Evening with Fred Astaire" program, dancing with Barrie Chase. So within the same week, Ginger Rogers and Fred Astaire were starring separately.

My experience with *Love and Let Love* did not dampen my enthusiasm for doing live theater. No "once bitten, twice shy" for me. In August 1959, I was asked to do a new play, *Pink Jungle,* by Leslie Stevens. *Pink Jungle* had a lot going for it, including a top-notch producer, Paul Gregory; a seasoned director, Joseph Anthony; and music by Vernon Duke. I was eager to return to Broadway—besides, how could I resist anything with "pink" in it? I said I'd do it.

The plot concerned females in the business world, and

although the show was not an out-and-out musical, I did
have one dance. I devised a number in which I danced
with an empty raincoat. Agnes Moorehead portrayed an
Elizabeth Arden–type head of a cosmetics company; I was
her right-hand woman, in charge of the dirty work like
hiring and firing. The strong supporting cast included Leif
Erickson, Ray Hamilton, and Maggie Hayes. *Pink Jungle*
was an expensive production; among other things, we
needed a turntable. (One strip of the stage would move
from stage left to stage right and another section of the
stage would move in the opposite direction.) I wasn't
worried because I had a great deal of confidence in Paul
Gregory. He had worked successfully with such stars as
Claudette Colbert and Charles Laughton, and I felt he
had enough stage production know-how to make this an
interesting show.

Pink Jungle would travel on the road to various cities on
its way to New York. The tour would give us a sufficient
amount of time for improvements . . . I thought. We
rehearsed for three weeks in Los Angeles, and opened in
San Francisco to mixed reviews at the Alcazar Theatre.
The author immediately proceeded to fix the various
places that needed strengthening. Consequently, the cast
had to speak new dialogue almost every night—always a
strain.

During the second week in San Francisco, American
Airlines asked me to christen two of its newest planes. It
sounded like fun, as well as good publicity, so I took time
off from rehearsals to launch the aircraft. The two planes
were placed nose to nose, and a platform had been built
to allow me to walk from one nose to the other to strike
each with a bottle of champagne. Below the platform
were interested observers, cameramen, and workmen. I
was handed a bottle of champagne for the first plane,

which had a wedge of wood wired to its nose to prevent damage.

"We have scored the bottle," said the publicity director. "You do not have to exert an enormous amount of energy. It'll break easily."

I took the bottle, and as the cameras began to roll I went into a perfect backswing. Cheers and applause followed the arc of the bottle as it came against the plane and went . . . thud. The bottle didn't break and the cheering stopped. "I thought you said you scored this," I remarked to the publicity man.

"We did, Miss Rogers."

"Okay," I said, laughing, "we'll try it again."

This time my aim was in earnest, and the bottle went "thud" once again. My face was as red as those of the publicity directors. I looked below and saw a workman on the tarmac. I called down and asked him to send me up a pair of his pliers. I took the pliers he gave me and held them in my right hand as I pressed the champagne against the target. I whacked the bottle with the pliers and, Bravo! The champagne spilled all over the nose of the first plane. I handed the pliers back to the gentleman and thanked him. Picking up the second bottle of champagne, I walked to the other plane's nose. Believe it or not, I had to go through the same business with another recalcitrant bottle. That night the television news was full of clips showing my trial and error.

It reminded me of the time many years earlier when Bess Truman stood ready to christen a submarine while cameras were clicking. She obviously had been told the same thing I had been told about the pre-scored bottle breaking on impact. With the bottle of champagne in her hand, Bess struck hard once, then twice; on the third try, she struck with all her might and the bottle broke. However, the ruffle on her hat fell down over her eyes, and the newsreel audience screamed with laughter. I only wished my experience had been that funny. The christening *was*

good publicity for American Airlines though. In gratitude, they sent me a charming gold and jade bracelet from Gumps. I proudly cherish it and the memory of that ridiculous incident.

After *Pink Jungle* played its three weeks in San Francisco, our next date was Detroit, at the Shubert Theatre. When I signed to do this play, I stipulated that my certified salary check was to be air-mailed each week to my business manager, A. Morgan Maree, Jr. and Associates in Los Angeles. At the close of my week in Detroit, I called the business office to ask them to take care of some bills. I was told that no checks had been received for the past five weeks.

When I told this to Mother, she immediately spoke to Paul Gregory's representative. There was a lot of hemming and hawing, but what it boiled down to was, they had not done what my contract specified. I had worked the past five weeks without remuneration. If I hadn't had a bill to pay, I wouldn't have known.

I didn't like having to ask for my salary, nor did I enjoy having to plead for rewrites. Leslie Stevens's wife was ill and he was not as responsive as he might have been. While I was sorry for his personal anguish, our show was on its way to New York in three weeks. I telephoned the hotel to speak to Paul Gregory about the play and the money he owed me, but he had left Detroit for Los Angeles.

"How could a producer desert his own show at this early stage?" I asked.

"Oh," his secretary said, "didn't he tell you he was going to produce a movie in Hollywood?"

That's all I needed to hear. The writer wasn't writing, the producer wasn't producing, and the show was standing still. A traveling show without its producer is like a saddle on a wooden horse. It goes nowhere. I emphati-

cally said that if the show was not ready for a proper New York opening by the time we reached Boston, they could forget about my being in the cast.

Pink Jungle opened at the Shubert Theatre in Boston on December 2, 1959, and I gave my notice. I said I was leaving because neither the writer, the director, nor the producer had done anything at all to make the necessary improvements. The show never made New York and closed for good in Boston on December 12. It took me until 1963 to get the money I was owed. As show business people say, "That's a long way to go for a laugh."

The only good thing to come out of *Pink Jungle* was getting reacquainted with Shirley Eder in Detroit. Shirley, a writer on the *Detroit Free Press*, came backstage after the opening night. I looked at her charming, sincere, and adorable face and said, "Shirley, come here into my dressing room—I want to talk to you."

I closed the door behind us and said, "Shirley Eder, I don't know you very well. But you've got an honest face. I'm going to ask you an important question, and I expect a sincere and honest answer."

She gave me a long quizzical, cautious look. "All right, shoot."

"Here it is. What do you think about this show you saw tonight and don't pull any punches."

Her pause was not surprising, because she knew what she was going to say, and I was afraid I did too.

"This show needs a doctor and won't last a week in New York as it is."

She began to break down the various parts she thought were weak, and I found I agreed with her analysis. Thereafter, she referred to it as "Pink Eye." We've been friends ever since.

I've always been interested in politics and have been a lifelong Republican. During the summer of 1960, I worked

for the Republican Party, campaigning for Richard M. Nixon. George Murphy and I had made a lot of speeches in California on behalf of Nixon's campaign for the presidential nomination. During a fundraising dinner, I was seated on the dais with several prominent Republican politicians, including President Dwight D. Eisenhower. He was seated two places away from me, and the men occupying those seats talked to each other throughout the speeches. On the way back to my chair after my speech, as I passed Eisenhower's chair, he said, "Very nice." More speeches followed.

Later, Eisenhower handed me a note which read, "How does it happen that I always get cheated out of sitting next to the pretty ladies?" It was signed Ike Eisenhower.

I was very flattered that the President wanted to sit next to me, and leaning over I said to him, "Well, we could ask these gentlemen to move." Darned if Ike didn't ask them to do just that.

I was pleased with the new seating arrangement as I'd never met Eisenhower before, much less talked with him. This gave us an opportunity to do just that.

In the summer of 1960, I finally fulfilled my desire to perform in the musical comedy *Annie Get Your Gun*. I did a five-city tour on the summer theater circuit on the East Coast. One of the theaters was in the round and a nearly tragic mishap resulted. The stage directions called for me to ride a bicycle rigged mechanically to travel in a circle. I was stretched out horizontally, with my feet propped on the handlebars, and as the bicycle circled, I aimed my shotgun in the air to knock out the lighting fixtures. During this particular performance, I began my curved route when suddenly a center cleat sprang loose. I realized I was about to be dumped, never dreaming what a spectacular dump it would be. I sailed through the air and

thumped smack on my back atop the baby grand piano, with one foot in the bass drum and the other in the bass fiddle.

The breath was knocked out of me and I felt as if I'd been hit by a truck. The first thought that came to my mind was, "Man is all right, and I am all right. God has to be with me. It couldn't be otherwise. He is where I am, I am where He is."

For a half-minute I lay on the piano, until one of the backstage crew came running down the aisle. He peered into the orchestra pit and said, "Give me your hand, I'll pull you up."

I felt as if I weighed a thousand pounds, but I knew I was all right. With this person's help, I stood on the stage and said to the audience, "I'm all right. I'll see you later." They audibly sighed with relief.

I went to my dressing room. Boy, oh boy, did I pray.

I asked the young man to look in the telephone directory for a Christian Science Practitioner and to call her. After explaining what had happened, he was to ask her for prayerful support. "Tell her, after the show, I will talk with her personally." He ran out quickly on his mission, and I changed my costume for the next scene. I kept my thoughts at a prayerful level and, as I stepped out on stage, received a show-stopping round of applause and finished the performance.

I continued my daily performances, supported by my own prayers and study, together with the support of the practitioner. Knowing I was the image of our perfect Father, I was soon doing what I should do with complete freedom from those problems I seemed to have faced. The entire cast recognized the validity of this healing, which they had witnessed before their very eyes. One of the cast said of my spectacular flight onto the piano, "You ought to keep that in the act!"

42

\mathcal{T}HE LAST WALTZ

WHEN THE SUMMER RUN OF *Annie Get Your Gun* WAS OVER, actor G. William Marshall came into my life. He was a good-looking fellow whom I'd seen at several parties over the course of a few weeks, and he paid me an enormous amount of attention. During our conversations, I learned he had been married to French actress Michèle Morgan, and that they had a son, Michael, aged fourteen. Bill and his son were living with Bill's mother in the San Fernando Valley. We talked a great deal about his boy and of his plans to send him to UCLA. Bill Marshall seemed to be a real family man.

We dated and saw each other constantly for about six months. He'd kiss me as he arrived to pick me up, and occasionally I smelled liquor on his breath. One evening, after a wonderful dinner, Bill looked at me very seriously and asked if I planned to marry again.

Romantically, I said, "Yes, I hope to."

Gazing at me with his soft blue eyes, he asked, "Could I be that lucky fellow? Will you marry me?"

I didn't pull any punches and asked point blank, "Bill,

413

do you drink? I mean, is it a casual thing with you, or is it somewhat of an obsession? I really have to know from you honestly what alcohol means to you. Because I just don't want to marry someone who drinks."

He took his time answering me. Then, looking me in the eyes, he said, "Alcohol means nothing to me! I promise you."

If only he could have kept that promise.

We were married on March 16, 1961, in Santa Monica, and within two weeks I realized I'd made a dreadful mistake. I couldn't get my own consent to stop right there, as I knew I should; this was the decision I would always regret not having made.

In talking to a friend shortly after my marriage, I complained to her that Bill was a drinker and that had I known this beforehand, I would never have married him.

She replied, "Why didn't you ask me? I would have told you!"

Well, I figured I could change Bill, and I tried. But during ten years of prayer and beseeching him, telling him it would be "curtains" for us if he didn't quit drinking completely, his response was to avoid the subject, or avoid me.

Not until ten years after I had sold my house at 1605 Gilcrest Drive did the present occupants tell me they had found a bottle of apricot brandy hidden up in the crawl-space above the library closet.

One evening Bill and I had an altercation when he came home with breath that would have set the house on fire had anyone lit a match near him. We exchanged words. When he grabbed my wrist and got belligerent, I pushed him, hard. Bill lost his balance and then, as if in slow motion, he fell back about ten feet and then landed smack

dab in a closet, on my spindly-legged sewing basket. Of course, he broke the basket. Everything, Bill included, went to the floor. I couldn't help laughing at the ridiculousness of the scene. He was sprawled out like a doll under a Christmas tree. I left him there and went to my bedroom to retire for the night. That was the last I saw of him for three or four days. This was one of a number of altercations we had after he had been out and about.

I had to work harder and harder because he borrowed money from me. I was already supporting my mother and her household, my ranch, and my own household and did not need this added financial strain. During the early years of our marriage, I performed in a lot of summer theater productions to pay for him. (One of these was Meredith Willson's *The Unsinkable Molly Brown,* which I did in Dallas for Tom Hughes of the Dallas Starlight Musicals. In the cast was a cute, sprightly young girl who had success written all over her face. She would eventually become known for her smooth and agile performances in *Peter Pan,* her Wheat Thins commercials, and the hit TV show "The Hogan Family." These have all added to the public's recognition of the charming little "Funny Face" of Sandy Duncan.)

Bill had overblown ideas. He decided he would expand his talents and produce films, and in 1964 he formed a corporation. Jamaica was chosen as the relatively inexpensive location for shooting his first project, *The Confession.*

Looking back, I cannot understand how I went on for so long and why I did what I did. My only defense is, he was my husband and I was trying to make my marriage work. I'd given up on other men because of alcohol and I didn't want to quit again. I foolishly thought I could make a difference. I did things I never would have done had I not been married to Bill Marshall. For one, I played the madame of a high-class brothel in *The Confession.* I never in this world would have agreed to such a thing had the producer not been my husband. Also in the cast were

newcomers Barbara Eden and Elliott Gould as well as my old friend Ray Milland. Bill's first attempt at film production was also his last. *The Confession* was a disaster. Among other things, the financial backers tried to confiscate the rushes before they were shipped back to the States. Eventually there was a lawsuit. As a result, the film production cost me the friendship not only of director William Dieterle, but also of the screenwriter, Allan Scott, from my RKO days and of co-star Ray Milland. I wanted to get away from the whole rotten mess and leapt at the chance to work in the musical *Tovarich*, which toured for five months.

When I returned home, Bill was still trying to get the film out of the hands of the backers and was in New York. One evening, I accepted a dinner invitation from some friends as they were going to one of my favorite restaurants in Beverly Hills, Chasen's. When I entered the restaurant, who should be at the table directly to the left of the entrance, staring me in the face, but Jacques Bergerac and his newly married third wife. He got up from the table, opened his arms wide, came to me, and gave me a bear-like hug, saying that he hadn't seen me (Pinkie) in such a long time. He told me he had just returned some six weeks ago from Rome where he had called on Pearl Beresford, the Christian Science Practitioner who had helped him in London.

He said he had had an infection in his hand, and the doctors told him he should take some injections, but he didn't want to do that. The doctors warned him that there would be serious complications if he did not. Very soon, his hand turned green, as gangrene had set in. He was frightened and called London to speak to Pearl to ask her if she would help him, metaphysically. After hearing of his problem, she told him that she would help him, but only if he obeyed her instructions. He was to study a certain chapter in *Science and Health* daily and then to telephone her some three days later.

He told me he suffered terrific pain, but gradually his fear ceased. When he called her back at the appointed time, he told her the swelling had diminished considerably and asked her to continue to work for him.

"I did what she asked me to do," Jacques said. He added, in a voice of triumph, "I was completely healed. You know, she is a wonderful woman."

This was the second dramatic healing he had experienced. The first one, in London, had been some time before, but he had not forgotten how he had been protected and beautifully healed—so much so that he had turned back to the one who had so lovingly and prayerfully supported his faltering faith. The embrace he gave me was more of a "thank you" than anything else, and I recognized it as such after thinking about it some time later.

Soon after *Tovarich* ended, I received an invitation from Twentieth Century–Fox to attend a luncheon in honor of the Shah of Iran and his queen. The Shah was a very striking-looking individual, and the eyes of all the female stars were on him. His queen was attractive, but not as stunning as I had expected her to be. I would have cast this pair much differently. Apparently the Shah agreed. He made another choice about a year and a half later, and this new queen bore him a son.

About a week after the luncheon, I was invited to play tennis with the Shah. Bill and I arrived and were greeted by a few of the film colony's tennis buffs. The group was obviously invited according to their tennis rank, socially and professionally. We had a nice chat with the Shah and his queen, asking them how they were enjoying California. They were aglow with the interesting movie sets they had visited.

The Shah had a great fondness for tennis, but the queen showed royal indifference. The Shah's partner was a pro-

fessional. I knew Bill and I were sunk before we started. The Shah played well enough to hold his own, but the pro never let a shot go by. He scrambled for every shot, running across the court in a frenzy to secure the shots the Shah missed. At the end of the match, he was wringing wet. The final score was 6–4, 6–3. Later, I learned that the Shah played with a pro because no one was allowed to beat the Shah.

In January 1965, I played the Queen in Rodgers and Hammerstein's television musical production "Cinderella." The production gave me the chance to be reunited with my friend Walter Pidgeon, who played the King. Stuart Damon was cast as the Prince and in the title role, making her television debut, was Lesley Anne Warren.

I made my last motion picture in March 1965 for Magna Pictures. *Harlow*, based on the life of actress Jean Harlow, was made using a new process called Electronovision. Unfortunately, the finished product was very grainy and not too viewable; it was done too fast . . . shot in just eight days! Director Alex Segal didn't have much of a script to work with, but the cast—Carol Lynley, Barry Sullivan, and Efrem Zimbalist, Jr.—tried their best. The costume designer for the film, Nolan Miller, achieved fame for his beautiful couturier clothes as well as for costuming the successful television series "Dynasty." Judith Crist of the *New York Herald Tribune* had this to say of my performance as the self-centered Mama Jean of actress Jean Harlow: "Looking both marvelously ravaged and lushly attractive, Miss Rogers survives the idiotic requirements of the script and makes us wish that she were doing more in movies—other movies, that is."

I didn't know at the time that *Harlow* would be my last motion picture. I had been turning down scripts that

were, in my opinion, too permissive in their dialogue and scenes. Hollywood was going in a whole different direction, one I didn't want to follow. I felt that the kind of films I made in my career were not the kind of films Hollywood was now interested in producing. I decided to look to my first love, the stage, to fulfill my acting needs.

43

ℋELLO, DOLLY!

ONE DAY IN MAY 1965, I HAD FINISHED A TENNIS GAME AT my hilltop home when a call came in from my theatrical agent, Louis Shurr. "Doc" Shurr had represented me for over a year and I'd instructed him that if ever a show on Broadway came along that might be of interest to me, he should be sure to inform me.

I didn't want to be limited only to making films. My thirst for the theater couldn't be appeased by just performing on the straw-hat circuit. I had played summer stock almost every other summer, and each time I would step on stage, the fond memories of my former years on the stage overcame me. Those in the theatrical world who have had the opportunity to work in all three mediums generally feel a great pull for the live theater. Almost every actor I've ever met who started his or her career on the stage has that same feeling.

"Ginger, I've got a great idea for you," said Doc. "How would you like to do a New York show?"

"That sounds fine. You know I'd love it. What have you in mind?"

"Well, Carol Channing will be leaving the show pretty soon, and David Merrick will need a replacement. I can just see you playing *Hello, Dolly!*"

To his surprise, my response was an immediate negative. "Louis, I saw the show in New York, and it is just not my cup of tea. I think Carol is very funny in the show. How you or anyone else could see me playing that role the kooky way she plays it is beyond me. So thank you very much, Doc, but the answer is no."

"I think you're wrong," he said. "I'll talk to you later."

I have always believed conclusively in prayer. However much I wanted to be active in my profession, I preferred to do what would be a blessing to all concerned, and that would come through my willingness to be obedient to God's direction. Therefore, my prayer was for right activity in whatever area of life He would direct me. Keeping my thoughts focused in this way, I would certainly know what should be "my work." So I continue to express gratitude for all the good that He has given me.

As I did every afternoon, I played tennis on my court and awaited direction. About ten days later, Doc Shurr called again.

"Ginger," he said, "I do think you ought to reconsider doing *Dolly,* because truly, dear, it is a perfect vehicle for you, and David Merrick is still looking for his Dolly number two."

"Louis, dear, as I said, I saw the show in New York, and it's just not for me, but thanks anyway and keep looking for something for me."

Each day I prayed for the right activity for me, knowing that God gives each one of His ideas their rightful place and that I would not be left out. A week later, after I had played three sets of hard tennis, the phone rang and again it was Doc Shurr.

"Ginger, I've never asked you what time limits you would impose on doing a Broadway show. What would be your feeling about doing a show for a year and a half?"

"I'd have to think about it," I answered. "That is a long time to be away from home. Although it depends what it is, and what excitement it would hold for me."

Of course, I figured with this kind of cross-examination, Louis would have something in mind like playing Gertrude to Burton's *Hamlet*.

He said, "Well, I hold an agreement for you to play for a year and a half on Broadway in . . . are you sitting down?"

"Yes," I said as I sat down. "Why?"

"Well, it's a bona fide contract for you to play a year and a half at the St. James Theatre on 44th Street in . . . *Hello, Dolly!*"

He hurriedly filled in the space left by my silence. "Merrick is certain that you would be a great Dolly for his Broadway company."

"But I told you the other day that I'm not the right type for—" and I stopped right there.

Suddenly the thought came to me, lightning doesn't strike three times in the same place. Why don't you read the script and see for yourself, before you judge it.

"Louis, do you have a script of the show I could read?"

"I'll send one immediately, but you will have to read it before 4:00. Merrick has to know by 7:00, New York time."

The book was delivered to me within the hour. I took it out on my veranda overlooking Beverly Hills, and on a warm California day started to read *Hello, Dolly!* Within the hour, I had read it and weighed the possibility of my playing the character of Dolly Levi. I realized that I had allowed my thoughts to be limiting. Each actress brings to a role her own individuality, personality, and charm. Why was I beguiled by the thought that I had to play the role like Carol? I was very close to making a big mistake by assuming that I could not be believable in the part of the matchmaker. Did Maurice Evans play *Hamlet* like Richard Burton or Sir Laurence Olivier? Obviously, the

answer is no. Well, dear God in heaven, thank you for patience. My answer to this will now be an absolute yes!

To prepare for *Hello, Dolly!* I rehearsed the dialogue at home. I hired Eddie Rubin to come up and hold book for me. One of the dancers, who knew all the choreography, was sent to run through some of the staging, though there was not actually much dancing at all. I also hired someone to come up and run through the songs with me to find my key. My house was filled with Jerry Herman songs and Michael Stewart dialogue. Even my tennis court was filled with the choreography and music for *Hello, Dolly!* I sent my measurements to New York so that the turn-of-the-century dresses of velvet brocade and taffeta could be manufactured by the costume designer, Freddy Wittop. The minute I got there, I was to go in for my first fitting. Everything was at the ready.

I arrived in New York with any and all contract problems solved. I was signed for a year with an option for a further six months. I was indeed thrilled at the prospect of being in New York City for that length of time. The date was set for Carol Channing to leave the show, and the night after her departure, I would open. Gower Champion, the director, who in times past had kept me socially and theatrically at arm's length, showed a mite more interest in my being his "second" Dolly, though I was never sure he was pleased I was there.

David Merrick didn't feel I needed to have a complete run-through. This really shook me up. I had never appeared on a stage in anything that hadn't had at least one run-through from beginning to end. In the ten days I was in New York before the opening, I was ready and willing to do every and all rehearsals. But the powers that be felt otherwise. The rehearsals worked so that on my first day,

I would do the opening scene with the entire cast; the second day, I would do the second scene with the entire cast; the third day, the third scene, and so on, until I had run the entire show in that fashion. Never was the complete show scheduled to be run through on one day, but this didn't strike me until the morning of opening night. I was stunned by the realization that I had never been through the entire show in one "go." The point, of course, was that Merrick, always mindful of the dollar sign, didn't want to pay the actors extra money or close down the show for one night while we did our complete run-through. This was very unprofessional and made it extremely difficult for me. You have to know the real timing between each scene and the sound of the other actors' dialogue leading up to your entrance. Familiarity with these sounds coming through your dressing-room monitor is helpful when you know your entrance is coming. That familiarity was missing, but by the time I realized it, I was immersed in Dolly Levi in her big hats and her bustles. I wanted to do the show, so I let it go.

My contract called for David Merrick to supply costumes, shoes, wigs, and a hairdresser, standard requirements in the theater. When I arrived in my dressing room on opening night, there was no wig. I found the stage manager and requested that the wig be brought to my dressing room post-haste. After twenty minutes passed, I again cornered the stage manager. "I must have that wig *now*. I must have the hairdresser *now*!" It was only two hours before the curtain went up, and I would be performing in front of a live audience.

At last there was a knock on my dressing-room door. A young *Hello, Dolly!* dancer dressed in her show costume walked in, holding a deep red wig in her hand.

"Is that my wig?" I asked.

"Yes," she said. "I'll put it on for you."

"No," I said, "I want the hairdresser who's going to be taking care of my hair to put it on."

"But Mr. Merrick has asked me to put your wig on you and take care of it."

"But aren't you one of the dancers?"

"Yes, I am," she answered, wondering what was bothering me.

"As a dancer, aren't you constantly busy?"

"Well, yes, but I can come up from the chorus room right at the beginning of intermission to check you out before the second act starts."

This was utterly ridiculous and not at all acceptable. Here I was at the zero hour and this curve was thrown at me. What could I do? "All right," I said, "let's get at it and put the wig on. I've no time to waste."

I had tightly pinned down my own hair, and the girl dancer began to put the wig on my flattened hair. It was a struggle. I took one look at it in the mirror and said, "You must be kidding!"

It looked as if she had put a red floor-mop on my head. I was a living Raggedy Ann doll. Bob Kelly, one of the best wigmakers in New York, had made this wig with my scalp measurements and the precise color. How could there have been such a mix-up, at this crucial hour. The little dancer started to comb the hair back to where she thought it might go.

"This is crazy," I said. "This is not what it is supposed to look like." With that I impatiently took the comb out of her hand and made an effort to see what I could do to make it look halfway decent. Anyone could see that this was a lost cause. It was impossible. "Would you be good enough to go out and call the stage manager?"

"What's the problem?" he said.

"Problem? Do you realize what time it is? This wig I'm supposed to wear throughout the whole show doesn't fit properly, and it is not dressed in the right fashion. I'm going to give you a message to take to Mr. Merrick,

pronto. If this wig is not accompanied by a professional hairdresser immediately, I will not go on tonight!"

You could see the unwillingness to deliver such a message to the great Merrick written all over his face. Realizing I was not kidding, he reluctantly went forward.

It was ten minutes before I got a response. Jack Schlissel, Merrick's right-hand man, sent back word from the front office that a hairdresser was en route. Time was of the essence. Finally, I heard the doorman outside my dressing room say, "She's in there."

After the knock on my door, my first question to the young woman standing outside my room was, "Are you a professional hairdresser?"

"Yes, ma'am. My husband is double-parked outside the stage door. May I please tell him how long I will be?"

I realized this poor girl, who had come to help me, had no idea she'd walked into a buzzsaw. "You go tell him that you are going to have to stay. From this very minute, we have less than an hour to correct this wig for the performance tonight." With a perplexed look on her face, she ran outside.

"Now," she said on her return, "where do I start?"

"Just take one look at this wig, and *you* tell *me!*"

Her hands were actually shaking as she worked with the wig. Something told me, however, that I was truly in the hands of a professional. For the first time that day, I felt a sense of composure.

With a sureness, she said, "Do you mind if we take the wig off and start fresh?"

"Do whatever you have to do."

Off went my wig and she examined the inside shell. "Do you know that this wig has been put on your head backwards?"

"What!" I exclaimed. I quickly explained to her the oddity of a girl dancer from the show being assigned as my hairdresser. "Wait till tomorrow. I'm going to have a heart-to-heart talk with Mr. Merrick."

This young lady was indeed another one of God's angels. She was certainly heaven-sent. Cathy Engel has often recalled the frantic moments preceding my opening night and that frightening moment when Bob Kelly told her to get over to the St. James Theatre to fix Ginger Rogers's wig. That one hour turned into three years. It's a good thing her husband, Jack, didn't wait outside!

Now I was wigged and rigged and ready to go on. I felt a bit disenfranchised. Merrick certainly had done his best to make me feel out on a limb. Mother would have come in handy, but she was at the hotel preparing to attend tonight's performance and I didn't know where Bill was. This wasn't going to get me down. As a professional performer, I was responsible for motivating the cast to ride the wave with me. I hadn't been on the New York stage in a musical since *Girl Crazy*. Thank the Lord, I had God on my side. Wasn't it Wendell Phillips who said, "One on God's side is a majority"?

When the curtain went up, I wondered why I had put myself through this terrible business, instead of staying in Beverly Hills to play tennis. But the moment the horse-drawn buggy halted in the middle of the stage, and I put down the newspaper that was covering my face, the audience went wild with applause (says she, modestly). From then on, the cues were picked up and you'd have thought I'd been playing this show every night for a year.

44

\mathcal{O}N MY WAY TO 1,116

NOW THAT I WAS IN NEW YORK, I NEEDED A PLACE TO LIVE.
Spoiled by the serenity of my hilltop home in Beverly
Hills, and remembering my hectic early days in New York,
I wanted to be outside the city's bustle. I rented a house
in Palisades, New York, from Katharine Cornell. The driv-
ing time between stage door and my new front door was
approximately twenty-five minutes—a little less if the
traffic over the George Washington Bridge was light.

I fell in love with Cornell's house, designed by her late
set-designer husband, Guthrie McClintic. The living room
was very spacious, with a huge fireplace. My little Irma
Scheid loved the generous kitchen with the wooden table
and two long narrow benches. The whole house was in-
triguing and the view from the bluff that looked over the
Hudson River to Dobbs Ferry was marvelous. Before
show time, on many a day, I would sit with my oils and
enjoy painting scenes from the window. The house was on
approximately four acres abutting uninhabited State prop-
erty, affording some interesting walkways and the most
precious commodity of all—privacy.

Hello, Dolly! remains one of my most precious theatrical memories. To think I refused the role twice! I made up for it, I hope, by missing only one performance in my entire run. My voice just vanished, and I decided not to go near the theater that night. Bibi Osterwald, my understudy, went on that evening. Bibi had complained to some of the cast that she'd never get a chance to play the role because I was a Christian Scientist. Well, she got her chance, her *one* chance. I relied on Christian Science and was back on stage the next night. My only regret was that on that particular night, some dear friends had flown in from Los Angeles to see my show before they took off for London. Instead, they came to my house and sat by my bed. They talked, and I listened. Well, at least I got to see them.

I was very, very happy appearing in the show and most heartened by the number of friends who came to see me. Some wonderful surprise guests included Robert Ryan, Douglas Fairbanks, Jr., Maureen O'Hara, Truman Capote, Joan Bennett, and Colonel Harlan Sanders. Knowing I wouldn't leave the theater on matinee days, every Wednesday and Saturday the Colonel had some of his delicious Kentucky Fried Chicken delivered to my dressing room. What a treat!

My dressing room was tiny. It had one chair for me and one chair for Irma. The rest of the space was taken up by my voluminous costumes and hats. Next door was a tiny bathroom. Nothing was luxurious. I did have an air conditioner, and thank goodness for that. Cold air is a quirk of mine, especially when I'm performing. Even when it was winter outside, I still liked to have the air conditioner on full blast.

Gary Morton and Lucille Ball unexpectedly arrived after one performance. She was wearing a white mink coat and I said, "Come on in, Lucy. I'm so glad to see you and Gary. Take off your coat and stay a while."

"Not on your life," Lucy said. "It's snowing in here!"

I was genuinely surprised another time when the doorman announced Richard Nixon, his wife, Pat, and their daughter Tricia. They came backstage after the final curtain to say "Hello." I had always been impressed with this gentleman. Unfortunately, my dressing room was smaller than a bathtub, so it was impossible to invite anyone to come in and visit. Like a little kid, I stood in the hallway of the theater, chatting with the Nixon family and grinning as my fellow players passed by to get out the stage door. I could almost hear their reaction as they filed past me, "Do you know who Ginger was talking to as we left the theater? That was . . ."

A special ramp had been built around the orchestra pit of the stage at the St. James Theatre to enable Dolly Levi to walk around it for a special number. Later, I would come out for my final bow in a beautiful white dress and would travel along the ramp thanking the audience. One night, I was walking very fast and before I knew what had happened, I had stepped off the ramp into the front row of the audience. A loud gasp swelled up from the theater. Fortunately, one man stretched his strong arms up and caught me under my arms to hold me up and brace my fall. He was shocked, and so was I. In a matter of seconds, several people rushed over to assist me in getting back on the ramp. An incredible burst of applause filled the theater as I bowed again to an overwhelming standing ovation. My bow was deep indeed to the unknown gentleman in the front row.

David Merrick arranged a party for the one-year mark on my contract. He presented me with a lovely anniversary bouquet of antheriums with a cute little straw doll's face stuck in the middle (I later painted this bouquet and it hangs over my fireplace). Among the guests were Phyllis and Bennett Cerf; Bob Hope; my leading man, David

Burns; the author of *Hello, Dolly!*, Michael Stewart; and Bill.

One of the most memorable nights of *Dolly* was during the blackout on the eastern seaboard. I was on stage, standing by the cash register. The theater was plunged into darkness just as I delivered the line, "As my late husband, Efrem Levi, used to say, 'Money is like horse manure. You have to spread it around to do any good!' " The stage manager pointed a flashlight onto the stage and I stood in its beam. I walked to the apron of the stage and said, "Now don't panic, be calm. Sit there and talk to each other, and I'll go check and see what the problem is." I walked off the stage, following the flashlight beam. When it became clear that the problem was not with the theater, nor even with the street, but with the entire eastern seaboard, I came back on stage and told the audience, "Sorry, folks, I can't help you. This is beyond my control."

Luckily, I was able to make it home to Palisades. It seemed to take forever because the traffic crept due to the lack of traffic signals, but we finally made it.

Another night, after returning home from the theater, I found a message from Doc Shurr telling me that I was invited to appear on "The Ed Sullivan Show" on any Sunday night that would fit my schedule. Was I interested in doing a number from *Dolly* on Ed's show? I happily agreed, and decided I would do "Before the Parade Passes By." Even though Sunday was my day off, the Sullivan show was a great live TV show, and I was happy to be a part of it.

Some shows on Broadway had a Wednesday matinee, but others played on Thursday. This gave working theater people a chance to see other shows. I asked my *Dolly* box office to arrange three tickets for me to go to see *Mame* at the Winter Garden Theatre. Cathy Engel, and a young singer, Christina Sloan, were my guests. Our seats were

on the left-hand side of the auditorium, just below the balcony. As we sat down, a few of the ladies in the audience recognized me and started to applaud. Then the balcony joined in and small fires of applause broke out in different sections with each recognition. I was somewhat troubled by this, because I had come to see, rather than to be seen. But being recognized is a rewarding part of the theatrical business, and Christina was thrilled for me as we sat there together.

"This audience really likes you," she said.

I buried my head in the program, reading about Angela Lansbury. Soon the show would start and my self-consciousness would slowly disappear. I was grateful when the orchestra started to play those wonderful Jerry Herman numbers.

After the final curtain, as soon as we were out on the street, I turned to Christina and Cathy and whispered, "I'm glad Angela is doing this show, and not me. She's wonderful in the show, but she was off stage half of the time changing costumes. I only change about seven times in *Dolly;* she changes about twenty-seven times." (I had to eat those words later on.)

While I was appearing in *Dolly,* Raymond Rohauer, film curator and program director of the Gallery of Modern Art, asked if he could honor me at the Gallery. I was very honored and thrilled to be asked.

On January 30, 1967, those who were interested in seeing me "tributed" came to the Huntington Hartford Theatre at the Gallery of Modern Art in New York City, where Mr. Rohauer announced all my theatrical endeavors over the years, with accompanying film clips. On the walls outside of the little theater were photographs taken by Helen Montgomery-Drysdale. The reviews of my show business history that appeared in the papers the next day were very good. This was my first tribute, and you can imagine my delight.

Aside from the wig incident at the beginning of my

Broadway run, almost everything about my *Dolly* tenure
was delightful. Of course, there were a few mishaps.
One winter matinee day, I left the Palisades house at
11:30 A.M. as usual (I always allowed two hours before
curtain for makeup, costume, and hairdressing). My
chauffeur was waiting and off we started in my black
Cadillac convertible. We had to travel a three-mile stretch
before we reached the entrance to the bridge. There was
a little hill, and ice had accumulated overnight. The
chauffeur headed the Cadillac up the little hill, but as it
reached the halfway mark, it started rolling backward.
We tried it again and again. It was like riding a rocking-
horse.

Finally he turned to me and said, "You'll never make
your matinee this way. May I turn back to your house, and
if you will allow me, I will take you in my car."

I agreed. We sailed up and down those icy hills as if we
were on skates, arriving only ten minutes late. I was ever
so grateful. Thanks to the chauffeur and his Volkswagen,
my record remained intact. I have never missed a per-
formance as a result of not leaving my house on time.

Professionally, my life was going splendidly. Personally,
my life, married to Bill Marshall, was not. Despite his
promise to me before our marriage, being out and about
and having a good time remained a priority for Bill. He'd
tell me he'd quit drinking, but I would find liquor behind
the bookcases or anywhere he thought I wouldn't find it.
But I usually did and I was heartbroken, for I truly wanted
to help Bill and I thought I could help him best by getting
him to quit drinking completely. He could be so wonderful
when he wanted to be, and when the need was there to
make an appearance with me at some function or at the
theater. But when I came home from the theater and he
had been home alone all evening, he had usually had a
few drinks, and this led to some unpleasant scenes. Fortu-

nately, Irma was there for me to talk with, and reminded me that Bill was often so nice. This was true. But those times were becoming fewer and farther between.

In February 1967, my stay at the St. James would be over. David Merrick wanted me to take a national touring company around the country to places where *Dolly* had not been performed by the Carol Channing company or where Merrick felt it could play successfully again. The accounting office informed me that during my run on Broadway in *Dolly*, there had never been an empty seat in the house. Merrick made more money during my year and a half than in the months prior to my taking over the show. I was ecstatic that this was the case.

Before the tour began in Denver, I had about three months off. Bill and I stayed in Katharine Cornell's house, so I could rest up a bit from the grind of eight shows a week before it began all over again. As April approached, I moved out of the rented house in Palisades, New York, and sent my belongings to Los Angeles, to Holmby Hills. I planned to rent a house for the eight weeks we would be there. My house on Gilcrest Drive was rented, and there was little reason to oust my tenant for that short space of time. Needless to say, it wouldn't be good business. I did not like living in someone else's house, but I preferred a house to a hotel for the two weeks of rehearsal and six weeks of performing.

From Los Angeles, we would travel to a number of cities including San Francisco, Seattle, Portland, Las Vegas (ah, there's a story that goes with that one), St. Louis, Omaha, Cincinnati, Milwaukee, Des Moines, Madison, Minneapolis, Shreveport, Dallas, Baltimore, Philadelphia, and Boston.

A week before *Dolly* was to open in Denver, Fred Astaire and I were invited to present the writing awards at the Academy Awards ceremony. The night of the presenta-

tion, April 10, I visited Fred in his dressing room and suggested something that might delight the audience.

"Fred, when I'm introduced, I'll come from the center of the stage. When you're introduced, you'll come from the side. As we meet at center, I'll hold my arm out and you'll grab my hand and whirl me around once or twice and then release me to walk to the microphone. What do you think?"

Ever the shy one, Fred's first reaction was negative.

"No, I don't think that's anything, Ginge," he said.

"Fred, it's a thirty-second applause getter. Let me act it out for you."

At that moment, Hermes Pan came in and I told him my idea.

"That's a good idea," said Hermes.

Fred was still unconvinced. Hermes followed me to my dressing room.

"Hermes, he'll listen to you. Convince him, won't you?" I pleaded.

"I'll try," he answered, and left. In a few minutes, there was a knock on the door. "He says he'll do it." Just as in the old days at RKO, Hermes and I rehearsed the steps.

When we were introduced, Fred and I did our impromptu steps, and the audience went wild. They clapped and clapped, and their applause asked for more!

After *Dolly* had been running in Los Angeles a week, my stage manager told me my ex-partner was out front. Did I want to ask him to come back? Of course I did, I said, and one of the ushers gave him the word during intermission that I would love to have him come backstage after the show. To my delight, Hermes was with him.

"I haven't seen you on the stage since *Girl Crazy,*" Fred said. "You seem to be having a good time. Are you?"

"Yes, indeed," I chortled.

Even though we had seen each other at the Academy Awards only four weeks before, it was nice to see him again, behaving in his usual shy, boyish way. He always

seemed to have an awkward time finding a place to rest his hands, but soon he found his pockets. The cast of the show was standing in line to be introduced to the great Fred. Usually, after a show, the cast can't get out of the theater fast enough, but this time was different.

Hermes Pan was full of smiles and very pleased to come back to say hello again. Together, Fred and Hermes looked like brothers. Their physiognomies seemed to come from the same mold.

San Francisco was a dream city for performers. Every audience was spectacular. I loved to go to the theater at night and prepare for them. They applauded, laughed, cheered, whistled, and couldn't have been nicer to us. The house was packed for every performance. Some darling friends, Lois and George Boden, came to see the show at least a dozen times while we were there. Often, when I knew of their arrival in advance, I'd arrange with our stage manager to allow them to come into the wings and see the show from there. They had a ball during our playing time there. Years afterward, they continued to tell me and their friends what a treat it was to be able to stand in the wings and watch a number that they'd seen numerous times from out front. "It was even more enchanting to watch at such close range," they'd say. (Isn't it a joy to make someone so happy?)

What a special kick it was to be in that unique city with good food in almost every restaurant: the Blue Fox, Trader Vic's, Ernie's, the Carnelian Room in the Fairmont, and many excellent fish houses along Fisherman's Wharf. Any stage producer who mentioned playing San Francisco always had my ear.

Another stop on our tour was the Paramount Theatre in Portland, Oregon. Here, there was an amusing occurrence every night and I shall never forget it. My dressing room was stage left, my entrance was from stage right. Because

the scenery was smack up against the brick wall at the rear of the theater stage, there was no way for me to cross to get to stage right. In order to make my entrance at every performance for that week, I had to walk around the block, in costume. It must have been quite a sight for the passersby to see a woman in an 1880s costume walking around the block.

I had to keep on my toes in dealing with David Merrick. There is nothing that man wouldn't pull to save himself a buck. When a producer puts in a contract that a show is to play Las Vegas, two shows a night, every night, for a six-week engagement, that producer should be taken to court. My contract with Merrick for my New York run in *Dolly* was written for eight shows a week, as are all general stage performance contracts. But in contracts for Las Vegas, the stage performances are automatically understood to number fourteen shows per week. This tricky loophole got past my agent, Doc Shurr. He was astounded and full of apologies when Merrick demanded his pound of my flesh.

I gathered my courage and took Mr. Merrick to arbitration. It was a distasteful thing to have to do, to fight the producer of my show, but I wasn't going to let him get away with maneuvering me into doing six extra shows a week. His lawyer was very snippy and tried in every way to belittle and embarrass me. I had to stand my ground. Merrick was hoping against hope to make this a squeeze play, forcing me to do fourteen shows weekly, for the same remuneration I received for performing eight shows weekly.

Finally I gave him an ultimatum: cancel my entire contract, or hire another actress to play the additional six shows. I reserved the right to choose the performances I preferred, and chose all of the dinner shows at 8:30, plus

the late show on Saturday night. Begrudgingly, Merrick accepted this condition.

Then he looked around to find an actress to do the remaining six shows. He found that Dorothy Lamour was available. When she came to Las Vegas, she appeared to have a chip on her shoulder. She never came near enough even to speak to me. I assumed our performing hours were too conflicting for any camaraderie, and left it at that. I never dreamed she was suffering from a misunderstanding. She blamed me for choosing the best of the fourteen shows, leaving, according to her, the "dregs." This was untrue. I made my choice before anyone else was hired, and had Dorothy Lamour been in my situation, I'm sure she would have picked the exact same performances. She was never part of the argument I had with Merrick.

A happy result of my Las Vegas stint was meeting a couple who've become two of my very best friends, Jim and Rosemary Graham. I always tried to attend my Christian Science Church every Sunday I had free, and Las Vegas was no exception. I always enjoyed playing Las Vegas, and now I had two more reasons to come to the town that never sleeps. Indeed, I've met many precious friends while attending the Christian Science Church in various cities. In Des Moines, I met Charles and Violet Ruden, two precious people who were Christian Science practitioners. Charles Ruden and Lelee had a connection even before we met. They were both students of Mrs. Gallie Indermille, C.S.B., the Christian Science Practitioner who helped Daddy John on that cold night in Fort Worth. Violet was a student of Dr. John Tutt, C.S.B., the practitioner who helped my mother during traumatic episode of my kidnapping. In Philadelphia I met Ellen and Sidney Luce. They became fast friends and were there when I needed to know where to go for good food after the show

or where to shop or where to find the best ice cream (that really got my interest).

Being away from home at Christmas is always hard on performers. Anything that a friend can do on that day in the city where you happen to be playing can be a great help in making it more homey.

When we were playing in Shreveport, Louisiana, the week before Christmas, I received a note with flowers from pianist Van Cliburn. I had met this wonderful artist at a party given by *Time* magazine for all the people who had appeared on its covers, mine being in April 1939. In his note, he invited me to his home for some Christmas punch and to enjoy some holiday music with his mother and some of their friends. Everyone sang Christmas carols to the music of Van's playing. It was a special night and I shall never forget his thoughtfulness.

After Shreveport, we went to Dallas, which was great fun for me—almost like playing for the hometown folks, even if it wasn't Fort Worth. The Texas audiences were wonderful to us, and we had a marvelous week, which ended the year 1967.

The next stop was Hershey, Pennsylvania, and the only way to get there on time from Dallas was to fly. Unfortunately, there was a blizzard in Pennsylvania at the time we were to land. The pilot did his best, but we were bounced around like a kite in a windstorm and almost didn't make it. This happened on New Year's Eve. What a way to start the new year.

My final stop on the national tour was the Shubert Theatre in Boston, where we opened in February 1968. I had performed with this touring company for the last ten months and wanted to give each of them a little something to express my gratitude and thanks for everything. We

had quite a large number of personnel as well as cast, and trying to decide what would be a good little present for each was a bit overwhelming. It's funny, theater audiences think everyone in the cast is bosom buddies with everyone else in the company. But it's not so. Each has his or her own mode of living and seldom do we get together socially, except at special times like to cut a birthday cake. You cheer for someone on his birthday, and the next day it's back to the same old standard "Hello, how are you today?" Business as usual. I was not on intimate terms with my fellow actors, but still, we were a company and I wanted to come up with an appropriate offering.

I got an idea. I decided to make gifts for everyone. I found a potter with a studio in Cambridge and made a deal with him to allow me the use of all his facilities. February in Massachusetts can be very cold. I hadn't realized the studio I rented was a Quonset hut made of aluminum on a cement floor. There was one little electric heater that blew out the heat like a puppy-dog's breath. I had to fashion my gifts in the bitter cold. My hands were in icy water shaping the various bowls, cups, saucers, ashtrays, and pitchers. I found my long fingernails did nothing to aid me on my way to complete an item. Even though I wore surgical rubber gloves hoping to keep this from occurring, my nails gouged through the entire wall of a nice half-completed vase. Of course, I would have to start all over. I worked each day from 11:30 A.M. until 4:00 P.M. except on Wednesdays and Saturdays and produced a wide variety of shapes and items. After they were dried, I painted a strip across the bottom of each item with a black matte glaze and with a sharp instrument wrote my signature to make the gift somewhat personal.

When I handed out my closing-night offerings, most of the recipients seemed to be cheered by the fact that personal time and effort had been put into their gifts. Isn't there a saying that it is "Truly a gift, when it has been made by the hands of the giver?"

Standing in the wings, ready to go on for my final bow, tears were flooding my eyes. Cathy, my hairdresser, came and stood beside me. She, too, was crying, and just before I went on, I grabbed her and hugged her and thanked her for her constancy and calmness from the first frantic night in New York to the final curtain in Boston, all 1,116 performances.

But now it was over, and I wanted to get home to my ranch in Oregon to rest.

45

\mathcal{M}AME

AFTER THE LONG RUN OF *Hello, Dolly!* IT WAS A JOY TO BE
flying to Oregon to begin the new year of 1968. To be out
of makeup and costume after three years of constantly
saying the same lines, putting on the same clothes, and
singing the same songs was a blissful change despite the
fact that all of this had been a wonderful, happy experi-
ence.

With a sigh of relief, we settled down in my little ranch
house overlooking the Rogue River to enjoy the quiet,
lovely view from my spacious living room. I loved watch-
ing the sunset over the hill from my patio porch and
listening to the night sounds of the river, flowing south-
ward and humming its river song as it bent from bank to
tree.

However, I needed a few weeks to get used to this
change of rhythm and wonderful change of pace. To
change from being a night person to a day person is not as
easy as it sounds. My theater schedule of sleeping from
3:00 A.M. until 11:00 A.M., with breakfast at noon, altered,
and I was back to a normal routine. In the theater, the

warm-ups and the performance provided just enough exercise. I found that if I played nine holes of golf or a set of tennis, it wore me out to the point where I couldn't give the best performance of *Dolly* that I knew I should and wanted to give. Now I could get back to the activities I loved and began bicycling or walking a mile or two every day. Soon I'd be ready to take on active sports.

Each night at my ranch, I found myself saying, "Isn't it great. I don't have to perform tonight!" Lest I be misunderstood, I truly love all forms of the performing arts. Fortunately, I like it best when I'm involved in the doing of them. But there comes a time, and this was it, when I need to be "on vacation."

My happy at-homeness was interrupted after ten days by an overseas telephone call. A gentleman with a very shrill, high-pitched voice introduced himself as Harold Fielding and said he was calling from London. "I am going to produce the musical comedy *Mame* at the Drury Lane Theatre here in London, and I would be most delighted if you would play the leading role. Would you be interested?"

The first question out of my mouth was "When?" The opening was not until February 1969, which would give me at least eight months to rest and prepare. I readily accepted.

Now I really had my work cut out for me. I don't know of anyone who loves to move. I certainly don't. *Mame*, like *Hello, Dolly!*, was going to cause no end of confusion in my private life. Doc Shurr made all the professional arrangements and I took care of everything else. I was to spend a year in London; therefore I again put the Gilcrest Drive house up for rent. This meant I had to take out my valuables and remove all personal items for storage. Mr. Fielding wanted me to arrive in London by plane, but I

wanted to arrive by ship. Bill said he'd find a ship that would get us there in seven days or sooner, and he did.

On the thirteenth day of December, we sailed for good 'ol England on the *Bremen*. The weather was absolutely wonderful. It was as though a silken thread was gently pulling us over the Atlantic to our arrival in Southampton. Jean Louis designed a beautiful lynx fur-trimmed coat over a sand-colored dress of the same material and a hat. I also wore hip boots in a matching sand color—the outfit was a knockout. I walked down the gangplank of the *Bremen* and right toward a greeting committee, arranged by Mr. Fielding, which included a full orchestra playing their heads off. *Mame* was my first stage appearance in England and the producer was turning it into a field day for publicity. He had also brought along most of London's press as well as representatives from *Time* magazine, which was doing a special story.

The train ride from Southampton featured movies, music, food, and drink. On their return trip, the reporters were able to interview me in between eating, drinking, and watching the films. By the time the train arrived in London some two and a half hours later, I had given a dozen interviews. Fielding wasn't finished with his bal-lyhoo. Inside the London train station, a horse-drawn carriage awaited me. How he got permission to get the contraption and the animal into the station, I'll never know. I was supposed to ride into this majestic city and wave to the public from my royal coach. Fielding had announced my arrival and said that if people lined the sidewalks, Ginger Rogers would wave to them. Sure I would, *if* there were people. As it was, I clip-clopped through the streets waving at any stray pedestrian who looked my way. In general, that person would return my greeting with a look that said, "Who is that nut? I don't know anyone who goes around in a horse and carriage waving at strangers, except the Queen."

At last we arrived at our temporary residence, the

Savoy Hotel. Bill and Irma had gone ahead and brought my armada of luggage in a fleet of taxis. Because I had a contract to play in London for a year, my luggage amounted to sixteen suitcases, makeup cases, and hat boxes. It was good to be off the ship and to have my feet on solid ground. I was shown to my room and was settling in when there was a knock at the door, followed by the entrance of a delegation from the immigration authorities. Somehow, in the confusion of the grand reception for me, Mr. Fielding had whisked me past customs and immigration without going through passport control. I was in the country illegally! Full of apologies and traditional politeness, they stamped my passport and decided not to search through my sixteen pink suitcases. Now, nearly five hours after my arrival, I was officially in England.

Rehearsals began as soon as I was settled. The first day's rehearsal was full of cameramen, swarming around trying to get photos for their newspapers. The photo they all wanted was of me in my long black silk stockings doing a high kick. Well, that's the picture they got, and the next day the photo was all over their newspapers. During rehearsals, we went through and put together the dance routines, songs, and dialogue. I had learned the score as well as the dances in Beverly Hills, so I was prepared. Onna White was there to take care of the choreography; the conductor was Ray Cook, whom we got to know as "Cookie." Lawrence Kasha, the director, was already present, awaiting my arrival. The cast of at least two dozen talented British players included Margaret Courtenay, Ann Beach, Barry Kent, and Gary Warren. I must say, we all had a very good time putting this show on its feet; everyone seemed quite amiable and open to direction.

February 20, 1969, opening night, was memorable on many counts. One of my very dear friends, Robbie Collins of Jacksonville, Oregon, was going to pay a surprise visit to London for my opening night. He thought it would be

fun for me to look down into the audience and see him sitting there.

Fun!

No one knows what that does to an actor, especially on an opening night. To see a familiar face gazing up at you is one of the most disturbing things that can happen (other than forgetting your lines).

Robbie decided not to tell me he'd planned to be in London for that "night of nights." He arranged for some chums, Jim and Mary Ragland of Ashland, Oregon, to come along with him and together they flew over the pole to London. Robbie decided someone else should be in the party, someone extremely important to me—my mother. Lelee hated to fly . . . and didn't. Unaware of this, Robbie began his campaign to get her over for my opening at the Drury Lane Theatre.

"But, Lela," he said, "this is Ginger's first time ever in front of a London audience. This is her opening night. Wouldn't you love to be in the audience? Just think, you could stay long enough to see her perform two or three times more!"

Because Mother knew my habit of telephoning her every night after the show, this couldn't be a surprise. If I did not find her home at four in the afternoon, it would make me wonder and worry. She knew I'd call her sister Jean to calm me down, and she would finally have to break the secret and tell me the facts. I never have liked surprises; I prefer to have the complete information. I was so touched by Mother's courage in flying overseas for the first time. That opening night was a wonderful success, and having my dear Lelee there made the evening complete.

For the next fourteen months, *Mame* played in London. My relationship with the British cast was very good. I had many lively conversations with Margaret Courtenay, who

played Vera Charles. She was warm and friendly to an American actress, which was nice because often, in other countries, Americans can be snubbed. The actors think less of Americans than they should because of the big problem of money. The British pay well, if they need your talents. As a result, we Americans sometimes don't seem to get a square deal from actors in other countries. They seem to be afraid to like us, fearing that if they do, we will swallow them up. For the most part, Americans love British actors (but then, we're such Anglophiles).

During one performance, Maggie and I were on stage together singing our duet, "Bosom Buddies." Unexpectedly, right in the middle of the song, I forgot my next line and couldn't come up with a thing. I decided to stop the number and ask Maggie if she remembered my next line. She laughingly told me she only knew *her* lines. I raced over to the orchestra pit to ask Cookie, our conductor, for his help. He mouthed something to me but I couldn't hear him. The audience members were being really good sports about this funny situation and laughed as I raced around the stage, trying to find someone to help me with my lines. I went off stage to the stage manager's prompt book, but it was not open to the correct page and he was nowhere to be found. All of a sudden, all by myself, I remembered my lyric and flew over to Cookie. I told him I remembered my line and asked why he didn't help me. Cookie pointed to his throat and whispered, "I've got laryngitis!" Maggie and I finished our number and the audience applauded even more than usual!

One of the most spectacular events of our century occurred during my *Mame* run. American astronauts landed on the moon on July 20. I was so excited I got up in the middle of the night (Greenwich Mean Time) to watch every bit of the moon landing. I sat there in the living room of my rented flat in Rutland Gate and cried like a baby, for the pride I felt as an American. Mainly, I was so grateful the "boys" were safe and sound. I watched

proudly as Neil Armstrong and Edwin "Buzz" Aldrin planted the first American flag on the surface of the moon from their *Apollo* spaceship.

Over the next couple of days, all the newspapers were filled with little else other than the moon landing and Neil Armstrong's first steps on the lunar surface. Sitting in my dressing room before the next Wednesday matinee, I was suddenly struck with an idea.

In the show, Mame's girlfriend, Vera Charles, has gotten a job for Mame in a musical show. Mame has to sit on a half moon that is lifted up to the middle of the set while Vera (Margaret) sings "The Man in the Moon Is a Lady" and Mame sings a soprano obbligato.

"This idea will be perfect," I said to myself!

I asked my secretary, Elaine Rieck, to go to all the theaters in the vicinity and bring back an American flag.

"But where am I supposed to find an American flag in England?"

"I don't know, just find one! You have two hours till curtain."

She ran out the door of my dressing room on her mission. This being a matinee day, I thought Elaine would have an easy time finding a flag in the middle of the day. Fortunately, the "Moon Lady" number was in the latter part of the first act so Elaine figured she had plenty of time before I really needed the flag. I continued with my makeup, confident that Elaine would come through. But then two hours passed since she left and still no flag, and the curtain was ready to go up. I needed the flag. Five ladies were changing me into my yellow satin pajama-like costume for my moon sitting.

Two seconds before Margaret's musical number started, Elaine came flying backstage with the biggest American flag you can imagine. It was as long as I was tall, and she explained quickly to me that it was the only one she could find and she was sorry it was too big.

There was my cue.

I grabbed this five-foot bunting and quickly accordion-pleated it in my fingers. I straddled the half moon with the flag hidden by my left thigh as Margaret started to sing her song. The stagehands hoisted me up to the middle of the stage while Margaret was down near the footlights. Straddling the moon as tightly as I could with my knees, I moved the pleated flag in front of my right leg, which was squarely facing the audience, and slowly unfurled the American flag. The audience laughed, applauded, and snickered.

Margaret knew by that time that something was happening on stage other than her song. She turned around to see what was going on. The audience, seeing the American flag, continued to praise our astronauts. After about three and a half minutes, the show returned to normal. When the applause was over for the number and the main curtains closed, the stagehands lowered me to the stage. One of the girls in the chorus was on hand to give me this message: "Margaret is furious with you."

I didn't have time to deal with Margaret's anger just then, as there was still more of the first act to finish. "I'll talk to her at intermission."

After the first-act curtain came down, I went to her dressing room to apologize. I rapped on her door. A gruff "Who is it?" was the response.

"Maggie, I'd like to talk to you. I want to apologize. May I come in?" She let me in. "I understand from one of the chorus girls that you are very mad at me."

"Well, after all, you did ruin my number."

"I certainly meant nothing malicious by what I did. I'm truly very sorry if I've hurt you."

"Well," Margaret said, "that was very unprofessional of you."

"But, Margaret, consider this . . . supposing the astronauts that just got to the moon were British instead of American, and you, Margaret, were playing my role. I'd understand it if you brought out a British flag. To do what

these astronauts have done is a major historic event. Can't you understand what a momentous achievement in history it is for my country? . . . The sheer joy over their accomplishment."

Margaret gave me a cold stare and said, "That was most unprofessional of you. I would never do such a thing."

"Okay," I said, "I can see you're not going to accept my apology. I shall now inform you, I plan to repeat that performance—at the next show." I took my leave to my dressing room to refresh my makeup and change my costume for the second act. During the show that evening, the flag bit went over just as big as it had at the matinee. But the glares I got from Margaret were enough to blow me down!

One night, on my day off from the show, Bill and I went to see Judy Garland at the Talk of the Town nightclub. I hadn't seen her since that day on the set of *The Barkleys of Broadway* and I really wanted to see her perform for a live audience. Unfortunately, she kept the audience waiting for an hour. When she at last appeared, she looked skinny as a rail; I don't think she even weighed one hundred pounds. There is a great deal of conjecture as to what she was doing. Everyone had something to say about it. She was taking barbiturates and uppers, as well as drinking. I'm sure all these things had an effect on her physical being and her performances.

This young lady needed some help, and I was hoping I could be of some help in stimulating her to change her mode of living. When I went backstage, I said to her, "Judy, you were wonderful. I love to watch you perform. Why don't we two girls have lunch together for some girl talk? I've never had the chance to sit and talk with you."

At the time Judy was married to a young man named Mickey Deans who was very possessive of her. He was in the dressing room this time and Judy turned to her husband and said, "Darling, can I have lunch tomorrow with

Ginger?" I could hardly believe my ears that she was asking permission.

"No," Deans answered, "you can't. We have some things to discuss tomorrow."

"But just to have lunch? I have to eat lunch anyway," Judy said.

"You won't have time, Judy. You have too much to do." Deans's tone was firm.

Judy looked at me forlornly. Her expression said, I guess I have to do what he tells me. This was an unusual switch for Judy. She had reached the point where she was taking directions instead of giving them. Apparently, she was letting her husband make all the decisions. I told Judy I was very sorry we couldn't have a heart-to-heart talk, and then I took my leave. These few encounters were the only ones Judy and I had, for soon after that engagement, Judy passed on.

My *Mame* contract called for a two-week vacation within the first year. Since I didn't get a vacation during *Hello, Dolly!* in my year and a half on Broadway, I had learned my lesson and requested time off during *Mame*.

In August the talented, leggy Juliet Prowse was hired to play *Mame* for those two weeks. Several months earlier, I had met an adorable gentleman, Sir Val Duncan, at church and he invited me and a few other guests to spend my vacation time at his villa in Majorca, off the coast of Spain in the Balearic Islands. I was thrilled. I had not been to Spain except briefly, with Jacques, many years before. Bill Marshall was not included in the guest list, which nearly broke his heart.

One day, Sir Val and I were out snorkeling in a remote part of the bay. Across the bay—perhaps three hundred yards away—two men were coming out of the water carrying a string of fish.

As they approached, I said, "Looks like you had a good catch."

"Yes, we did," they said in a French-Spanish accent.

"Where did you catch those?" I inquired.

In halting English, one of them said, "Say, aren't you Ginger Rogers?"

"Yes, I am."

He excitedly introduced his friend.

"How did you know me?" I asked.

"Doesn't everybody?" he replied.

"Does this always happen?" Sir Val asked incredulously.

"More or less," I said.

"But it's amazing it could happen in such a remote area—in a foreign country with only a handful of people."

I shrugged at his disbelief. "Where are you from?" I asked the fishermen.

"Majorca. May we hitch a ride with you on the way back?" they asked.

Sir Val agreed they could if they were willing to wait until the end of the day, which they did.

During that same summer, the Irish Rose Growers Association honored me by naming a rose after me. This was a newly created rose in a salmon-pink color. When they were showing me the new "Ginger Rogers" rose at a flower show in London, the Queen Mother was also viewing the beautiful flowers.

My hosts, Christopher and Eileen Mann, offered to introduce me to her. I was delighted.

Soon we were shaking hands and admiring my rose.

"It's a lovely rose," she said.

"I'm very proud to have a rose named after me," I replied.

Later in the fall, I had the great privilege to be invited to perform before the Queen herself, at the annual Command Performance. I did a number from *Mame* and afterward was presented to Her Majesty, Queen

Elizabeth II. I had read in *LIFE Magazine*, many years before, that the Queen's nanny had said that when Elizabeth and her sister, Margaret, were little girls, they had pretended to be Ginger Rogers and Fred Astaire.

Allegedly, Elizabeth stood in front of the mirror and said, "Now, *I'm* Ginger Rogers." And then she pranced around the room. I was dying to know if that had happened. The presentations, however, are very formal and I thought it would be rude to inquire.

Mame was a darling show to perform, though it was a much heavier show to do than *Dolly*, as I had some twenty-seven changes of costume. Anyone who plays that role agrees that the audience is seeing only half the performance. The other half is off stage, where Mame is being attended by five lady dressers.

Each time I came off stage, it was choreographed so that one dresser would have my next outfit on the floor in a circle, a wrap or coat that went with the outfit was readied by another person, the cane umbrella or hat was handled by another lady, the fastening of the dress was handled by someone else, and the shoes or boots were dealt with by yet another. There is no rest for the actress who plays Mame. Coming off stage is like making a pit stop during the Indianapolis 500. Everybody had something to do to you. Most times, even to refresh your makeup was an impossibility until intermission.

By the last week of the run, my understudy had never had an opportunity to step in. The last six days of *Mame* were a memorable time because my record of not missing a performance was in jeopardy. I came to work on Monday with a heavy cold and was feeling very ill. My voice had vanished and I despaired. Each day the challenge was there: "Give up!" *No*, I thought. One on God's side is a majority. I called a practitioner in California, explaining and requesting metaphysical, prayerful help. I had all the

symptoms of pneumonia: the fever, the perspiring, and so on. Still I reported to work on Tuesday, praying constantly.

Thank heavens I had a tiny microphone attached to my bra; otherwise I don't think I would have been heard past the first row. Between the dialogue, I uttered to myself parts of the Lord's Prayer and the 23rd Psalm, and kept my thoughts Godward. My strength slowly returned. My voice became stronger. My dancing became lighter. My friend Ellen Luce had seen my opening performance and had bought tickets for Saturday night's closing performance. When she came backstage that night, she said, "I have never seen you give a more spirited, joyous performance than you gave tonight."

After the final curtain, the entire cast came by to pay their fond farewells. As they stood at the door to my dressing room to say goodbye, I overheard bits of their conversation. Apparently there had been a major betting game going on as to what day I would collapse and have to be replaced. They were stunned at my recovery. My understudy was of course downhearted at never having a chance to go on. One of the wise ones said to me, "I heard you studied Christian Science. I never knew very much about it. But now I have seen its results and if that's what it can do, I'm going to look into it, because none of us thought you would ever make it."

Once again, I presented each member of the cast with a handmade piece of pottery. Harold Fielding got a different kind of handmade item. I realized what I wanted to make for him once the clay was in my hands. I decided to do a sculpture of a horse on an ice pond with the lady rider looking half scared to death. The horse's two front legs were spread in opposite directions and the lady rider was high off the saddle with an expression of, "Heavens, what do I do now?"

I brought it in to the owner of the kiln and asked to have it put in as well. He looked at me and then at the figure and said, "Dear lady, this hunk of clay is too dense to fire, it will explode unless we drill a hole through it, giving the air a place to escape—if there's any bubble in it, which there most certainly must be."

Well, this gentleman knew his clay certainly better than I did. With a sense of trepidation, I let him take my artistic work and drill a hole in the base of the horse, which he did most successfully, and then he put it in the kiln. It came out perfectly, and then I glazed it.

Fielding was so pleased with it that he put it in his office on a shelf two feet above his desk. When I went into his office some two years later, I said, "Where's my equestrian, Mame?"

He pointed to the shelf and said, "I put it there right after you gave it to me, and it has been there ever since."

46

\mathscr{A} HARD LESSON LEARNED

IN APRIL 1970, AFTER MY STINT IN *MAME* WAS OVER, BILL
and I moved to Paris where we rented a dear apartment
at 40 Rue Spontini just off Avenue Foch. I had been asked
by a Parisian theatrical producer to perform in a French
version of *Mame*. I thought this a wonderful idea, and
started learning the songs and dialogue. I had memorized
two songs and about fifteen pages of dialogue when the
show was cancelled.

Loving France as I did, I decided we should stay in
Paris a while longer. Our apartment had a view from the
living-room window of the magnificent Eiffel Tower. It
was while I was living there that my mother and Bill put
pressure on me to sell my house in Beverly Hills. I had
been renting it out more than living in it lately, and
Mother thought it was financially sound to put it on the
market. Besides, she said it needed a new roof! She han-
dled all the details of the sale. When I returned to the
States, I used the ranch in Oregon as my base. This was
one time I'm not so sure Mother knew best. I adored that
house on Gilcrest Drive and have regretted selling it ever
since.

Bill had to go back to the United States on business. When he returned, our marriage began its inexorable movement toward separation and divorce. Our relationship was growing more and more difficult, our differences about financial matters alone a source of great strain.

Within a few months after Bill's return to Paris, I received a business telegram asking me to return to the States for a few days. I decided, in light of this event, to place my jewelry in a safety deposit box in the Bank of America.

Knowing I would be leaving Paris soon for several weeks, Bill asked me where I'd placed my jewelry.

I told him.

He asked me if I had put his name on the sheet as my husband.

I told him, honestly, that I had not.

He suggested that I didn't trust him.

I replied that my motives were not as he'd described. He continued to pressure me to include his name on the list of people who could enter the box. My explanation for not doing so was simple. As everything in the box was mine, I thought my name was the only name necessary.

It became a big issue between us, and finally I asked him to go to the Bank of America with me and I walked him inside and had his name put on the sheet that authorized him to have access to the box.

I got on the plane and as I was flying to New York, the little voice within me said, "You shouldn't have done that."

"But," I replied to the little voice, "I was only trying to prove to him that I trust him."

When I had taken care of the business I came to do, off I went back to Paris to the strained relationship with Bill. More and more, it was becoming something I didn't want or need.

The day after I arrived, I went to the bank to get into my safety deposit box and, lo and behold, some of my

jewelry was gone. I simply faced Bill with it and asked him, "Did you take my jewelry?"

"Yes, I did." He was honest about it, and apologetic. Evidently, he had needed some money, and had had to sell some jewelry to buy francs. He promised to get the jewelry back for me.

Since Bill hadn't met me at the plane with the car, I asked him where the Rolls was. He said it was safely parked in an underground parking garage. Everybody knows that Paris is one big underground parking garage!

Soon after, I got word that Bill was seeing a girl whose father was an officer in the French army. I was told by a person from the bank that he had brought a young lady into the bank with him. My neighbors on the third floor of the apartment house told me at dinner one night that Bill had the Rolls out and this young lady was with him. Well, that was the straw that broke the camel's back. This new information was all I needed to finally make my decision. We were through, the marriage was over. I asked my good friend Ellen Luce to come over from London to help me pack. I was going home for good!

As I was packing my things, I looked out from the balcony that overlooked 40 Rue Spontini and saw a tiny red car drive up. Bill got out, walked around to the driver's side, got down on his knees in the street, and put his arm around the driver for a goodnight kiss.

When he came upstairs and opened the door, he looked at me as if looking in the window of a hardware store. I was the first to speak. "Bill, I've had it. I am leaving for the States. Where is my car?"

"I told you, in an underground garage," he said, and out he walked.

The next day I consulted a French lawyer friend to see what I could do about the Rolls. "If you are to find the car, you will have to remain in Paris while the search goes on. And besides," he said, "in France, what's yours is your husband's."

I decided I needed to get out of the marriage more than I needed the car. I couldn't afford to stay in France, not working, to scour all the underground garages in Paris. I went back to my home in Oregon and filed for divorce.

P.S. The Rolls Royce has never been returned, nor my jewelry.

47

*M*EETING SOME PRECIOUS NEW FRIENDS

EVEN THOUGH I NOW MADE OREGON MY HOME, I WANTED TO have a house in Southern California to be closer to any television work that came up. In the spring of 1972 Mother and I were visiting Frank Sinatra at his home near Palm Springs, so I asked Frank about the desert climate.

"I love it and you'll love it," he said. Well, his assurances got me going, and the next day I had a real estate person take me around to see some homes in the area. I found one right in the middle of a golf course. It had a pool and a beautiful garden. This was the sort of house I had been looking for. What really sold me were the thirty-six rose bushes and two gardenia hedges. I bought the house immediately, only to discover that in all four bathrooms, there were only showers—no tubs! I had been blinded by the roses. I also purchased a small house for Lela so she could be nearby. Many years later, I sold that house to Gerald Ford, who used it for his Secret Service operations.

In the early 1970s, I made some television appearances. I loved working, but I also *had* to work—to support myself and my mother. I appeared on "The Dick Cavett Show,"

"The Dean Martin Show," "The Dinah Shore Show," "The Tonight Show," and "Here's Lucy." A funny incident happened while I was appearing on "The Mike Douglas Show," broadcast from Philadelphia. We rehearsed in the morning and the show was shot later that afternoon. Prior to the taping, Mike asked if, after my introduction, I would do a few ballroom dance steps with him, of no particular consequence, that would get us to our respective chairs. That sounded fine to me, so I said okay.

After Mike introduced me, he grabbed my hand, whirled me around a few times, and leaned me back in a backbend. Unfortunately, he lost his balance, and we both tumbled to the floor. It didn't seem as though he'd planned this, but, naturally, he's a good enough actor to cover his tracks. I was completely surprised by this accidental, humorous, bruise-making entrance.

He apologized after the show, explaining that he had a bad hold on my waist, and when I went, he lost his balance to the point that we both ended up on the floor. Not the most ladylike entrance, but naturally, the audience loved it! One thing for sure, I never forgot "The Mike Douglas Show."

As always, live theater continued to capture my heart. I was asked to take a production of *Coco* on a tour of eight cities during the fall of 1971. It was a joy to wear costumes designed in the Chanel fashion. However, I reserved the right to change the original script in one place. At the end of the first act, the final word said by my character was a word I would never say. I demanded that it be changed if I were to do the show. The producers agreed. Many times during the run of the show, parents would come backstage to thank me for taking "that word" out of the script, because now they could bring their children to the show. Several months later, I did a production of *Mame* in

Houston, only this time in the round. That type of stage made those twenty-seven costume changes a bit more challenging!

Tom Hughes of the Dallas Starlight Musicals contacted my agent, Barry Freed, about my appearing in a production of *No, No, Nanette*. My dear friend Shirley Eder and I had seen Ruby Keeler do the rehash of this show in New York a few years earlier. At one point during the show, I sat open-mouthed, staring at Helen Gallagher and Bobby Van dancing together. Shirley turned to me and said, "What's the matter? You look so strange."

"Watch this number, Shirley," I said, "watch this number."

And as it came to a thunderous conclusion, I turned to Shirley to explain my strange reaction. "That dance number is practically step for step like a number Fred and I danced in *The Story of Vernon and Irene Castle*."

"You're kidding," she said.

"No, I'm not. They've made a few minor changes, but in principle, that is the audition number we did in front of Lew Fields." (The choreographer later won a Tony Award for this show.)

Shirley asked, "Are you going backstage to see Ruby?"

"Of course, we're friends, I want to say hello. And I think I'll speak to Bobby about the dance!"

Shirley and I visited with Ruby in her dressing room, telling her how charming she was, and how much fun it was to see her in front of the footlights again. I had no sooner gotten this out of my mouth than the smiling, tall, and handsome Bobby Van walked into the room.

Ruby introduced us, and Van, with a twinkle in his eye and a smile on his face, said challengingly, "Did you notice anything?"

"Did I notice anything? Didn't you see my mouth wide open in amazement as I watched the number between you and Helen Gallagher? How in the world did you get

it so precisely, step by step, except for a few minor changes?"

"Well, it wasn't exactly easy. We ran the film about thirty-eight times."

I laughingly said, "I see you're a quick study." That tickled him.

Now, three years later, Tom wanted me to come to Dallas to play Ruby's part in *No, No, Nanette* for a two- or three-week stint.

"The only way I would possibly do it, Tom, is if the dance that was done in the New York show by Helen Gallagher and Bobby Van is transferred over to my character."

"I can arrange that," Tom said.

The number stopped the show—at every performance. I was not of a mind to let another character in the play dance the dance I had done on the screen.

The Entertainment Hall of Fame wanted to honor Fred Astaire and asked me to be on the television presentation of the awards and hand him a gold medal in recognition of his great dancing. I agreed to do it because I enjoyed doing anything for my former partner. Gene Kelly was to introduce me. While we rehearsed the dialogue, the producer brought the medal to me in a small box. Just before the show went on the air, we did a rough run-through. When we came to the moment of presentation, a voice from the booth came over the loudspeaker and said, "Miss Rogers, this is where you hand Mr. Astaire his medal."

"Yes, I know," I said.

During the telecast, I was standing backstage, looking at the television monitor. Next thing I knew, Fred was at my elbow. On the monitor was the "Bouncin' the Blues" dance number we had performed in *The Barkleys of Broadway*.

As I watched it, Fred leaned over to me and said, "I

think that's one of the best numbers we ever did." I was very happy to hear him say that, because I personally loved that number.

After the dance clips were shown, Gene Kelly walked out on stage and introduced me. I took the medal in my hand and walked out to the podium on the apron of the stage. Just as I was to open my mouth to congratulate Fred, Mr. Kelly came from behind me and swept the medal out of my hand.

"If you think you're going to give this medal to Fred, you're crazy!" Then he proceeded to read my lines off the teleprompter and handed the medal to a very befuddled Fred.

Fred stuttered a dozen thank-yous and looked at me as if to say, "Did you lose your voice?" I couldn't say or do anything and just stood by. To this day, I do not know who gave Kelly permission to do something assigned to me. Does anyone out there know?

In 1972, the J. C. Penney Company asked me to be a fashion consultant. I was selected from a list of thirty-five actresses by George Abbott, not the theatrical writer-director, but the pantyhose king for J. C. Penney. My contract lasted three years, during which I traveled around the country giving interviews and talking about Penney's special line of lingerie, particularly pantyhose. I also designed the Ginger Rogers line of lingerie, which had my initials, "GR," on the items. I came up with some ideas and mentioned them to George. I thought he should make net hose for women, but he dismissed the suggestion. Of course, net hose later became the rage. I also tried to convince William Batten, head of J. C. Penney, to push boots. He said boots were on their way out and would be finished in ten months. It's twenty years later, and they're still around, Bill.

In 1973, I went to Athens, Greece, to be a judge at the

Miss Universe contest. Janice and George Abbott, my precious friends, accompanied me, and after my contest duties were fulfilled, we visited Beirut, Lebanon. My good friend Sidney Luce had told me, "If you don't see Beirut now, you'll never see it like this again!" I took his advice and Jan, George, and I had a wonderful time seeing "the Paris of the Mediterranean." Most of the shops and signs had "Lela" written all over them, so I felt my mother was right along with me. How awfully tragic that we have now witnessed the destruction of that glorious city.

A few months later I received an invitation through Secretary of State Henry Kissinger to a visit in the Oval Office with the President.

Nixon was perfectly charming to me. He ordered a cup of coffee for each of us, and as we sat there, I told him how much I admired him. Then he opened a drawer and pulled out a small package, saying, "I suppose you have a dozen of these? But Pat says it's always nice to have an extra one."

I opened the box, and in it was a metal compact with the presidential seal on the cover. Then he reached down again and got another box. This one contained a pair of cuff links. "This is for your Republican boyfriend."

I thanked him profusely.

Later, I often wondered if our conversation was recorded on those secret tapes. It wouldn't have harmed anyone if it was. Soon, we were interrupted by the White House photographer, who wanted to take a few pictures. He took them, and I realized that I must leave and not hold the President in conversation much longer.

"Mr. President, thank you for letting me come and see you. And so goodbye for now."

"Goodbye, Miss Rogers, and thank you for coming."

As I walked down the long hall, leaving the Oval Office,

I heard a deep guttural voice say, "I thought you were coming in to see me." The head that poked around the doorway belonged to Henry Kissinger. I told him what a nice conversation I had had with the President and thanked him for paving the way for my visit to President Nixon.

In my travels for J. C. Penney, I went to Atlanta, Georgia. The city of Atlanta had always been of great interest to me, even when I was playing in vaudeville. My doing an interview brought my presence to the attention of the governor of the state. The publicity department of J. C. Penney called me at my hotel to ask if I would like to meet the governor in his office. I was pleased to accept this invitation, and prepared for my visit with Governor Jimmy Carter.

I telephoned my mother the night before to ask what she knew about my Georgia host. She told me she understood Carter was a most likable fellow and she thought he probably would be easy to talk with, "so relax, he's not going to bite you."

I arrived exactly at the appointed time and was greeted by Governor Carter in the foyer to his office. Mother was right; he was just adorable, smiling all the time and interested in the kind of work I did, especially since it involved music.

"Was Fred difficult to work with?"

He seemed to be interested in the fact that Fred wasn't temperamental.

"No!" I said. "Fred has always been on an even keel. He is most professional."

"Now," he said, "I'd like to show you some of my trophies." With that, he opened the door to his business office.

"See that wall?" he said.

It was filled with at least three hundred hard hats he

had collected from workmen on big building jobs. "Each person who has come into this office has brought me a hard hat from his job."

The hats were all the colors of the rainbow, and he told me the names of the various buildings they were from, which made that hat-covered wall unusually interesting. I went over to the wall and picked a hat off its little hanger, looked inside the curve of the hat, and saw a name.

Just then, Carter said, "That hat was from . . ." and then he spoke the name of the giver, proving he knew every name written in the various hats, and from what project each had originated. But what he was really telling me was that he remembered every single individual who had contributed to his unusual collection.

Checking my wristwatch, I realized that it was growing late and, after all, I hadn't been asked to spend the weekend. "It's getting late," I said, "and I must not detain you any longer, but I will tell you it has been a most interesting afternoon talking with you. Thank you for letting me meet the governor of the wonderful state of Georgia and enjoy the State House and its very important tenant."

I liked this gentleman very much, not because he was a governor, but because he was warm and gracious. He is a truly caring individual. A few years later, when I was in Washington attending the first Kennedy Center Honors (I was invited to attend because they were honoring Fred Astaire), I walked into the East Room of the White House along with hundreds of other people who expected to shake hands with the President of the United States.

Finally, I ended up face to face with President Carter, who took my hand in his, shaking it warmly. He said meekly, "Do you remember me?" I just about fell through the floor.

When my contract with J. C. Penney ended, I was invited to go to Chicago and perform in *40 Carats* at the Drury

Lane East Theatre for three months and then to take the show to some other cities during the summer.

While I was in Chicago, Irma Scheid and my dog, Mr. B, were with me. The hotel accommodated all of us—love me, love my dog! While Irma was walking Mr. B on State Street, he suddenly stopped and sat up on his haunches for at least five minutes, looking intently at something. As if he were at a tennis match, his head moved from side to side.

A passerby finally said, "What is that dog looking at?"

"The people passing by and the traffic," said Irma.

The only time Mr. B would stop in traffic was at the sight of a limousine. He always waited to see who stepped out before going about his business. Perhaps he was looking for me.

Another incident during the run of that show in Chicago concerned my habit of taking Mr. B to my dressing room. He curled up patiently under the dressing-room table to await my return. The theater was not pleased to have a dog on the premises and told me that Mr. B could not stay. "Take me and my dog or I won't open in this show," was my ultimatum. Needless to say, Mr. B stayed and so did I!

However, one night when I was on stage he somehow escaped from the dressing room to the wings and spotted me on stage. His tail started wagging, and he trembled with delight at discovering me. Just as he was about to put his paws on stage and rush out to me, Irma saw him and grabbed for his tail.

Mr. B and I both might have been fired that night.

When *40 Carats* closed at the end of the summer of 1975, I decided that instead of doing somebody else's material, dialogue, and songs, I should do those musical numbers associated with my own career.

With this thought in mind, I formed the Rogers Rogue

River Revues, and *The Ginger Rogers Show* was born. I asked Hal Borne, my longtime friend and pianist on all the RKO films I did with Fred, to be my conductor. I contacted Onna White to see if she was available to choreograph the show and we hired four very talented men to dance with me, Michael Cody, Jeff Parker, Ron Steinbeck, and Jim Taylor. Not surprisingly, I asked Jean Louis to design my costumes, and he made me some perfectly beautiful things. One of the gowns was a copy of a dress I had danced in; the rest were original ideas of our joint conception. We began rehearsing in September 1975 and opened in Oklahoma City in December. For the next five years, we toured around the country—and the world.

One performance in Dallas had a wonderful turn of events for me and one with special memory. It had been raining cats and dogs that night and word came backstage to me, just before the show's end, that my grade-school English teacher was in the audience. She had been told to come backstage after the performance. Before the final curtain, I always made a goodnight speech to our audience. This night, I asked the audience if they would bear with me as I wanted to introduce them to a very important person in my experience, my fifth-grade English teacher, Mrs. Ruthie Browning Zant.

She was standing in the stage-right wings and I clasped her hand and pulled her out on stage with me. She reluctantly followed. I did not see the umbrella that she was dragging by her right hand. At center stage, I put my arm around her. The top of her head barely reached to my nose, and I felt her squirming in a peculiar way, but finally she stood quite still.

The applause continued, and I explained to the audience that "if I didn't speaka da English good, it was alla her faulta!" I kissed her brow and as we left, the curtain came down. Back in my dressing room, I told her how thrilled I was to have her come to a performance and hoped she didn't mind my pulling her out on stage. "But,"

I added, "what was that peculiar squirming you were doing while my arm was around your shoulders?"

She looked at me with the adorable twinkle in her eye that had always made me want her class never to end, and said, "Well, I was making a leg."

"A what?" I said.

"Well, when you're out on the stage, in front of an audience, aren't you supposed to do like the models do, put one leg in front of the other—you know," she added, "and make a leg!"

I howled with laughter. My precious little English teacher, wanting to be a pro on her first entrance.

A few years later, San Antonio, Texas, was about to have an exhibition on famous Texas women, called "A Celebration of History." I was invited to come down as one of those Texas ladies who had made a name for themselves, and I readily accepted. Lady Bird Johnson and I were the only two who made the trek, and the nicest part of the whole three days was that my darling English teacher would be there. In her recollections, she told of the time that I had said to my mother and dad at the dinner table one night, "Ruthie Browning, my English teacher, is coming to live with us."

That was the first my mother knew of the invitation. Ruthie was engaged to be married at the time and therefore did not want to have to sign a long lease on her little apartment. When she told this story to me, one of her favorite students, I readily offered to share my quarters on Cooper Street with her.

Happily, my mother liked Ruthie very much, though she was astounded that I would invite someone to live at our house without her permission. Besides, we had only two bedrooms. But Ruthie came anyway.

Ruthie knew how much I adored her, and she said to me, "The one thing I will remember, Virginia," and then

she stopped, realizing that it wasn't Virginia anymore, "was sleeping in that bed with you. It was like having someone ride a bicycle on your back. When you were sleeping, your little feet were constantly moving, and it's not surprising to me that you've earned your living with your feet." Ruthie could do anything—knit, embroider, tat, or cook—and she did it with a sense of humor.

"I loved your sense of the fitness of things," Ruthie said. "You seemed to have a sense for rightness that was more adult than childlike. Whenever I had to go to the principal's office, I would put you at my desk during my absence, because I always knew that you would keep the class in order by your own innate desire to do things the way you thought your teacher would do them. Even though you were a child, I always felt I was talking to an understanding individual."

I think—I certainly hope—that I retained that sense of rightness all my life.

Seventeen years after last appearing with my nightclub act in Las Vegas, I was back, this time at the Desert Inn, doing two shows a night. Putting on a show of this sort calls for a number of people, both on stage and behind the scenes. My personnel included my four male dancers, stage manager, two wardrobe girls, hairdresser, secretary, drummer, conductor, and me—a total of twelve people.

Jennifer, my wardrobe young lady, was sitting in the sun at her hotel pool, dozing and sunning while half-listening to the babble of voices around her. She overheard a few people near her talking about having been at the Desert Inn the night before to see my show. The last number in my show was danced to the tune of "The Carioca," and I was dressed in black silk tights and a black leotard. Over this was a flamenco-style ruffled black taffeta skirt, trimmed in brilliants, making the costume very leggy indeed.

Jennifer, overhearing these favorable comments, could contain herself no longer. She thought it would be fun to tell them that she worked for me. The woman turned to her in all sincerity and said, "You do, really? Could you tell me, are those really her legs?"

With a dumbstruck expression, Jennifer burst into laughter, rolled off her lounge chair, and started pounding the ground in amusement at the innocence of that remark. She couldn't wait to get to the theater that night to tell me, and many a time, when our group got together after the show, someone would say to me with a poker face, "Are those really your legs?"

I played the Desert Inn for six weeks. Quite a number of VIPs came through Vegas and a few of them ended up in our audience. One evening, I had a special treat awaiting me when the maitre d' of the Crystal Room telephoned backstage to tell me that one of my co-stars was seated out front. You can imagine the pleasure I found in announcing to the audience that Cary Grant was with us and would he please stand up. He did, and he looked as handsome as ever. He looked happy and content when he came backstage to say hello. Since Cary didn't introduce her by name to me, it is my impression that the woman who was with him as his secretary was Barbara Harris, who later became his wife.

Another night there were twenty-three celebrities in the audience. I introduced members of the Rockettes, who stood up and took their bows. In 1980 I appeared with these beautiful young women at the Radio City Music Hall, where I did a capsule version of my nightclub act.

I always looked forward to appearing in one of my favorite American cities with my nightclub act. I love San Francisco, especially its weather. The cool mornings are sometimes foggy, like London, but even on the hottest of days one can always count on a breeze off the bay.

Anyone who knows me at all is aware that I will sleep on the front porch if it offers a breeze. I love the air to circulate around me, much to the displeasure of many of my friends and family. Windows must be wide open wherever I go. It became known among my friends that it was a "thing" with me—so much so that whenever I went to a dinner party in a private home, the hostess would explain to my distressed dinner companions, ". . . but Ginger always insists upon opening a window near her. I've saved her the trouble and am putting her in a draft." My need for air is not uncommon among performers. The exception I've heard of is Lena Horne. She insists on working in a non-air-conditioned theater because she can't keep her voice if the air is cold. She never has any trouble filling the house; she's a performer who's worth watching even in sweltering heat.

The Ginger Rogers Show played the Venetian Room at the Fairmont Hotel in San Francisco for two weeks. One night, after my goodnight speech to the audience, a happy-faced man stood up from his table and yelled out to the laughter of the audience, "You have just set back Social Security thirty years!"

It was during this 1976 engagement in San Francisco that I became acquainted with a young woman who lived in nearby San Carlos. I met Roberta Olden at a Press Club luncheon and was very impressed with the posters she had put up behind the dais. There were more than twenty posters and photographs of me decorating this backdrop. When I asked about them, she told me she was a longtime fan and collector. Subsequently, whenever I played Las Vegas, Reno, or San Francisco, I always saw two pink carnations in the spotlight when I was taking my bows, and Roberta would frequently come back to visit with me after the show.

About ten months after I met Roberta, I found myself in need of a new secretary, as the young lady who worked for me at the time, Jenny Senior, wanted to return to her

husband, start a family, and not travel so much. Roberta had hinted to Gil, my hairdresser, that if the position became available, she would love to try out as my secretary. Well, here was the opportunity, and Roberta has been working for me since 1977.

In the late 1970s I continued to take my show on the road, appearing in major cities around the United States and touring worldwide to Sydney, Australia; Ottawa, Canada; and Mexico City. One fabulous city we traveled to was London.

I was thrilled at the prospect of performing again in front of a British audience, and the London Palladium was just the place. We played a very successful two weeks there. Of course, I stayed over for a vacation and some shopping after the show closed. One special reason for staying was an invitation I received from Chris Ellis of EMI Records. He saw my show at the Palladium and asked me to cut a record of my show songs for his label. This was a real thrill, for I had not made a record in over fifteen years. The orchestrations of the songs were a bit different from those used in my show, and I added a few other numbers associated with my career. All in all, it turned out very well indeed.

48

ONE MUST TAKE THE "U" OUT OF MOURNING

In May 1977, I had to face the greatest trauma of my life. My beloved Lelee fell ill and began to fail. My mother was the most important person in my experience. What was it that made me respect my mother so much? She was not only pretty, she also had a steel-trap mind with a comprehension of what was going on around her, and she always knew who was holding the trump card. Now that she's gone, people have said that she lit a fire under those who didn't hire me as an actress, and that she'd threaten and cajole those who couldn't see me for dust! I never knew her to intimidate anyone. If people didn't like my personality, she'd say, "She'll grow on you!" There were those who just didn't like Lelee, period, because she was always a mile ahead of those who disapproved of her.

Jealousy reared its ugly head for those who couldn't steer Lelee the way they wanted. Mother was one of the best storytellers I've ever known and became somewhat of a raconteur. As she told a story, you could really see it happening. You never wanted the story to end. At many

a Hollywood party, she held one corner of the room in suspense.

I rented a house for her near my home and had nurses around the clock. It cost approximately $5,000 a day and I didn't have that kind of money. I had to keep working. I went into Mother's bedroom one morning to speak with her. Mother knew I had a contract to go to the Paper Mill Playhouse in New Jersey to perform my show for two weeks. I didn't want to leave her. I told her I'd rather stay beside her and hold her hand. Practically speaking, though, I really had to get out and earn some dough. I remember she said to me, "Well, you go ahead and do it."

The only reason I left her was because I needed money. It never occurred to me to go to a bank and get a loan. I'd never done anything like that before, so I didn't do it then. I was too used to making my own way.

I went to New Jersey and made the money to pay the bills, which were astronomical by this time. The head nurse attending my mother asked her if she would go into a hospital, where it would be easier for them to take care of her. Mother consented. When the nurse called and asked me, I said if that's what Lelee said, then we should get her where she wants to go. I figured the nurses knew what they were talking about and as long as my mother agreed, it was fine with me. She went into a hospital and her younger sister Jean went to see her every day.

I had been at the Playhouse only a week when the call came from my Auntie Jean. I never could bear to think of the day when I would have to say goodbye to my mother; now it had come and I wasn't even with her. I didn't know what to do. I was in a fog. I turned my thoughts to God and prayed.

That evening, I was able to perform the show without any problems, until I came to the one song that hit me right between the eyes. It was from *Mame*, the song "If He Walked into My Life." Anyone who knows the lyrics of that song will understand how it must have affected me.

At the end of the number, I came off stage to change my costume. Jennifer, my wardrobe girl, told me later that I didn't remember what I was to do next, nor what costume I was to wear. She pushed me into my next costume and wiped the tears from my face. Then I was out the door again and onto the stage for a dance number, followed by the finale. The rest of the show was done in a daze.

Never had I had an experience equal to this one.

My dear friend Robbie Collins called and said he was flying out to be with me. Robbie was very close to my mother; she had kind of "adopted" him as a son and I considered him a brother. I still do. Robbie lives in Singapore now, but we've remained close. Anyway, he flew out and his sister Janet came in from Connecticut and the two of them literally gave me freedom. They answered all the phones and letters and inquiries so that I could perform. Angelo del Rossi, the manager of the Paper Mill Playhouse, came to see me and asked if I was going to go back to California. I told him no. He was surprised.

"You don't mind staying and doing your show?"

"I do mind," I answered. "I'm going to do it because it's what I signed up to do." I remember his reply; he just said, "Bravo."

When I came to my senses, I realized that we cry for ourselves because we are ignorant of what is *true*. We are ignorant of the goodness of God. Too often we are prone to believe the hell that is preached in the Bible, when we should believe the love the Father has for each of His children. "If a son shall ask bread of any of you that is a father, will he give him a stone? or if he ask a fish, will he for a fish give him a serpent? Or if he shall ask an egg, will he offer him a scorpion? If ye then, being evil, know how to give good gifts unto your children: how much more shall your heavenly Father give the Holy Spirit to them that ask him?" (Luke 11:11–13).

My Lelee lived a full life; she was well into her eight-

ies when she passed on. She loved God and she taught me how to love Him, too. She gave me the gift of Christian Science—it sustained her and continues to sustain me.

49

A POTPOURRI

IN JANUARY 1980, I WAS ASKED TO COME TO PARIS TO DO A
mini-version of my show at the Moulin Rouge, celebrating
its ninetieth anniversary and benefiting UNICEF. I was
one of three American acts chosen to appear; the others
were Charles Aznavour and Peter Ustinov. After I arrived
in Paris, there was a deluge; by evening the rain was
coming down in torrents, but I didn't mind as I was en-
sconced in my favorite Parisian hotel, the Meurice. I was
in bed most of that day after rehearsal as I was quite ill.
I called overseas to a Christian Science Practitioner and
asked her to support me prayerfully in this ordeal. I was
feeling a little bit better by the time I got to the theater
that night. But I fell asleep as he was doing my coiffure,
so my hairdresser, Gil Cardoza, had to prepare my hair
while I was prone on the bed.

I arrived at the theater entrance and was escorted to a
third-floor dressing room. It was 10:30 P.M. The show
hadn't started and I was last on the bill. Between the
inclement weather and the late hour, I was certain people
would depart long before I appeared on stage; probably

I'd be performing for only a few couples, if that! I entertained a few fleeting thoughts about going back to the hotel and getting into bed, but instead, I asked for a cot. For the next four hours, the music of the show filtered up the steps to my room. Roberta would occasionally come up and tell me who was on, and how much longer I had to wait.

During this time, I prayed I would be capable of doing what I had promised to do. Two Bible quotations came to me: "For he performeth the thing that is appointed for me: and many such things are with him" (Job 23:14) and "And we know that all things work together for good to them that love God, to them who are called according to his purpose." (Rom. 8:28). I remembered Mrs. Eddy's admonition from *Science and Health:* "Hold thought steadfastly to the enduring, the good, and the true, and you will bring these into your experience, proportionably to their occupancy of your thought." Finally, I went to sleep. I was awakened by Roberta, who told me I had about fifteen minutes.

As I walked down the three flights of stairs, I was thanking God that I was able to do this much. I stood in the wings for five minutes and recited the Lord's Prayer. A devilish intruding thought tried to take my peace away: "There couldn't possibly be very many people left out there by now, what with the rain and all." At that moment, I prayed sincerely, "Father, we've traveled all this way to be of some service."

Peter Ustinov, the master of ceremonies, announced, ". . . and here she is, Miss Ginger Rogers!"

The applause was exciting and I responded gleefully. I had always wanted to be on a stage in front of a Paris audience, and when I walked out before the generous, friendly, and enthusiastic crowd, the entire physical problem I had been facing all day vanished. Contrary to my apprehension, it seemed that no one had left, even though it was after 2:00 in the morning. At the end of my seg-

ment, Peter Ustinov came out and made a surprise speech.

"Ginger, as you were a good friend of one of France's greatest talents, who appeared many, many times here at the Moulin Rouge, we feel that you will be delighted to own this treasure: the hat of that great star, Maurice Chevalier."

Peter then handed me a straw hat. I was so very honored and touched that I could only mumble a word of gratitude and tell them how honored I was to have been presented with this thoughtful gift. Someone took it out of my hand and placed it on my head and cameras started clicking. The hat is now encased under glass in my home in memory of my *darling* friend Maurice. I had met Maurice in the early 1930s at a party given by producer William Goetz and his wife, Edie. I admired Maurice's talent very much and at my request, Maurice had sent me an autographed photo, on which he wrote, "To my white love." In French this must mean "pure, unfettered by any physical attraction," and I loved him for it. That night I went peacefully and gratefully into my soft, welcome bed at the Hotel Meurice. I was happy and most grateful to experience the strength and well-being that I enjoyed throughout my performance. No one ever suggested that there was any let-down in my theatrical performance.

The papers and magazines the next day were filled with the event of the night before at the Moulin Rouge, whose ninetieth birthday shall forever be remembered by me. When one thinks of the fabulous talents that have appeared on that stage, as well as the multitude of artists, like Toulouse-Lautrec and Renoir, who have sat in the audience and later drawn or painted posters, I am indeed grateful to have been among those great artists.

I stayed in Paris for another week because I could hardly tear myself away from that beautiful city. I went shopping and accepted some invitations to go to the showings of the couturiers. My friend Nancy Edwards of

Oklahoma City and Rancho Mirage made her first visit to Paris with me, and it was especially fun to encourage her to see many interesting things.

One day, a call came from Jacques Bergerac, who said to me, "I hear you were at the Moulin Rouge."

"It was a splendid evening," I said.

"Why don't you take lunch with me tomorrow at the Plaza Athénée?"

"Will I get to meet your wife?"

"We'll see," he said. "Meet you at the restaurant."

So the next day, in a striking purple skirt and chiffon blouse with matching shoes and my lynx coat, I went to see Jacques again, for the first time in perhaps fifteen years. At the Plaza, Jacques gave me his characteristic open-armed reception. We sat down at the restaurant table and he helped me off with my coat. "It's nice to see you again, Jacques. How is it that you did not bring your new wife?" (I was talking about his fourth wife.)

As he was taking my coat and placing it in the hands of a waiter, he mumbled something to the effect that "she was unable to make it for reasons I didn't understand."

He began to question me. How was I doing? Was I happy?

Fine, I said to the first question; yes, I said to the second. We covered in conversation some of the years that had passed between our marriage and the present.

His difficulty in seeing his daughters was one of his main complaints. I merely sat and listened with an occasional, "That's too bad."

People in the restaurant were ogling us from the time we sat down. What a strange world. These two people were married and divorced, and now they were sitting there and talking to each other as though nothing had happened.

I checked my watch, as I had made an appointment to see the collection of Hanae Mori. I said to Jacques, "The show starts in about ten minutes."

"I'll walk you," he said. He called for the check and in five minutes we were on our way. "Happily, for your sake," he said, "you do not have far to walk."

He helped me into my lynx coat and as we passed the checkroom, he put down a ticket and a tip, and the girl handed him his coat, which he put on as we walked out. It was a fur coat and on his 6'3" frame, this coat fell to the top of his shoes. The two of us, walking down the street together, must have looked like two stuffed teddy bears.

Waiting for me on the corner were Nancy Edwards and Roberta. I introduced them to Jacques, and we said our farewells.

"Don't forget to call me when you come back into town again," he said.

And with that, the two teddy bears went their separate ways and haven't seen each other since.

When I think about it, Jacques and I did have an exciting romance. His hearty laughter, his charming accent, and his open arms of affection to anyone who loved the sound of "The Marseillaise" never fully expressed the depth of his chauvinism. To him, anything French had to be the best. In fact, nothing else really existed. In some of these thoughts I have concurred. However, it has been said that I'm "as American as apple pie" and many times in our arguments we would find ourselves "besting" the other's nationalism. He thought he won, but then he is now in France, and I am now in America.

While in Paris, I was asked to present my show in its entirety at the Olympia Theatre. Now I'd really have an opportunity to perform before the Parisians! I returned to Los Angeles to work on additional material for the show, and then flew back again. On February 25, 1980, *The Ginger Rogers Show* opened at the Olympia. Borrowing from Maurice Chevalier the practice of a foreigner explaining his work to his audience, I told the Paris audience

in French what I was going to sing to them in English. It was somewhat appealing to the French audience to have an American make an attempt in their tongue, even if the French was somewhat crucified. I learned a French song to sing as an encore, and I was pleased with the affection the audience showed me. The reviews of me and my show were treasures. Now I had more Paris treasures— Maurice's hat and heart-warming reviews.

After the show closed, I was invited to perform in Buenos Aires and opened there on March 15. I was somewhat apprehensive about my show being in English and my being unable to speak Spanish. The atmosphere of the audience's acceptance was an unexpected thrill. It turned out that many Argentinians spoke English quite well, and those who didn't didn't seem to mind.

They had put us up at the Hotel Bauen in the President's Suite—a penthouse which was much too small for me, much less for the heads of state. The weather was humid, and as always, the air was still and dank. The air-conditioning did as much good as an ice cube sitting in a dish. When Roberta and I rang for the elevator, as we had to be on our way to rehearsal at the theater, we noticed that the lights in the hall had gone out. We pressed the elevator button again.

Not a sound. Looking at our wristwatches, we knew we just had to go to the stairs and walk down. Starting from the nineteenth floor, we had at least a ten- or twelve-minute walk to reach the lobby. On the floor below us, a family of four—mother, father, a young boy of about four-teen, and his little sister—had started making a rapid descent.

The mother said, "I cannot believe this. I was told that this was a five-star hotel!"

The young boy said, "Yes, Mother, but in this country, they use a fifteen-star rating system."

That cute remark kept us amused while we continued down, and away we sped to the rehearsal. My show ran for an hour and twenty minutes, and the audience couldn't have been nicer. The theater was not air-conditioned, and according to the weather bureau, this was the hottest day Buenos Aires had experienced in one hundred years. When friends came backstage later to say hello, they asked me how it was possible to go through the show and not even fan myself or make a verbal reference to "your unusual weather."

"Well," I said, "you knew it, and I knew it. There was no reason to burden the audience with it."

Visiting the various haunts I had been to see on my earlier trip was very nostalgic, and I was delighted to see a more open-faced attitude than I had seen in the Perón years. I liked the people I met very much, and performing for them made me happy because of their genuineness.

On closing night, the theater was filled and the weather still had not shed its steamy humidity. I was on my last song, about to say adios to the audience, when a dozen teenagers came down the center aisle singing special lyrics to the tune of "Hello, Dolly!" They went something like this: "Goodbye, Ginger. Well goodbye, Ginger. Hurry up and come back here again. You need to know, Ginger, We like you so, Ginger . . ." and so on. In an unprecedented act, these youngsters spontaneously created their own little farewell and it brought big old salty tears to my eyes.

I hated to say goodbye.

With only three weeks at home before I was due in New York, I took full advantage of my pool and the splendid desert weather. Roberta and I repacked my pink suitcases and headed for five weeks in New York.

My engagement at the Radio City Music Hall was something to look forward to. To be able to perform in this

huge theater, which seats approximately six thousand people, was terrific. I had been asked to do a capsule version of my nightclub act, and I would have twelve men with me, instead of my usual four. It was also an opportunity to work with those lovely, leggy Rockettes, all thirty-six of them.

Performing at the Music Hall is much like performing in Las Vegas, two shows a day. However, at Radio City I did have a day off. One of my longtime friends, Don Pippin, was the conductor, and he composed a special song for me to sing for my opening. The show did so well that I was asked to remain for another three weeks.

I spoke to my agent, Milton Goldman, at ICM, who looked at the contract for my next engagement, a summer tour of the musical *Anything Goes*, and said I could stay the extra three weeks. Based on that information, Robert Jani, producer of the Music Hall show, gave three weeks' vacation to the crew of the production that was to follow my stint. In talking to my lawyer, Ernie Del, out in California, I mentioned to him that I would be staying on at the Music Hall before going on to my next engagement.

"You can't do that," Ernie said.

"Why not? Milton looked at my *Anything Goes* contract and I don't start work until July." (This was May.)

"Did Milton happen to turn the contract over and read the dates for the rehearsal period?" Ernie asked.

Ernie contacted Milton to ask about this, and sure enough, on the other side of the contract were the rehearsal dates, big as life. This meant I couldn't stay the extra three weeks at the Music Hall. Fortunately, Jani was able to secure Carol Lawrence to take my place for the remaining weeks. I was truly sorry not to be able to continue at the Music Hall, but I was already signed for *Anything Goes*.

As it turned out, it would have been better if I hadn't done this musical that summer.

Sid Caesar was my co-star, and we had a great time

with the show. His humor was always infectious, and I found myself laughing in my dressing room, listening to him on stage. Unfortunately, we had only one number together, "Friendship." The kids in the show were all very energetic, and the audiences seemed to enjoy it.

Backstage, the relationship with the producer/director/choreographer was another matter. Steven Bohm had difficulty finding enough money to keep the show going from week to week. I heard through the grapevine that he had to mortgage his house, twice, to meet the weekly payroll. We played in various cities throughout the United States, ending in Los Angeles in November 1980. When it came time to pay the company, Sid, and me, the coffers were empty. Well, now I was out a week's pay, and had to sue him to get my money. P.S.: I still don't have it!

In March 1981 I was invited by Godfrey Sperling, Jr., a senior Washington columnist for *The Christian Science Monitor*, to come to the Gridiron dinner, which is held every year in Washington, D.C. Various members of the news media do amusing tongue-in-cheek satiric skits and songs about politicians. Whether they plan to make fun of the President or the Speaker of the House, they go at it tooth and nail. I did a little soft shoe with Philip Geyelin, an important newspaperman. It brought the house down, but not because of me; the audience couldn't get over Mr. Geyelin's dancing ability. After the number, I was taken to the dais and seated two seats away from President Reagan and right next to the Secretary of Defense, Caspar Weinberger. I'd hardly been seated when the "speeches" began.

Everyone was trying to tell a story that topped the other fellow's. Soon it was Ronnie Reagan's turn, making light of a speech prior to his, which pleased the audience no end.

Suddenly, he focused his attention on me and said, "Ginger, I'm so glad you came to Washington today to grace the Gridiron Evening." Then the President turned

to the main part of the audience and continued, "You see, Ginger and I made a movie together called *Storm Warning*, and frankly I never knew what that title meant until I met Tip O'Neill!"

The audience roared.

I had tickets to leave Washington the next morning, and my secretary and I climbed aboard a plane to Palm Springs. Just prior to our arrival one of the stewardesses came to me and said, "Have you heard, someone shot the President."

I couldn't wait for the plane to land. When it did, one of the airline employees came on the plane and confirmed the rumor about our President, but fortunately the shot was not fatal. Everyone was praying for him and, helped by his sense of humor, the President came through the crisis with flying colors.

In January 1982, I was asked to attend a dinner party given on the stage of Radio City Music Hall. I was presented with a beautiful glass ornament by the Music Hall because I was the female movie star who had had more films—a total of twenty-three—than any other woman open in that theater. Cary Grant was the top male star.

Seated at my table was the talented writer-director Joshua Logan. He had written a musical play several years before that he wanted to produce again. Josh wanted me to play the title role in *Miss Moffat*. The production of *Miss Moffat* that opened in Indianapolis in January 1983 featured a mix of professional (Actors Equity union) performers and local little theater talent. The show was a musical version of Emlyn Williams's play *The Corn Is Green*. Only this time, it was situated in the South, instead of Wales.

The script needed some work, but the playwright wasn't available.

The music needed some work, but the composer wasn't available.

The show needed a "doctor," but none was available. Josh had become ill during rehearsals, and had to return to New York to see his doctor, who advised bed rest.

That left it up to the assistant director and me. We did our best to get the show on its feet in time, and enjoyed the two-week run. It would have been better if the creative team had been around to support the actors, but as they say, "That's show biz!"

A few months later, my dear friend Doris McClory, wife of Congressman Robert McClory, called and asked if I would consider performing for the Congressional Wives Club Luncheon honoring Nancy Reagan. I was delighted to have this opportunity and readily accepted. I contacted my New York conductor, Elliott Finkel, and we put together some songs from my show, minus the dancing, to entertain the First Lady and the congressional wives. It was a thoroughly wonderful afternoon. As Nancy came off the dais after the luncheon, we spoke. She looked a bit thin and I asked her how she managed to keep her figure so trim. She answered, "I worry a lot!" I guess that's normal if your husband is President of the United States.

Five months later, Nancy Reagan and I again crossed paths. A telephone call from the First Lady's secretary found me in Oregon. Mrs. Reagan wondered if I would like to come to a state dinner in Washington, D.C., to be given in honor of Karl Carstens of the Federal Republic of Germany.

It was a great honor that afternoon to stand on the White House lawn listening to remarks from President Reagan and President Carstens. After the speeches, the fife and drum corps performed and their sounds were thrilling to the ear. The applause was spontaneous at the

conclusion of their stint. They deserved it for their pluper-
fect precision.

The four principals disappeared into the White House
and shortly thereafter, we too headed inside. Within three
minutes, I had to put pen in hand as I was swamped with
requests for autographs.

One of Mrs. Reagan's secretaries saw my plight and
said, "Come into this room."

"Just one more," I said, and then followed the advice of
my rescuer. Before long, a car was brought, and the White
House staff saw to it that Roberta and I were on our way
back to the Mayflower Hotel.

This particular evening I wore a navy blue chiffon gown
with a pleated skirt and pleated long sleeves. The dress
gave the appearance of being quite décolleté but there
wasn't an inch of flesh showing that wasn't covered with
navy blue chiffon. The dress was a design by my friend
Nolan Miller. Everyone who saw the gown wanted to
know who designed it.

The limousine arrived at my hotel with a Marine Corps
escort to take me to the White House. It was a delicious
dinner, and I had the great joy of sitting next to Vice
President George Bush. After dinner, we moved to an-
other room for dancing. Vice President Bush said to me,
"Come on, let's dance." He led me onto the dance floor
and away we went. As we were dancing, Bush told me of
a gentleman who wanted to dance with me this particular
evening.

"Who is that?" I inquired.

"Well, he's right over here," Bush said, as he steered
me around to the other side of the floor. There, standing
beside me, was George Shultz. "Here she is, George, as
promised. May I dance with your wife?"

So Bush danced with Mrs. Shultz, and I danced with the
Secretary of State. I found out several months later that
Mr. Shultz had always wanted to dance with me. Fortu-
nately, the White House photographer recorded the

event. I got a letter later from Shultz's aides requesting my autograph on this photo of the two of us. They wanted to surprise him on his birthday. On that day, while he was in the air, en route to somewhere, this birthday surprise was presented to the Secretary. I in turn requested Shultz's autograph on my copy of the photo.

Over the next few months, I continued to travel and make some public appearances. Most of all I loved being quiet at home, trying to find the time to read, relax, and paint. One break in my routine came in May 1984 when the Smithsonian Institution arranged a special luncheon in my honor. It seems the dress I wore in *Top Hat* for the "Piccolino" dance number was being donated by my friend, Paul Becker, to the museum. The dress had held up quite well over the almost fifty years! It now resides in the Americana exhibit, near Irving Berlin's special piano and Dorothy's ruby slippers from *The Wizard of Oz.*

One evening when I was in New York City, my cousin Phyllis and her husband, Bob Wagner, invited me to a party at their home. I dolled up as she always invited some very interesting folks. The gracious dinner was peopled with a group of about eighteen VIPs, and after dinner a man playing an accordion came up the stairs to the living room. I found myself close to him and the great show music he was playing and soon started singing those songs, from *Girl Crazy* onward. The group gathered around as they usually do, and one of the guests said, "Have you ever made records?"

I replied in the positive and he asked, "How much is it today to make a record album?" I gave my approximation of the cost at the time.

"Would you like to make more?" asked Harry Helmsley.

"Yes," I smiled. "Of course I would."

At that moment, Leona Helmsley walked up and said

with a growling expression, "Harry. Harry, I'm going home. Are you coming with me?"

Harry didn't move. Leona turned on her heel and stomped out of the room and down the stairs to the ground floor, slamming the front door on her way out. A limousine engine was heard starting up and driving away.

The music resumed and I continued singing. In about ten minutes, the doorbell rang and up the stairs came Leona again. She literally marched into the room and said, "Harry! Let's go home. Come on, now."

Harry stood his ground.

I felt it was time I left the area of explosives and moved into the front parlor, only to hear the front door slam again. I'm surprised she didn't break the glass in Phyllis's front door.

Two weeks later I went with some friends to Carnegie Hall to hear my friend Francis Albert Sinatra. I had just sat down when I felt someone come into the row behind me. The next thing I knew, there was a tap on my shoulder. Leona Helmsley said, "Look. Here's what I got after you talked to my husband at Phyllis's party." She jiggled her new four-carat pear-shaped diamond earrings at me. "Now, talk with him again," she said. "I need a new pair of ruby earrings."

A few months later, Alexander Cohen asked me to come to New York City to take part in his "Night of 100 Stars II." I had taken part in the first "Stars" two years earlier and knew this would be just as exciting. This time, I was dancing in the show with a new partner, Dick Van Dyke. We had a marvelous time during rehearsals, for there were about forty dancers in our segment. The stage at the Radio City Music Hall is one of the largest in the country, but our dance was done on a postage-stamp-sized floor, raised off the stage about one foot. When we finished at the rehearsal hall, we all moved over to the Music

Hall for a final run-through. I was making my entrance at the back of this tiny stage when it moved away from me, just as I put my foot on it. I fell off the back end into the arms of a stagehand and was not hurt. All concerned rushed to me to see if I was okay and then we continued. Unfortunately, Debbie Allen was on the front of this moving floor and she fell off, but nobody saw her. She complained later, "Nobody came to *my* rescue to pick me up like they did for Miss Rogers!"

I had always harbored a desire to direct a musical, and my long-awaited opportunity finally arrived in 1985. I was asked by producer Robert Kennedy to direct *Babes in Arms* in Tarrytown, New York, for four weeks.

What a joy to work with such wonderful music and lyrics as Richard Rodgers and Larry Hart gave us in this show: "My Funny Valentine," "Where or When," "The Lady Is a Tramp," "Johnny One Note," and the title song, "Babes in Arms."

We had a lot of fresh-faced young performers in this show; it was a very talented cast and I had a wonderful time directing them. Had *Babes in Arms* had the proper financial backing, it could have made it to Broadway. Even so, I discovered how much I liked directing and how satisfying it was.

When I'm not working or traveling, my main source of relaxation comes from my painting. Gallery owners have wanted to have a one-person show of my work, but I never had the time to organize my paintings. Well, now was the time. Gregg Juarez, a gallery owner and friend of mine, arranged for a show and sale at his gallery in Palm Desert. As we were hanging the paintings for display, I realized these were my children—I couldn't sell them! Gregg told me I had to sell a few so the customers

wouldn't get mad. I managed to put a few up for sale, but couldn't part with the rest. So now they are joyously hung in my home for all to see.

March 1986 was a milestone of a sort. The Joffrey Ballet was honoring dear Hermes Pan for his contributions to dance and I was asked to attend the dinner. Fred Astaire was also invited, and we two sat together enjoying the evening honoring our dear friend and colleague. It was fun to be with Fred as we watched our dance clips. Unfortunately, that evening was the last time we appeared in public together and the last time I ever saw him. He was there with his darling new wife, Robyn, who has since become a close friend of mine.

Early in 1991, I received two very special tributes. Hunter Todd of the Houston International Film Festival contacted me to ask if I would accept a Lifetime Achievement Award from the Festival. I was thrilled.

The airplane tickets were sent and I flew to Houston along with my secretary, Roberta. I had a lovely suite at the Wyndham Warwick Hotel and spent three gracious days there. The night of the big hurrah arrived and dinner and the awards took place at the Houston Museum of Fine Arts, where several of the film festival's participants' films were shown. It was a long night, for the list of winners was unending; however, all had smiling faces as they came up to the podium to receive their silver or gold awards.

At the end of the evening, Hunter Todd paid a delightful tribute to me and handed me their award—the Lone Star Statuette, a golden male holding a five-pointed star (for Texas). It was a wonderful evening and I shall always thank the good people of Texas for the continuous love they have shown me over the years.

* * *

The other tribute came via June Haver MacMurray. June sent me a lovely letter asking if the Friends of Childhelp could honor me with a lifetime achievement award. June and Frances Franklin were the event chairpersons and First Lady Barbara Bush is the national honorary chairman. June explained the proceeds from the event would benefit the programs of Childhelp USA and fund a new children's activities center at the Village of Childhelp in Beaumont, California. Since helping needy children and those who have been abused or neglected is indeed a worthy cause, I readily said I would love to help.

I contacted my friend Nolan Miller and asked him to design a gown for this special evening. The coat was a metallic reddish material with sequins throughout over a peach chiffon pleated gown. The ballroom of the Beverly Hilton Hotel was filled with six hundred folks helping with this cause. Included among the guests were colleagues Alice Faye, Frances Dee, Buddy Rogers, Virginia Mayo, Esther Williams, Ann Miller, Roddy McDowall, and leading men George Montgomery, Francis Lederer, and Efrem Zimbalist, Jr. The entertainment was provided by Donald O'Connor leading a great group of dancers tapping out routines to tunes from my career. Andy Williams sang, as did Toni Tennille. Rich Little did his imitations of VIPs and Jack Haley, Jr. did a yeoman's job of producing the film clips. Bob Hope was on the dais and commented, "I never realized what a triple threat Ginger Rogers was—Wow!" Bob then introduced my sweet friend Jimmy Stewart, who handed me the wonderful award—a lovely crystal vase.

It was a glorious evening for me. May I say grateful thanks to those involved in producing this event, which occurred almost fifty years to the day after I received my Academy Award for *Kitty Foyle.*

50

ANS

FANS.

What would people in my industry do without them? They are the lifeblood of the success of any film. Certainly mine have been loyal and devoted throughout the years. Although the sacrifice of privacy is a great price to pay, I feel that signing autographs is my way of thanking people for their appreciation of my work. I therefore try to cooperate graciously in giving my signature.

Although I haven't been active on stage or screen for several years, requests for autographs and pictures keep coming. At my Oregon office alone, there are up to five hundred requests a month.

Of course, there are some amusing aspects to being approached by fans. When meeting a celebrity, a fan often becomes flustered and brings forth some jumbled remarks.

"Oh, Miss Rogers, *you* are my greatest fan!" is one of the commonest flubs.

"I've seen all your pictures," a fan will exclaim, adding, "You're much prettier in person." I'm never sure whether

I should feel complimented or depressed that I haven't looked that great in my more than seventy films!

"Didn't you used to be Ginger Rogers?" is another common phrase, as is "Aren't you the one in all those Astaire pictures?"

Usually the encounters with fans are a joy. I remember one sweet incident that happened at the Los Angeles airport when I was on my way to Phoenix. The flight was late, so my friend Billi Cheatwood and I found a snack bar to pass the time.

As we passed by a table for two, there sat a mother and her tiny daughter, each enjoying a dish of ice cream. As I passed by, I thought I heard the little one say, "Dinga waggas."

My ear suddenly translated that sound to mean, Ginger Rogers. As we were seating ourselves I said to Billi, "Did you hear that?"

"What?" she exclaimed.

"Well, as we passed that table with the mother and the little girl, she called my name, I think. It sounded like my name."

I had no more finished this explanation than I heard the pat, pat of little feet coming in our direction and before I knew it, this tiny girl put a piece of paper under my nose and said, "Would you thine dis for me?"

"Well, I would be delighted to," I said with genuine interest in such a tiny one who knew me well enough to recognize me in a strange place when no adult had prompted her. Immediately, her mother appeared at my elbow with apologies.

"I am so sorry, Miss Rogers, to interrupt your privacy, but when she saw you walk in here, she even left her ice cream to come and ask for your autograph."

"How old is she?" I asked.

"Four, but she has seen every film that's been available to us on television, and she has learned to point you out and call you by name."

"How in the world," I said, "could a little four-year-old know me?"

"Well," her mother continued, "these past two years at Easter time she's looked forward to seeing the television show of Cinderella in which you play the role of the Queen and Walter Pidgeon, the King. You wore beautiful robes with a crown on your head, and she was so impressed. Miss Rogers, you might be interested to hear what she said just after you passed our table five minutes ago."

"I would indeed," I chuckled.

Her mother said she had looked up at me with her big eyes and said, "But, Mother, what's a queen doing in an airport?"

With that I hooted with laughter, as did Billi. While we were finishing our 7-Ups, two people who had been sitting near the window passed our table to reach the cashier, and the young man put his hand on my shoulder and said, "Miss Rogers, the acoustics in here are so good that we heard the whole conversation with the little girl. And not only did we think it was adorable, but my wife and I would like to say, though we may not be as cute as that little four-year-old, how much we have enjoyed your work."

There are occasions, and they are rare, when fans can be demanding. One such occasion was in New Orleans, Louisiana, when I was appearing in *Anything Goes*. I went to the candy counter of a specialty shop, because all of us in our show loved the various flavors. The saleslady was striving to be helpful when a woman walked up to me, tapped me on the shoulder, and said, "Miss Rogers, I'd like your autograph."

"Fine," I said. "Just as soon as I've completed this transaction, I'd be happy to give it to you."

She waited about two minutes, as I said to the saleslady, "Some of those over there and some of those over here . . ."

She interrupted, "Miss Rogers, I asked you for your autograph!"

And I replied, "I'd be happy to give it to you, just as soon as I finish this transaction."

She huffily said, "Never mind, I didn't want it anyway."

As she marched off, two young women who were at the far corner of the counter, and who had seen and heard this, slowly worked their way up to where I was standing and about to pay the saleslady for the candy. They said, very quietly, "Miss Rogers," as though they'd rehearsed it to say it in tandem, "may we have your autograph?"

I said, "You certainly can. As soon as I get my change, I'd be happy to give you an autograph."

They said, "We saw what happened just now, and we would be happy to wait for you. I'm sorry that lady was so rude to you."

I said, "Well, that's all right. Some people have a short fuse. They want what they want when they want it, not considering the other fellow. So may I thank you both for being so understanding."

My change came. I counted it, quickly put it in my pocket, and said, "Now I'll be happy to take care of your request." The young women walked away, smiling happily.

I don't mind signing autographs in public, except during a hot meal. Otherwise, I am very willing and try to be cordial to my fans. Sometimes an autograph consisting of just my name has been sold. In learning not to be taken advantage of in this way, I always personalize each autograph.

Sometimes my public encounters with celebrities can be amusing. I remember one in which I was asked to appear on "The Tonight Show" to sing a couple of Gershwin songs.

When I finished, I walked over to the chair next to Johnny Carson's desk. We chatted a bit about my nightclub show, and then he leaned over and said, "Ginger, you

know everybody always asks how old a person is. Would you mind telling us how old you are?"

Momentarily taken aback, and at a loss for words, I didn't quite know how to respond to this impertinent question. But then it came to me: "I'll tell you, Johnny, if you tell us how old you are."

He looked at me with a challenging look and then said, "Everybody knows I'm fifty-two. So, then, tell us how old you are."

"You know, Johnny, the Good Book says that God created His creation in six days and rested on the seventh. Therefore, I can only be six days older than you!"

He looked at me with a glare that said, "How dare you take advantage of me. After all, I'm the host!" His balloon deflated, and not knowing what to say in retort, the only thing left for him to do was say, "We'll be right back."

51

*L*IFE'S VOYAGE

LOOKING BACK AT MY LIFE'S VOYAGE, I CAN ONLY SAY THAT it has been a golden trip. A thousand words are not enough to express my gratitude for the excitement, glamour, adventure, and infinite variety I have experienced. That kidnapping chase between my parents was only the beginning of a saga that kept unfolding in unbelievable ways—each more dramatic than the next.

Performers are very fortunate. By the virtue of our talents and recognition by the public through films and stage work, we have an entree to people and places not accorded the average person. I feel honored to have been introduced to royalty in Great Britain, to have met most of the American presidents since Franklin D. Roosevelt, and to have been invited to shake hands and exchange ideas with leaders of other nations.

This very fact brings with it a responsibility. As celebrities, whether we like it or not, we represent our country wherever we are. Our behavior and attitude are reflections upon ourselves and upon America. We didn't ask for this role, but our films have been shown around the world.

That big movie screen has made entertainers larger than life. The public expects us to be larger than life. We aren't. We are human beings, with problems and challenges in life. But somehow our celluloid fame requires us to be the role models for young and old. In the old days, the Hollywood studios were concerned about our image and dictated a code of behavior. Sadly, today our stars are like shooting comets—here today, gone tomorrow. Unsavory actions swim in the headlines. No wonder poor Judy Garland never had a chance. Working out problems under the public microscope is not easy. Anyway, I do feel responsible to the public, and that's why I have turned down films for reasons of raw and rough language or a tawdry and worthless plot or unnecessary violence. What kind of statement does such a film make to our society, and what kind of standard does it present? Fortunately, films like *Dances with Wolves* restore our faith in good themes and excellence in production.

I may not be very popular for these views, but I keep thinking that young people look to us for some sort of measuring stick for how they should speak and act. I can only tell them from my own experience that if they cling to their principles and work, work, work, their dreams and goals in life will be realized. I never depended on someone else to support me—the government, welfare, husbands, or relatives. Furthermore, I did not serve or drink alcohol, and I never felt this was a hindrance to my career in any way.

Our young people are a precious commodity. Although I don't have children of my own, I love the young. They are so fresh and open to everything wonderful. My sense of family has expanded to include those youngsters I have met on my travels here and abroad. The children of my friends almost feel like they are my own. I am interested in everything they do, in their marriages, in their children, and in their careers.

How blessed I am to have darling friends—more than

you can count on hands and feet. Yes, the applause from audiences is as sweet as nectar, but close friends are priceless. They are there for you in times of need and at other times, too.

Could anyone with such a wealth of friends and a rich life have any regrets? There are very few. However, I do regret that my marriage to Lew Ayres didn't work out. Another regret was the sacrifice of privacy, not being able to go to and fro freely. For those in the limelight, solitude becomes a cherished quality. My ranch in Oregon provides me with that wonderful hideaway. Also, my home in the California desert and my church give me two other safe places. There is a price to pay in life for everything, and I wouldn't have done it any differently.

Going back to friends. In February 1991, I had something happen that deeply touched my heart. My sweet secretary, Roberta, who has been with me fourteen years, planned a surprise party for me to celebrate the fiftieth anniversary of winning the Academy Award for my performance in *Kitty Foyle*. She had been making these plans for a whole year without my knowing it. Of course, she kept disappearing and taking secretive phone calls. I thought she was having a secret affair. One rainy night my self-appointed brother, Robbie Collins, was here from Singapore and we decided to go to dinner at my country club. Suddenly we were ushered into a private room, and there were sixty of my dearest friends from all over the United States and as far away as the Virgin Islands. My jaw dropped. I was stunned. Ordinarily I don't like surprises. In fact, I hate them. But this one I loved. The devotion and thought that went into such an occasion brought tears to my eyes and heart. Even Walter Annenberg, publisher and former United States ambassador to Great Britain, was there with his lovely wife, Leonore, to make some remarks. He recalled trying to persuade my mother to let him date me when I was starring in *Girl Crazy*. She wouldn't agree because she

thought Walter was far too sophisticated for me. I shall always cherish this gift from Roberta. And I would be remiss if I did not mention her patience and tireless dedication to me and to my book.

One thing I must confess—although it has probably become evident already. I am a thorough softy when it comes to animals. I love them. Dogs and cats are my passion. Their love is unchanging, unconditional, and unbounding in warm kisses and wiggling bodies. I've had at least nine dogs. They've been all sizes and breeds—many strays. Whether I was away four minutes or four months, the greeting was indescribably exuberant. Dogs have personalities, and my white miniature poodle, Skipper, has plenty.

There is still much I would like to do. For starters, I would like to pursue directing musicals. That has become a new dimension in my life. Painting in oils and sketching portraits in charcoal has been part of my repertoire for a long time. I would like to continue this.

As the curtain comes down on my final thoughts, I would like to use a line from my one-woman show that has meant a great deal to me through the years. It is part of the scientific interpretation of the Lord's Prayer by Mary Baker Eddy: "And Love is reflected in love." This says everything I want to say and more.

Blessings.

FILMOGRAPHY

FEATURE FILMS

Young Man of Manhattan 1930 Paramount
Director: Monta Bell; Producer: Monta Bell; Screenplay: Robert Presnell, from a story by Katherine Brush; Cinematographer: Larry Williams; Music and lyrics: Irving Kahal, Pierre Norman, and Sammy Fain. Cast: Claudette Colbert, Norman Foster, Charles Ruggles, Ginger Rogers.

Queen High 1930 Paramount
Director: Fred Newmeyer; Producer: Lawrence Schwab and Frank Mandel; Screenplay: Frank Mandel, from a play by Edward H. Peple; Cinematographer: William Steiner; Music and lyrics: B. G. DeSylva and Lewis Gensler, Dick Howard and Ralph Rainger, Arthur Schwartz and Ralph Rainger, E. Y. Harburg and Henry Souvain. Cast: Charles Ruggles, Frank Morgan, Ginger Rogers, Stanley Smith.

The Sap from Syracuse 1930 Paramount
Director: A. Edward Sutherland; Screenplay: Gertrude Purcell, from the play by John Wray, Jack O'Donnell, and John Hayden; Cinematographer: Larry Williams; Music and lyrics: E. Y. Harburg and Johnny Green. Cast: Jack Oakie, Ginger Rogers, Granville Bates, George Barbier.

505

Follow the Leader 1930 Paramount
Director: Norman Taurog; Screenplay: Gertrude Purcell and Sid Silvers, based on the play *Manhattan Mary* by William K. Wells, George White, B. G. DeSylva, Lew Brown, and Ray Henderson; Cinematographer: Larry Williams; Music and lyrics: Lew Brown, B. G. DeSylva and Ray Henderson, Irving Kahal and Sammy Fain. Cast: Ed Wynn, Ginger Rogers, Stanley Smith, Lou Holtz, Lida Kane, Ethel Merman.

Honor Among Lovers 1931 Paramount
Director: Dorothy Arzner; Screenplay: Austin Parker; Cinematographer: George Folsey. Cast: Claudette Colbert, Fredric March, Charles Ruggles, Ginger Rogers, Monroe Owsley, Avonne Taylor.

The Tip Off 1931 RKO-Pathé
Director: Albert Rogell; Producer: Charles R. Rogers; Screenplay: Earl Baldwin; Story: George Kibbe Turner; Cinematographer: Edward Snyder. Cast: Eddie Quillan, Robert Armstrong, Ginger Rogers, Joan Peers, Ralf Harolde.

Suicide Fleet 1931 RKO-Pathé
Director: Albert Rogell; Producer: Charles R. Rogers; Screenplay: Lew Lipton, from the story "Mystery Ship" by Commander Herbert A. Jones, U.S.N.; Cinematographer: Sol Polito. Cast: Bill Boyd, Robert Armstrong, James Gleason, Ginger Rogers, Harry Bannister.

Carnival Boat 1932 RKO-Pathé
Director: Albert Rogell; Producer: Charles R. Rogers; Screenplay: James Seymour; Story by Marion Jackson and Don Ryan; Cinematographer: Ted McCord. Cast: Bill Boyd, Ginger Rogers, Fred Kohler, Hobart Bosworth, Marie Prevost, Edgar Kennedy.

The Tenderfoot 1932 First National & Vitaphone
Director: Ray Enright; Screenplay: Earl Baldwin, Monty Banks, and Arthur Caesar, based on the story by Richard Carle and George S. Kaufman; Cinematographer: Gregg Toland. Cast: Joe E. Brown, Ginger Rogers, Lew Cody, Vivien Oakland, Robert Greig, Spencer Charters.

The Thirteenth Guest 1932 Monogram
Director: Albert Ray; Producer: M. H. Hoffman; Screenplay: Frances Hyland, based on the novel by Armitage Trail; Cinematographer: Harry Neumann and Tom Galligan. Cast: Ginger Rogers, Lyle Talbot, J. Farrell MacDonald, James Eagles.

Hat Check Girl 1932 Fox
Director: Sidney Lanfield; Screenplay: Barry Conners, Philip Klein, and Arthur Kober, from the novel by Rian James; Cinematographer: Glen MacWilliams; Music and lyrics: L. Wolfe Gilbert and James Hanley. Cast: Sally Eilers, Ben Lyon, Arthur Pierson, Ginger Rogers, Monroe Owsley.

You Said a Mouthful 1932 First National & Vitaphone
Director: Lloyd Bacon; Screenplay: Robert Lord and Bolton Mallory, based on a story by William B. Dover; Cinematographer: Richard Towers. Cast: Joe E. Brown, Ginger Rogers, Preston Foster, Farina, Sheila Terry, Guinn Williams.

42nd Street 1933 Warner Bros. & Vitaphone
Director: Lloyd Bacon; Choreographer: Busby Berkeley; Screenplay: Rian James and James Seymour, based on the novel by Bradford Ropes; Cinematographer: Sol Polito; Music and lyrics: Harry Warren and Al Dubin. Cast: Warner Baxter, Bebe Daniels, George Brent, Ruby Keeler, Guy Kibbee, Una Merkel, Ginger Rogers, Ned Sparks, Dick Powell, Allen Jenkins, George E. Stone.

Broadway Bad 1933 Fox
Director: Sidney Lanfield; Screenplay: Arthur Kober and Maude Fulton; Story by William R. Lipman and A. W. Pezet; Cinematographer: George Barnes. Cast: Joan Blondell, Ricardo Cortez, Ginger Rogers, Adrienne Ames.

Gold Diggers of 1933 1933 Warner Bros. & Vitaphone
Director: Mervyn LeRoy; Producer: Jack L. Warner; Choreographer: Busby Berkeley; Screenplay: Erwin Gelsey and James Seymour, based on a play by Avery Hopwood; Cinematographer: Sol Polito; Music and lyrics: Harry Warren and Al Dubin. Cast: Warren William, Joan Blondell, Aline MacMahon, Ruby Keeler, Dick Powell, Guy Kibbee, Ned Sparks, Ginger Rogers.

Professional Sweetheart 1933 RKO-Radio
Director: William A. Seiter; Executive Producer: Merian C. Cooper; Screenplay: Maurine Watkins; Cinematographer: Edward Cronjager; Music and lyrics: Edward Eliscu and Harry Akst. Cast: Ginger Rogers, Norman Foster, ZaSu Pitts, Frank McHugh, Allen Jenkins, Gregory Ratoff, Edgar Kennedy.

A Shriek in the Night 1933 Allied
Director: Albert Ray; Producer: M. H. Hoffman; Screenplay: Frances Hyland; Story by Kurt Kempler; Cinematographer:

Harry Neumann and Tom Galligan. Cast: Ginger Rogers, Lyle Talbot, Purnell Pratt, Arthur Hoyt.

Don't Bet on Love 1933 Universal
Director: Murray Roth; Producer: Carl Laemmle, Jr.; Screenplay: Murray Roth, Howard Emmett Rogers, and Ben Ryan; Cinematographer: Jackson Rose. Cast: Lew Ayres, Ginger Rogers, Shirley Grey, Charles Grapewin, Tom Dugan, Merna Kennedy.

Sitting Pretty 1933 Paramount
Director: Harry Joe Brown; Producer: Charles R. Rogers; Screenplay: Jack McGowan, S. J. Perelman, and Lou Breslow, suggested by Nina Wilcox Putnam; Cinematographer: Milton Krasner; Music and lyrics: Mack Gordon and Harry Revel. Cast: Jack Oakie, Jack Haley, Ginger Rogers, Thelma Todd, Gregory Ratoff, Lew Cody.

Flying Down to Rio 1933 RKO-Radio
Director: Thornton Freeland; Executive producer: Merian C. Cooper; Associate producer: Lou Brock; Screenplay: Cyril Hume, H. W. Hanemann, and Erwin Gelsey, from a play by Anne Caldwell and based on an original story by Lou Brock; Cinematographer: J. Roy Hunt; Music and lyrics: Vincent Youmans, Gus Kahn, and Edward Eliscu. Cast: Dolores Del Rio, Gene Raymond, Raul Roulien, Ginger Rogers, Fred Astaire, Eric Blore, Franklin Pangborn.

Chance at Heaven 1933 RKO-Radio
Director: William A. Seiter; Executive producer: Merian C. Cooper; Associate producer: H. N. Swanson; Screenplay: Julian Josephson and Sarah Y. Mason, from the story by Viña Delmar; Cinematographer: Nick Musuraca. Cast: Ginger Rogers, Joel McCrea, Marian Nixon, Andy Devine, Lucien Littlefield.

Rafter Romance 1934 RKO-Radio
Director: William A. Seiter; Executive producer: Merian C. Cooper; Producer: Alexander McKaig; Screenplay: H. W. Hanemann and Sam Mintz, from a story by John Wells; Cinematographer: David Abel. Cast: Ginger Rogers, Norman Foster, George Sidney, Robert Benchley, Laura Hope Crews, Guinn Williams.

Finishing School 1934 RKO-Radio
Director: Wanda Tuchock and George Nicholls, Jr.; Executive producer: Merian C. Cooper; Screenplay: Wanda Tuchock and Laird Doyle, from a story by David Hempstead; Cinematographer: J. Roy Hunt. Cast: Frances Dee, Billie

Burke, Ginger Rogers, Bruce Cabot, John Halliday, Beulah Bondi.

20 Million Sweethearts 1934 First National & Vitaphone
Director: Ray Enright; Screenplay: Warren Duff and Harry Sauber; Story by Paul Finder Moss and Jerry Wald; Cinematographer: Sid Hickox; Music and lyrics: Harry Warren and Al Dubin. Cast: Pat O'Brien, Dick Powell, Ginger Rogers, Four Mills Brothers, Allen Jenkins, Grant Mitchell.

Change of Heart 1934 Fox
Director: John G. Blystone; Producer: Winfield Sheehan; Screenplay: Sonya Levien and James Gleason, from the novel *Manhattan Love Song* by Kathleen Norris; Cinematographer: Hal Mohr; Music and lyrics: Harry Akst. Cast: Janet Gaynor, Charles Farrell, James Dunn, Ginger Rogers, Shirley Temple.

Upperworld 1934 Warner Bros. & Vitaphone
Director: Roy Del Ruth; Screenplay: Ben Markson, from the story by Ben Hecht; Cinematographer: Tony Gaudio. Cast: Warren William, Mary Astor, Ginger Rogers, Andy Devine, Dickie Moore, J. Carrol Naish.

The Gay Divorcee 1934 RKO-Radio
Director: Mark Sandrich; Producer: Pandro S. Berman; Screenplay: George Marion, Jr., Dorothy Yost and Edward Kaufman, from the *Gay Divorce*, book by Dwight Taylor, musical adaptation by Kenneth Webb and Samuel Hoffenstein; Cinematographer: David Abel; Music and lyrics: Cole Porter, Mack Gordon and Harry Revel, Con Conrad and Herb Magidson. Cast: Fred Astaire, Ginger Rogers, Alice Brady, Edward Everett Horton, Erik Rhodes, Eric Blore.

Romance in Manhattan 1934 RKO-Radio
Director: Stephen Roberts; Producer: Pandro S. Berman; Screenplay: Jane Murfin and Edward Kaufman, from a story by Norman Krasna and Don Hartman; Cinematographer: Nick Musuraca. Cast: Francis Lederer, Ginger Rogers, Arthur Hohl, Jimmy Butler, J. Farrell MacDonald.

Roberta 1935 RKO-Radio
Director: William A. Seiter; Producer: Pandro S. Berman; Screenplay: Jane Murfin, Sam Mintz, and Allan Scott, from the play *Roberta*, music by Jerome Kern, book and lyrics by Otto Harbach, and from the novel *Gowns by Roberta* by Alice Duer Miller; Cinematographer: Edward Cronjager. Cast: Irene Dunne, Fred Astaire, Ginger Rogers, Randolph Scott, Helen Westley, Claire Dodd, Victor Varconi.

Star of Midnight 1935 RKO-Radio
Director: Stephen Roberts; Producer: Pandro S. Berman; Screenplay: Howard J. Green, Anthony Veiller, and Edward Kaufman, from the novel by Arthur Somers Roche; Cinematographer: J. Roy Hunt. Cast: William Powell, Ginger Rogers, Paul Kelly, Gene Lockhart, Ralph Morgan, Leslie Fenton, J. Farrell MacDonald, Vivien Oakland.

Top Hat 1935 RKO-Radio
Director: Mark Sandrich; Producer: Pandro S. Berman; Screenplay: Dwight Taylor and Allan Scott; Cinematographer: David Abel; Music and lyrics: Irving Berlin. Cast: Fred Astaire, Ginger Rogers, Edward Everett Horton, Erik Rhodes, Eric Blore, Helen Broderick, Lucille Ball.

In Person 1935 RKO-Radio
Director: William A. Seiter; Producer: Pandro S. Berman; Screen Play: Allan Scott, from the novel by Samuel Hopkins Adams; Cinematographer: Edward Cronjager; Music and lyrics: Oscar Levant and Dorothy Fields. Cast: Ginger Rogers, George Brent, Alan Mowbray, Grant Mitchell, Samuel S. Hinds.

Follow the Fleet 1936 RKO-Radio
Director: Mark Sandrich; Producer: Pandro S. Berman; Screenplay: Dwight Taylor and Allan Scott, based on the play *Shore Leave* by Hubert Osborne; Cinematographer: David Abel; Music and lyrics: Irving Berlin. Cast: Fred Astaire, Ginger Rogers, Randolph Scott, Harriet Hilliard, Astrid Allwyn.

Swing Time 1936 RKO-Radio
Director: George Stevens; Producer: Pandro S. Berman; Screenplay: Howard Lindsay and Allan Scott, from a story by Erwin Gelsey; Cinematographer: David Abel; Music and lyrics: Jerome Kern and Dorothy Fields. Cast: Fred Astaire, Ginger Rogers, Victor Moore, Helen Broderick, Eric Blore, Betty Furness, Georges Metaxa.

Shall We Dance 1937 RKO-Radio
Director: Mark Sandrich; Producer: Pandro S. Berman; Screenplay: Allan Scott and Ernest Pagano, based on a story by Lee Loeb and Harold Buckman; Cinematographer: David Abel; Music and lyrics: George Gershwin and Ira Gershwin. Cast: Fred Astaire, Ginger Rogers, Edward Everett Horton, Eric Blore, Jerome Cowan, Ketti Gallian, William Brisbane.

Stage Door 1937 RKO-Radio
Director: Gregory La Cava; Producer: Pandro S. Berman;

Screenplay: Morrie Ryskind and Anthony Veiller, from the play by Edna Ferber and George S. Kaufman; Cinematographer: Robert de Grasse; Music and lyrics: Hal Borne and Mort Greene. Cast: Katharine Hepburn, Ginger Rogers, Adolphe Menjou, Gail Patrick, Constance Collier, Andrea Leeds, Samuel S. Hinds, Lucille Ball, Ann Miller, Eve Arden, Franklin Pangborn, Jack Carson.

Having Wonderful Time 1938 RKO-Radio
Director: Alfred Santell; Producer: Pandro S. Berman; Screenplay: Arthur Kober, adapted from the play by Arthur Kober; Cinematographer: Robert de Grasse; Music and lyrics: Sammy Stept and Charles Tobias. Cast: Ginger Rogers, Douglas Fairbanks, Jr., Peggy Conklin, Lucille Ball, Lee Bowman, Eve Arden, Dorothea Kent, Richard "Red" Skelton, Donald Meek, Jack Carson.

Vivacious Lady 1938 RKO-Radio
Director: George Stevens; Executive producer: Pandro S. Berman; Producer: George Stevens; Screenplay: P. J. Wolfson and Ernest Pagano, from a story by I. A. R. Wylie; Cinematographer: Robert de Grasse; Music and lyrics: Jack Meskill and Ted Shapiro. Cast: Ginger Rogers, James Stewart, James Ellison, Beulah Bondi, Charles Coburn, Frances Mercer.

Carefree 1938 RKO-Radio
Director: Mark Sandrich; Producer: Pandro S. Berman; Screenplay: Ernest Pagano and Allan Scott, based on an original idea by Marian Ainslee and Guy Endore; Cinematographer: Robert de Grasse; Music and lyrics: Irving Berlin. Cast: Fred Astaire, Ginger Rogers; Ralph Bellamy, Luella Gear, Jack Carson, Clarence Kolb, Franklin Pangborn, Hattie McDaniel.

The Story of Vernon and Irene Castle 1939 RKO-Radio
Director: H. C. Potter; Executive producer: Pandro S. Berman; Producer: George Haight; Screenplay: Richard Sherman, based on the stories "My Husband" and "My Memories of Vernon Castle" by Irene Castle; Cinematographer: Robert de Grasse; Original music and lyrics: Con Conrad, Bert Kalmar, and Herman Ruby. Cast: Fred Astaire, Ginger Rogers, Edna May Oliver, Walter Brennan, Lew Fields, Etienne Girardot, Janet Beecher.

Bachelor Mother 1939 RKO-Radio
Director: Garson Kanin; Executive producer: Pandro S. Berman; Producer: B. G. DeSylva; Screenplay: Norman Krasna, from a story by Felix Jackson; Cinematographer: Robert de

Grasse. Cast: Ginger Rogers, David Niven, Charles Coburn, Frank Albertson, E. E. Clive, Elbert Coplen, Jr.

Fifth Avenue Girl 1939 RKO-Radio
Director: Gregory La Cava; Executive producer: Pandro S. Berman; Producer: Gregory La Cava; Screenplay: Allan Scott; Cinematographer: Robert de Grasse. Cast: Ginger Rogers, Walter Connolly, Verree Teasdale, James Ellison, Tim Holt, Kathryn Adams, Franklin Pangborn.

Primrose Path 1940 RKO-Radio
Director: Gregory La Cava; Producer: Gregory La Cava; Screenplay: Allan Scott and Gregory La Cava, from the play by Robert L. Buckner and Walter Hart; Cinematographer: Joseph August. Cast: Ginger Rogers, Joel McCrea, Marjorie Rambeau, Henry Travers, Miles Mander, Queenie Vassar, Joan Carroll.

Lucky Partners 1940 RKO-Radio
Director: Lewis Milestone; Executive producer: Harry E. Edington; Producer: George Haight; Screenplay: Allan Scott and John Van Druten, adapted from the story "Bonne Chance" by Sacha Guitry; Cinematographer: Robert de Grasse. Cast: Ronald Colman, Ginger Rogers, Jack Carson, Spring Byington, Harry Davenport.

Kitty Foyle 1940 RKO-Radio
Director: Sam Wood; Executive producer: Harry E. Edington; Producer: David Hempstead; Screenplay: Dalton Trumbo, from the novel by Christopher Morley; Cinematographer: Robert de Grasse. Cast: Ginger Rogers, Dennis Morgan, James Craig, Eduardo Ciannelli, Ernest Cossart, Gladys Cooper, Katharine Stevens, Odette Myrtil, Mary Treen.

Tom, Dick and Harry 1941 RKO-Radio
Director: Garson Kanin; Producer: Robert Sisk; Screenplay: Paul Jarrico; Cinematographer: Merrit Gerstad. Cast: Ginger Rogers, George Murphy, Alan Marshal, Burgess Meredith, Joe Cunningham, Jane Seymour, Lenore Lonergan, Phil Silvers.

Roxie Hart 1942 20th Century–Fox
Director: William A. Wellman; Producer: Nunnally Johnson; Screenplay: Nunnally Johnson, based on the play *Chicago* by Maurine Watkins; Cinematographer: Leon Shamroy. Cast: Ginger Rogers, Adolphe Menjou, George Montgomery, Lynne Overman, Nigel Bruce, Phil Silvers, Sara Allgood, William Frawley, Spring Byington, George Chandler.

Tales of Manhattan 1942 20th Century–Fox
Director: Julien Duvivier; Producer: Boris Morros and S. P. Eagle; Screenplay and original stories: Ben Hecht, Ferenc Molnar, Donald Ogden Stewart, Samuel Hoffenstein, Alan Campbell, L. Fodor, L. Vadnay, Laszlo Gorog, Lamar Trotti, Henry Blankfort; Cinematographer: Joseph Walker. Cast: Charles Boyer, Rita Hayworth, Ginger Rogers, Henry Fonda, Cesar Romero, Roland Young, Gail Patrick.

The Major and the Minor 1942 Paramount
Director: Billy Wilder; Producer: Arthur Hornblow, Jr.; Screenplay: Charles Brackett and Billy Wilder, suggested by a play by Edward Childs Carpenter from a story by Fannie Kilbourne; Cinematographer: Leo Tover. Cast: Ginger Rogers, Ray Milland, Rita Johnson, Robert Benchley, Diana Lynn, Lela Rogers, Raymond Roe, Frankie Thomas, Jr., Edward Fielding.

Once Upon a Honeymoon 1942 RKO-Radio
Director: Leo McCarey; Producer: Leo McCarey; Screenplay: Sheridan Gibney; Story by Sheridan Gibney and Leo McCarey; Cinematographer: George Barnes. Cast: Ginger Rogers, Cary Grant, Walter Slezak, Albert Dekker, Albert Basserman.

Tender Comrade 1943 RKO-Radio
Director: Edward Dmytryk; Producer: David Hempstead; Screenplay: Dalton Trumbo; Cinematographer: Russell Metty. Cast: Ginger Rogers, Robert Ryan, Ruth Hussey, Patricia Collinge, Mady Christians, Kim Hunter, Jane Darwell.

Lady in the Dark 1944 Paramount
Director: Mitchell Leisen; Producer: Mitchell Leisen; Screenplay: Frances Goodrich and Albert Hackett; based on the play by Moss Hart; Cinematographer: Ray Rennahan; Music and lyrics: Kurt Weill and Ira Gershwin, Johnny Burke and Jimmy Van Heusen, Robert Emmett Dolan, Clifford Grey and Victor Schertzinger. Cast: Ginger Rogers, Ray Milland, Warner Baxter, Jon Hall, Barry Sullivan, Mischa Auer, Phyllis Brooks.

I'll Be Seeing You 1944 Selznick International
Director: William Dieterle; Producer: Dore Schary; Screenplay: Marion Parsonnet, based on the radio play by Charles Martin; Cinematographer: Tony Gaudio; Music and lyrics: Sammy Fain and Irving Kahal. Cast: Ginger Rogers, Joseph Cotten, Shirley Temple, Spring Byington, Tom Tully.

Weekend at the Waldorf 1945 Metro-Goldwyn-Mayer
Director: Robert Z. Leonard; Producer: Arthur Hornblow,

Jr.; Screenplay: Sam and Bella Spewack, suggested by a play by Vicki Baum; Cinematographer: Robert Planck; Music and lyrics: Sammy Fain and Ted Koehler. Cast: Ginger Rogers, Lana Turner, Walter Pidgeon, Van Johnson, Edward Arnold, Keenan Wynn, Robert Benchley, Xavier Cugat.

Heartbeat 1946 RKO-Radio
Director: Sam Wood; Producer: Robert and Raymond Hakim; Screenplay: Hans Wilhelm, Max Kolpe, and Michel Duran; Cinematographer: Joseph Valentine; Music and lyrics: Paul Misraki and Ervin Drake. Cast: Ginger Rogers, Jean Pierre Aumont, Adolphe Menjou, Basil Rathbone, Eduardo Ciannelli.

Magnificent Doll 1946 Universal
Director: Frank Borzage; Producer: Jack H. Skirball and Bruce Manning; Screenplay: Irving Stone; Cinematographer: Joseph Valentine. Cast: Ginger Rogers, David Niven, Burgess Meredith, Peggy Wood, Horace (Stephen) McNally.

It Had to Be You 1947 Columbia
Director: Don Hartman and Rudolph Maté; Producer: Don Hartman; Screenplay: Norman Panama and Melvin Frank; Story by Don Hartman and Allen Boretz; Cinematographer: Rudolph Maté and Vincent Farrar. Cast: Ginger Rogers, Cornel Wilde, Percy Waram, Spring Byington, Ron Randell, Thurston Hall, Anna Q. Nilsson.

The Barkleys of Broadway 1949 Metro-Goldwyn-Mayer
Director: Charles Walters; Producer: Arthur Freed; Screenplay: Betty Comden and Adolph Green; Cinematographer: Harry Stradling; Music and lyrics: Harry Warren and Ira Gershwin, George Gershwin and Ira Gershwin. Cast: Fred Astaire, Ginger Rogers, Oscar Levant, Billie Burke, Gale Robbins, Jacques Francois.

Perfect Strangers 1950 Warner Bros.
Director: Bretaigne Windust; Producer: Jerry Wald; Screenplay: Edith Sommer, adapted by George Oppenheimer, based on a stage play by Ben Hecht and Charles MacArthur from a drama by L. Bush-Fekete; Cinematographer: Peverell Marley. Cast: Ginger Rogers, Dennis Morgan, Thelma Ritter, Paul Ford, George Chandler, Marjorie Bennett.

Storm Warning 1950 Warner Bros.
Director: Stuart Heisler; Producer: Jerry Wald; Screenplay: Daniel Fuchs and Richard Brooks; Cinematographer: Carl

Guthrie. Cast: Ginger Rogers, Ronald Reagan, Doris Day, Steve Cochran, Hugh Sanders.

The Groom Wore Spurs 1951 Universal
Director: Richard Whorf; Producer: Howard Welsch; Screenplay: Robert Carson, Robert Libbott, and Frank Burt, based on a story by Robert Carson; Cinematographer: Peverell Marley. Cast: Ginger Rogers, Jack Carson, Joan Davis.

We're Not Married 1952 20th Century–Fox
Director: Edmund Goulding; Producer: Nunnally Johnson; Screenplay: Nunnally Johnson, from a story by Gina Kaus and Jay Dratler; Cinematographer: Leo Tover. Cast: Ginger Rogers, Fred Allen, Victor Moore, Marilyn Monroe, David Wayne, Eve Arden, Paul Douglas, Eddie Bracken, Mitzi Gaynor, Louis Calhern, Zsa Zsa Gabor, James Gleason.

Monkey Business 1952 20th Century–Fox
Director: Howard Hawks; Producer: Sol C. Siegel; Screenplay: Ben Hecht, Charles Lederer, and I. A. L. Diamond; Story by Harry Segall; Cinematographer: Milton Krasner. Cast: Cary Grant, Ginger Rogers, Charles Coburn, Marilyn Monroe, Hugh Marlowe.

Dreamboat 1952 20th Century–Fox
Director: Claude Binyon; Producer: Sol C. Siegel; Screenplay: Claude Binyon; Story by John D. Weaver; Cinematographer: Milton Krasner. Cast: Clifton Webb, Ginger Rogers, Anne Francis, Jeffrey Hunter, Elsa Lanchester, Fred Clark.

Forever Female 1953 Paramount
Director: Irving Rapper; Producer: Pat Duggan; Screenplay: Julius J. Epstein and Philip G. Epstein, suggested by the play *Rosalind* by James M. Barrie; Cinematographer: Harry Stradling. Cast: Ginger Rogers, William Holden, Paul Douglas, James Gleason, Pat Crowley.

Black Widow 1954 20th Century-Fox
Director: Nunnally Johnson; Producer: Nunnally Johnson; Screenplay: Nunnally Johnson, from a story by Patrick Quentin; Cinematographer: Charles G. Clarke. Cast: Ginger Rogers, Van Heflin, Gene Tierney, George Raft, Peggy Ann Garner, Reginald Gardiner, Otto Kruger.

Twist of Fate 1954 British Lion Corp. (Released in Great Britain as *Beautiful Stranger*.)
Director: David Miller; Producer: Maxwell Setton and John R. Sloan; Screenplay: Robert Westerby and Carl Nystron; Original story by Rip Van Ronkel and David Miller; Cinema-

tographer: Ted Scaife. Cast: Ginger Rogers, Herbert Lom, Stanley Baker, Jacques Bergerac, Coral Browne.

Tight Spot 1955 Columbia
Director: Phil Karlson; Producer: Lewis J. Rachmil; Screenplay: William Bowers, based on the play *Dead Pigeon* by Lenard Kantor; Cinematographer: Burnett Guffey. Cast: Ginger Rogers, Edward G. Robinson, Brian Keith, Lucy Marlow, Lorne Greene.

The First Traveling Saleslady 1956 RKO-Radio
Director: Arthur Lubin; Producer: Arthur Lubin; Screenplay: Devery Freeman and Stephen Longstreet; Cinematographer: William Snyder. Cast: Ginger Rogers, Barry Nelson, Carol Channing, David Brian, James Arness, Clint Eastwood.

Teenage Rebel 1956 20th Century–Fox
Director: Edmund Goulding; Producer: Charles Brackett; Screenplay: Walter Reisch and Charles Brackett, from a play by Edith Sommer; Cinematographer: Joe MacDonald. Cast: Ginger Rogers, Michael Rennie, Mildred Natwick, Rusty Swope, Lili Gentle, Louise Beavers, Irene Hervey, John Stephenson, Betty Lou Keim, Warren Berlinger, Diane Jergens.

Oh! Men, Oh! Women. 1957 20th Century–Fox
Director: Nunnally Johnson; Producer: Nunnally Johnson; Screenplay: Nunnally Johnson, from the play by Edward Chodorov; Cinematographer: Charles G. Clarke. Cast: Dan Dailey, Ginger Rogers, David Niven, Barbara Rush, Tony Randall.

The Confession 1965 Kay Lewis Enterprises (Also known as *Quick, Let's Get Married*, 1971.)
Director: William Dieterle; Producer: William Marshall; Screenplay: Allan Scott; Cinematographer: Robert Brenner. Cast: Ginger Rogers, Ray Milland, Barbara Eden, Elliott Gould, Walter Abel, Pippa Scott, Michael Ansara, Cecil Kellaway.

Harlow 1965 Magna
Director: Alex Segal; Executive producer: Brandon Chase; Producer: Lee Savin; Screenplay: Karl Tunberg; Cinematographer; Jim Kilgore. Cast: Ginger Rogers, Carol Lynley, Efrem Zimbalist, Jr., Barry Sullivan, Hurd Hatfield, Lloyd Bochner, Hermione Baddeley, Audrey Totter.

STAGE APPEARANCES

1925–1928	Vaudeville Theatres—Touring the United States
1929	*Top Speed*—New York City
1930	*Girl Crazy*—New York City
1951	*Love and Let Love*—New York City
1959	*The Pink Jungle*—San Francisco to Boston
1960	*Annie Get Your Gun*—New England states
1961	*Bell, Book and Candle*—New England states
1961	*Calamity Jane*—New England states
1962	*Husband and Wife*—Phoenix
1963	*The Unsinkable Molly Brown*—Western states
1963	*A More Perfect Union*—La Jolla
1964	*Tovarich*—United States tour
1965–1968	*Hello, Dolly!*—New York City and National Touring Company
1969–1970	*Mame*—London
1971	*Coco*—New England states
1974	*No, No, Nanette*—Dallas
1974–1975	*40 Carats*—Chicago
1975–1979	*The Ginger Rogers Show*—United States and international cities
1980	*Anything Goes*—United States tour
1983	*Miss Moffat*—Indianapolis
1984	*Charley's Aunt*—Edmonton

INDEX